New Philosophy for New Media

New Philosophy for New Media

Mark B. N. Hansen

The MIT Press Cambridge, Massachusetts London, England

First MIT Press paperback edition, 2006

MIT Press books may be purchased at special quantity discounts for business or sales promotional use. For information, please email <special_sales@mitpress.mit.edu> or write to Special Sales Department, The MIT Press, 55 Hayward Street, Cambridge, MA 02142.

This book was set in Adobe Garamond and Rotis Sans Serif by Graphic Composition, Inc., and was printed and bound in the United States of America.

Sections of chapter 2 are drawn from "Cinema beyond Cybernetics, or How to Frame the Digital-Image," *Configurations* 11.1 (winter 2002): 51–90. A different version of chapter 3 appeared as "Seeing with the Body: The Digital-Image in Post-Photography," *Diacritics* (2003). A different version of chapter 4 appeared as "Affect as Medium, or the 'Digital Facial Image,'" *Journal of Visual Culture* (August 2003). An earlier version of chapter 6 appeared as "The Affective Topology of New Media Art," *Spectator* 21.1 (winter 2001): 40–70.

Library of Congress Cataloging-in-Publication Data

Hansen, Mark. B. N.
 New philosophy for new media / Mark B. N. Hansen.
 p. cm.
 Includes bibliographical references and index.
 ISBN-13 978-0-262-08321-8 (hc. : alk. paper)—978-0-262-58266-7 (pbk. : alk. paper)
 1. Aesthetics. 2. Body, Human (Philosophy). 3. Digital media—Philosophy. 4. Image (Philosophy). 5. Digital art—Philosophy. I. Title.

BH301.M3H36 2003
111'.85—dc21
 2003042236

10 9 8 7 6 5 4 3

Contents

List of Figures

All images courtesy of the artist unless otherwise noted.

Acknowledgments

Like any book, this one is the fruit of a long and debt-ridden gestation period.

The project evolved through a series of group experiences, each of which made a crucial contribution to what you find before you. I thank Kate Hayles and the students in her 1998 NEH summer seminar for planting the initial seeds. I thank my students at Stanford University, Scott Bukatman, and the entire Department of Art History for offering me a forum to immerse myself in the field of new media art. I thank Tim Lenoir, Casey Alt, Steven Meyer, Haun Saussy, and the members of the Writing Science Group at Stanford University for compelling my first focused engagement with video and new media art and also for many stimulating discussions in and around the field of contemporary imaging technologies. I thank the Center for Media Art in Karlsruhe, Germany, and especially Annika Blunk, Jeffrey Shaw, Birgit Wien, and Thomas Zandegiacomo Del Bel, for their generous welcome and for furnishing a wealth of material indispensable to my research. I thank the students in my 2001 graduate seminar on the body at Princeton University for challenging and (I can only hope) strengthening my theoretical engagement with Bergson, Deleuze, and much else besides. And finally, I thank Irving Lavin and the members of the Art History Group at the Institute for Advanced Study who helped me frame my argument in the context of the wider institutional practices at work in the contemporary art world.

Along the way, I have had the chance to try out my arguments on many welcoming and helpful ears and eyes. I especially thank audiences at the Society for Science and Literature conference in 2001, at the Society for Cinema Studies conferences in 2001 and 2002, at the DAC conference in 2001, at the American Comparative Literature Association in 2001, at the Stanford Writing Science Workshop in 2002, and at the Surviving the Photograph conference at Princeton in 2000. An embarassingly large number of colleagues, students, and

friends have made important contributions of various sorts. I especially thank Karen Beckman, Dave Boothroyd, Stuart Burrows, Eduardo Cadava, Taylor Carman, Michel Chaouli, Bruce Clark, Jonathan Crary, Hugh Crawford, Craig Dworkin, Diana Fuss, Eric Gordon, Raiford Guins, Michael Hardt, Martin Jay, John Johnston, Douglas Kahn, Jeannie Kim, Friedrich Kittler, Jonathan Lamb, Tom Levin, Juliet MacCannell, Brian Massumi, John Matson, Tara McPherson, Steven Meyer, J. Hillis Miller, Timothy Murray, Dietrich Neumann, Dan Novak, Brigitte Peucker, Stephen Phillips, Beatriz Preciado, John Protevi, Ingeborg Rocker, Michael Sayeau, Jeffrey Shaw, Elaine Showalter, Stephanie Smith, Vance Smith, Vivian Sobchack, Kirk Varnedoe, Bill Viola, Jennifer Waldron, John Walsh, Geoffrey Winthrop-Young, Michael Wood, and Michael Wütz. I thank Roger Conover, my editor at MIT Press, for his encouragement and candid advice. I remain indebted to Tim Lenoir, Bruce Clarke, and three anonymous readers for truly inspiring feedback. I can only hope that my attempts to respond to their incisive comments have made my argument a more persuasive one for academic and nonacademic readers alike. I owe a special debt of gratitude to Kate Hayles, for opening my eyes to the fascinating correlations between literature and media and for encouraging me to follow my intellectual interests wherever they might lead, and to Tim Lenoir, for his morale-sustaining enthusiasm at my effort to defend human embodiment and for his far-sighted vision of its urgency at this moment of massive technological change.

This project was assisted through various forms of institutional support. I am deeply grateful to the School of Historical Studies at the Institute for Advanced Study, the Mellon Foundation, the National Endowment for the Humanities, Princeton University, and Stanford University for grants and leave time that made possible the research and writing of this project. I can't say enough about my colleagues in the English department at Princeton. Not only have they offered an environment conducive to intellectual growth, but they have very generously allowed me to pursue my own path toward understanding the expanded role of literature in today's multimedia cultural environment.

I wish to extend a special thanks to the artists themselves, the vast majority of whom I know only through email. It is their experimentations with new media that have, quite literally, made this project possible.

Finally, I thank Mimi and Wilson, who make the rest of my life special.

I dedicate this book to my father, whose love of art inspired my own.

Foreword

Tim Lenoir

Haptic Vision: Computation, Media, and Embodiment in Mark Hansen's New
Phenomenology

The intertwined themes of ocularcentrism and disembodiment have been cen-
tral to critical studies of new media since its beginnings more than two decades
ago. Of course, metaphors of vision and light have always been coupled with
notions of abstraction and immateriality, but in an era saturated with computer-
generated imaging modalities the theme of disembodiment had taken on rad-
ical new dimensions. Electronic digitality has been accused of eviscerating the
real and of liquidating reference, truth, and objectivity.[1] Whereas analog pho-
tographs adhered to reality by virtue of their physical modes of production,
digital images are fabricated through layers of algorithmic computer processing
with no trace of the materially mimetic qualities of film, (predigital) photog-
raphy, or (analog) television. The digital image is a matrix of numbers, a table
composed of integers, a grid of cells capable of being stored in computer
memory, transmitted electronically and interpreted into an image by a display
device (such as a video screen) or printer. Citing 1989 as the dawn of the post-
photographic era when digital recording and processing began to replace pho-
tography, William Mitchell claims that "Images in the post-photographic era
can no longer be guaranteed as visual truth—or even as signifiers with stable
meaning and value."[2]

Having crossed into the territory of the post-photographic era, concern
that electronic digitality was about to deterritorialize the human subject was
not far behind. Closely associated with the loss of reference in the production
of images, philosophers and media theorists such as Paul Virilio, Jonathan
Crary, and William Mitchell registered a profound shift taking place in the

institutions constituting the subjectivity of the viewer and, indeed, even the dematerialization of the observer altogether. Jonathan Crary has argued that new technologies of image production have become broadly institutionalized within the military, medicine, science, media, and the arts, with a concomitant restructuring of traditional institutions, transformation of social practices, and instantiation of new belief structures. According to Mitchell, "A worldwide network of digital imaging systems is swiftly, silently constituting itself as the decentered subject's reconfigured eye."[3] For Crary this shift that is taking place in visual culture as a result of computer-based image processing signals that important functions of the human eye are being supplanted by practices in which visual images no longer have any reference to the position of an observer in a "real," optically perceived world. Crary writes,

> If these images can be said to refer to anything it is to millions of bits of electronic mathematical data. Increasingly, visuality will be situated on a cybernetic and electromagnetic terrain where abstract visual and linguistic elements coincide and are consumed circulated, and exchanged globally.[4]

For Crary, as for Mitchell, in the shift to digitality the embodied human observer with her repertoire of techniques for decoding sensations is displaced by a new abstract regime of computer code where standards of vision are set by machinic processes of pattern recognition and statistical sampling. With the advent of computer technology allowing a satellite, MRI scanner, or tunneling microscope to capture and process an image, then send it to another computer where the image is analyzed and interpreted in terms of other algorithms and data-processing techniques, vision becomes machinic; and in the process human observers are placed on the same plane as machines of vision.[5]

The work of Crary, Virilio, Mitchell, and others has directed attention to the power of manipulation inherent in new visualization technologies and the tendency of digital imaging to detach the viewer from an embodied, haptic sense of physical location and "being-there." Reflections on problems of reference connected with digital imaging were magnified and extended to other senses with the introduction of early work on virtual reality in the mid-1980s and early 1990s. But even prior to the development of practical VR systems, critical and popular discourse concerning the prospects of virtual reality and its

representation in literature and film coded the perception of new electronic media as abstract, disembodied, and decontextualized information. In his 1965 paper, "The Ultimate Display," Ivan Sutherland, who constructed the first head-mounted display in the 1960s preparing the way for experimentation with VR, emphasized the power of a digital display connected to a computer to reshape the physical conditions of embodiment: "There is no reason why the objects displayed by a computer have to follow the ordinary rules of physical reality," Sutherland wrote: "The ultimate display would, of course, be a room within which the computer can control the existence of matter."[6] Developing the notion of virtual reality as providing access to an abstract transcendent realm, in the first cyberpunk novel *Neuromancer,* William Gibson defined cyberspace as "a consensual hallucination" and as "the nonspace of the mind."[7] Such ideas were given powerful visual presentation in numerous popular films from 1982 to 1992, bracketed by *Tron* (1982) and *Lawnmower Man* (1992) in which protagonists are uploaded through the net into cyberspace and where bodies as informational patterns fuse in the ecstasy of virtual sex. The struggle over embodiment has continued in filmic representations right up to the present, thematized in films such as the *Matrix* trilogy, where obsolete humans struggle to regain their mastery over material reality and their own bodies, by becoming Zen masters of cyberspace embedded in a quantum-computational universe where the world is a computer and everything in it a simulation.

From the very beginning of critical engagement with computer technology, concern has been voiced about the potential, feared by many, celebrated by some, of the end of humanity. The fear that technological developments associated with computer technology, artificial intelligence, robotics, and more recently nanotechnology will succeed in displacing humanity through an evolutionary process leading first to a cyborg/human assemblage and ultimately to the extinction and replacement of the human altogether has been with us at least since the writings of Leroi-Gourhan in the 1960s.[8] These ominous early speculations have been repeated in various forms throughout the intervening years and have been given added substance by authoritative figures such as Bill Joy of Sun Microsystems, who titled his April 2000 *Wired Magazine* essay, "Why the future doesn't need us: our most powerful 21st century technologies—robotics, genetic engineering, and nanotech—are threatening to make humans an endangered species."[9] Sounding a different note, Ray Kurzweil, an

AI researcher and recipient of numerous awards including the 1999 National Medal of Technology for his inventions in the area of text and speech recognition, has put a celebratory twist on this story with detailed timelines and imaginative narratives of how the posthuman transformation will take place over the next decades: by 2040, Kurzweil predicts, fourth-generation robots will have human capabilities, and by 2099, according to Kurzweil, human thinking and machine intelligence will have merged with no meaningful distinction left between humans and computers.[10]

N. Katherine Hayles has given a useful summary definition of the view of the posthuman circulating in the musings of these theorists. According to Hayles, the posthuman view configures human being so that it can be seamlessly articulated with intelligent machines. In the posthuman, there are no essential differences or absolute demarcations between bodily existence and computer simulation, cybernetic mechanism and biological organism, robot teleology and human goals.[11] A central conception fueling this version of posthuman ideology is the notion of information as disembodied, a view that Hayles locates precisely in the Shannon-Weaver theory of information and the debates surrounding it among members of the early cybernetics movement in the Macy Conferences held from 1943 to 1954. The Shannon-Weaver theory, which set the agenda of those meetings, views information stochastically or probabilistically. The central notion of information in Shannon and Weaver's work is that the information carried by a message or symbol depends on its probability of being selected. It is carried discretely as symbols encoded as binary digits, which are selected from a set of possible symbols. For Shannon the issue was not about communicating significance or meaning but simply about optimizing the ratio of signal-to-noise in message transmission. Shannon measured information as inversely proportional to the probability of a signal reaching its receiver, and its quality in this formulation is determined by message length, complexity, and signal integrity. The *meaning* of the symbols encoding a message is completely irrelevant, though a binary digit may represent the toss of a coin (heads or tails) or the fate of the universe (expand or collapse). Hayles makes the valuable point that Shannon and Weaver sought a general formulation of information that could be calculated as the same value regardless of the contexts in which it was embedded. Conceived in this way information was in-

dependent of context, a probability function with no dimensions, no materiality, and no necessary connection with meaning.[12]

In contrast to the notion of information developed by Shannon and Weaver, which treated information as completely decontextualized and separate from meaning, the British researcher Donald McKay was developing an alternative notion that included recognizing not only the probability of selecting a message as its informational value, but also a structural component of a message that indicates how it is to be interpreted. Structural information in McKay's view is semantic and has to be calculated through changes brought about in the receiver's mind. This notion of information strongly correlates the nature of a representation with its effect, making information an action measured by the effect it has on the receiver. Put simply, whereas the Shannon-Weaver model treats what information is, the McKay model measures information by what it does. This mutual constitution of message and receiver seemed too subjective and difficult to measure and so was dropped by the American cyberneticists, even though it continued to be central for the British school of information theory. Hayles argues that alternative models of information were available. The path taken was not inevitable, and the (Shannon-Weaver) version that was accepted was due to historical contingencies related to the strength of allies and the availability of quantitative techniques associated with the Shannon model. An alternative discourse could have been constructed. Rather than simply acquiescing in a view of the posthuman as an apocalyptic erasure of human subjectivity, the posthuman, Hayles argues, can be made to stand for a positive partnership among nature, humans, and intelligent machines.

In *New Philosophy for New Media* Mark Hansen addresses the issues of embodiment, agency, and digitality that have been central to these debates concerning posthumanism. The key position Hansen sets out to critique is represented in the extreme by Friedrich Kittler. In *Gramophone, Film, Typewriter,* Kittler makes the Shannon-Weaver notion of information as disembodied the center of his own theory of new media. In one of his typically hyperbolic but eminently quotable statements, Kittler opens with the claim that when all movies, music, phone calls and texts reach households linked by optical fiber networks, the formerly distinct media of television, radio, telephone, and mail

converge, standardized by transmission frequencies to bit format. This convergence of all media under the digital regime actually spells the end of media. Media effectively become different interfaces to the ubiquitous flow of information:

> Before the end, something is coming to an end. The general digitization of channels and information erases the differences among individual media. Sound and image, voice and text are reduced to surface effects, known to consumers as interface. Sense and the senses turn into eyewash. Their media-produced glamour will survive for an interim as a by-product of strategic programs. Inside the computers themselves everything becomes a number: quantity without image, sound or voice. And once optical fiber networks turn formerly distinct data flows into a standardized series of digitized numbers, any medium can be translated into any other. With numbers, everything goes. Modulation, transformation, synchronization; delay, storage, transposition; scrambling, scanning, mapping—a total media link on a digital base will erase the very concept of medium. Instead of wiring people and technologies, absolute knowledge will run as an endless loop.[13]

With digital convergence Kittler sees human perception—indeed human beings themselves—becoming obsolete. As Hansen points out so forcefully, according to Kittler in the post-medium condition, the pure flow of data will no longer need to adapt itself to human perceptual ratios. In contrast to Kittler, here a representative of theorists who focus on digital media as sites of disembodiment, Hansen has developed a new phenomenology, elaborated in dialogue with the works of Walter Benjamin, Henri Bergson, and Gilles Deleuze, which emphasizes the role of the affective, proprioceptive, and tactile dimensions of experience in the constitution of space, and by extension visual media. For Hansen visuality is shaped in terms of these more visceral bodily elements rather than by the abstract power of sight, and he maintains that the body continues to be the active framer of the image, even in a digital regime.

New Philosophy for New Media builds on and radically extends some crucial notions from Hansen's first book, *Embodying Technesis: Technology Beyond Writing.* Crucial to both works is a radical break with representationalism and

indeed with the tendency to assimilate phenomena of both natural and technical agency to linguistic models—the problem of incorporation. The problem of relating language to practice has been a key concern for theorists of various disciplines. The problem is particularly salient for issues of how code and program are inscribed in material reality no less than how disruptive changes in bodily experience get assimilated to language. Hansen simply cuts the Gordian problematic of how inscription relates to incorporation and the related issues of theory to practice and of representations to material agency. For over a decade science has sought accounts for how theoretical representations of nature are constructed and attached to the world. Some of us looked to poststructuralist approaches that took up issues of the technologies of representation, inscription and the material aspects of communication, frameworks deriving from literary and media scholars such as Derrida and Friedrich Kittler. Closely allied with such approaches have been laboratory-intensive accounts such as Hans-Jörg Rheinberger's account of "epistemic things," while others explored sociologically inspired models of the "mangle of practice" and "trading zones," or the construction of "epistemic cultures." As Hansen has shown brilliantly, there was a deep-seated ambivalence about material agency in these studies. On the one hand we wanted to grant practice and indeed even technology a materiality of its own—Bruno Latour has even advocated a Parliament of Things—but on the other hand, nature and technology in these accounts are always somehow "humanized" as a social/cultural construction. In his first book, *Embodying Technesis,* and in the rich elaboration and extension of the model in *New Philosophy for New Media,* Hansen criticizes theorists from the fields of poststructuralist theory and cultural studies for having stopped short of embracing the truly radical aspects of their critical stance toward representationalism. According to Hansen, Derrida, Bourdieu, Baudrillard, and others all engaged in a common pattern of reduction—Hansen calls it *technesis*—in which a stated interest in embracing technological materiality is compromised in order to safeguard the integrity and autonomy of thought and representation. He shows that this strategy functions by collapsing radical material exteriority into a merely relative exteriority paradoxically situated *within* the domain of thought.

Hansen's aim is to offer a positive program for embracing the rich materiality of technology that frees it from being embedded in discourse and

representation. The position he stakes out draws deeply on Henri Bergson's defense of the affective, prediscursive body as the active source of meaning. Hansen finds empirical support for this Bergsonist program and its relevance to our current concerns about posthumanism and digitality in the work of cognitive scientists such as Francisco Varela, Edwin Hutchins, Andy Clark, Antonio Damasio, and others who have defended the notion of the extended mind. From Hansen's perspective technologies alter the very basis of our sensory experience and drastically affect what it means to live as *embodied* human agents. They accomplish this by reconfiguring the senses at a precognitial or even paracognitial level (not to privilege one level over the other) prior to conscious perception and assimilation to language.

This bold and ambitious program was only sketched in *Embodying Technesis*. *New Philosophy for New Media* carries that program further by offering an account of how the body is modified through interactions facilitated by digital technology. The key notion is that of the frame. Despite the fact that Bergson did not find much material relevant to his theory of perception in early cinema, which was in its infancy exactly at the moment Bergson was writing, he characterized the external world as a universal flux of images. The body is itself an image among other images—in fact a very special kind of image Bergson calls a "center of indetermination," which acts as a filter creatively selecting facets of images from the universal flux according to its own capacities. The body, then, is a source of action on the world of images, subtracting among external influences those that are relevant to its own interests. Bergson calls such isolated image components "perceptions."

Gilles Deleuze argued that the notion of the movement-image based on cut and montage, indeed the entire process of framing at the heart of mature cinema was in fact a perfect analogue to the world of images described by Bergson, where "image = movement."[14] He sought to correct Bergson's dismissal of cinema by redeeming it as an experimental laboratory for philosophy: a site for studying perception, representation, space, time, and memory; a medium for grasping the shifting relationship of the articulable and the visible—ontology; a site for exploring the classification of images and signs as preparatory for the creation of concepts—epistemology. Hansen argues, however, that in claiming Bergson for his own philosophy of the cinema, Deleuze recast essential components of Bergson's bodily aesthetic, most crucially the faculty of affection.

In his commentary on Bergson, Deleuze defines the "affection-image" as the third component of subjectivity, filling the interval between the other two components, perception and action. This move seems perfectly consistent with Bergson, but Deleuze introduces a subtle change that manages to subsume affection as a subcomponent of perception. Affection, for Deleuze, designates a modality of perception: indeed, an attenuated or short-circuited perception that ceases to yield an action, and instead brings forth an expression. (In film, it is the close-up shot of the face.) By rendering affection as a variety of perception, Deleuze has fundamentally transformed Bergson; for in *Matter and Memory* Bergson treated affection as an independent bodily modality in its own right differing in kind from perception. According to Hansen, Deleuze effectively dissolves the constitutive link of affect to the body and appropriates it to the movement-image. This gesture enables Deleuze to define the body as an assemblage of images:

> All things considered, movement-images divide into three sorts of images when they are related to a centre of indetermination as to a special image: perception-images, action-images, and affection-images. And each one of us, the special image or the contingent centre, is nothing but an assemblage of three images, a consolidate of perception-images, action-images and affection-images.[15]

In effect Deleuze has reduced affection to a formal process of technical framing, and in the process he has disembodied affect, locating it outside the subject in the world of technically assembled images. In this account the body becomes relatively passive, a site of technical inscription of movement-images instead of the active source framing otherwise formless information. On the one side is the world of preformed images, technically framed as movement-images; on the other is the sensorimotor apparatus of the individual that passively correlates them.

Hansen turns to recent developments in new media and the neurosciences to provide an alternative to Deleuze's reading of the affect-image and to reclaim Bergson's understanding of embodiment in an account of how the body "enframes" information. Rather than erasing an active role of the sentient body in the production of media effects as Friedrich Kittler's interpretation of

digital media would have it, Hansen argues that media convergence under dig-
itality actually increases the centrality of the body as framer of information: as
media lose their material specificity, the body takes on a more prominent func-
tion as selective processor in the creation of images. The digital image on a
computer screen is no longer the same object as the photograph it may digitally
simulate. In contrast to this static object, the digital image involves a processing
of data, the constant refreshing of the interpretation of that data through an
interface projected on the screen at a frame rate that makes it appear static, but
this image is in fact highly dynamic, capable of being modified at any moment.
The digital image is processual. It is also capable of supporting interactivity of
the user, who can click on a portion of the image, zoom in, or initiate another
operation through a hyperlinked connection. In certain applications the image
is in fact an interface to some remote action, such as a surgical procedure.

Hansen argues that the processual and interactive features of the digital
image provide grounds for replacing the notions of the time-image and move-
ment-image as described by Deleuze. In their place a new image regime, the
digital image, is emerging. Based on the act of enframing information, Hansen
argues the digital image, an interactive techno-sensorimotor hybrid, should be
seen as the source for any technical frame designed to make information per-
ceivable by the body. *New Philosophy for New Media* is Hansen's brilliant phe-
nomenological odyssey aimed at critiquing and revising Deleuze's treatment of
the movement-image in which the cinematic image is purified of connection
with the human body, and resuscitating and updating Bergson's notion of the
primary framing function of the body by aligning it with recent developments
in information technology and new media arts. Hansen argues that every im-
age regime, including the digital, is primarily enframed by an "embryogenic"
connection with the human body. In contrast to Deleuze's arguments on tech-
nical framing as the source of the image, which is then correlated to the body—
indeed, inscribed on the body as screen—Hansen's "Bergsonist vocation"
asserts that there is no information (or image) in the absence of the form-giving
potential of human embodiment.

To update Bergson's pre–Information Age perspective, Hansen draws on
a number of theorists, most notably on the work of Raymond Ruyer,[16] an over-
looked French information theorist who shared and extended Donald McKay's
critique of the Shannon-Weaver notion of information by arguing that infor-

mation requires a frame to be constituted as information, and that frame is provided by the active constitution and assembly of human embodiment. Following this line of argument, "machinic vision," the turn of phrase in recent work where computers are claimed to process data into images that are then sent to other computers to be read, is something of an oxymoron. This can be "vision" only by analogy in Hansen's view. Vision, indeed any system involving "information," requires an interpreter, and that interpreter is the material human body grounded in the wetware of our sensorimotor systems.

Deleuze presented his complex cinematic philosophy as a deep conversation with the works of semioticians, phenomenologists, and the products of cinematic art, such as the works of Eisenstein, Vertov, Griffith, Hitchcock, and many others. In a similar fashion Hansen's rich new media philosophy is born from dialogue with the works of Bergson, Deleuze, and many contemporary theorists of digitality and new media, all interwoven in a complex critical appreciation of the works of new media artists. Hansen's analyses and interpretations of these new media artworks, many of which are challenging in their own right and by no means transparent, demonstrate an incredible depth of appreciation and will serve to orient a critical audience to these important works. But Hansen's goal—carried off masterfully—is to include new media artwork as evidence for the various stages of his debate with Deleuze, Kittler, and others, in his rehabilitation and updating of Bergson for the digital age. Hansen's defense of a Bergson-inspired approach to media requires an expansion and indeed inversion of the hierarchy of the senses that has occupied art historical discourse on digital media. Jonathan Crary and many other theorists who have followed his lead have argued that new digital media are relocating vision to a plane severed from a human observer while traditional functions of human vision are being supplanted by new media practices in which visual images no longer refer to the position of an observer in a "real," optically perceived world. Hansen takes issue with this view and argues for displacing an abstracted sense of vision as the primary sense in favor of the internal bodily senses of touch and self-movement. Vision becomes "haptic" in Hansen's effort to relocate visual sense-making in the body. Hansen argues for the primacy of affective and interoceptive sensory processes that generate a "haptic spatiality," an internally grounded image of the body prior to and independent of external geometrical space. This view has a range of interesting consequences for the

interpretation of other new media. For instance, virtual reality in Hansen's view is not the simple product of technical advances in computer graphics. The ability to process more polygons and run hierarchies of shading algorithms faster is not the only source of the virtual reality experience, but is rather grounded in the biological potential of human beings. Virtual reality, Hansen argues, is a body–brain achievement. The source of the virtual is thus not technological, but rather a biologically grounded adaptation to newly acquired technological extensions provided by new media. In making his argument Hansen draws selectively on the work of new media artists that foreground the shift from the visual to the affective, haptic, and proprioceptive registers crucial to the Bergsonian turn.

The fruitful conversation Hansen elicits among new media artworks, neurobiology, and phenomenology throughout the book is an impressive achievement. As an illustration the final chapter of the book is a tour de force treating the central problematic of the book. The centerpiece of the Bergsonian turn, of course, is the theory of affect. The affective body is the "glue" that underpins consciousness and connects it with subperceptual sensorimotor processes. It is through this affective channel that Hansen wants materially to link the flow of information in the digital image and the body as frame. Recent work in the neurosciences provides the material link he is looking for. Francisco Varela, in particular, made a powerful argument about the sources of time consciousness that perfectly suits Hansen's thesis.

In his work on what he called "enactive cognition," Varela argues that mental acts are characterized by the concurrent participation of several functionally distinct and topographically distributed regions of the brain and their sensorimotor embodiment. All forms of cognitive act arise from coherent activity of subpopulations of neurons at multiple locations. They are dynamic self-organizing patterns of widely distributed regions of the brain rather than organized as sequential arrangements as the computer metaphor—information flows upstream—would model it. At the deepest level the relation and integration of these components gives rise to temporality. Varela writes:

> A central idea pursued here is that these various components require *a frame or window of simultaneity that corresponds to the duration of the lived present*. In this view, the constant stream of sensory activation and motor

consequence is incorporated within the framework of an endogenous dynamics (not an informational-computational one), which gives it its depth or incompressibility.[17]

The key point for Hansen's thesis is that Varela treats the emergence of time as an endogenous bodily framing process grounded in self-organizing neuronal assemblies rather than an externally applied "technical" frame as advocated by Deleuze, particularly in *Cinema 2*. Varela (and other contemporary neuroscientists) distinguish at least three time scales arising via phase-locking of neuronal activity into synchronous emergent neuronal ensembles (1/10 scale; 1; and 10 scales). At the lowest level, nonperceptible microphysical registrations, with no direct perceptual correlate, self-organize into the durational immediacy of the "now." Varela claims that these endogenously generated integrative frameworks account for perceived time as discrete and nonlinear. The "now" of the present is a duration lasting .3 sec; and (contrary to the informational computational model of the brain) it is not a steady string of temporal quanta, like a ticking clock, but rather a "horizon of integration." "Thus," according to Varela,

> We have neuronal-level constitutive events that have a duration on the 1/10 scale, forming aggregates that manifest as incompressible but complete cognitive acts on the 1 scale. This completion time is dynamically dependent on a number of dispersed assemblies and not on a fixed integration period; in other words it is the basis of the origin of duration without an external or internally ticking clock.[18]

In addition to time being an endogenously generated flow based on layers of dynamical self-organizing neuronal assemblies, a second feature of Varela's work crucial to Hansen's argument is that temporal flow is bound up biologically with affect.[19] Indeed, Varela argues that affect *precedes* temporality and "sculpts" the dynamics of time flow.[20] Affect provides the bond between temporal flow and perceptual event. In elaborating on this idea Hansen turns to the work of video artist Bill Viola. Viola has experimented in several video installations using high-speed film to capture events transpiring in the present that escape the frame rates of normal perception. Fascinated by the saturation

of emotion in still images from video shot at this speed (384 frames per second), Viola concludes that "emotions are outside of time." In several installations Viola has experimented with this idea by digitally converting to video film shot at high speed and then projecting the resulting video back at normal speed. As Hansen notes, the cinema-digital-video hybrid technique exposes the viewer to minute shifts in affective tonality well beyond what is visible to natural perception. In Varela's terms, Viola's installations technically expand the "now" revealing the role of affect in the flux of consciousness. Rather than machinic components inscribing and controlling the flux of consciousness, Viola's work uses digital technology as a mediator for making visible the imperceptible affective processes framing the digital image.

This example is emblematic of the thesis Hansen works throughout *New Philosophy for New Media*. Viola's hybrid digital video installation illustrates the positive engagement of the body with technology. We are daily exposed to machinic events, such as the processing of data flows in our computers, and increasingly we are becoming immersed in a ubiquitous computing environment of machinic processes transpiring well below the .3 sec threshold of the "now." Rather than being the unconscious sites of inscription for these digital flows—sites that may be of limited use in a future posthuman environment—Hansen argues that new media art such as Viola's demonstrates how the affective and sensorimotor body serves to catalyze and frame information into the human-perceived digital image. In a very material sense the body is the "coprocessor" of digital information. Moreover, while Hansen's digital aesthetic views technology as an extension of human capability that enlarges the grasp over the material world, his analysis of works such as Viola's *Quintet for the Astonished* underscores that life is ultimately creative, unrecordable, and always in excess of what can be inscribed and made available for repetition. *New Philosophy for New Media* is a challenging work of astonishing breadth and erudition, offering timely resources for engaging questions of posthumanity.

Notes

1. Jean Baudrillard, *Simulations,* New York: Semiotext(e), 1983, pp. 2–4.

2. William J. Mitchell, *The Reconfigured Eye: Visual Truth in the Post-Photographic Era,* Cambridge, Mass.: MIT Press, 1992, p. 57. Mitchell noted that in 1989, the sesquicenten-

nial year of the invention of photography, ten percent of all photographs were touched up by digital processing. "And the opening of the 1990s will be remembered," Mitchell wrote, "as . . . the time at which the computer-processed digital image began to supersede the image fixed in silver-based photographic emulsion" (ibid., p. 20).

3. Ibid., p. 85.

4. Jonathan Crary, *Techniques of the Observer: On Vision and Modernity in the Nineteenth Century,* Cambridge, Mass.: MIT Press, 1992, p. 2.

5. John Johnston, "Machinic Vision," *Critical Inquiry* 26 (autumn, 1999), pp. 27–48. Johnston urges us to consider machinic vision as broader than simply reduction to technological image processing: "Machinic vision . . . presupposes not only an environment of interacting machines and human-machine systems but a field of decoded perceptions that, whether or not produced by or issuing from these machines, assume their full intelligibility only in relation to them" (p. 27).

6. Ivan Sutherland, "The Ultimate Display," *Proceedings of the International Federation of Information Processing Congress,* New York, May 1965, vol. 2, pp. 506–508.

7. William Gibson, *Neuromancer,* New York: Ace, 1984, p. 51.

8. André Leroi-Gourhan, *Le geste et la parole. Dessins de l'auteur,* Paris: A. Michel, 1964–1965, translated as *Gesture and speech,* tr. Anna Bostock Berger, Cambridge, Mass.: MIT Press, 1993.

9. See <http://www.wired.com/wired/archive/8.04/joy.html>.

10. Ray Kurzweil, *The Age of Spiritual Machines: When Computers Exceed Human Intelligence,* New York: Penguin, 1999, p. 280.

11. N. Katherine Hayles*, How We Became Posthuman: Virtual Bodies in Cybernetics, Literature, and Informatics,* Chicago: University of Chicago Press, 1999, p. 3.

12. Ibid., p. 52.

13. Friedrich Kittler, *Gramophone, Film Typewriter,* tr. Geoffrey Winthrop-Young and Michael Wutz, Stanford, Calif.: Stanford University Press, 1999, pp. 1–2.

14. Gilles Deleuze, *Cinema 1: The Movement-Image,* tr. Hugh Tomlinson and Barbara Habberjam, Minneapolis, Minn.: University of Minnesota Press, 1986, pp. 58–59.

15. Ibid., p. 66.

16. Raymond Ruyer, *La cybernétique et l'origine de l'information,* Paris: Flammarion, 1968.

17. Francisco Varela, "The Specious Present: A Neurophenomenology of Time Consciousness," in Jean Petitot, Francisco J. Varela, Bernard Pachoud, and Jean-Michel Roy,

eds., *Naturalizing Phenomenology: Issues in Contemporary Phenomenology and Cognitive Science,* Stanford, Calif.: Stanford University Press, 1999, pp. 272–273 (italics in original).

18. Ibid., pp. 276–277.

19. Ibid., pp. 295–298.

20. Ibid., p. 301.

Introduction

It should come as no surprise that Walter Benjamin's "Work of Art" essay casts a long shadow over contemporary discussions of new media art. In this famous and widely influential essay, Benjamin detailed a shift in the function and ontology of art in the age of technical reproducibility. Once it had become reproducible through mechanical procedures such as photography, he claimed, art underwent a fundamental metamorphosis, losing its status as a unique object tied to a single time and place (its "aura"), but gaining in return a newfound flexibility, a capacity to reach a larger, indeed mass audience, and to effect a hitherto unimagined political impact. All of this, of course, is so commonplace today as to be the material of cultural *cliché*.

Nonetheless, no one would deny the continued impact of Benjamin's essay on our efforts to think through the function of media in culture and art. One explanation for this continued impact would seem to be the very resonance of the problematic of the medium, which, although central to the now contested history of modernism in all the arts, is given a specifically technological inflection by Benjamin—an inflection particularly resonant in today's cultural climate. We are, in a sense, over the aura, but we are not through with the medium; or, at any rate, we would like to think that we're not. Indeed, Benjamin's reflections on the medium have never been more urgent than now, in the context of claims that, with digitization, media have become thoroughly and bidirectionally interchangeable (Jay David Bolter and Richard Grusin's notion of "remediation") or, even more radically, that media have simply become obsolete (Friedrich Kittler's "digital convergence"). Against the background of these neo-McLuhanesque positions, Benjamin's complex investment in the concept of medium—concretely embodied in his engagement with film—stands as a beacon of hope that media can continue to matter in the digital age.

In her recent essay, "Reinventing the Medium," art historian Rosalind Krauss gives particularly cogent form to this hope. According to Krauss, Benjamin inaugurated the generalization of the medium that inspired the major wave of conceptual art by the likes of Dan Graham, Robert Smithson, and Ed Ruscha; taking off from Benjamin, these artists deployed photography not as a specific medium, but precisely as a hybrid form, one whose dependence on the caption compromised any claims it might make to aesthetic autonomy. Krauss accordingly traces Benjamin's salience for the artists of the late 1960s and '70s to the shift that distinguishes the "Work of Art" (1935) essay from his earlier meditation on photography (1929): whereas the latter focused on the decay of the aura as a tendency within photography's own internal history, the former views the photographic as a shorthand for reproducibility *per se,* and thus as the very source for the demise of the aura across all the arts. Via this shift, Benjamin theorized the passage to what Krauss has, to my mind rather ambiguously, dubbed the "post-medium condition."

Extending consideration of Benjamin's crucial contribution beyond the 1970s to today's digital art, other aspects of his argument surface with renewed intensity. First, what was once a discrete aesthetic reaction to the capitalist imposition of universal exchangeability across all culture has now become an intrinsic element of technology itself. If, as Krauss emphasizes in comparing Benjamin to Marcel Duchamp, the reproducible work of art correlates with a minimal aesthetic rooted in the simple act of "framing pieces of the world through the camera's lens," this reign of the formal becomes something like a tyranny once the digital offers the possibility for the universal and limitless interconversion of data. Insofar as it operates a wholesale technical equalization of medial materiality, digitization marks the advent of a "post-medium condition" that is, as Friedrich Kittler has forcefully shown, shockingly literal: pushed to its most radical extreme, as it is in Kittler's work, digital convergence promises to render obsolete the now still crucial moment of perception, as today's hybrid media system gives way to the pure flow of data unencumbered by any need to differentiate into concrete media types, or in other words, to adapt itself to the constraints of human perceptual ratios. In the wake of the transformations that give rise to such claims, the correlation Benjamin foregrounds between the formalist aspect of the aesthetic act and the physiological shock-effect of modernist art takes on an unprecedented significance. Indeed, this

correlation lends a newfound specificity to the oft-celebrated redemptive dimension of Benjamin's aesthetics, for if the hypostatization of the formal act of framing reality vacates the artwork of its Romantic trappings (specifically, its autonomy and its objective status as the bearer of truth or the idea), and if the shock-effect relocates the impact of the work squarely in the domain of experience, this is all in the service of a redemption of embodied experience: a renewed investment of the body as a kind of *convertor* of the general form of framing into a rich, singular experience. One might even characterize this properly creative role accorded the body as the source for a new, more or less ubiquitous form of aura: the aura that belongs indeliby to *this* singular actualization of data in embodied experience.

In *New Philosophy for New Media,* I attempt to fill out this picture, merely suggested in Benjamin's late work, by correlating the aesthetics of new media with a strong theory of embodiment.[1] (For clarity's sake, let me specify that I am using the term "embodiment" in the sense it has been lent by recent work in neuroscience: as inseparable from the cognitive activity of the brain.)[2] In line with this understanding and in order to develop an account of new media embodiment, I propose to reconsider French philosopher Henri Bergson's theory of perception and, in particular, to take seriously the crucial emphasis Bergson places on the body as what he calls "a center of indetermination within an acentered universe." On Bergson's account, the body functions as a kind of filter that selects, from among the universe of images circulating around it and according to its own embodied capacities, precisely those that are relevant to it. This emphasis on the body takes center stage at the very beginning of Bergson's *Matter and Memory,* where he explains its function as a privileged image among images:

> [T]here is *one* [image] which is distinct from all the others, in that I do not know it only from without by perceptions, but from within by affections: it is my body. I examine the conditions in which these affections are produced: I find they always interpose themselves between the excitations that I receive from without and the movements which I am about to execute, as though they had some undefined influence on the final issue. . . . [T]he act in which the affective state issues is not one of those which might be rigorously deduced from antecedent phenomena, as a movement from a movement; and, hence, it really adds something new

to the universe and to its history. . . . *All seems to take place as if, in this aggregate of images which I call the universe, nothing really new could happen except through the medium of certain particular images, the type of which is furnished me by my body. . . .* My body is, then, in the aggregate of the material world, an image which acts like other images, receiving and giving back movement, with, perhaps, this difference only, that my body appears to choose, within certain limits, the manner in which it shall restore what it receives.[3]

Regardless of how more recent critics have understood him, to my mind Bergson remains first and foremost a theorist of embodied perception: with his central concepts of affection and memory—both of which are said to render perception constitutively *impure*—Bergson correlates perception with the concrete life of the body.

Bergson's understanding of the embodied basis of perception derives from his more general philosophical project, set out in the first chapter of *Matter and Memory,* to overcome the symmetrical errors of idealism and realism by *deducing* perception from matter. According to Bergson, the world is composed of an aggregate of images, and perception demarcates the selection of a subset of this aggregate by a "center of indetermination." The philosophical problem he faces is how to reconcile the specific aggregate of images that appears to my body functioning as such a center of indetermination and the aggregate of images that comprises the universe as a whole: "How is it," he asks, "that the same images can belong at the same time to two different systems: one in which each image varies for itself and in the well-defined measure that it is patient of the real action of surrounding images; and another in which all images change for a single image and in the varying measure that they reflect the eventual action of this privileged image?"[4] His solution is to reconfigure perception as a *diminution* or *subtraction* from the universe of images: what distinguishes my perception of a material object from that object as it is in itself is not something internal to my brain or something added by me (as it is for idealist positions), but the fact that I can perceive it only by isolating certain of its aspects, leaving the rest aside.

For all his effort to balance the two systems of images, Bergson's deduction of the body as a center of indetermination commits him to endow the

body with strongly creative capacities. If the affective body introduces specific constraints on what can constitute relevant aspects of an image, then it can legitimately be said to condition its own deduction from the universe of images. Indeed, Bergson's theorization of perception as an act of subtraction installs the affective body smack in the center of the general deduction of perception:

> [A]n image may *be* without *being perceived*—it may be present without being represented—and the distance between these two terms, presence and representation, seems just to measure the interval between matter itself and our conscious perception of matter. . . . [Nonetheless,] the representation of an image [is] less than its presence [and it suffices] that the images present should be compelled to abandon something of themselves in order that their mere presence should convert them into representations. . . . Representation is there, but always virtual—being neutralized, at the very moment when it might become actual, by the obligation to continue itself and to lose itself in something else. To obtain this conversion from the virtual to the actual, it would be necessary, not to throw more light on the object, but, on the contrary, to obscure some of its aspects, to diminish it by a geater part of itself, so that the remainder, instead of being encased in its surroundings as a *thing,* should detach itself from them as a *picture.* Now, if living beings are, within the universe, just "centers of indetermination," and if the degree of this indetermination is measured by the number and rank of their functions, we can conceive that their mere presence is equivalent to the suppression of those parts of objects in which their functions find no interest. They allow to pass through them, so to speak, those external influences which are indifferent to them; the others isolated, become "perceptions" by their very isolation.[5]

What is more, Bergson places his emphasis on the body as a source of action; it is the action of the body that subtracts the relevant image from the universal flux of images: "Our representation of matter is the measure of our possible action upon bodies: it results from the discarding of what has no interest for our needs, or more generally, for our functions."[6]

Despite his own condemnation of cinema in *Creative Evolution,* Bergson's theory of perception, and specifically his understanding of the body as a

center of indetermination, furnishes the basis for a philosophical understanding of image media. This, of course, is an affiliation that has already been put to good use by French philosopher Gilles Deleuze in his two-volume study of the cinema. Deleuze's great insight is to have realized that Bergson's conception of the image finds perfect instantiation in the cinema; according to Deleuze, Bergson was mistaken to condemn cinema as a spatialization of flux, since his concept of the movement-image actually describes a more nuanced understanding of cinema. The key notion here is that of the interval (as in montage cinema), which, in constituting a cut between shots, introduces "a gap between the action and the reaction."[7] For Deleuze, this function of the cut, and of framing to which it is immediately related, is perfectly homologous with that of the body as a center of indetermination: the process by which the body isolates certain aspects of images to generate perceptions is, Deleuze insists, "an operation . . . exactly described as a *framing:* certain actions undergone are isolated by the frame and hence, . . . are forestalled, anticipated."[8] Yet, in order to assert this homology, Deleuze finds himself compelled to bracket Bergson's embodied concept of affection—affection as a constitutive *impurity* of *this* body's perception—and to offer in its place a formal understanding of affection as a specific permutation of the movement-image. Affection as a phenomenological modality of bodily life gives way to affection as a concrete type of image—the affection-image—defined exclusively by the protracted interruption of the sensorimotor circuit, the interruption, that is, of the *form* of the movement-image.

Deleuze's neo-Bergsonist account of the cinema carries out the progressive disembodying of the center of indetermination. This disembodying reaches its culmination in the second volume of his study devoted to what he calls the "time-image." In a certain sense, the time-image—an image that, rather than subordinating time to movement in space, presents time directly—can be understood as a realization of the cinema's capacity to instance the universal flux of images, or more exactly, to divorce perception entirely from (human) embodiment. While the montage cut and the frame—both central in the first volume of Deleuze's study—remain homologous to the diminution that constitutes perception on Bergson's account, the "interstice between two images" that marks the direct presentation of time literally *instantiates* the uni-

versal variation of images: "If the cinema does *not* have natural subjective perception as its model, it is because the mobility of its centers and the variability of its framings always lead it to restore vast acentered and deframed zones. It then tends to return to the first regime of the movement-image; universal variation, total, objective and diffuse perception."[9] By rendering cinema homologous with the universal flux of images as such, Deleuze effectively imposes a purely formal understanding of cinematic framing and thus suspends the crucial function accorded the living body on Bergson's account.

To deploy Bergson's embodied understanding of the center of indetermination as the theoretical basis for our exploration of new media art, we will have to redeem it from Deleuze's transformative appropriation. In the most general sense, this will require us to defend the sensorimotor basis of the human body from the assault Deleuze wages against it. To do so, we will have to revise our conception of the sensorimotor itself. For the body that surfaces in the wake of the digital revolution—the very body that forms the "object" of contemporary neuroscience—has scant little in common with the associational sensorimotor body of Deleuze's *Cinema 1*. The sensorimotor dimension of this contemporary body comprises far more than the passive correlate of linkages between images, and indeed, serves to accord the body creative capacities—what Brian Massumi has recently theorized as the potential to broker qualitative difference: "If you start from an intrinsic connection between movement and sensation," notes Massumi, "the slightest, most literal displacement convokes a qualitative difference, because as directly as it conducts itself it beckons a feeling, and feelings have a way of folding into each other, resonating together, interfering with each other, mutually intensifying, all in unquantifiable ways apt to unfold again in action, often unpredictably."[10] Insofar as the sensorimotor nexus of the body opens it to its own indeterminacy, it is directly responsible for the body's constitutive excess over itself. In this respect, motion functions as the concrete trigger of affection as an active modality of bodily action. In what follows, I shall call this "affectivity": the capacity of the body to experience itself as "more than itself" and thus to deploy its sensorimotor power to create the unpredictable, the experimental, the new. Active affection or affectivity is precisely what differentiates today's sensorimotor body from the one Deleuze hastily dismisses: as a capacity to experience its own

intensity, its own margin of indeterminacy, affectivity comprises a power of the body that cannot be assimilated to the habit-driven, associational logic governing perception.

This broadly Bergsonist theme is given its most forceful expression in philosopher Gilbert Simondon's account of the process of individuation.[11] According to Simondon, affectivity is precisely that mode of bodily experience which mediates between the individual and the preindividual, the body and its "virtual" milieu: whereas perception appeals to structures already constituted in the interior of the individuated being, affectivity "indicates and comprises this relation between the individualized being and preindividual reality: it is thus to a certain extent heterogeneous in relation to individualized reality, and appears to bring it something from the exterior, indicating to the individualized being that it is not a complete and closed set [*ensemble*] of reality."[12] As the mode of experience in which the embodied being lives its own excess, affectivity introduces the power of creativity into the sensorimotor body.

Beyond simply defending the sensorimotor body, our effort to redeem Bergson's embodied conception of the center of indetermination will ultimately require us to reverse the entire trajectory of Deleuze's study, to move not from the body to the frame, but *from the frame (back) to the body.* What we will discover in the process is that the frame in any form—the photograph, the cinematic image, the video signal, and so on—cannot be accorded the autonomy Deleuze would give it since its very form (in any concrete deployment) reflects the demands of embodied perception, or more exactly, a historically contingent negotiation between technical capacities and the ongoing "evolution" of embodied (human) perception. Beneath any concrete "technical" image or frame lies what I shall call *the framing function* of the human body *qua* center of indetermination.

This change in the status of the frame correlates directly with the so-called digital revolution. If the embodied basis of the image is something we can grasp clearly only now, that is because the so-called digital image explodes the stability of the technical image in any of its concrete theorizations. Following its digitization, the image can no longer be understood as a fixed and objective viewpoint on "reality"—whether it be theorized as frame, window, or mirror[13]—since it is now defined precisely through its almost complete flexibility and addressability, its numerical basis, and its constitutive "virtuality."

Consider, in this regard, the account offered by French engineer and media artist, Edmond Couchot:

> A numerical image is an image composed of small "discrete" fragments or elementary points, to each of which can be attributed whole numerical values that position each of them in a system of spatial coordinates (in general of the Cartesian sort), in two or three dimensions. . . . These numerical values render each fragment an entirely discontinuous and quantified element, distinct from other elements, on which is exercised a total command. The numerical image manifests as a matrix of numbers (a table composed of columns and rows) contained in the memory of a computer and capable of being translated through the form of a video or print image. One can from this point on integrally synthesize an image by furnishing the computer with the matrix of values adequate to each of these points.[14]

If the digital image is an accumulation of such discontinuous fragments, each of which can be addressed independently of the whole, there is no longer anything materially linking the content of the image with its frame, understood in its Bergsonist-Deleuzean function as a cut into the flux of the real. Rather, the image becomes a merely contingent configuration of numerical values that can be subjected to "molecular" modification, that lacks any motivated relation to any image-to-follow, and indeed that always already contains all potential images-to-follow as permutations of the set of its "elementary" numerical points. This situation has led new media critic Lev Manovich to proclaim the obsolescence of the image in its traditional sense: since the digital image culminates the transition from an indexical basis (photography) to sequential scanning (radar), it substitutes for the image proper a processual realization of information in time that appears as a traditional image only for contingent reasons (i.e., because scanning is fast enough to simulate the appearance of a static image).[15]

Why is it, then, that we continue to speak of the image, even following its digital transfiguration (dissolution)? Why do we take recourse to a hybrid conception of the image as, at once, an analog surface and a digital infrastructure?[16] Why, given the disjunction between surface appearance and materiality, do we continue to associate a given set of numerical coordinates or of information

with a visually perceivable form? Manovich's concepts of the "image-interface" and the "image-instrument" speak directly to this set of questions, insofar as they subordinate the image to the bodily manipulation of information. As interface or instrument, the image does not comprise a representation of a pre-existent and independent reality, but rather a *means* for the new media user to intervene in the production of the "real," now understood as a rendering of data. "New media," Manovich concludes, "change our concept of what an image is—because they turn a viewer into an active user. As a result, an illusion-istic image is no longer something a subject simply looks at, comparing it with memories of represented reality to judge its reality effect. The new media image is something the user actively *goes into,* zooming in or clicking on individual parts with the assumption that they contain hyperlinks. . . ."[17]

As I see it, digitization requires us to reconceive the correlation between the user's body and the image in an even more profound manner. It is not simply that the image provides a tool for the user to control the "infoscape" of contemporary material culture, as Manovich suggests, but rather that the "image" has itself become a process and, as such, has become irreducibly bound up with the activity of the body. Thus, rather than simply abandoning it to its own obsolescence or transforming it into a vehicle for interfacing with information, we must fundamentally reconfigure the image. Specifically, we must accept that the image, rather than finding instantiation in a privileged technical form (including the computer interface), now demarcates the very process through which the body, in conjunction with the various apparatuses for rendering information perceptible, gives form to or *in-forms* information. In sum, the image can no longer be restricted to the level of surface appearance, but must be extended to encompass the entire process by which information is made perceivable through embodied experience. This is what I propose to call the *digital image.*

As a processural and necessarily embodied entity, the digital image lays bare the Bergsonist foundation of all image technology, that is, the origin of the perceivable image in the selective function of the body as a center of indetermination. No matter how "black-boxed" an image technology (or technical frame) may seem, there will always have been embodied perception at/as its origin. In relation to today's electronic technosphere, however, Bergson's theorization of this process of embodied selection must be updated in at least one

important respect: rather than selecting preexistent *images,* the body now operates by filtering *information* directly and, through this process, *creating* images. Correlated with the advent of digitization, then, the body undergoes a certain empowerment, since it deploys its own constitutive singularity (affection and memory) not to filter a universe of preconstituted images, but actually to *enframe* something (digital information) that is originally formless. Moreover, this "originary" act of enframing information must be seen as the source of all technical frames (even if these appear to be primary), to the extent that these are designed to make information perceivable by the body, that is, to transform it into the form of the image.

This account of how the body enframes information and creates images comprises the theoretical project at stake in the corpus of new media art that I analyze in this book. To support this account, I shall focus on work by various artists who deploy digital technology in order to pursue this "Bergsonist vocation" of framing the digital image. As I see it, the most significant aesthetic experimentations with new media carry on the legacy of Bergson's valorization of intelligence over instinct, and specifically, his understanding of technology as a means of expanding the body's margin of indetermination. Indeed, contemporary media artists appear to be doing nothing else than adapting this Bergsonist vocation to the concrete demands of the information age: by placing the embodied viewer-participant into a circuit with information, the installations and environments they create function as laboratories for the conversion of information into corporeally apprehensible images. Indeed, the bodily dimension of contemporary artistic practice helps explain the continued relevance of the image following its dissolution as a technically stable frame: it is in the form of the image—the visual image above all, but also the auditory image and the tactile image—that digital information is rendered apprehensible. Accordingly, the reinvestment of the image as a contingent configuration of information itself holds the key to the continued relevance—and indeed, to the indispensability—of the human in the era of digital convergence. As the process that yields the image—that transforms formless information into an apprehensible form—framing is crucial to all contemporary new media art practices.[18]

My decision to focus on the visual dimensions of the digital image follows directly from the theoretical ambition motivating this project. Rather

than a survey of new media art, my study aims to theorize the correlation of new media and embodiment. Toward this end, I have found it most useful to focus on works by new media artists that foreground the shift from the visual to the affective registers and thereby invest in the multimedia basis of vision itself. In this sense, my decision is above all a strategic one: if I can prove my thesis (that the digital image demarcates an embodied processing of information) in the case of the most disembodied register of aesthetic experience, I will, in effect, have proven it for the more embodied registers (e.g., touch and hearing) as well. Moveover, this strategic decision resonates with the interests of contemporary artists themselves: even those artists not directly invested in these embodied sense registers can be said to pursue an aesthetic program aimed first and foremost at dismantling the supposed purity of vision and exposing its dirty, embodied underside. Following from and extending Bergson's investment in bodily affection, contemporary media art has operated what amounts to a paradigm shift in the very basis of aesthetic culture: a shift from a dominant ocularcentrist aesthetic to a haptic aesthetic rooted in embodied affectivity. As if in direct response to the automation of vision achieved by digital computing, artists have focused on foregrounding the foundation of vision in modalities of bodily sense: insofar as they catalyze an awakening of their viewers to this bodily foundation, the works they create might indeed be understood as efforts to specify what remains distinctly "human" in this age of digital convergence.

We can now gather, under the rubric of the "Bergsonist vocation" of new media art, the three narrative strands that I shall interweave in the concrete analyses to follow. First: how the image comes to encompass the entire process of its own embodied formation or creation, what I shall call the digital image. Second: how the body acquires a newly specified function within the regime of the digital image, namely, the function of filtering information in order to create images. And third: how this function of the body gives rise to an affective "supplement" to the act of perceiving the image, that is, a properly haptic domain of sensation and, specifically, the sensory experience of the "warped space" of the body itself.

In the seven chapters comprising my study, these three threads will combine to tell the story of a fundamental shift in aesthetic experience from a model dominated by the perception of a self-sufficient object to one focused

on the intensities of embodied affectivity. To the extent that this shift involves a turning of sensation away from an "object" and back onto its bodily source, it can be directly correlated with the process of digitization currently well underway in our culture: for if the digital image foregrounds the processural framing of data by the body, what it ultimately yields is less a framed object than an embodied, subjective experience that can only be felt. When the body acts to enframe digital information—or, as I put it, to forge the digital image— what it frames is in effect itself: its own affectively experienced sensation of coming into contact with the digital. In this way, the act of enframing information can be said to "give body" to digital data—to transform something that is unframed, disembodied, and formless into concrete embodied information intrinsically imbued with (human) meaning.

Each of the seven chapters of my study engages a specific aspect of this coevolution of aesthetics and technology in order to demarcate a concrete stage in the ensuing shift from perception to affectivity.

The three chapters gathered in Part I, "From Image to Body," treat the disjunction of embodied response from its status as a strict correlate of the image in three registers: the aesthetico-historical, the philosophical, and the scientific.

Chapter 1 tackles what is perhaps the key aesthetic question confronting our assimilation of new media: are they really "new," and if so, why? Through analyses of two recent and influential arguments—art historian Rosalind Krauss's conception of the "post-medium condition" and media scholar Lev Manovich's cinematographic empiricism, both of which, to a greater or lesser extent, deny the newness of new media—the chapter urges an investment in the body beyond its strict homology with the "pulsatile" materiality of the image and the cinematic condition of immobility.

Chapter 2 engages the work of pioneering new media artist Jeffrey Shaw as an aesthetic deployment of Bergson's embodied conception of the center of indetermination. In a sustained negotiation with the nexus of image, space, and body, Shaw's career trajectory reveals a gradual displacement of the body's function as a material screen within a physical space of images in favor of the body–brain's capacity to generate impressions of "virtual totality" through selective filtering of information. This transformation in the body's role parallels a material shift in the status of the frame: from a static technical image to an

embodied framing function performed by the viewer. By tracing this aesthetic extension and updating of Bergson's philosophy to a philosophical counter-tradition in the history of cybernetics that insists on the intimate correlation of information and (embodied) meaning, the chapter credits Shaw with articulating the "Bergsonist vocation" that informs contemporary aesthetic experimentation with the digital.

Chapter 3 addresses the transformation in the function and status of visual culture in the wake of the automation of vision. By analyzing artworks that engage photography in its digital form, the chapter foregrounds the vast divide separating scientific and aesthetic responses to the computer mediation of vision: whereas researchers aim to optimize a sightless "vision" that overcomes human perceptual limitations, artists invest in the bodily dimensions that inform (human) vision. Following this analysis, the correlation of image and body can be seen to have come full circle from where we began: rather than forming a quasi-autonomous technical frame that strictly regulates bodily response, the image has now been revealed to be a delimited product of a complex bodily process.

The three chapters comprising Part II, "The Affect-Body," focus on the aesthetic consequences of this disjunction of body from image and the ensuing reembodiment of the latter. Each forms a concrete stage in the philosophical redemption of Bergson's embodied theory of perception from Deleuze's transformative appropriation.

Chapter 4 focuses on the "digital facial image" as a counterpart to the cinematic close-up analyzed by Deleuze. Whereas the close-up is celebrated for its expressive autonomy, the digitally generated facial image functions to catalyze a profound affective reaction in the viewer. By interpreting this difference as a symptom of the radical alienation of the realm of the digital from the phenomenal world of human experience, the chapter associates digitization with a movement from the "affection-image" back to that bodily affectivity which it is said to suspend. As the artworks here analyzed demonstrate, what is at stake in our negotiation with the "digital facial image" is the very possibility of interfacing with the digital, and this possibility, far from involving a disembodying of the human in the service of computer commands (as is the case in the standard human–computer interface), involves a configuration of digital information with the affective dimensions of human experience.

Chapter 5 engages the "facialization" of the body (or the "imagization of affection") in a far wider domain of scientific, cultural and aesthetic practice: virtual reality (VR). While most applications of VR endorse a disembodied form of visual experience, certain artistic deployments have focused on the constitutive spatial paradox of this alleged "perceptual" technology: the fact that there simply is no external space where virtual perception can be said to take place and where a perceived object can be located. These artistic experimentations with VR thus expose a limitation in Bergson's theory—its fundamental attachment to perception—as it comes to be "instantiated" in the contemporary digital environment. What happens in the experience of these artistic VR environments can no longer be called perception; instead, it is the result of a "body–brain achievement" that creates an internal, bodily space for sensation.

Chapter 6 focuses on a single work by a younger artist, *skulls* (2000) by Robert Lazzarini, which instantiates as its "aesthetic content" the shift from perception to self-affection or affectivity as the dominant phenomenological experience associated with the digital. A sculptural installation that confronts the viewer in "real, physical" space, *skulls* accords a certain generality to the analysis of the preceeding chapters. Offering sculptures of four digitally warped skulls to the viewer's gaze, the work solicits perception for what will become an experience of its own short-circuiting. As the viewer tries to negotiate these odd perceptual objects that, it becomes increasingly clear, are not continuous with the space she occupies, she becomes ever more disoriented and disturbed; and as her disorientation mounts, it gradually gives rise to an internal, affective reaction that will ultimately take the place of perception entirely. Insofar as it culminates my defense of Bergson against Deleuze, this affective experience facilitates a corporeal registering of a deformed spatial regime that comprises something like a human equivalent of the alien "space" of the digital. As a "produced analogy" for the digital itself, this corporeal registering revalues the Deleuzean "any-space-whatever" by underscoring its fundamental attachment to bodily activity: it results from the displacement of visual (perceptually apprehensible) space in favor of a haptic space *that is both internal to and produced by the viewer's affective body.*

The lone chapter that makes up Part III, "Time, Space, and Body," traces this capacity of the affective body to create haptic space to an even more

fundamental aspect of its function—its continual self-production through an ongoing process of emergence to presence. Engaging the topic of "machine time" that has become most urgent in the face of today's global telecommunications networks, the chapter invests media art with the capacity to mediate machine time for embodied human experience. Focusing on the digitally facilitated temporal deceleration deployed in the work of artists Douglas Gordon and Bill Viola, the chapter shows how aesthetic experimentation with the digital functions both to enlarge the threshold of the "now" of phenomenological experience and to catalyze an aesthetic experience of this enlargement in the form of an intensification of affectivity. In this way, the potential for new media art to expand the experiential grasp of the embodied human being—that is to say, its Bergsonist vocation—is carried over to the embodied processing of time itself. By opening experience to the subperceptual inscription of temporal shifts (machine time), the work of Gordon and Viola demonstrates why affectivity must be understood to be the condition for the emergence of experience per se, including what we normally think of as perception.

As this brief synopsis makes clear, the argument presented here follows a precise trajectory and is meant to be cumulative. Accordingly, as you make your way through this study, you may find a schematic table useful as a guide. Table I.1 attempts to isolate the permutations undergone by the central pairing of body and image at each stage of the argument.

Table I.1

Chapter	Theoretical Aim	Body	Image	Artwork
1	To liberate the body from its strict correlation with the image	From body as correlate to the pulsatile rhythm of work and as immobilized receptive center for image to body as liberated from both of these limitations	From image as guiding principle of aesthetic experience to image as mere trigger for independent bodily activity	Coleman's Box; Pfeiffer's The Long Count; ART+COM's The Invisible Shape of Things Past; Waliczky's The Way
2	To isolate what differentiates body (bodily framing) from the technical image (preconstituted frame)	From body as a physical screen for image to body-brain as a mental source for impression of "virtual totality"	From externally originating source of possible perceptions to product of an internal bodily process (bodily framing of information)	Shaw's Corpocinema, MovieMovie, Viewpoint, Points of View, Inventer la Terre, The Narrative Landscape, Place: A User's Manual, Place: Ruhr
3	To link bodily framing to the bodily "underside" of vision	From body as the center of perception—a disembodying of vision—to body as the contaminating affective basis for human visual experience	From correlate of bodily perception (i.e., vision) to obsolete function (for computer "vision") to correlate of bodily affection no longer restricted to visual domain	Blade Runner; Rogala's Lovers Leap; Waliczky's The Garden, The Forest; Shaw's Place: A User's Manual, The Golden Calf
4	To restore the intrinsic link of affection with the body	From epoché of body in the affection-image to reinvestment of body as the source of affection via a supplementary sensorimotor contact with information	From autonomous affection-image (cinematic close-up) to image as affective response to digital information ("digital facial image")	Geisler's Counting Beauty 2.1; van Lamsweerde's Me Kissing Vinoodh (Passionately); Corchesne's Portrait no. 1; Mongrel's Color Separation; Feingold's If/Then, Sinking Feeling; Huge Harry

Table I.1 (continued)

Chapter	Theoretical Aim	Body	Image	Artwork
5	To differentiate affectivity categorically from perception	From transcendence of body in visually dominant VR experience to reinvestment of body-brain as affective source for creation of "virtual" space	From simulation of physical reality to "absolute survey" (nonextended mental apprehension) of bodily generated space	Penny's *Fugitive*; Shaw's *EVE, I-Cinema*; Gromala's *Virtual Dervish*; Scroggins and Dickson's *Topological Slide*; Wennberg's *Parallel Dimension, Brainsongs*; Smetana's *Room of Desires*; Dunning and Woodrow's *Einstein's Brain*
6	To correlate affectivity with a shift from visual space to haptic space	From body as source for perception of extended, geometric space to body as affective source for haptic space	From correlate of perceptual gaze to processural affective analogy for the "warped space" of the computer	Lazzarini's *skulls*; Kalpakjian's *Hall, Duct, HVAC III*
7	To trace the bodily capacity to create space to the temporal basis of affectivity	From affective body as the source for haptic space to affectivity as the bodily origin of experience *per se* (embodied temporality), including perception	From objective, perceptually apprehensible "object" to "subjective image" that can only be felt	*Transverser*; Reinhart and Wiedrich's *TX-Transform*; Gordon's *24-Hour Psycho*; Viola's *Quintet of the Astonished*

Part I

From Image to Body

Between Body and Image: On the "Newness" of New Media Art

Theoretical Aim	Body	Image	Artwork
To liberate the body from its strict correlation with the image	From body as correlate to the pulsatile rhythm of work and as immobilized receptive center for image to body as liberated from both of these limitations	From image as guiding principle of aesthetic experience to image as mere trigger for independent bodily activity	Coleman's Box; Pfeiffer's The Long Count; ART+COM's The Invisible Shape of Things Past; Waliczky's The Way

Before commencing the series of exemplary analyses that will make up the heart of this study, I propose to address a question that is absolutely central to my undertaking: what is it about new media that makes them "new"? This question is the source of much confusion, as well as much contentious debate, among contemporary critics of media and culture. For almost every claim advanced in support of the "newness" of new media, it seems that an exception can readily be found, some earlier cultural or artistic practice that already displays the specific characteristic under issue. This situation has tended to polarize the discourse on new media art between two (in my opinion) equally problematic positions: those who feel that new media have changed everything and those who remain skeptical that there is anything at all about new media that is, in the end, truly new. No study of new media art can afford to skirt this crucial issue.

Since the task of specifying and unpacking precisely what is new about new media will comprise one of the primary concerns of my study, let me begin by sketching out how I think the Bergsonist vocation outlined in the introduction furnishes us with a promising basis to demarcate the specificity of new media art. As I see it, the reaffirmation of the affective body as the "enframer" of information correlates with the fundamental shift in the materiality of media: the body's centrality increases proportionally with the de-differentiation of media. What is new about new media art concerns both terms in this economy, and indeed, their fundamental imbrication with one another. For if digitization underwrites a shift in the status of the medium—transforming media from forms of actual inscription of "reality" into variable interfaces for rendering the raw data of reality—then not only can the medium no longer be said to be "motivated," in the sense of having an elective affinity with the

concrete reality it presents, but the very task of *deciding* what medial form a given rendering shall take no longer follows from the inherent differences between media (which have now become mere surface differences). The reality encoded in a digital database can just as easily be rendered as a sound file, a static image, a video clip, or an immersive, interactive world, not to mention any number of forms that do not correlate so neatly with our sensory capacities. Viewed in this way, the digital era and the phenomenon of digitization itself can be understood as demarcating a shift in the correlation of two crucial terms: media and body. Simply put, as media lose their material specificity, the body takes on a more prominent function as a selective processor of information.

Not surprisingly, selection becomes even more crucial in relation to new media (and specifically, to new media art) than it was in the context of Bergson's universe of images. In the first place, the artist must select medial interfaces most likely to realize her aesthetic aims, all the while remaining cognizant that this selection is a supplemental action on her part, not something specified by the material constraints of the data. Moreover, the viewer must participate in the process through which the mediated digital data is transformed into a perceivable image: in conjunction with the medial interface, the embodied activity of the viewer functions to restore some form of "motivation"—a *supplementary* motivation—between the image interface and the digital data, since the selections imposed by the medial interface must be affirmed through their resonance with the selections performed by the body. We could say, to put it in simple terms, that it is the body—the body's scope of perceptual and affective possibilities—that informs the medial interfaces. This means that with the flexibility brought by digitization, *there occurs a displacement of the framing function of medial interfaces back onto the body from which they themselves originally sprang.* It is this displacement that makes new media art "new."

To give substance to this claim, let us consider two recent and influential arguments concerning new media, one by an art historian and another by a media critic, both of which significantly—*and purposefully*—downplay the "newness" of new media art. As I see it, both arguments are fundamentally limited by their disciplinarity—by an adherence to a particular conception of the medium, on the one hand, and to the institution of the cinema, on the other. Neither is capable of grasping the *aesthetic* newness of new media art: its resistance to capture by now dated, historical forms of art and media criticism. Not

incidentally, in both cases, what I claim as specific to new media art concerns the refunctionalization of the body as the processor of information. New media art calls on the body to inform the concept of "medium" and also to furnish the potential for action *within* the "space-time" of information. As ground-clearing exercises, these demonstrations are intended to contextualize the analyses that make up the heart of this study in relation to the discourses and institutions most central to the emergent "field" of new media art. Accordingly, they are intended both to justify my call for an aesthetics of new media embodiment that emerges out of the problematic of the digital image and to specify exactly how such an aesthetics must break with certain constitutive axioms of the disciplines of art history and media studies.

In her recent study of art "in the age of the post-medium condition," art historian Rosalind Krauss attempts to situate the reconceptualization of the medium within the framework of a nuanced, expanded understanding of modernism. As an alternative to the Greenbergian orthodoxy, this account of modernism proposes a concept of medium as "aggregative and thus distinct from the material properties of a merely physical objectlike support."[1] This *reinvention* of the medium, moreover, is possible only following the generalization of the medium (or of art) discussed in this volume's introduction, since it focuses on the retrospective (re)discovery of conventions that derive from, but remain irreducible to, the physicality of a specific medium. For this reason, a medium can be reinvented only once it has become obsolete; so long as it is new, the space separating its physicality from its status as a set of conventions remains invisible, and the medium, far from opening itself to aesthetic repurposing, can only be a pale, yet faithful reflection of the universalizing logic of capitalism. At the limit, this understanding would seem to preclude us from doing art history in the present, and indeed, if Krauss cannot herself quite abide by this dictate, it must be said that the contemporary artists she champions—James Coleman, William Kentridge, Cindy Sherman—are all devoted to a sustained practice of media archaeology.

There is, however, a deeper logic to Krauss's position, a logic that draws its critical force from the opposition between two contemporary media practices—the aforementioned archaeology on the one hand, and, on the other, the "international fashion of installation and intermedia work, in which art essentially finds itself complicit with a globalization of the image in the service of

capital."[2] These two contemporary practices represent divergent legacies of the same modernist moment, that moment when the shift from structuralist film to video brought about the possibility for an entirely new conception of the medium in a properly post-medium age. If structuralist film took a first step in this direction by foregrounding the diversity of the physical support, it nonetheless compromised this start by dedicating itself to the production of "the unity of this diversified support in a single, sustained experience."[3] (Krauss mentions Michael Snow's *Wavelength* as the preeminent example.) By contrast, some early experimentation with video (e.g., Richard Serra's *Television Delivers the People*) successfully preserved the aggregative, "self-differing" condition of the televisual medium against all tendencies at unification. As Krauss puts it, "modernist theory [of the canonical, Greenbergian mold] found itself defeated by [the] heterogeneity [of television]—which prevented it from conceptualizing video as a medium—[and] modernist, structuralist film was routed by video's instant success as a practice. For, even if video had a distinct technical support—its own apparatus, so to speak—it occupied a kind of discursive chaos, a heterogeneity of activities that could not be theorized as coherent or conceived of as having something like an essence or unifying core."[4] It is precisely the appropriation of this aggregative, self-differing condition that demarcates artistic deployments of media from the "international fashion of installation and intermedia." Following on the heels of Marcel Broodthaers, the high priest of post-medium art production, contemporary artists like James Coleman and William Kentridge foreground the status of the medium (for Coleman, the projected slide tape; for Kentridge, CEL animation) as a set of conventions distinct from its physicality; for this reason, moreover, their respective practices can be understood as creating counternarratives, narratives that resist the "leeching of the aesthetic out into the social field in general."[5]

As much as it contributes to our understanding of new media, this conception of the "reinvention" of the medium does not—and indeed by definition cannot—suffice to theorize new media art. Both because of the stricture against the aesthetic repurposing of still contemporary media and because of its antipathy toward any positive rehabilitation of the technical dimensions of the various media, Krauss's construction of art in the age of the post-medium condition must simply bracket out the field of new media art, as something

that (at best) must await the (purportedly inevitable) moment of its technical obsolescence in order to support an aesthetic practice.

Clearly, some supplementation of Krauss's position is necessary if we are to have any hope of doing justice to new media art, not to mention much of video installation art from its earliest closed-circuit forms to today's projection environments. Fortunately, Krauss herself furnishes the necessary "ingredients" of such a supplementation in her essays (together with art historian Yve-Alain Bois) for the catalog of the Pompidou Center's 1996 *Formless* (*Informe*) exhibition. Given my earlier argument for the Bergsonist vocation of new media art, it will come as no surprise that this supplementation concerns the role of the body, which, I think, remains something like the unmentioned correlate—or, better still, the requisite processing site—of the self-differing, aggregative condition of the medium. Indeed, we could easily imagine the digital image as the exemplar of this self-differing condition, since (as we have seen) it is, at any moment or in any concrete actualization, the aggregation of a set of autonomous fragments, each of which is manipulable independently of the rest.[6] Our brief examination of the digital image in the introduction suffices to make salient what remains invisible on Krauss's account: namely, that the self-differing condition of the digital "medium," if we can even still use this term,[7] requires bodily activity to produce any experience whatsoever. Far from being the source of a reductive unification of diversity, the body is the very place where such diversity can be retained in a nonreductive aggregation. As such, it is itself an integral dimension of the medium.

To find concrete support for this view, we could turn to the work in phenomenological aesthetics from Erwin Strauss and Henri Maldiney to José Gil and Brian Massumi, where the synesthetic capacities of the body are shown to precede the experiences of discrete sensory modalities.[8] Alternatively, we could cite the work on infant psychology by Daniel Stern, where an amodal "proto-sensory" flux is similarly shown to precondition the differentiation of the sense modalities.[9] Or, again, we could invoke Deleuze's concept of a "transcendental sensibility" that foregrounds the reality-constituting function of the senses prior to and independently of their coordination in the "philosophemes" of object "recognition" and "common sense."[10] But, perhaps more immediately eloquent on this score than any such outside reference are Krauss's

own arguments, in *Formless,* for the bodily or corporeal basis of the alternate modernism she and Bois are seeking to enfranchise. In her chapter entitled "Pulse," for example, Krauss offers Marcel Duchamp as the progenitor of a line of artistic practice (a line that leads directly to the early video work of Bruce Nauman and Richard Serra, to the flicker film, and beyond this, to more recent film installation work by James Coleman) focused on assaulting, in the most frontal manner imaginable, the regime of visual autonomy. What is important here is not simply the introduction of a temporal dimension designed (as Bois puts it in his introduction) to agitate the visual field "by a shake-up that irremediably punctures the screen of its formality and populates it with organs."[11] More crucial still is the way this strategy brings the body into the very fabric of the work, making it a constitutive dimension of the aesthetic of "pulse." Speaking of Duchamp's *Rotoreliefs,* Krauss argues that their "throb . . . opens the very concept of visual autonomy . . . to the invasion of a . . . dense, corporeal pressure"; this is, moreover, precisely "because the pulse itself, in its diastolic repetitiveness, associates itself with the density of nervous tissue, with its temporality of feedback, of response time, of retention and protention, of the fact that, without this temporal wave, no experience at all, visual or otherwise, could happen."[12] According to Krauss, Duchamp's seminal embodying of vision functions to render it "impure" and to disturb the laws of "good form," as it opens the aesthetic object to a kind of ongoing rhythmic or pulsatile exchange with the viewer.

How fitting, then, that Krauss's account of this bodily impurification of vision recapitulates, almost to the letter, the terms of Bergson's account of the affective impurification of perception:

> To tie visuality to the body . . . is to render it "impure," an impurity that *Anémic Cinéma* sends skidding along the circuitry of the whole organism in the kind of permanently delayed satisfaction we connect with desire. What seems to drive the repetitive pulse of one organ dissolving into the image of another is a sense of the erosion of good form, and experience of the *prägnanz* in the grip of the devolutionary forces of a throb that disrupts the laws of form, that overwhelms them, that scatters them. And it is here that Duchamp invents the pulse as one of the operations of the *formless,* the pulse that brings the news that we "see" with our bodies.[13]

As the father figure of an alternative modernism, Duchamp informs us that there simply is no such thing as a pure, punctual visuality. Or rather, to pursue the analogy with Bergson, that if there is such a thing, it would be available only as a *nonhuman* form of perception, something more or less akin to the universal flux of images on Bergson's account: a pure opticality unmediated by the (human) body (including the eye). The body, then, impurifies vision constitutionally, since, as Krauss points out, there would be no vision without it: like the affective dimension of perception, the corporeal holds a certain priority in relation to vision.

This priority, I would insist, is precisely the priority of the proto-sensory invoked in the various research programs mentioned above: it stems not simply from the embodied nature of vision (i.e., the fact that the eye is an organ), but more fundamentally from the fact that the body is the site where all sensory information is processed and where information from distinct senses can be interchanged, exchanged, fused, and (in the case of true synesthesia) cross-mapped. The body is the precondition not just for vision, but for sensation as such. It is why there *is* sensation at all. And indeed, in her comments on one specific legacy of the Duchampian moment, namely, the flicker film, and its contemporary appropriation by James Coleman, Krauss seems to recognize precisely this primordial function of the body. As she sees it, the flicker film exploited the recalcitrant attachment of the afterimage with the viewer's body by deploying this phenomenal dimension independently of the cinematic persistence of vision; in the rapid-fire alternation of starkly contrasting frames (black and white, black and image, color shades, etc.), the flicker film is said to "heighten" the phenomenon of the afterimage: projected onto the "visually 'empty' spaces provided by the 'flicker's' intermittancies of black leader," the afterimage becomes a place *in between* frames where we can—supposedly— "'see' . . . the bodily production of our own nervous systems, the rhythmic beat of the neural network's feedback. . . ."[14]

Appropriated by James Coleman as the material for an early film installation, this heightened (because bodily) phenomenon of the afterimage becomes the basis for a transfer of sensation between the work and the body. Coleman's *Box* appropriates found footage of the Gene Tunney–Jack Dempsey fight of 1927 (figure 1.1). Cut into short sequences of three to ten frames that are interrupted by short spaces of black, the film yields a pulsing movement

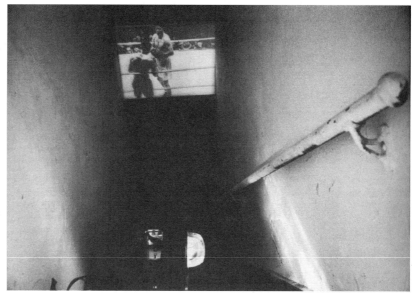

Figure 1.1
James Coleman, *Box (ahhareturnabout)* (1977). Found footage of Tunney–Dempsey boxing match of 1927, cut to generate pulsing rhythm.

that takes the form of repetition whose very anticipatory motivation *is* the viewer's corporeal expectation of a return. While this pulsatile component of the piece is said to reflect the repeated jabs and feints of the two boxers, Krauss insists that the representational dimension of the work is subordinate to its rhythmic component: "The fact, however, that the viewer's own body, in the guise of its perceptual system and the projected afterimages it is automatically 'contributing' to the filmic fabric, is also being woven into the work means that *Box*'s subject-matter is somehow displaced away from the representational place of the sporting event and into the rhythmic field of two sets of beats or pulses: the viewer's and the boxer's."[15] The work functions to convert the rhythm of the represented boxing match into the rhythms of the viewer's bodily response.

Yet when Krauss then goes on to invert the relationship between representational content (boxing) and the repetitive form of the work—claiming that "*Box* is not 'about' the violence of the sport of boxing but, rather, that the image of this brutal sport is 'about' the violence of repetition"—she effectively reasserts the *objective* status of the aggregative and self-differing condition of the medium: it is, as she puts it, the *image* of the repetitive rhythm of boxing—

and not the pulsatile rhythm of the viewer's bodily experience—that accords the work its aesthetic intentionality (its "aboutness"). Thus, the work—not the body—remains the privileged term in the aesthetic equation. This explains Krauss's insistence on the centrality of the modernist figure of shock, for the interchange between work and viewer can be sustained only as long as the two mirror each other perfectly, only as long as the "shock" of the "portrayal of black-gloved fists punching into white, yielding flesh . . . is *echoed* in the viewer's own body by the luminous explosions of the afterimage," and vice versa, in an infinitely proliferating oscillation.[16]

However we choose to evaluate its success as an account of Coleman's *Box,* Krauss's conception of the pulsatile dimension of the medium simply cannot do justice to more recent works of media art, where digital processing operates precisely to decouple body from image. Consider, for example, Douglas Gordon's digitally facilitated manipulation of the temporal flow of the filmic image in a work like *24-Hour Psycho* (1993). Rather than presenting us with an objective component whose rhythmic repetition echoes the pulse of the viewer's bodily experience, Gordon's greatly decelerated projection of Hitchcock's *Psycho* (at 2 frames per second rather than the usual 24) foregrounds the radical *disjunction* between its pace and the frenzied affective experience of the viewer whose every whit of attentiveness is insistently focused on anticipating the shift to the next frame (see figure 7.3). Here, not only are we far from the modernist aesthetics of shock, but the slowness of the projection strips the work of representational "content" (e.g., its unfolding as movement via repetition) such that whatever it is that can be said to constitute the content of the work can be generated only in and through the viewer's corporeal, affective experience, as a quasi-autonomous creation (and not, importantly, as an echo of the *objective* self-differing condition of the medium).[17]

Another still more recent work foregrounds, in even more insistent terms, the inadequacy of Krauss's conception—its failure to subordinate the representational component of the artwork to bodily sensation. With an irony that is at once aesthetic, historical, and technical, Paul Pfeiffer's *The Long Count* (2001) returns to the theme of boxing, and indeed to the very correlation of repetitive representational content and pulsatile experience foregrounded in (Krauss's analysis of) Coleman's *Box,* only to vacate it in the most brutal manner imaginable: by digitally removing the very source of the represented

Figure 1.2
Paul Pfeiffer, *The Long Count* (2001), courtesy of the artist and the Whitney Museum. Television footage of Muhammad Ali fight with boxers digitally removed.

shock—the boxers themselves (figure 1.2). *The Long Count* is a three-part digital video installation based on the final rounds from three of Muhammad Ali's most famous fights: *I Shook Up the World* against Sonny Liston in the United States in 1964, *Rumble in the Jungle* against George Foreman in Zaire in 1974, and *Thrilla in Manila* against Joe Frasier in 1975. Using commercially available software, Pfeiffer has removed the images of the boxers and the referee and has filled in the gaps left by this removal with images of the cheering crowd. As Debra Singer observes, this deliberately rough editing process has the effect of transforming "the boxers' massive figures into ghostly traces of their former selves, insubstantial contours weaving in the ring and bouncing off the ropes in constant flux."[18] What remains to be seen on the three tiny monitors (each of which is secured to a steel pipe protruding about three feet from the wall a little below eye level) are the looped images of these three boxing matches without boxers—images, that is, of boxing matches comprised exclusively of fluid warping of air, rhythmic stretching of the ring's boundary ropes, undulating crowd excitement and cheering, all overlayed with a soundtrack composed of

recorded interviews with the four boxers edited to remove their words and thus leaving only sounds of breathing and background static.

That the work nonetheless functions to produce a profound affective response via its rhythmic impact on the viewer's body testifies to the assymmetry on which I have been insisting: here, more clearly than in *Box,* it is the viewer's body *in itself* (and no longer as an echo of the work's "content") that furnishes the site for the experience of the "work's" self-differing medial condition. Indeed, Pfeiffer's own account of the historical significance of the documentary footage foregrounds the autonomy of bodily affect that lies beneath the representational content of media images: "This footage is the beginning of the sports figure as a global media image. . . . It's the forerunner of something that's now taken for granted. In a way, removing the boxer brings it back to something truer to life—the power of *that* moment and *that* figure."[19] Here, then, we are brought face to face with the potential of the digital to effectuate a new, and in some important sense, more direct connection with the affective power of an image that has been transformed into cliché. In Pfeiffer's *The Long Count,* the bodily experience of rhythmic repetition or pulse is itself the medium of the work: it is the site where the "layering of conventions" that constitute any medium (including, and indeed especially, in the case of today's supposed universal medium, the digital) must be said to take place.

Returning to our discussion of the self-differing condition of the medium, we can now say precisely what difference the digital makes, and also why it is not only legitimate, but of the utmost importance, for us to develop an aesthetics of contemporary media embodiment. Because digitization allows for an almost limitless potential to modify the image, that is, *any* image—and specifically, to modify the image in ways that disjoin it from any fixed technical frame—the digital calls on us to invest the body as that "place" where the self-differing of media gets concretized. As the basis for an aesthetics of the digital, moreover, this investment is not something that must await the future obsolescence of the digital as a medium in the narrow sense (assuming it even is one),[20] but can—and indeed must—be undertaken today. In part, this is because an embodied aesthetics of the digital need not yield the kind of cognitive gain that remains the payoff on Krauss's (in this respect canonically art-historical) account, but can rest content with simply allowing the sensory body

to process the conventions of media without explicitly recognizing their self-differing condition. For a theory of art in the specifically "post-medium" condition named by the digital, the body itself is invested with the responsibility of preserving within itself the self-differing condition of media. If the "digital" names the self-differing condition of media *par excellence* (since it has no "natural" physical support), then the process of embodiment must form an integral part of it: embodiment is *necessary* to give it a place, to transform its endless self-differing into a concrete experience of today's informational (or "post-medium") environment.

For reasons touched on in the introduction, we might expect to find in media critic Lev Manovich's *The Language of the New Media* a justification for the "newness" of new media. Manovich, we there had occasion to observe, pronounces the obsolescence of the image in its traditional sense. This obsolescence stems from "the most fundamental quality of new media"—their *programmability*—which, Manovich stresses, "has no historical precedent." Accordingly, new media can and must be distinguished from old media by their different ontological status, and indeed, their total material fluidity: rather than being anchored to a specific material support, new media are fully manipulable, digital data. As Manovich puts it, "[c]omparing new media to print, photography, or television will never tell us the whole story. For although from one point of view new media is indeed another type of media, from another it is simply a particular type of computer data, something stored in files and databases, retrieved and sorted, run through algorithms and written to the output device. . . . New media may look like media, but this is only the surface."[21]

This promising distinction notwithstanding, the account of new media Manovich goes on to offer in *The Language of the New Media* does not adequately theorize its implications and, indeed, most often seems devoted to correlating new media with the earlier media types from which (on this understanding at least) it would seem to require differentiation. Whether this is because of Manovich's stated aim to furnish "a record and a theory of the present" (rather than speculations about the future)[22] or a more obscure theoretical incapacity to see beyond contemporary framings of media, the result is a picture that constantly threatens to reduce new media to a mere amplification of what came before.

The first principle of this reduction is the central role Manovich accords the cinema. As he sees it, cinema is now the dominant cultural form and thus plays a fundamental role in the cultural configuration of new media. "A hundred years after cinema's birth," he states, "cinematic ways of seeing the world, of structuring time, of narrating a story, of linking one experience to the next, have become the basic means by which computer users access and interact with all cultural data. In this respect, the computer fulfills the promise of cinema as a visual Esperanto."[23] Yet while this assessment may be correct as an empirical observation on the current appearance of the computer interface (here one need only think of the extensive role of cinematic sequences in current video games or the introductory flash clip so ubiquitous on today's Web sites), Manovich's installation of cinema as the dominant aesthetic medium (or set of conventions) overdetermines—and consequently limits—his understanding of the aesthetic potential of new media.[24]

In part, this limitation is due to an equivocation in Manovich's argument regarding cinema—an equivocation stemming from his oscillation between two distinct conceptions of cinema. On the one hand, Manovich uses "cinema" as a general term designating what he calls a "cultural interface": in his estimation, cinema includes "the mobile camera, representations of space, editing techniques, narrative conventions, spectator activity—in short different elements of cinematic perception, language, and reception. Their presence is not limited to the twentieth-century institution of fiction films; they can be found already in panoramas, magic lantern slides, theater, and other nineteenth-century cultural forms; similarly, since the middle of the twentieth-century, they have been present not only in films but also in television and video programs."[25] On the other hand, Manovich circumscribes "cinema" as a historically and technically specific media type—the projection of a moving image on a screen in a darkened theater to largely immobilized viewers. While this oscillation allows him both to install cinema in a dominant position as a nearly universal cultural interface and simultaneously to criticize and attempt to think beyond some of its restrictive concrete conventions, it imposes a theoretical double bind on his analysis that effectively compromises—always already or before the fact, as it were—his claims for the "newness" of new media. Thus, no matter how strongly Manovich foregrounds the resistance of new media art to the conventions of "cinema" in the narrow sense, his insistence on its

circumscription within "cinema" in the broad sense serves to constrain the argument, to defeat it from the start as it were, since it remains the case that new media function first and foremost to extend the sway of cinema.

For Manovich, this situation comprises nothing less than the "paradox of digital visual culture": the fact that, "although all imaging is becoming computer-based, the dominance of . . . cinematic imagery is becoming even stronger."[26] To my mind, by contrast, this situation demarcates a fundamental limitation of Manovich's analytic framework, since, unable to think beyond the cinematic metaphor, he can only reify the empirical state of new media today and thereby validate it as the ontology of new media per se.[27] Here, the problem would seem to be the utter generality of the notion of "cinema," which, as a kind of shorthand for visual culture as such, can no longer be demarcated as a particular (even if particularly dominant) historical moment in the evolution of that culture. Indeed, by including within "cinema" nineteenth-century precinematic devices and forms of visual culture that emphasize corporeal movement and were subsumed by cinema proper, Manovich neutralizes an important countertradition to cinematic immobility that, as I shall argue, is "reactivated" in contemporary new media art.

In what concrete ways does the burden Manovich places on the cinema overdetermine—and thus limit—his account of the aesthetic potential of new media? First, as I have already said, his position extends the sway of the "cinematic" in the narrow sense, and in particular serves to ratify cinematic immobility *as the default condition of the human–computer interface* (HCI).[28] In arguing that the "window into a fictional world of a cinematic narrative has become a window into a datascape,"[29] Manovich emphasizes how the HCI perpetuates precisely those most restrictive conventions of cinema as an institution: to view the computer screen, he stresses, we must assume a position of immobility akin to that of the cinema and, as in the cinema, we must allow our gaze to be drawn into a world that "exists" on the hither side of the screen. Indeed, if we now spend more time in front of the computer than the cinema screen, as the vast majority of us most certainly do, the advent of the HCI can *only* be viewed as *extending the (cinematic) condition of immobility* to unprecedented and hitherto unimaginable bounds. Still, it is not so much that Manovich is wrong to make these observations, but rather that their "correctness" as an evaluation of today's situation calls on us to divorce our theorizing

of new media (and particularly our understanding of new media art) from the empirical givens of today's most prevalent new media forms and conventions. The fact that the HCI extends the sway of immobility must be seen as occasion for criticism of the cinematic heritage of new media, and beyond that, for exploration of unheeded or unprecedented alternatives.

This brings me to the second limitation of Manovich's position: the inadequacy of the cinematic metaphor (even in the broad sense) as a means to theorize the digital image. Recalling our above discussion of the digital image—and specifically Edmond Couchot's definition of it as an aggregate of quasi-autonomous, independently addressable, numerical fragments—we can now see how it is fundamentally antithetical, at least at the material level, to the form of the frame. Since the set of elementary numerical points comprising a digital image contains within itself, as alternative permutations of these points, all potential images to follow, and since therefore, any point whatever can furnish the link to the next image, the digital image *explodes* the frame. Defined in this way, the digital image remains ungraspable from the standpoint of Manovich's positivist vision, since for him new media, because they are above all cinematic in form, are *necessarily* constrained by the convention of rectangular framing.[30] Once again, Manovich's own stricture against separating theory and empirical observation prevents him from developing the basic material or ontological significance of the digital. For even if today's empirical deployment of the digital image remains bounded by the rectangular framing of the cinema, the fact is that (unlike the photograph or the cinematic frame) it *need no longer be so bounded.*[31] Regardless of its current surface appearance, digital data is at heart polymorphous: lacking any inherent form or enframing, data can be materialized in an almost limitless array of framings; yet so long as it is tied to the image-frame of the cinema, this polymorphous potential will remain entirely untapped.

Given that Manovich's depiction of digital technology is undoubtedly the most rich and detailed available today, there is some trenchant irony to this limitation:[32] it is almost as if what Manovich grasps from a technical, theoretical standpoint—that is, precisely how novel the digital really is—must immediately be contained within a comfortable culturalist frame. Consider in this regard Manovich's account of the hybrid form of new media: "*the visual culture of a computer age is cinematographic in its appearance, digital on the level of*

its material, and computational (i.e., software driven) in its logic."[33] We might expect some recognition of the radical flexibility of the digital image to follow from this seemingly nuanced account, but nothing of the sort does in fact come. Rather, asking himself whether "cinematographic images . . . will at some point be replaced by very different images whose appearance will be more in tune with their underlying computer-based logic," Manovich confidently replies in the negative. "Cinematographic images," he reasons, are simply too "efficient" as vehicles "for cultural communication" ever to be done away with, or even displaced from their prominent position.[34] One need hardly embrace Kittler's radical posthumanism to recognize the imperializing anthropocentrism at stake here: beyond the theoretical question of whether we should constrain our understanding of the digital to its narrow function *for us,* Manovich's position undermines the very technical autonomy that he so insightfully attributes to the digital. The ultimate implication of his argument is quite narrowly, and indeed defensively, humanist: since the digital will always be manifested as the cinematographic image—that is, as images designed for human consumption, images that "are easily processed by the brain"[35]—we need attend to only those aspects of its materiality that bear on this manifestation.

This conclusion, in turn, brings us to the third, and for our purposes, most significant, limitation of Manovich's position: the narrow circumscription of possibilities for alternative aesthetic deployments of the digital. At this point, it will come as no surprise that this circumscription follows directly from the *epochē* to which the generalized institution of the cinematic (necessarily) submits the function of viewer mobility. What we discover from Manovich's various discussions of animation, virtual reality, and (alleged) aesthetic alternatives to the cinematic trajectory is that the potential for viewer mobility to catalyze a fundamental reconfiguration of the viewer's relation to the digital image—or, more precisely, a *production of the digital image in and as the processural embodiment of information*—is consistently undermined in favor of arguments that strengthen the tie linking the digital to the cinematic and its predominant condition of immobility. This reduction manifests itself at both the macro- and the microlevel of Manovich's argument. In the broad picture, it informs Manovich's claim that contemporary digital art carries out a certain return to the precinematic—namely, a reenfranchisement of animation techniques that were (necessarily) excluded in the (contingent) historical develop-

ment of classical film language. And, more locally, it underwrites Manovich's account of virtual reality technology as an instance of a countertradition of "simulation" in which the continuity of scale between physical and representational space takes precedence over all other factors, including viewer mobility.

Consider Manovich's definition of "digital cinema": "*Digital cinema is a particular case of animation that uses live-action footage as one of its many elements.*"[36] Implied in this definition is a generalized understanding of cinema that, though different from its earlier generalization as a "cultural interface," nonetheless serves to demarcate the concrete institution of cinema as a part of a larger techno-socio-historical complex, or in other words, to extend the term "cinema" so as to encompass the prehistory of cinema in nineteenth-century techniques of animation as well as its redemptive return in the digital. Manovich's argument thus unfolds as a more or less cut-and-dried story of cinema in the digital age enriching itself by reaffirming its earliest roots: "Manual construction and animation of images gave birth to cinema and slipped into the margins . . . only to reappear as the foundation of digital cinema. The history of the moving image thus makes a full circle. *Born from animation, cinema pushed animation to its periphery, only in the end to become one particular case of animation.*"[37] Despite his claim that cinema's regime of realism was nothing more than "an isolated accident in the history of visual representation," there remains a disturbing linearity and even hints of technical determinism in his account.[38] For what the digital realizes, in reenfranchising the conventions of animation, is something like the "essence" of cinema: "What was once supplemental to cinema becomes its norm; what was at the periphery comes into the center. Computer media return to us *the repressed of cinema.*"[39] This return of the cinematic repressed is catalyzed by the technical capacities of digital media—specifically, the vastly expanded role played by the manual construction of images independent of any aesthetic imperative.

By restricting the function of digital media to the manual *construction* of images, Manovich effectively ignores another equally important element in the precinematic regime of visuality: the *manual production of movement.* As art historian Jonathan Crary has demonstrated, *all* of the precinematic devices involved some central element of manual action on the part of the viewer.[40] One had to yank outward on the two strings supporting the circular face of the thaumatrope; to spin the phenakistiscope, the stroboscope, and the zootrope

with one's hand; to flip manually through the flip book; to crank the handle of the zoopraxiscope and the mutoscope; to move one's neck and head in relation to the diorama; to walk around within the space of the panorama; and even manually to replace the slides in the stereoscope.

That these manual actions were not simply extraneous to the experience of the illusion of movement—and that they functioned precisely to render this experience a profoundly embodied one—has been suggested by film scholar Linda Williams.[41] According to Williams, there is a sort of elective affinity between the tactile "interfaces" of the precinematic devices and the pornographic image: in both cases, an experience of touch is integral to the *efficacy* of the visual spectacle.[42] Yet what these instances foreground—and what serves to demarcate them from other forms of image perception—is precisely their disjoining of the experience of touch in the viewer from the force of the image. In them, touch functions to bring the body to life, to facilitate the body's experience of itself, and not just (as in cinema proper) to embody the illusion of the image. In these instances, as Williams puts it, touch "is *activated by* but not *aimed at* . . . the absent referent. Though quite material and palpable, it is not a matter of feeling the absent object represented but of the spectator-observer feeling his or her own body."[43] That is to say, touch in the experience of precinematic visual devices, as in the experience of the pornographic image, requires more involvement on the part of the viewer than cinema typically demands. The aim in both cases is not simply to create a circuit linking the image and the body where the goal is to confer believability on the image, but rather to bring into play a *supplementary* element of bodily stimulation, itself independent of the "force" of the referent, which accompanies, so to speak, the experience of the image and confers a more concrete sense of "reality" on it.[44] This the precinematic regime accomplishes in an altogether literal fashion: through direct manual and tactile stimulation.

Recent phenomenological and scientific research has shed light on precisely how and why such manual, tactile stimulation functions as "reality-conferring" in the sense just elucidated. Phenomenologist Hans Jonas, from whom I borrow this felicitous term, has shown that the disembodied (and hence, supposedly most "noble") sense of vision is rooted in and dependent on touch for its reality-conferring affective correlate.[45] Likewise, empirical research on animal perception—most notably, Held and Hein's famous experi-

ment on comparative visual learning in motor-active and passive kittens—has shown that the cross-mapping of vision and bodily activity is a fundamental prerequisite for proper physiological development.[46] And more recently, interdisciplinary visionaries like the Chilean neuroscientist Francisco Varela have brought these two perspectives together: according to Varela, the capacity of the "embodied mind" to adapt quickly to new virtual realities demonstrates the plasticity of the nervous system and the operative role of bodily motility in the production of perception.[47] Together, these sources stress the importance of an *ergodic* dimension to perceptual processes and the experience of visual images: putting the body to work (even in quite minimal ways) has the effect of conferring reality on an experience, of catalyzing the creation of a singular affective experience, that is, one that is qualitatively different from (but that can be deployed to *supplement*) the "verisimilitude" or "illusion" of the cinematic image.

Manovich's decision to ignore this manual dimension of the precinematic regime has significant consequences for his understanding of the function of contemporary new media art. Indeed, if mobility and manual play are fundamental to what I am calling the Bergsonist vocation of aesthetic experimentations with the digital image, then it follows that Manovich's conception of digital cinema simply cannot do justice to the more adventurous—and hence more significant—of these experimentations. This is not simply because his circular history effectively reimposes the linear, teleological, and technodeterminist model of (traditional) cinema history that, as Crary puts it, flattens the "dialectical relation of inversion and opposition" between precinematic devices and cinema proper.[48] More significant still is the fact that, by bracketing out the manual and tactile dimension of the precinematic regime, Manovich strips his own analysis of the historical tools required to grasp just how much difference the transfer of the cinematic from the dark, illusionist space of the movie theater to the bright, layered "small window on a computer screen" actually makes,[49] and beyond that, how this difference can be deployed as the basis for an entirely different regime of visual experience, one that recurs to and expands the central function played by the body, not in lending reality to a virtual, representational space, but in actually creating the image within itself.

One symptom of this limitation can be found in Manovich's account of virtual reality (VR). According to Manovich, VR inaugurates an ambivalent,

indeed *paradoxical,* visual regime, since it couples a radically new freedom of mobility (where the viewer's body is coupled to the movement of the camera through space) with an unprecedented imprisonment of the body (which is "physically tied to the machine"). This paradox of VR reaches its extreme in applications (like the Super Cockpit developed by the Air Force in the 1980s) that perfectly synchronize the virtual world with the physical world. Such synchronization—or more precisely, continuity of scale across the physical–virtual divide—locates VR in what Manovich characterizes as an "alternative tradition" to that of representation: the tradition of simulation. Whereas the representational tradition (from Renaissance painting to cinema) splits the viewer's identity between the physical space and the space of the representation, simulation (from the mosaic and fresco to VR) places the spectator in a single coherent space encompassing the physical space and the virtual space that continues it. Yet in bringing the simulation tradition to a culmination, VR introduces an important difference, for instead of relying on an illusionist representation of the continuity between physical and representational space, it simply abolishes the divide altogether: "In VR," claims Manovich, "either there is no connection between the two spaces . . . or, conversely, the two completely coincide. In either case, *the actual physical reality is disregarded, dismissed, abandoned.*"[50] What this means is that the new mobility and immersive effect of the virtual image comes at a significant cost, since it requires not only the imprisonment of the viewer but the total subordination of physical space. Contrasted with the mosaic and the fresco, which furnished decorations in a physical space of action, VR (and here it is anticipated by the nineteenth-century panorama) empties the physical space entirely.

Once again, however, we must ask after the cost of Manovich's neglect of the tactile aspects of the interface. Put bluntly, Manovich seems to overlook the *physical dimension* that is at issue in the body's experience of space, regardless of whether the space concerned is an actual physical space or a simulated, virtual one. To grasp how this oversight can easily become a fundamental limitation of Manovich's theory, consider the case of telepresence (or teleaction) where the virtual space forms a medium linking the body with a physical space to which it is not proximate.[51] Could Manovich say of the telepresence interface what he affirms of VR, namely that the "physical space is totally disregarded" and "all 'real' actions take place in virtual space"? Can the reality effect

of telepresence be understood without an account of the physicality of the virtualized body? As a kind of test case for Manovich's concept of simulation, the example of telepresence underscores the limitation of his general distinction between representation and simulation and suggests the necessity of triangulating this binary with a third term, namely, hallucination (by which I mean, following recent research in perception, the fact that the embodied mind actually *creates* what it sees).[52] For, in addition to the actual action facilitated through a telepresence interface (say, virtual surgery), there necessarily takes place, within the body of the participant, an embodied experience: a bodily processing of the action that has the effect of "making it real" for the participant. Indeed, it is precisely this "hallucinatory" dimension, applied to virtual reality more generally, that explains the capacity for the VR interface to couple our bodies with (almost) any arbitrary space, and not just spaces that are contiguous with the physical space we happen to occupy or even spaces that are like those we typically occupy.[53]

This same limitation also compromises Manovich's celebration of supposed aesthetic alternatives to the dominant configuration of the HCI as a simple prolongation of cinema. Citing ART+COM's *The Invisible Shape of Things Past* and several computer animations by Tamás Waliczky (projects that I shall have occasion to address in the body of my text), Manovich invests artworks with the capacity to "refuse the separation of cinematic vision from the material world" and thus interrupt the "universalization of cinematic vision by computer culture."[54] All of these projects are said to employ a "unique cinematic strategy" that, unlike most computer interfaces, has a "specific relation to the particular world it reveals to the user."[55] Accordingly, *Invisible Shape* uses a virtual interface to facilitate access to historical data about Berlin's history which, arrayed as digitized "film objects" stacked one after another in depth, is given a concrete form, something akin to a book (figure 1.3); in so doing, Manovich concludes, the project forms a "virtual monument to cinema," one in which the records of the camera's vision are made into material objects of a very specific type and one antithetical to the cinema's current generalized function as a "toolbox for data retrieval and use." Similarly, Waliczky's computer animations (*The Garden, The Forest, The Way*) all deploy variant perspectival systems that challenge the single-point perspective of the post-Renaissance representational tradition (figure 1.4); by modifying the spatial structure of the

Figure 1.3
ART + COM, *The Invisible Shape of Things Past.* Data about Berlin's history arrayed as digitized, booklike "film objects."

animated worlds in order to render them a function of the changing camera position, Waliczky makes "camera and world . . . into a single whole," thereby giving the cinematic interface a materiality concretely correlated with the world it presents. In no way, though, does Manovich see these examples as marking a break with the "cinematic metaphor." No matter how much they might resist the dominant generalization of cinematic vision, their importance continues to derive from their instantiation of the cinematic logic Manovich attributes to new media; they simply deploy cinema in an alternate modality.[56]

What is missing from Manovich's exposition of these works is any account of the significant role accorded the body as the "operator" of an alternative, post-cinematic interface with data. By short-circuiting our habitual experience of the space of the image, for example, Waliczky's animations call into play a haptic or tactile production of space in which the body itself, deprived of "objective" spatial referents, begins to *space* or to *spatialize,* that is, to create space *within itself* as a function of its own movement (whether this be actual physical movement or the surrogate movement facilitated by a virtual interface). For this reason, it is striking to see Manovich simply extend the cine-

Figure 1.4
Tamás Waliczky, *The Way* (1996). "Inverse perspective system" causes objects to diminish in size as the depicted figures run toward the viewer.

matic convention of immobility to these works, in explicit contravention of his own call for an "info-aesthetics" that would foreground the movement of the viewer and the role of touch.[57] What this shows, I would suggest, is just how much Manovich's hands seem to be tied by his own argument concerning the cinematic interface.

There are, nonetheless, moments when Manovich's analysis seems to escape the theoretical double bind imposed by his positivist stance. Just as Krauss's arguments concerning the formless functioned to supplement her reflections on the medium, Manovich's own concrete analysis of two recent works by Australian-born media artist Jeffrey Shaw furnishes a means to complicate his empiricist bias, and specifically, to pinpoint how the aesthetic investment of bodily mobility and manual play accord what we above called the *amodal* or *proto-sensory* body an operative role in producing the digital image. As the key exhibit of the next chapter and a constant reference thereafter, Shaw's work plays a prominent role in my three-pronged narrative concerning the digital image, the body, and the haptic.

Both of Shaw's recent media platforms, *EVE* (or *Extended Virtual Environment*) and *Place* foreground the similarities and differences between

Figure 1.5
Jeffrey Shaw, *EVE (Extended Virtual Environment)* (1993-present). Interface platform combining domed image surface, cinematic framing, and viewer mobility. (See plate 1.)

various technological interfaces, including panorama, the geodesic dome, cinema, video, computer games, and VR. In *EVE,* for example, Shaw combines the function of a domed image surface (that is, a semispherical panorama), the cinematic interface, and the mobility of VR: viewers occupy a large inflatable dome on whose surface a projector, located in the middle of the dome, casts a framed image; this image, in turn, is controlled by a single (privileged) viewer who wears a helmet that directs the trajectory of the projection (figure 1.5). In *Place: A User's Manual* (1995), Shaw's first deployment of his *Place* interface, a 360° panorama is combined with a video interface, controlled by a joystick, that facilitates navigation of the image as a typical computer space. Viewers oc-

cupy an elevated central rotating platform and, by means of a joystick, manip- ulate an underwater video camera in order to zoom into and out of eleven "virtual" photographic cylinders that exactly reduplicate, within the illusory space of the image, the cylindrical physical space contained within the 360° panorama (figure 1.6). What is important, as Manovich astutely grasps, is how Shaw manages to juxtapose these various interfaces *without dissolving their respective integrity:* "rather than collapsing different technologies into one," notes Manovich, Shaw "'layers' them side by side; he literally encloses the interface of one technology within the interface of another."[58] Manovich further claims, again astutely, that this layering of technologies serves to draw out the respective conventions constitutive of each interface medium: "By placing interfaces of different technologies next to one another within a single work, Shaw foregrounds the unique logic of seeing, spatial access, and user behavior characteristic of each."[59] This juxtaposition, moreover, would seem to blend Manovich's

Figure 1.6
Jeffrey Shaw, *Place: A User's Manual* (1995). Interface platform combining a 360° panorama with navigational capacities of video camera. (See plate 2.)

two traditions of visual culture—representation and simulation—in an un-precedented mix: "The tradition of the framed image, that is, a representation that exists within the larger physical space that contains the viewer (painting, cinema, computer screen), meets the tradition of 'total' simulation, or 'im-mersion,' that is, a simulated space that encloses the viewer (panorama, VR)."[60]

Still, despite his incisive characterizations of both works, Manovich has absolutely nothing to say about what exactly happens when these two tradi-tions meet in this way. Nor does he mention the fact that both works involve the body in significant ways, ways that specifically recur to the precinematic moment: *EVE* foregrounds the mobility of the viewer *as the requisite condition for image movement and hence for the "event" of confrontation between interface traditions;* and *Place: A User's Manual* deploys the manual manipulation of a joystick *as the means for the viewer to become the activator of movement in the vir-tual image space.* As I understand them, Shaw's works thus call on us to ask what it is, exactly, that allows the superposed interfaces to function "together" with-out ceding their specificity. They compel us to explore what it is about the tac-tilely and kinesthetically active body that allows it to synthesize the imaging capacities (the medial conventions) of divergent media interfaces into a coher-ent, complex experience of the digital image.[61] For this reason, they will serve as a sort of guide for us as we explore the bodily interface with information that is at issue in works of new media art and in our negotiation with the contem-porary infosphere more generally.

Framing the Digital Image: Jeffrey Shaw and the Embodied Aesthetics of New Media

Theoretical Aim	Body	Image	Artwork
To isolate what differentiates body (bodily framing) from the technical image (preconstituted frame)	From body as a physical screen for image to body-brain as a mental source for impression of "virtual totality"	From externally originating source of possible perceptions to product of an internal bodily process (bodily framing of information)	Shaw's Corpocinema, MovieMovie, Viewpoint, Points of View, Inventer la Terre, The Narrative Landscape, Place: A User's Maual, Place: Ruhr

> . . . [A]ll my works are a discourse, in one way or another, with the cinematic image, and with the possibility to violate the boundary of the cinematic frame—to allow the image to physically burst out towards the viewer, or allow the viewer to virtually enter the image.
>
> —Jeffrey Shaw

You are standing on a rotating platform in the middle of a 360° panoramic screen (figure 2.1). Directly in front of you is an underwater video camera with a joystick interface, a monitor, and a microphone. This camera is connected to a projector, which brings to life a 120° frame within the larger 360° panoramic surface. By manipulating the joystick, you slowly move this 120° frame clockwise and counterclockwise and then, setting your sites on something you see in the image space, you zoom into the virtual landscape projected in front of you, entering one of eleven image "cylinders" that present panoramas of different sites in the *Ruhrgebiet,* the industrial region in Germany that has recently undergone the shocks of postindustrialization (figure 2.1b). Because these eleven cylinders are "homeothetic" with the physical panoramic space in which you find yourself, your movement from the physical to the virtual image space is accompanied by a feeling of continuity that partially obscures the difference between physical and virtual space. Once inside an image cylinder, the landscape panorama becomes a cinematographic sequence and the projection surface acquires depth and surrounds you (figure 2.1c). Your capacity to move within the image space doubles the movement of the images in front of you, yielding an exhilarating indifferentiation between your "subjective" embodied movement and the "objective" mechanical movement of the image. Indeed, as you navigate by moving the video camera left and right and zooming in and out, entering and exiting other image cylinders, the central platform on which you are

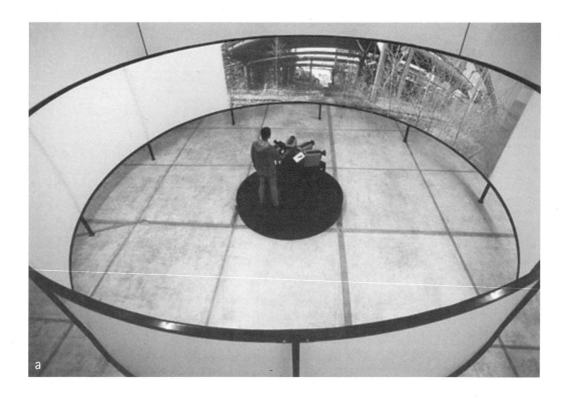

Figure 2.1
Jeffrey Shaw, *Place: Ruhr* (2000). An interface featuring live-action images of eleven sites in Germany's industrial region (*Ruhrgebiet*). (a) View of video platform and live-action sequence featuring one industrial scene. (b) Vertical view of rotating video camera platform and 120° framed image. (c) Close-up of live-action image of Germany's industrial region. (See plate 3.)

perched and the projected image slowly shift in sync with each other, fusing into a single movement encompassing both your bodily sense of location in space and the virtual space of the image. Accordingly, your experience of this image environment gradually yields a felt coordination of your bodily movement with your "virtual" navigation of the image space, as the virtual space of the image is transformed from an impersonal cognitive idea into an immediately graspable, profoundly personal experience, one that centrally features your body—that is, your proprioceptive and affective body—as interface.

This work—*Place: Ruhr* (2000) by Jeffrey Shaw—is the most recent in a series of interactive environments that focus on the confrontation of antithetical image interfaces and traditions of visual culture. In this work, Shaw specifically adds one more media interface to the repertoire he had assembled earlier in *Place: A User's Manual* (1995)—cinematic movement. (When you enter an image cylinder, the depicted world does not remain static, as it did in the ear-

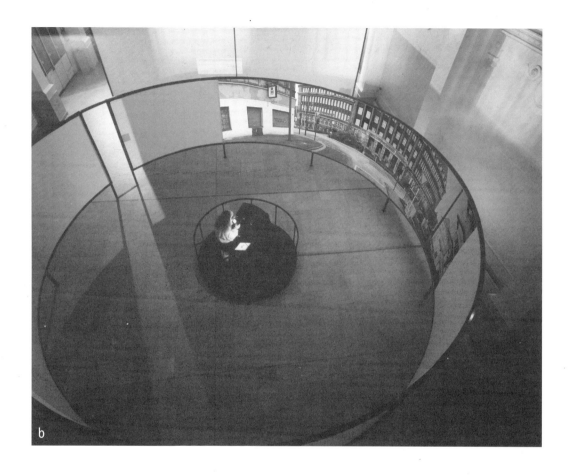

b

lier work, but immediately begins to move, effectively doubling your own movement through the image space with the capacity of the image to move for itself.) In so doing, Shaw's *Place: Ruhr* polarizes, in the most effective manner possible, the technically "highest" forms—cinema and virtual reality—of the two antithetical interface traditions central to all his work.[1] By granting the image the capacity for self-movement, the interactive environment overlays the cinematic convention of framing on top of the panoramic convention of immersive illusionism in a way that inverts the autonomy of the cinematic frame, making it the vehicle for the viewer's navigation of the image and a "trigger" for a "virtual" synthesis of the whole image (the panorama) in the viewer's embodied mind.

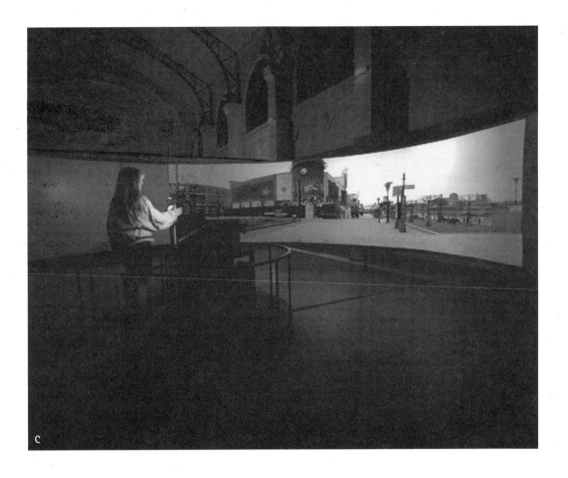

c

In thus confronting image and interface conventions with one another, Shaw's *Place: Ruhr* culminates a more than 35-year-long critical-creative engagement with the nexus of space, image, and body.[2] Specifically, by shifting the task of reconciling the conflicting demands of these conventions from the body's kinesthetic movement within the image space to the body–brain's capacity for "transpatial" synthesis, Shaw's latest work foregrounds the "virtual dimension" of embodied human life. In this respect, Shaw's work—and his development as a media artist—bears witness to one of the most crucial theoretical tenets of this study, namely, that the virtual is a quality of human (and, more generally, organic) life and can only erroneously be equated with technology. Far from being a synonym of the digital, the virtual must be under-

stood as that capacity, so fundamental to human existence, to be in excess of one's actual state. In this regard, Shaw's work will furnish eloquent testimony against the posthuman technical "machinism"—exemplified by the work of self-proclaimed "media scientist" Friedrich Kittler—that sees the digital as a transcendence of the human itself.

If Shaw's work can nonetheless be said to exemplify the Bergsonist vocation I have attributed to contemporary new media art, it is precisely because it deploys technology as a means to elicit or trigger the virtual. In line with Bergson's understanding of technology as an extension of intelligence, Shaw's aesthetic deployment of technology—from expanded cinematic environments to virtual reality—functions both to foreground and, what's more important, to expand the body's function as a center of indetermination. This is precisely what media artist and ZKM director Peter Weibel means when he likens Shaw's work to a "user's manual" for the world itself:

> [Shaw's] art is technical relational art. The arrangement of the technology is simultaneously the shaping of the relationship between image and viewer. Once the relationship between the image of the world and the viewer of the world has been defined as one which is technological, then it can be expanded and changed solely by technical means. Greater degrees of freedom in the relationship to the world and increased possibilities of using the "world," or at least its images, according to one's own notions are dependent on this development of a controllable technical relation between images of the world and viewers of the world. To see the world (of images) as a user's manual ultimately implies a heightened ability to view and use the world according to one's own notions, more individually, more subjectively. . . . The world as a user's manual is a world of modality.[3]

Weibel's assessment pinpoints precisely how Shaw's aesthetic deployment of technology enables a form of selection akin to Bergson's conception of perception as subtraction. In fact, Shaw's work might be said to fuse the major insights of *Matter and Memory* and *Creative Evolution,* making technology a supplement to the body and thus a means of expanding both the body's function as a center of indetermination and its capacity to filter images.

Shaw's work thereby introduces a crucial techno-historical dimension into the body's selective function that corresponds to the change in the "ontology" of the contemporary technosphere—to the fact that it is no longer (preconstituted) *images,* so much as inchoate *information,* that the technologically extended body is now called on to filter. For this reason, Shaw's career trajectory—which closely parallels the development of technology over the past thirty-five years—witnesses a progressive deterritorialization of the Bergsonist ontology of images, and moreover, one that diverges fundamentally from Deleuze's trajectory in the *Cinema* volumes. Shaw begins by placing the body within a larger universe of images, only to focus increasingly on the body's (or body–brain's) capacity as a quasi-autonomous center of indetermination—its capacity to create image-events by processing inchoate information. Whereas Deleuze disembodies the Bergsonist conception of the center of indetermination in order to equate it with the function of the cinematic frame, Shaw relentlessly assaults the boundary of the cinematic frame in order to foreground the bodily basis of the movement-image, and later, of the virtual image itself.

A reconstruction of Shaw's career will, accordingly, provide the perfect vehicle for a neo-Bergsonist theorization of new media embodiment that avoids the two tendencies we discovered in our analyses of Krauss and Manovich: respectively, the subordination of the body to the image and the ratification of the cinematic condition of immobility. From his earliest experimentations with expanded cinema, Shaw's engagement with the nexus of space, image, and body has sought to counter the subordination of the body to the cinematic image and to liberate the space beyond the image as the correlate of the body's excess over the image. In the aesthetic experience of new media, Shaw explains, the viewer "physically senses the feeling of movement conveyed by the image and believes that it is he or she who is in movement."[4] Using technology to maximize this transfer from image (or information) to body is the constant, if evolving, aim of all of Shaw's work.

From Image to Space: Shaw's Early and Middle Works

Viewed as an aesthetic meditation on Bergson's theory of perception, Shaw's career can be divided into (at least) three distinct phases, each of which carries out a certain technological deterritorialization of the body as a privileged image

or center of indetermination. In schematic terms, these partially overlapping phases are: (1) Shaw's work in expanded cinema and pneumatic architecture (roughly 1966 to 1978); (2) Shaw's aesthetic exploration of the virtualization of the image in works using "virtual slide projection techniques" and later the computer (roughly 1975 to 1995); and (3) Shaw's juxtaposition of image interfaces and conventions to catalyze bodily affect (1993 to the present). These phases operate a progressive escalation of the transfer from image to body, such that an initial investment in situating the body "within" the image and thereby transforming the latter into a space for kinesthetic activity gives way to a production of space—or, more precisely, of a nonempirical or "transpatial" process of spacing—within the body. In this way, Shaw's career witnesses the shift from the image as a technical frame to the problematic of framing formless information increasingly central to contemporary media culture. It is this trajectory, its correlation with the advent of digitization, and its profound aesthetic consequences that justify Shaw's privileged position as the artist most responsible for defining the Bergsonist vocation of contemporary new media art.[5]

Shaw's overriding concern with using technology to break out of the frame of the image—and thereby empower the body—serves from the very start to differentiate his work from that of his peers. Peter Weibel pinpoints Shaw's "emphasis on architecture and space rather than image" as that factor which differentiates his expanded cinema work from "comparable explorations such as those Gene Youngblood describes in his book 'Expanded Cinema' (1970)."[6] And Shaw himself attributes his attraction to the genre of installation to its substitution of architecture for the image as the integrating frame of the artistic work.[7]

This concern with the space beyond the image marks the first phase in Shaw's deterritorialization of the Bergsonist ontology of images. By emphasizing the dynamic coupling of the image environment and the activity of the body within it, Shaw's initial experiments in expanded cinema already delimit the Bergsonist universe of images into a selective "virtual" milieu or space specifically correlated with the body or bodies active within it. These experiments furthermore invert the "strict law" connecting perception and action on Bergson's account in a highly productive manner: rather than facilitating a perception that would be the measure of the body's zone of indetermination— that would appear "at the precise moment when a stimulation received by

matter is not prolonged into a necessary action"[8]—these expanded cinematic environments collapse perception back into (bodily) action, such that there occurs an indifferentiation between perception and the body's kinesthetic sense. By transforming the body into a screen that literally "selects" images by absorbing them, Shaw's environments institute a strict proportional correlation between action and perception: without the activity of the body within the space of the image, there would simply be no perception at all.

Shaw's first expanded cinema work of 1966, *Continuous Sound and Image Moments* (figure 2.2), exemplifies his deployment of space beyond the image to collapse the distance constitutive of perception (the distance between perceiving body and image perceived). The work consists of a hand-drawn black-and-white animated film loop, accompanied by sound elements, nonsynchronously projected onto four screens and subsequently incorporated into image environments like *Emergences of Continuous Forms* (figure 2.3). According to Shaw, the work was "conceived as a cinematic expansion of pictorial means," in which the "process of making thousands of drawings (rather than any individual picture)" forms the subject of an aesthetic experience. To achieve this shift from image to constructive process of reception, Shaw broke the images into short segments, with each one being shown only for a few frames, thus constituting, as he puts it, "momentary retinal impressions that assimilate in time into an insubstantial yet coherent multiformity."[9] According to the original synopsis, the aim of the project was to exploit the temporal thresholds of perception in order to shift the "support" for the work from the image to the temporal process of embodied reception:

> The film explores the boundaries of audio/visual perception and comprehension in time. This involves the expressive exploitation of the very short time intervals possible on film down to one frame or 0.04sec for an image moment. Seen on such a time scale, the images are perceived subliminally and only in the experience of the film as a continuous repetition will the identity and sequence of the images become more or less fully realized. Thus the inner forms of the film *will grow within the observer as a time experience*—the appearance, perception of order from fleeting sound and image moments (i.e. from an audio/visual flux).[10]

Figure 2.2
Jeffrey Shaw, *Continuous Sound and Image Movements* (1966). Hand-drawn black-and-white animated film loop, with sound elements, projected non-synchronously on four screens.

Figure 2.3
Jeffrey Shaw, *Emergences of Continuous Forms* (1966). Image environment that incorporates *Continuous Sound and Image Movements.*

Despite its clear debt to structuralist film,[11] this work announces Shaw's fundamental aesthetic divergence from the "pulse" aesthetic theorized by Rosalind Krauss. Because it deploys techniques designed to foreground the formless virtuality of its motivating "graphic idea" and thereby to assault the cinematic frame,[12] *Continuous Sound and Image Moments* breaks the pulsatile isomorphism linking image and body, freeing the latter to carry out a virtualization that is autonomous from the procession of images.

The subordination of image to bodily reception within an expanded cinematic space finds its most radical expression in Shaw's 1967 "performance events," *Corpocinema* and *MovieMovie*. These two events move beyond *Continuous Sound and Image Moments* by exploding the categorical divide between two-dimensional screen (image) and three-dimensional space. In them, the entire event space (the space within an inflatable dome) becomes a potential or virtual screen for images projected from the outside, and the activity of participants within the space plays a crucial role in actualizing that potential, both by con-

Figure 2.4
Jeffrey Shaw, *Corpocin-
ema* (1967). Perfor-
mance event inside
air-inflated, transparent
dome combining pro-
jected images, inflatable
tubing, paint, smoke,
and viewers' bodies.

structing and manipulating absorbent surfaces (screens) and by offering their
bodies as such surfaces. For this reason, these works represent the culmination of
a shift in Shaw's interest from the filmstrip to what Anne-Marie Duguet glosses
as the "uncertain status of the projected image, the image-in-formation."[13]

Corpocinema employed a large air-inflated transparent PVC dome
onto which were projected various image sequences, including cartoons, fea-
ture films, documentaries, and slides of abstract imagery, according to specific
themes (figure 2.4). Because of the dome's transparency, its potential function
as a cinematic screen was displaced in favor of its function as an architectural
frame. In this respect, the dome perfectly instantiates Bergson's conception of
the universe of images, in which each image is "bound up with all other images"
and "continued by those which follow it":[14] by letting images pass through it
without subtracting anything from them, the transparent dome materializes
the virtuality of the pure flux of images. However, just as this universe contains

privileged images, Shaw's dome encloses a space of "physical events and performed actions" that function as temporary screens.[15] Thus, the perception of the image is made to depend on zones of fleeting opacity created by the introduction into the dome of inflatable polythene tubing, fire-extinguishing foam, smoke, steam, water spray, and confetti, as well as the bodies of the performers, and by the application of colored powder, paint and crepe paper on the dome's surface. This subordination of the image to the actions of the performing body can be said to materialize Bergson's conception of perception as virtual action,[16] except that here, rather than being a measure of the distance separating action from the image, perception is made to coincide with the production of the image through action. Otherwise put, rather than having an existence independent of the potential action of the perceiver, the image exists only in and through the actions of the perceiving body.

The collapse of perception and bodily action is even more forcefully expressed in *MovieMovie,* where a second, opaque surface is added within the transparent dome (figure 2.5). Serving as a screen for the projected images as well as a platform or stage for the action of the performers, this second pneumatic surface formed a constantly shifting volume, thereby transforming the flat cinematic screen into a "three-dimensional kinetic and architectonic space of visualization."[17] Because the pneumatic, opaque, volumetric screen underwent continual modification as a function of the movement of bodies on it, the images it screened were subject to continuous deformation. As a result, bodily actions functioned to determine the perception (screening) of images in an even more profound way than in *Corpocinema:* here, the entire space of perception within the dome is made to fluctuate in sync with the movement of the bodies within it, such that all screen effects—the opaque volumetric surface, the opaque elements introduced into and applied onto the domed surface, and the participants' bodies—contribute to the identification of action and perception. If the translucent and opaque volumes can be said to instantiate Bergson's correlated concepts of perception as virtual action and affection as actual action (action of the body on itself), what is thereby carried out is a technological deterritorialization of affection beyond the "boundaries" of the body—indeed, an extension of the active body into its "virtual" milieu that dissolves the distance between them and thereby transforms perception (a "virtual" ac-

tion of the body on an image at a distance from it) into an expanded form of affection (an intensification of the body-milieu's sense of itself).

In his own account of his career as a media artist, Shaw cites the deployment of the computer as a watershed moment:

> My current work indeed stands in a relation of continuity [to my work of the 1960s and 1970s]. In *Legible City*, bicycle riding is truly an important element, in the sense that one experiences one's whole body as the causal power of the entire journey. But this is not the whole story. The work was originally constructed as a prototype with only a joystick as interface, and even in this case the work already came into being, even though it only allowed for a minimal amount of manual activity. Bodily

Figure 2.5
Jeffrey Shaw,
MovieMovie (1967).
Performance event incorporating opaque,
constantly shifting volume within a transparent dome filled with
images, objects, and
bodies.

participation is an important element, but the work has many more experiential dimensions. With these technologies, I have the ability to deepen the complexity of images and references. That yields an intellectual space, one that simply could not be reached in the inflatable [and expanded cinema] works.[18]

Rather than downplaying the centrality of the body, this nuanced evaluation expresses a crucial shift in Shaw's understanding of the nexus interlinking space, image, and body: whereas the earlier works focused on deframing the image in order to effect a certain indifferentiation of all three, the "computer-aided" works specifically invest the body as the site of a bodily, but also an "intellectual," event. In these works, the body, rather than being assimilated into the deframed image-space, stands over against a now virtualized image-space, and thereby acquires a more fundamental role as the source of the actualization of images. If the corporeal and intellectual processing it performs still functions to "give body" to the image, it does so not by lending its physical, extended volume as a three-dimensional screen for the image but rather by creating an image-event out of its own embodied processing of information.

This shift in Shaw's understanding of the space-image-body nexus sets the tone for the second phase of his artistic career: from this point forward, Shaw's concern will be with the body–brain activity that goes into producing and circumscribing virtual images.

While this shift is exemplified by Shaw's turn to digital imagery in the mid-1980s, it is already at work in his artistic production well before the deployment of the computer. Accordingly, what might be said to characterize this phase in his work is a general concern with the generation of the image and an embrace of the image as a disembodied form (in the sense of lacking a material autonomy or, alternatively, depending on the viewer's body–brain activity for its actualization). This second phase in Shaw's career accordingly marks a certain break with Bergson—a deterritorialization of the Bergsonist conception of the body that contravenes Bergson's own understanding of the body as a privileged image within a larger universe of images. Rather than existing as a screen or filter within the space of the image, as it did in Shaw's expanded cinema environments, the body (or body–brain) is now invested with the task of generating the image through its internal processing of carefully configured in-

Figure 2.6
Jeffrey Shaw, *Viewpoint*
(1975). Optical interface
that deploys two slide
projectors, mirrors, and
reflective surfaces to
fuse real and projected
images.

formation. The disembodiment characteristic of the virtual image is thus syn-onymous with its dependence on the activity of the body–brain: lacking any material autonomy of its own, the image does not preexist its actualization and can be given body only through this activity. In a more direct way than in Shaw's subsequent engagement with exclusively virtual spaces, here it is the very divide between the virtual and the physical that is most significant. The aesthetic experience solicited by these works juxtaposes a spectatorial synthesis that seamlessly fuses virtual and physical space with a background awareness, triggered by certain material elements, that the events thus fused belong to in-compossible space-times. In this way, attention is drawn to the capacity of the spectator's body–brain activity effortlessly to produce a virtual image out of heterogeneous material.

Viewpoint (1975) is the first of Shaw's works to explore the fundamental role of the spectatorial synthesis (figure 2.6). This installation consisted of two

structural elements: an optical viewing console housing a pair of slide projectors and a large "retro-reflective" projection screen. A semitransparent mirror in the viewing console served as both window onto the screen and reflective surface that directed the projected images onto the screen. Because the screen was treated with a reflective surface coating, all the light projected on it was directed back to the projection source; consequently, the projected image could be seen only from the viewing console and would appear as a gray surface from any other position in the installation. It is, accordingly, the tension between space and image that lies at the heart of this work:[19] while the architectural elements of *Viewpoint* are designed to encourage "a strong illusory conjunction between the real and projected spaces," the static form of the projected images functions to undermine just such a conjunction. As a result, if the spectator still experiences a fusion of the two spaces, it will be clear that this results less from the illusory power of the image than from the synthetic power of the spectator's body–brain activity. In this way, Shaw effectuates a shift from the image as a materially autonomous entity to the image as a "immaterial" or "virtual" entity that can be embodied only through the spectatorial synthesis.

This dematerialization of the image reaches its culmination in Shaw's earliest works involving the computer and digitized imagery. In *Points of View* (1983), Shaw deploys a computer-supported optical system—what he called "a see-through virtual reality system"—to reexamine the issue of point of view in light of the interactive capacities afforded by the computer and digitized imagery. First developed in *Virtual Projection Installation,* this system coupled a semitransparent mirror (not unlike that of *Viewpoint*) with a computer screen onto which two wire-frame images of a cube were displayed (figure 2.7). By turning the display system, the spectator could observe the rotation of the cube projected into the installation space. Here, the function of the screen—to absorb images—has been entirely assimilated into a viewing system dynamically coupled with the spectator. Expanding this interface system, *Points of View* presents a "theater of signs" whose stage and sixteen hieroglyphic "protagonists" are constituted by a three-dimensional computer graphics simulation projected onto a large screen in front of an audience (figure 2.8). The event of the work was controlled by one audience member using a dual joystick interface derived from flight simulation technology. This interface allowed the operator to move her virtual point of view 360° around the stage and 90° up,

Figure 2.7
Jeffrey Shaw, *Virtual Projection System* (1983). Interface platform combining semitransparent mirror and computer screen; permits viewer to rotate a cube projected within the image space. (a) Close-up of optical interface machinery. (b) Image of cube as seen through *Virtual Projection System*.

down, forward, and backward. The resulting theater of signs thus hosted a gaze liberated from any single, privileged, external point of view—a fluid, constantly morphing perspective free to roam nomadically within the virtual stage space. From the moment that the spectator enters the scene, the relevance of viewpoint diminishes in favor of her omnidirectional action potential within the virtual image space. Indeed, rather than a discrete material image, the scene becomes a "theater of operations" that immediately and dynamically determine the unfolding of the virtual theatrical event.[20]

Together, the liberation of point of view from its configuration in the image and the wholesale abolition of the function of the screen set the stage

for the development of the hybrid interface system—the fusion of viewing window and panorama—that would become the trademark of Shaw's later computer-aided artworks. First instantiated in *Inventer la Terre* (1986), this interface system installs the notion of "virtual totality" as the dominant aesthetic effect of Shaw's art. Like the virtual image synthesized in *Viewpoint,* the impression of virtual totality can occur only through the body–brain activity of the spectator: since the spectator perceives only a subset of the environment at any given moment, she can intuit the whole environment only via a synthesis that fuses the convention of the viewing window with the convention of omnidirectional movement through an informational space. In line with Shaw's consistently anticinematic program, this fusion has the effect of dynamically coupling the window with the spectator's movement, thus freeing it from its static cinematic function: from a "fixed frame that allows exploration of depth alone," the window is transformed into "a dynamic framework whose move-
. ment triggers the discovery mode."[21]

Figure 2.8
Jeffrey Shaw, *Points of View* (1983). Expanding *Virtual Projection System,* presents a "theater of signs" whose stage and sixteen hieroglyphic "protagonists" are constituted by a three-dimensional computer graphics simulation.

Figure 2.9
Jeffrey Shaw, *Inventer la Terre* (1986). (a) Rotatable column housing optical video interface that superimposes projected virtual image and image of physical museum space. (b) Close-up image of superimposed virtual and physical spaces.

a

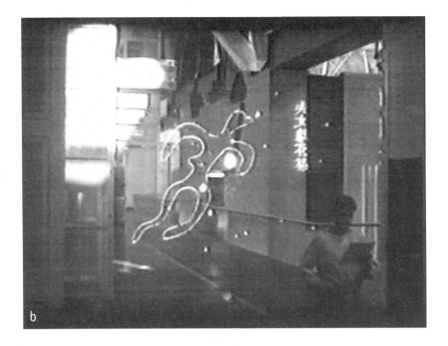

Inventer la Terre consists of a chrome-plated column housing an optical system constituted by a video monitor, a fresnel lens and a semitransparent mirror (figure 2.9). Looking through the viewing aperture in the column, the spectator perceives a large virtual image projected into the museum space and overlaid on her view of the physical environment. By pushing the two handles mounted on the column, the spectator can rotate the column and thereby control the movement of the virtual image. The spectator initially sees a 360° panorama representing six symbolic sites in a landscape, and, as she rotates the column, moves her point of view within the omnidirectional panorama floating around her. Focusing her "window" on one of these six sites, the spectator can trigger a three-minute video sequence concerning its thematic significance by pushing a button located on the column handle. Following this video sequence, the spectator is returned to the initial panoramic image at which point she can select another symbolic site to explore. Here, the hybrid window-panaroma interface is deployed as a figure for the power through which "digital pictures" are called into being: insofar as these pictures "reside materially

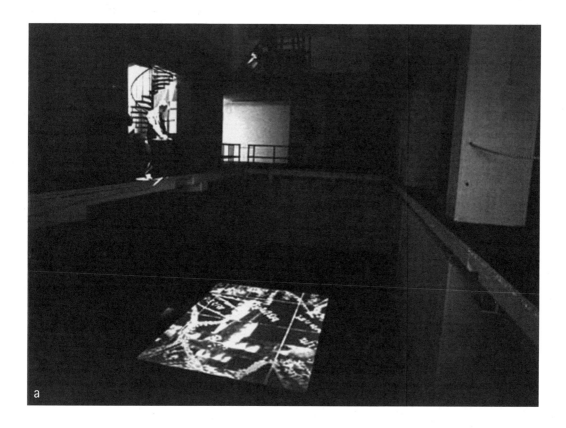

Figure 2.10
Jeffrey Shaw, *The Narrative Landscape* (1985).
(a) Interactive image environment consisting of discrete image levels; foregrounds viewer's activity as principle of framing. (b) Close-up showing image levels.

inside the computer," the "computer screen functions like a window through which the viewer chooses what to look at."[22]

Another work from the same period, *The Narrative Landscape* (1985), explicitly correlates the deframing of the interface with the digital infrastructure of the virtual image (figure 2.10). In this installation, images are projected onto a large screen lying flat on the floor of the exhibition space. By means of a joystick, the spectator, who stands on a surrounding balcony, is able to interact with the image environment. Specifically, the spectator uses the joystick to pan laterally over the surface of the image and to zoom into and out of a selected fragment of the image. Zooming all the way into an image triggers a "digital transition" to a new image that is experienced by the spectator as a jump from one image "level" to another. As Shaw explains, the aim of this work is precisely

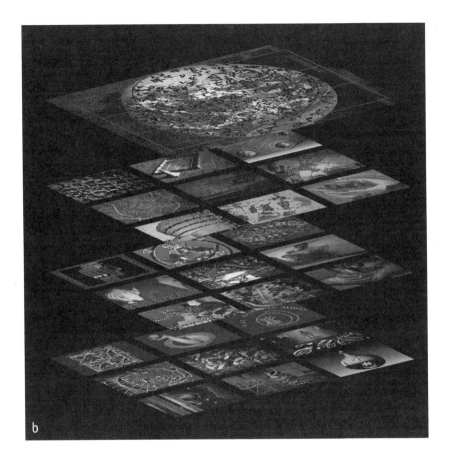

b

to furnish an experience of the volumetric raster of numeric values comprising digital space and thereby expose the infrastructural instability of the digital image: "Because these images are a digital raster, the action of zooming is also a process of increasing abstraction as the pixels become progressively larger. The different levels of representation induced by this digital deconstruction is a formal and conceptual attribute of this work."[23] Rather than simply trading in the fixed technical frame of the traditional image for a new technical framework, however, *The Narrative Landscape* (like all of Shaw's computer-aided work) foregrounds the body–brain activity of the spectator as that element which performs the switching of levels and the intuition of virtual totality. As Shaw puts

it in his 1992 lecture, "Modalities of Interactivity and Virtuality," the "interactive structure of *The Narrative Landscape* shows that the spatial boundaries of the digital image do not have to be defined by the traditional perimeter of a 'picture frame.' Instead, a virtual image space of any dimension can be created, and the viewer can explore it by moving his 'viewing window.'"[24] To the extent that such exploration depends on the viewer's synthesis, this work perfectly expresses Shaw's aesthetic investment in the vituality of the body–brain and his artistic program of using digital technology to trigger and expand this virtuality—in short, to catalyze the virtualization of the body.

If we contrast this refunctioning of the cinematic convention of the viewing window with Deleuze's assimilation of the Bergsonist center of indetermination into the cinematic frame, we can fully appreciate the vast divide separating the post-cinematic (new media) aesthetic exemplified by Shaw's career from any recuperation of the cinematic legacy, no matter how (philosophically and aesthetically) radical. Whereas Deleuze deploys the cinematic frame in order to disembody the center of indetermination and thus free cinema to operate an inhuman "perception," Shaw transforms the cinematic frame into a function of the larger process of spectatorial synthesis. Accordingly, rather than opening onto an extended real—the world beyond or before man—the cinematic frame becomes a mere vehicle for creating an impression of virtual totality that can be realized only through a body–brain achievement.

Although this refunctioning of the cinematic frame already implies a fundamental reconfiguration of the status and function of framing, it is not until 1993, with the creation of *EVE (Extended Virtual Environment),* that Shaw's work carries out this reconfiguration. For it is only in *EVE* and, more markedly still, in the two versions of *Place,* that Shaw divorces the function of framing—what I have been calling the spectatorial synthesis or the spectator's body–brain activity—from the perception of *images* and redirects it to the truly remarkable capacity human beings have for generating (mental) images out of digital information. This will require a deepening of Shaw's insight into the human "framing function"—a deepening that can be appreciated only by way of a theoretical exploration of the experiential impact of the digital revolution. Accordingly, before we consider the third stage in Shaw's career as a

media artist, let us take a detour through the cybernetic prehistory of contemporary digital convergence.

From Information to Meaning: Revising the Legacy of Cybernetics

Without a doubt, it is German "media scientist" Friedrich Kittler who has most provocatively engaged the post-(anti-)humanist implications of digitization.[25] "Media determine our situation," Kittler has famously intoned; they "define what really is" and "are always already beyond aesthetics."[26] For Kittler, the digital revolution marks the endgame in the long-standing war of technology and art; with digitization, the perceptual-aesthetic dimension of media becomes mere "eyewash," a hangover of a bygone, humanist epoch:

> *Optical fiber networks.* People will be hooked to an information channel that can be used for any medium—for the first time in history, or for its end. Once movies and music, phone calls and texts reach households via optical fiber cables, the formerly distinct media of television, radio, telephone, and mail converge, standardized by transmission frequencies and bit format. . . . The general digitization of channels and information erases the differences among individual media. Sound and image, voice and text are reduced to surface effects, known to consumers as interface. Sense and the senses turn into eyewash. Their media-produced glamour will survive for an interim as a by-product of strategic programs. Inside the computers themselves everything becomes a number; quantity without image, sound, or voice. And once optical fiber networks turn formerly distinct data flows into a standardized series of digitized numbers, any medium can be translated into any other. With numbers, everything goes. Modulation, transformation, synchronization; delay, storage, transposition; scrambling, scanning, mapping—a total media link on a digital base will erase the very concept of medium. Instead of wiring people and technologies, absolute knowledge will run as an endless loop.[27]

For Kittler, in other words, the radical potential of digitization is its capacity to inscribe the real entirely independently of any interface with the human. And

while this potential might today seem more a matter of science fiction than an incipient reality, Kittler cites the inexorable logic of technical development as the basis for his discursive mode of critical future anteriority. As with the "slaves" of *The Matrix* whose vicarious virtual existence blinds them to their function as human energy cells, our sensory interface with technology is said to obscure its cold indifference to our needs and demands. It is as if we were literally blinded by technology: as a "dependent variable" of an autonomous technological logic, our sense perception is relevant only insofar as it serves the interests of capitalist institutions, only as a target of revenue-generating "entertainment."[28]

Applied to the domain of digital art, Kittler's concept of digital convergence yields a theory of the *obsolescence of the image*—a radical suspension of the image's (traditional) function to interface the real (information) with the human sensory apparatus. In the terminology of my argument, Kittler configures the digital image as an autonomous *technical* image—one that carries out its work without any necessary or intrinsic correlation whatsoever to human perceptual ratios. If the digital image can be said to replace photographic, cinematic, and televisual images with a wholly new technical image, that is because it fundamentally reconfigures the very concept of "image," stripping it of a correlation-by-analogy with the human body and thus rendering it a purely arbitrary construct. This reconfiguration is precisely what is at stake in Kittler's recent account of the radical flexibility and total addressability of computer graphics:

> In contrast to the semi-analog medium of television, not only the horizontal lines but also the vertical columns [of the computer image] are resolved into basic units. The mass of these so-called "pixels" forms a two-dimensional matrix that assigns each individual point of the image a certain mixture of the three base colors: red, green, and blue. The discrete, or digital, nature of both the geometric coordinates and their chromatic values makes possible the magical artifice that separates computer graphics from film and television. Now, for the first time in the history of optical media, it is possible to address a single pixel in the 849th row and 720th column directly without having to run through everything before

and after it. The computer image is thus . . . forgery incarnate. It deceives the eye . . . with the illusion or image of an image, while in truth the mass of pixels, because of its thorough addressability, proves to be structured more like a text composed entirely of individual letters.[29]

Unlike any *analog* image, the computer or digital image does not comprise a static cut into the flux of the real; instead, it captures a virtual block of information. Moreover, since "each point in the [computer] image in fact has an infinite number of possible neighbors," the form in which we *perceive* the digital image—as a two-dimensional representation of a particular configuration of this virtual block of information—is purely arbitrary, unconnected by any analogical relation to the numerical reality it expresses. Following its digitization, the image becomes akin to a text composed of individual letters, one that is, strictly speaking, unreadable.

Since it nonetheless remains the case that digital images *can* be perceived by us, the crucial question concerns the status of such perception: Does the correlation between imaging and human perception demarcate something intrinsic about information itself, namely, its orientation to the communicational purposes of human beings? Or is it simply a hangover of a soon-to-be obsolescent technical system?

We have already seen that, for Kittler, the latter is unequivocally the case: not only does the digital image promise the conversion of the durational dimension of phenomenological experience into a synchronic "virtual dimension" of a two-dimensional matrix, it also strips aesthetics of any intrinsic correlation with human perceptual experience:

The complete virtualization of optics has its condition of possibility in the complete addressability of all pixels. The three-dimensional matrix of a perspectival space made into discrete elements can be converted to a two-dimensional matrix of discrete rows and columns unambiguously but not bijectively. Every element positioned in front or behind, right or left, above or below is accorded a matching virtual point, the two-dimensional representation of which is what appears at any given time. Only the brute fact of available RAM space limits the richness and

resolution detail of such worlds, and only the unavoidable, if unilateral, choice of the optic mode to govern such worlds limits their aesthetics.[30]

Like the image itself, aesthetics becomes a purely arbitrary function of algorithmic processing, more a function of technical limitations than any "will to art" on the part of human creators.

Faced with such undaunted technical determinism, we can legitimately wonder what to make of the efforts of new media artists like Jeffrey Shaw, whose work pursues precisely the reverse trajectory to Kittler's "virtualization of optics"? Can Shaw's work be written off as mere "eyewash," a last-ditch effort to delude ourselves to the inhuman destiny of digital technology? Or does it rather tap into some fundamental correlation linking information to human embodiment—a correlation that simply falls outside the scope of Kittler's "scientific" modeling of digital technology?

With his understanding of the digital image as a challenge to cinema, Deleuze asserts the priority of aesthetics over technology and thus directly contests the premise of Kittler's concept of digital convergence. For Deleuze, the digital image is the culmination of a technical mutation that can be productive of a rebirth of the cinema—or, more exactly, of the birth of a "post-cinema"— only if it gives rise to a new "will to art":

> [N]ew automata did not invade content without a new automatism bringing about a mutation of form. The modern configuration of the automaton is the correlate of an electronic automatism. The electronic image, that is, the tele and video image, the numerical image coming into being, either had to transform cinema or to replace it, to mark its death. . . . The new images no longer have any outside (out-of-field), any more than they are internalized in a whole; rather, they have a right side and a reverse, reversible and non-superimposable, like a power to turn back on themselves. They are the object of a perpetual reorganization, in which a new image can arise from any point whatever of the preceding image. . . . The new automatism is worthless in itself if it is not put into the service of a powerful, obscure, condensed will to art, aspiring to deploy itself through involuntary movements which nonetheless do not restrict it. An original will to art has already been defined by us in the

change affecting the intelligible content of cinema itself: the substitution of the time-image for the movement-image. So that electronic images will have to be based on still another will to art. . . .[31]

What accounts for the mutation in form that defines the numerical (digital) image is precisely the way digitization challenges and transforms the problematic of framing constitutive of the art of cinema.[32] Rather than marking the obsolescence of framing as such—as it does for Kittler—the flexibility constitutive of the digital image operates a modification of the time-image, a new mode of framing or the actualizing of the virtual: specifically, it resituates the source of the virtual from the interstices between (series of) images to interstices *within* the image itself. In a sense, it *incorporates* the virtual within the actual, making the image the source of an infinite number of potential alternate framings—a limitless generation of other images from any part of itself. In sum, whereas Kittler concentrates on the technical autonomy of the computer image, Deleuze correlates its constitutive addressability with a fundamental shift in the status of the virtual *as a dimension of human experience.*

Accordingly, for Deleuze, the technical flexibility of the digital image has as a necessary aesthetic correlate a mutation in the function of framing. Specifically, digitization explodes the frame, extending the image without limit not only in every spatial dimension but into a time freed from its presentation as variant series of (virtual) images. In this sense, the digital image poses an aesthetic challenge to the cinema, one that calls for a new "will to art" and one whose call is answered by the neo-Bergsonist, embodied aesthetic of new media art. Because the digital image necessarily raises the question of what or who will step in to take over the task of framing (framing being necessary to institute a difference between the actual and the virtual and thus to catalyze the actualization of the virtual), its technical flexibility necessarily points beyond itself, to something that takes place beyond informatics, in the source and the receiver of information. "The life or the afterlife of cinema," notes Deleuze, "depends on its internal struggle with informatics. It is necessary to set up against the latter the question which goes beyond it, that of its source and that of its addressee. . . ."[33] With this call for a movement beyond informatics, we come upon what is (or would be) genuinely novel about the "post-cinema" of the digital image: it is an art form that requires us not only to specify the

process of framing that is constitutive of it, but also to produce such a framing in and through our own bodies.

Insofar as it asserts the priority of aesthetics over technology, Deleuze's call for a movement beyond informatics allows us to pinpoint the error informing Kittler's conception of the digital image—his perpetuation of a misguided notion concerning the autonomy of information. By appropriating Claude Shannon's mathematical theory of information as the basis for his theory of digital convergence, Kittler in effect ratifies a conception of information as both dematerialized and structurally separated from any correlation with meaning. It is easy to see how such a conception informs Kittler's configuration of the digital image as an autonomous technical image: insofar as it operates the digital conversion of a three-dimensional space into a two-dimension "virtual" matrix, the digital image is simply the result of the computer's processing of algorithms in its search for "the optimal algorithm for automatic image synthesis."

Kittler marks his debt to Shannon in a short text devoted to the history of communication media. Proposing to historicize Shannon's model of information, Kittler demarcates two decisive breaks in the history of communication: first, the decoupling of interaction and communication through the introduction of writing, and second, the decoupling of communication and information that began with telegraphy and reached its zenith with the digital computer. It is this second decoupling that informs Kittler's understanding of digitization as a vehicle for wholesale technical dedifferentiation:

> [I]f data make possible the operation of storage, addresses that of transmissions, and commands that of data processing, then every communication system, as the alliance of these three operations, is an information system. It depends solely on whether the three operations are implemented in physical reality to what extent such a system becomes an independent communication technology. In other words, the history of these technologies comes to an end when machines not only handle the transmission of addresses and data storage, but are also able, via mathematical algorithms, to control the processing of commands. It is thus no coincidence that not until the start of the computer age, that is, when all

operations of communications systems had been mechanized, was Shannon able to describe a formal model of information.[34]

That this wholesale conversion of material into informational communication has not come to pass[35] attests to the formalist motivation underlying Kittler's interest in Shannon: his embrace of Shannon's formalization of information secures him the right—at least in theoretical terms—to reconfigure the second historical decoupling of communication and information as a radical technical de-differentiation. Kittler's theory of digital convergence can thus be traced directly to his embrace of Shannon's structural separation of information from meaning, which means that it will succeed or fail according to the latter's plausibility.

The structural separation of information from meaning is a function of the technical determination of information. Since information represents a choice of one message from a range of possible messages, it must be defined probabilistically: it concerns not what a particular message says so much as what it does not say.[36] For this reason, information must be rigorously separated from meaning, which can, at best, form a supplementary level subordinate—and indeed, without any essential relation—to the so-called technical level. When Kittler subordinates aesthetics to media, he is simply retooling the very autonomy accorded the technical in Shannon's original theory.

What remains decisive for Kittler, then, are precisely the formal properties of Shannon's model: as the basis for the technical de-differentiation that constitutes the logical culmination of the historical decoupling of information from communication, Shannon's model allows Kittler to postulate an informational posthistory. From the standpoint of the optoelectronic future, the human or so-called Man—as well as the entire range of so-called media effects said to comprise a media ecology—must be revalued as the purely contingent by-product of a preparatory phase in the evolution of information toward fully autonomous circulation.

We can now truly appreciate the implications of Kittler's recent work for understanding the digital image. The very term "digital image" can only involve a contradiction, since it couples the (covertly) operative category for the epoch of media differentiation (the image) with the (explicitly) operative category of

optoelectronic posthistory (the digital). This explains Kittler's effort, in the paper on computer graphics, to rework the very category of the image by stripping it of its correlation with embodied media effects and assimilating it to the "virtualization of optics." Rather than announcing the obsolescence of the cinematic image in the age of the digital, Kittler's work thus pronounces the digital obsolescence *of the image's traditional correlation with embodied sense.* In the process, moreover, Kittler radicalizes (the occultation of) the problematic of framing we introduced above: following Shannon's formal definition of information, convergence emphasizes the "frameless" equivalence or seamless translatability among what formerly have been called media.

Another theory of communication contemporaneous with Shannon's not only furnishes the basis for an alternative to Kittler's technical dedifferentiation thesis, but captures precisely what seems to be at stake in Shaw's aesthetic experimentation with the embodied framing of information. At the heart of British cyberneticist Donald MacKay's "whole theory of information" is the notion that, despite Shannon's success at formalizing its technical properties, information is intrinsically connected with meaning, and specifically with embodied meaning. Proposing to clarify the "place of 'meaning' in the theory of information," MacKay thus sees his aim as supplementing Shannon's theory with something that can make it "whole"—that can transform it into a theory of *human* communication. MacKay's whole theory of information is, accordingly, concerned with reconciling two processes, or two *sides* of the process of communication: on the one hand, the production of representations, and on the other, the effect or function of representations, which is equivalent, as we shall see, to their reception (though not to their observable behavioral consequences). MacKay distinguishes these two sides of the process of communication as *selection* and *construction,* respectively; the former corresponds to Shannon's technical definition of information, and the latter designates factors that specify the context for the operation of selection.

We can grasp the advantages of MacKay's theory of meaning—and its consequences for our understanding of information—by contrasting it with Warren Weaver's proposed supplement to Shannon's original theory.[37] Whereas Weaver identifies meaning with behavioral change and subordinates it to the technical properties of a message, MacKay's theory *preserves the autonomy of the*

nontechnical. What he calls the process of "construction" simply cannot be collapsed into the process of "selection": construction does not merely supplement the technical theory of information by furnishing "message[s] about how to interpret a message,"[38] but rather specifies a context for selection *as a part of a larger whole theory of information.* Because information selects from a probabilistic matrix of possible behavioral responses (what MacKay calls the "conditional probability matrix" or CPM), it is necessarily correlated with meaning.[39] Accordingly, whereas, for Shannon and Weaver, selection is in the end a purely technical affair, for MacKay, it has as much to do with nontechnical properties of the behavioral patterns of the receiver as with technical properties of the message itself.

For MacKay, in other words, the technical operation of a message is *necessarily* conditioned by the *nontechnical* context out of which it is selected, which is to say, the "range of possible states of orientation" of this or that *particular* receiver.[40] His theory accordingly furnishes an information-theoretical equivalent to Bergson's subtraction theory of perception: specifically, it establishes (human) embodiment in its entirety as the *context* that determines what information will be selected in a given situation. By affirming that meaning is indispensable to a whole theory of information and that it is a function of embodied reception, MacKay thus lays bare the basis for Jeffrey Shaw's aesthetic program: the intrinsic correlation linking human embodiment and information.

We can thus understand MacKay's whole theory of information as a theory of framing beyond the function of any imaginable technical frame. With his definition of information as the "selective function of the message on an ensemble of possible states" of the embodied receiver's orientation, MacKay builds the function of framing into the very process through which information is created. Specifically, the receiver's internal structure performs the crucial function of converting incoming stimuli into "internal symbols."[41] In this process of conversion, the receiver's internal activity generates symbolic structures that serve to frame stimuli and thus to *in-form* information: this activity converts regularities in the flux of stimuli into *patterns* of information, and these patterns, far from being the disembodied flux of Kittler's imagining, are generated out of a process of embodying data.[42] Rather than an operation performed on preconstituted information from the outside, framing (or the

specification of a selective function on an ensemble of states of the CPM) is an activity that quite literally *constitutes* or *creates* information. The bottom line for MacKay is that information remains meaningless in the absence of a (human) framer and that framing cannot be reduced to a generic observational function, but encompasses everything that goes to make up the biological and cultural specificity of this or that *singular* receiver. The *meaning* of a message, MacKay concludes, "can be fully represented only in terms of the full basic-symbol complex defined by all the elementary responses evoked. These may include visceral responses and hormonal secretions and what have you. . . . [A]n organism probably includes in its elementary conceptual alphabet (its catalogue of basic symbols) all the elementary internal acts of response to the environment which have acquired a sufficiently high probabilistic status, and not merely those for which verbal projections have been found."[43]

As the basis for his own inchoate call for a new "will to art," Deleuze cites French bio-philosopher Raymond Ruyer's philosophical analysis of cybernetics; specifically, he credits Ruyer with asking the "question of the source and addressee of information" and with constructing "a notion of 'framer' which has connections with [and, we might add, significant differences from] the problems of cinematographic framing."[44] Extending Deleuze's invocation, I would credit Ruyer's critique of cybernetics in *La Cybernétique et l'origine de l'information* with providing an important—and more or less completely neglected—philosophical deepening of MacKay's critical supplementation of Shannon's mathematical theory. For my purposes, it is Ruyer's correlation of the priority of embodied reception with what he calls the "transpatial" domain of human themes and values that is most significant. For, with this correlation, Ruyer furnishes a bio-philosophical basis for the priority of the human framing function over any possible technical frame, and thus shows that it has always already been at work, buried as it were beneath the glitter associated with the technical.

Proposing to develop a "positive reinterpretation of cybernetics stripped of its mechanist postulates,"[45] Ruyer rejects the simulation thesis that forms the basis for Kittler's media science. As Ruyer sees it, this problematic is responsible for all the failures of cybernetics, including its failure to understand meaning: "all the internal difficulties of cybernetics stem from the same error of principle

and from the ill-fated postulate according to which informational machines are the integral equivalent of living and conscious nervous systems."[46] To remedy this situation, Ruyer proposes a conception of the coevolution of the human and technology, in which it is recognized, first, that the technical is and has always been intrinsic to the human (and to the living more generally), and, second, that the binary opposition of the mechanical and the living must be replaced by a threefold hierarchy that involves a certain privileging of what he calls "primary" (that is, organic) and "secondary" (human) "consciousness" over "organic" and "mechanical" machines.[47]

Not only does Ruyer's philosophical critique of cybernetics affirm MacKay's insistence on the priority of embodied meaning, but it explains why meaning can be introduced into information theory only by beings endowed with a transpatial dimension, that is, a capacity to participate in a nonempirical domain of themes and values. Ruyer's perspective can thus help us tease out the profound implications of MacKay's work as a theory of framing. Specifically, it establishes that the digital image, no matter how complex its intertwining in concrete technical "liasons," ultimately originates in consciousness. In other words, the establishment of a technical circuit, no matter how autonomous *in function,* always contains within it the "equipotentiality" correlated with the consciousness (or the form of conscious life) that first produced it, just as this consciousness itself contains within it the equipotentiality correlated with the more basic (primary) consciousness that produced it.[48] In the same way that there is no higher (or secondary) consciousness without primary consciousness, there is no machine function without the form of conscious life from which it emerges:

[T]he transmission itself, insofar as it remains mechanical, is only the transmission of a pattern, or of a structural order without internal unity. A conscious being, by apprehending this pattern as a whole [*dans son ensemble*], makes it take on [*le fait devenir*] form. . . . [S]ound waves on the telephone have been redrawn [*redessinées*] . . . by electrical relays, and if an ear, or rather if a conscious "I" was not, in the end, listening to all the stages of the informational machine, one would only ever discover fragmented functions and never a form properly speaking. The use of the machine by human beings, for [their] "information" in the psychological

sense, misrepresents [*fait illusion sur*] the nature of the machine. One benevolently attributes to each of its stages the formal order that only appears at the end, thanks to something which is not the machine. . . . If the physical world and the world of machines were left completely to themselves, everything would spontaneously fall into disorder; everything would testify that there had never been true order, consistent order, in other words, that there had never been information.[49]

Ruyer's threefold hierarchy thus foregrounds the human (and ultimately, the biological) basis of information: though machines might continue to function when their "embryogenetic" heritage is forsaken, this function would be entirely without meaning. From his perspective, those, like Kittler, who posit an autonomy of the digital simply have things backward: if "the digital" poses a danger, it is the danger of a *false,* not a real, autonomy—the danger that cybernetics will forget the human (and biological) basis of information and thus squander the opportunity for us to undergo an informational phase of our human (and biological) technogenesis.

To this argument concerning the *function* of informational machines, Ruyer adds a crucial claim regarding the *purpose* of such function: it is only meaning that can enframe information, and meaning can be introduced into information theory only by way of the transpatial:

The manufacture [*fabrication*] of calculating and reasoning machines is second relative to the embryogenetic production [*fabrication*] of the living brain. Let us admit that the functioning of nervous circuits and synaptic switches is of the same nature as the functioning of electric circuits and *flip-flop* units [*cellules flip-flop*]. This simply proves . . . that there are machines in the organism, but not that the organized being is a machine. This would prove that the unobservable being which comes forward [*se manifester*] as the first human unit [*cellule*] is capable of constructing, without a machine, organic machines capable in turn of manufacturing automatic nonorganic machines, which can themselves even control nonautomatic machines. This would prove that what one calls the organism is at once what is observable in space and a nonobservable *x,* which supports the entire chain of automatisms, both internal and external.[50]

Unlike the cybernetic machine, the organism encompasses both a machinic (organo-physical) and a transpatial (axiological) dimension. While the former, precisely because it remains observable in space, can be modeled by the cybernetic machine, the latter cannot. As a nonobservable x—a being capable of what Ruyer calls an "absolute survey" or pure "self-enjoyment"[51]—the organism thus enjoys a nonempirical or transpatial existence, an absolute experience of itself that is not accessible to an observer and not constitutable as a scientific object. Insofar as it is responsible for informing the physical with meaning, this transpatial domain constitutes the source of information: it is what produces information on the basis of meaning, that is, from out of a transpatial domain of themes and values.

With this crucial claim, Ruyer supports and extends MacKay's argument for the centrality of the embodied receiver's internal structure in processing information into "internal symbols." Like MacKay, Ruyer attributes the crucial role of *in-forming* the flux of stimuli, or *creating* information, to internal processes of the organism that cannot be accounted for within the terms of cybernetics's governing equation: "the assembly [*le montage*][52] (in the active sense of the word) of a given mechanism is something entirely different than the assemblage [*le montage*] (in the passive sense) of this mechanism as already constituted and functioning. The active assembly is the work of consciousness, which is the creator of connections [*liasons*] according to a meaning [*sens*]. The passive assemblage is the ensemble of connections once they are stabilized [*rétablies*] and once the automatic assemblage can substitute itself for connections improvised by consciousness."[53] Where Ruyer goes beyond MacKay is in correlating this crucial role of embodied processing with the transpatial dimension of conscious life: what differentiates the active assembly of consciousness from the passive assemblages of organic and technical machines is precisely the organic being's constitutive equipotentiality, or the fact that it dwells in meaning.

It is precisely this transpatial dimension of consciousness that informs Ruyer's conception of framing and differentiates it fundamentally from Deleuze's appropriation of the cinematic frame as a deterritorialization of Bergson's conception of the center of indetermination. Put bluntly, framing is the activity through which consciousness actualizes the transpatial domain constitutive of human (organic) life. This is why Ruyer insists that the brain functions as the

"convertor" *(convertisseur),* and consciousness as the "act of conversion," between the transpatial and the physico-empirical.[54] Against the fatal tendency of cybernetics to hypostatize the "framed part" of communication, Ruyer seeks to restore the "framing function" of consciousness. Insofar as it serves to actualize the equipotentiality of the living in empirical informational circuits, framing furnishes the mechanism through which meaning *inheres* in information, and for this reason, can properly be said to *create* information.

Let us return to the problematic of the digital image. We can now see precisely how Ruyer's work grapples with the problematic of the digital image, or in other words, with the problematic of framing once the (technical) image has been exploded into a limitless flux of information. What Ruyer's positive retooling of cybernetics demonstrates is that information always requires a frame (since framing is essential for the creation of information) and that framing always originates in the transpatial meaning-constituting and actualizing capacity of (human) embodiment. Ruyer's perspective thus inscribes an intrinsic constraint on the process of technical dedifferentiation described by Kittler: on the one hand, digital convergence cannot betoken the frameless equivalence or seamless translatability among formerly separate media, since without the delimitation of a message—an actualization of the virtuality of information—there would be no information to speak of; and on the other hand, so-called Man must not be relegated to the junk pile, to the pathetic status of a dependent variable with an uncertain prognosis, since the transpatial, meaning-giving dimension of (human) embodiment comprises the very source of the enabling constraint of framing.

By foregrounding the framing function, Ruyer's work thus furnishes the theoretical basis for an updating of Bergson's embodied theory of perception. Specifically, Ruyer's work shows how any technical circuit or image is necessarily the product of an embodied framing of information, of an actualization of the transpatial dimension in an empirical form. By thus exposing the informational infrastructure of Bergson's concept of the image, Ruyer retools the crucial notion of the center of indetermination—and its fundamental embodiment—for theorizing today's "universe of information." Moreover, Ruyer's conception of framing lays bare the crucial principle of aesthetic experimentation with digital information—the *intrinsic* correlation of technical images (*qua* objectified products of embodied framing) with the affective (transpatial)

experience that went into their production. Since technical circuits and images are nothing but concrete actualizations of a transpatial equipotentiality, they are necessarily infused with specific affective tonalities and thus with irreducible "traces" of human embodiment. By creating informational circuits in which the function of the technical image is rendered fundamentally instrumental, artists like Jeffrey Shaw underscore the irreducibility of the affective transpatial "origin" of technical images; and, by liberating the framing function from its long-standing subordination to the technical image, they both foreground and deploy the embodied (human) creative capacity to enframe digital information.

Framer Framed: Axiological Synthesis in the Digital Environments of Jeffrey Shaw

It is precisely this aesthetic program—and the cybernetic countertradition it puts into action—that informs the final phase of Shaw's critical-creative engagement with the nexus of space, image, and body. Here the hybrid viewing-window/panorama interface is deployed, not simply as a means to trigger an impression of a "virtual totality," but more profoundly, as the catalyst for an intuition of the transpatial synthesis through which such an impression is generated. In this respect, Shaw's most recent works mark the completion of his career-defining trajectory from an engagement with expanding the image into kinesthetic space to his experimentation with the body's capacity for "transpatial" spacing—for creating a nongeometrical, internal space where information is enframed. Otherwise put, Shaw's recent works give aesthetic form to the trajectory traced by Ruyer's critique of cybernetics: the movement from the technical frame (the image) to a confrontation with its constitutive condition of possibility, the (human) framing function.

As my presentation of *Place: Ruhr* at the beginning of this chapter demonstrated, the third phase in Shaw's development is characterized by his juxtaposition of antithetical image systems or interfaces, and more generally, of incompossible media traditions. Both *Place: A User's Manual* and *Place: Ruhr* rework and extend the nineteenth-century panorama, the first system for immersing spectators *within* the space of a painting or two-dimensional representation. Furthermore, both utilize a central, rotating observation platform with a video camera interface; both present eleven image "cylinders,"

comprised of digitized data stored in a computer, each of which "contains" a virtual panoramic world; and both utilize a microphone to trigger the appearance of three-dimensional block words and sentences in the image space. Yet, in both cases, rather than collapsing the various frames—the interfaces or "navigation methods"—of these different media, Shaw layers them in a way that catalyzes an experience quite different from the immersion normally invoked in reference to digital works. Thus, in both works, the "reality effect" of the panorama—the effect of being situated within a totalized, 360° image space—is undercut by the cinematic interface literally layered on top of it; wrested from its normal context in which it too produces a reality effect proper to its medial materiality, the cinematic frame serves instead to delimit particular image spaces *within* the immersive space of the panorama and thus to foreground the general framing function of media interfaces. Likewise, the immersive reality effect afforded by the video camera interface—which allows the participant to zoom in and out of the eleven cylinders located "within" the image space—is undercut by the concrete homology that binds together the virtual cylinders and the actual panorama; as Shaw explains, "[e]ach of these virtual panoramic cylinders in the computer-generated landscape has the same height and diameter as the projection screen, so that locating himself at the centre of these pictures the viewer can completely reconstitute the original 360-degree camera view on the screen. In this way the work locates the panoramic imagery in an architectonic framework that correlates the design of the virtual landscape with that of the installation itself, so making the virtual and the actual spaces coactive on many levels of signification."[55] The effect of this spatial configuration is to make the virtual dimension dependent on the coordinates of the *actual* physical space in which the viewer finds herself.

It is, accordingly, the complex deployment of the aesthetic effect of immersion most typically associated with virtual reality technologies that differentiates the two versions of *Place* (and the same could be said for Shaw's media platform, *EVE*)[56] from his earlier aesthetic experimentations with hybrid interface systems. Instead of simply fusing the viewing window and panorama into a hybrid interface for more complex interaction with the image, these works deploy the viewing window as a frame opening onto a vast virtual world and thus exploit the tension between the two conventions—representation and illusionism—which they respectively exemplify. Whereas a work like *In-*

venter La Terre aimed above all to draw the viewer's attention to the digital in-frastructure of the virtual image and deployed the computer as an agent of selection that functioned *in place of* the viewer's embodied filtering, the two versions of *Place* seek to expose the origin of the virtual image in the body–brain achievement of embodied (human) framing of information. In this way, they stage the shift—from the quasi-autonomous technical image to the fram-ing function—that characterizes the aesthetic function in the digital age.

We can differentiate two valences—almost two phases—in Shaw's aes-thetic experimentation with the framing function, both of which contest the separation of medium from materiality that informs Kittler's conception of digital convergence. On the one hand, the juxtaposition of media interfaces in the two versions of *Place* works to expose the concrete "affective content" that is, as it were, built into particular media interfaces. By combining variant me-dia interfaces in ways that interrupt their preinscribed effects, the two versions of *Place* turn these interfaces back on themselves, simultaneously drawing at-tention to the affective aesthetic effects of their materiality as concrete media (think of the graininess of early photography or the superreality of technicolor cinema) and foregrounding their newly accorded function as (to some extent interchangeable) instruments for interacting with digital data. On the other hand, precisely because they solicit the navigation of a complex virtual space in the very act of turning media interfaces back on themselves, the two versions of *Place* catalyze a shift in the viewer's relation with these interfaces and the in-formation they serve to frame. To experience the virtual space offered by these environments, the viewer is forced to overcome the short-circuiting of these media interfaces precisely by operating a transpatial synthesis within her own body–brain: rather than channeling her processing of digital information ex-clusively through preconstituted media interfaces, the viewer is made to appre-ciate the constitutive instrumentality of such apparatuses and to glimpse the origin of their function in her own active process of embodied framing.

To grasp what is at stake in Shaw's third phase, it is crucial that we ap-preciate the intimate correlation between these two valences. For it is precisely because the confrontation of antithetical media interfaces generates conflicting affective aesthetic effects that it can catalyze a shift in perceptual modality—from perception passively guided by a technical frame to perception actively cre-ated via (human) framing. Lev Manovich is thus right to stress the performative

dimension of the *Place* environments, even if his understanding falls short of uncovering its profound consequences: "By placing interfaces of different technologies next to each other within a single work," claims Manovich, "Shaw foregrounds the unique logic of seeing, spatial access and user behavior characteristic of each technology. . . . Once the user moves inside one of [the] cylinders, she switches [from a mode of of perception typical of cinema] to a mode of perception typical of [the] Panorama tradition."[57] Manovich's analysis falters because he treats the "switch" as a simple perceptual correlate of a shift from one technical interface to another. He thereby misses what is truly at issue in the experience of the work. Beyond offering the viewer an opportunity to try out different interfaces, the *Place* environments so intensely focus attention on the process of perceptual switching itself that the viewer is compelled to ask what exactly it is that permits her to suture incompatible media frames. This is why the aesthetic experience these environments catalyze cannot be restrictively understood as the empirical correlate of particular interfaces: not unlike the synthesis that yields stereoscopic vision, the transpatial synthesis at issue here involves much more than a simple technical framing of information. It is truly a body–brain achievement.

It will come as no surprise, then, to discover that Ruyer's conception of the "axiological synthesis" helps clarify the synthesis solicited by Shaw's environments. In both cases, what is at stake is a confrontation of *nonsuperposable* "intuitions" that yields a synthesis that would be "impossible on the empirical plane":[58]

> [W]hat interests us is the manner in which we apprehend and perceive axiological depth. We know already, broadly speaking, that [this manner] is essentially affective. We know more precisely that, under its extreme form, when depth is steep [*escarpé*], and gives way to axiological *feed back* [circuits] that are too "tight" [*serrés*], [the] perception [of depth] becomes vertigo and anxiety. At the core of axiological vertigo, there is, as we have already seen, a gap, a conflict between two orders otherwise tightly conjugated. . . . However . . . in visual perception of three-dimensional space, a major role is played by the conflict between the two retinal images. Two stereoscopic views of the same landscape, even though they represent the same objects, are not superposable. The synthesis is oper-

ated only by the intuition of depth which reconciles what could only re-main irreconcilable so long as one only had access to two dimensions. . . . There is, in the axiological order, something quite analogous to the stereoscopic effect. Two axiological intuitions in conflict, despite being necessarily related to the same objects by the individual who experiences them, tend to evoke an intuition analogous to the intuition of geomet-ric depth in visual perception.[59]

If we follow out this comparison, we can begin to fathom precisely why the su-turing of nonsuperposable media interfaces can take place only through an "in-tuition of depth" in a dimension beyond the empirical plane. When the affective aesthetic effects of different media interfaces come into conflict, they generate something like axiological vertigo—the viewer is caught between two (or more) incompatible affective commitments—which can be resolved only by a jump to a higher dimension: by an intuition that the viewer's capacity for framing information is the very origin of the affectively experienced val-ues placed on concrete media interfaces. Given the deep bond linking affec-tivity and the axiological synthesis, it is, moreover, hardly surprising that the dominant effect of such an intuition is a heightened affective experience, a felt recognition of the viewer's active role in framing the confrontation of non-superposable frames.

Anne-Marie Duguet perfectly captures the complexity of Shaw's final works in her meditation on the digital transformation of aesthetic experience: as she sees it, "the confrontation between two different levels of reality entails a composite experience, an inevitable twinning of contradictory perceptions for a spectator who is simultaneously active in both. The observation and con-templation of a scene compete with the act of bringing it into being. . . ."[60] Following the suggestion of Shaw himself, Duguet invokes Duchamp's concept of the "*inframince*" (infra-thin) to make sense of this twinning of contradictory perceptions. Loosely defined as the differences between two samenesses,[61] the *inframince,* in this case, demarcates the imperceptible boundary between two dimensions of bodily activity: between technically framed perception and affec-tive self-intuition. The body, Shaw notes, "has become an intangible subject of fascination. . . . Representation is, and always was, the domain of both our embodied and disembodied yearnings. It is in the friction of this conjunction

that we experience the euphoric dislocation of our present condition. Like Duchamp's 'inframince,' this is an insubstantial zone of disillusion where, after all is said and done, there remains only an imperceptible yet ubiquitous plenitude of being."[62] By calling the body "an insubstantial zone of disillusion," Shaw foregrounds its dual role in today's digital environment as both the material "site" where information gets embodied and an "absolute domain" of self-affection, an *infraempirical* plenitude that can only be felt.

When he then goes on to emphasize that the artwork is more and more embodied in the interface and indeed in the communication within and between viewers, Shaw pinpoints what Duguet would call the "operative value" of the digital—its function as a trigger for a transpatial synthesis that comprises nothing less than a *virtualization* of the body.[63] Following this aesthetic deployment of the digital, simulation is retooled from a vehicle supporting the illusion of reality to one facilitating a "realism of reference points": a few simulated architectural elements—"indicators of similitude"—manage to "produce sufficient analogy to test the differences between two samenesses" and, indeed, to expose the infrathin boundary separating the empirical and transpatial dimensions of bodily experience.[64] In other words, digital simulation is deployed as the trigger for an experience that exposes the immanence of the virtual within the *infraempirical* body itself.

It is precisely such an experience that is at issue in Shaw's *Place* environments. In the process of catalyzing a shift from *perception* via concrete media interfaces to the *affectively tinged* exposure of their origin in the (human) framing function, these environments reconfigure the virtual, transforming it from an abstract, disembodied dimension of any dynamic process into a creative dimension of human embodiment itself—an excess of the body over itself. More specifically, these environments call on us to recognize the difference between the *impression* of "virtual totality" that inheres within the panorama interface and the *intuition* of it in the viewer's durational suturing of partial frames. While the former is materially instantiated in the digital infrastructure of the environments, the latter can occur only by way of the complex durational structure of the viewer's experience: it is an intuition that effectuates the body's capacity to virtualize itself through those modalities—memory, anticipation, affectivity—that render it constitutively *in excess* of itself. What this means is

that the digital simulation of virtual totality, despite containing all possible permutations of the media environment, is in reality *less than* the partial perceptions that serve to actualize it at the same time as they virtualize the perceiving body. Duguet is thus right to stress that the *Place* environments stage the exhaustion of their own supposed virtuality only to catalyze a very different, embodied virtualization: the structural limitation characteristic of Shaw's environments (e.g., the specification of 11 image-cylinders) "allows—or almost allows, in the context of an installation—for the exhaustion of all possibilities, *directing re-directed attention back to what constitutes the scene,* thereby rejecting headlong flight into infinite navigation of the virtual (as hyped by the hypermedia)."[65] Via this redirection, the viewer is led to perceive the digitally instantiated virtual totality—the digital image considered as the ultimate technical frame—as a false virtuality: a construction of a "total image" that jettisons the very agent of its own creation.

With this conclusion, we can grasp exactly how Shaw's aesthetic experimentation with the digital operates an aesthetic deployment of the MacKay-Ruyer lineage of cybernetics. The two versions of *Place* engage digital technology in order to offer the opportunity for the experience of a virtual dimension—and for a virtualization of the body—that makes good on the intrinsic link between meaning and information. By channeling the digital through the body, they give rise to an experience of the virtual rooted in the fundamental correlation of information and human embodiment. Just as it is embodied reception that introduces meaning into information, it is the transpatial axiological synthesis that virtualizes the digital infrastructure, transforming its merely formal or abstract permutations into a host of potentially meaningful "messages"—messages capable of triggering the creative force of bodily affectivity. In a way that returns us to the neo-Bergsonist imperative motivating Shaw's entire development as a media artist, we could say that the digital architecture offered by the two versions of *Place* furnishes a concrete extension of the body's capacity to process information, to receive information as inherently meaningful. Here we can wholeheartedly concur with Duguet's observation that "the interface cannot be identified solely with a technical apparatus, however complex that may be, since the interface also includes the virtual architecture defining the exploratory modalities of the work—the manipulations that it implies are

not only of a functional nature, but also *make* sense."[66] If these manipulations *make sense,* that is ultimately because they are the strict correlates of the bodily processing of information that they themselves solicit.

By deploying the intrinsic correlation of digital information with embodied human meaning, Shaw's *Place* works—and the entire career they can be said to crown—set the agenda for the neo-Bergsonist imperative I have associated with new media art more generally. Precisely insofar as they expose the (human) framing function lying beneath all constituted technical frames, Shaw's recent works can properly be said to open the path for a younger generation of artists whose aesthetic experimentations unpack, in an impressive variety of directions, the constitutive contribution of the body and the shift from a predominantly perceptual aesthetic to an affective one. And Shaw's attention to the materiality of media interfaces—to their significance as ciphers of bodily affect whose significance becomes paramount in today's digital environment—furnishes an important precedent for younger artists as they seek to deploy digital technologies toward aesthetic ends that neither retreat into a defensive aesthetic of nostalgic materialism (Krauss) nor remain content with an empiricist functionalism (Manovich). As we shall see repeatedly in the remainder of this study, the works of these artists invest in the potential of the digital to enhance the specificity of aesthetic experience and to reembody visual culture in a manner fundamentally antithetical to the still dominant cinematic tradition.

3

The Automation of Sight and the Bodily Basis of Vision

In a well-known scene from the 1982 Ridley Scott film *Blade Runner,* Rick Deckard scans a photograph into a 3-D rendering machine and directs the machine to explore the space condensed in the two-dimensional photograph as if it were three-dimensional (figure 3.1). Following Deckard's commands to zoom in and to pan right and left within the image space, the machine literally unpacks the "real" three-dimensional world represented by the two-dimensional photograph. After catching a glimpse of his target—a fugitive replicant—reflected from a mirror within the space, Deckard instructs the machine to move around behind the object obstructing the two-dimensional photographic view of the replicant and to frame what it sees. Responding to the print command issued by Deckard, the machine dispenses a close-up photograph of the replicant that is, quite literally, a close-up of an invisible—indeed nonexistent—part of the two-dimensional original. And yet, following the fantasy of this scene, this impossible photograph is—or would be—simply the image of one particular data point within the data set that makes up this three-dimensional dataspace.

As fascinating as it is puzzling, this scene of an *impossible* rendering—a rendering of two-dimensional data as a three-dimensional space—can be related to the crisis brought to photography by digitization in two ways. On the one hand, in line with the film's thematic questioning of photography as a reliable index of memory, this scene foregrounds the technical capacity to manipulate photographs that digital processing introduces. In this way, it thematizes the threat posed by digital technologies to traditional indexical notions of photographic realism. On the other hand, in what has turned out to be a far more prophetic vein, the scene presents a radically new understanding of the photographic image as a three-dimensional "virtual" space. Such an understanding presupposes a vastly different material existence of the photographic

Theoretical Aim	Body	Image	Artwork
To link bodily framing to the bodily "underside" of vision	From body as the center of perception—a disembodying of vision—to body as the contaminating affective basis for human visual experience	From correlate of bodily perception (i.e., vision) to obsolete function (for computer "vision") to correlate of bodily affection no longer restricted to visual domain	*Blade Runner;* Rogala's *Lovers Leap;* Waliczky's *The Garden, The Forest;* Shaw's *Place: A User's Manual, The Golden Calf*

Figure 3.1
Still from *Blade Runner*
(Ridley Scott, 1982),
courtesy of Warner
Brothers Home Video.
Rick Deckard navigates a
two-dimensional image
as a three-dimensional
space.

image: instead of a physical inscription of light on sensitive paper, the photograph has become a data set that can be rendered in various ways and thus viewed from various perspectives.

The first position corresponds to the arguments made by William Mitchell in his now classic book, *The Reconfigured Eye*. In a comprehensive analysis of the techniques and possibilities of digital imaging, Mitchell concentrates on demarcating the traditional photographic image from its digital *doppelgänger*. The specter of manipulation has always haunted the photographic image, but it remains the exception rather than the rule: "There is no doubt that extensive reworking of photographic images to produce seamless transformations and combinations is technically difficult, time-consuming, and outside the mainstream of photographic practice. When we look at photographs we presume, unless we have some clear indications to the contrary, that they have not been reworked."[1] To buttress this claim, Mitchell sketches

three criteria for evaluating traditional photographic images: (1) does the image follow the conventions of photography and seem internally coherent? (2) does the visual evidence it presents support the caption or claim being made about it? and (3) is this visual evidence consistent with other claims we accept as true?[2] Clearly, with the development of digital imaging techniques, these criteria and the constraint imposed by the difficulty of manipulation lose their salience. The result, according to Mitchell, is a "new uncertainty about the status and interpretation of the visual signifier" and the subversion of "our ontological distinctions between the imaginary and the real."[3]

These conclusions and the binary opposition on which they are based need to be questioned. Beyond the morass of difficulties involved in any effort to affirm the indexical properties of the traditional photograph, we must evaluate the adequacy of Mitchell's conception of digitization. To this reader, Mitchell's depiction of digital photography as manipulation of a preexisting *image* imposes far too narrow a frame on what digitization introduces. We might do better to describe digital photography as "synthetic," since digitization has the potential to redefine what photography is, both by displacing the centrality accorded the *status* of the photographic *image* (i.e., analog or digital) and by foregrounding the procedures "through which the image is produced in the first place."[4] Digital photography, that is, uses three-dimensional computer graphics as a variant means of *producing* an image: "Rather than using the lens to focus the image of actual reality on film and then digitizing the film image (or directly using an array of electronic sensors), we can . . . construct three-dimensional reality inside a computer and then take a picture of this reality using a virtual camera also inside a computer."[5] In this case, the referent of the "virtual" picture taken by the computer is a data set, not a fragment of the real. Moreover, as Lev Manovich points out in his historical reconstruction of the automation of sight, the perspective from which the picture is taken is, in relation to human perception, wholly arbitrary: "The computerization of perspectival construction made possible the automatic generation of a perspectival image of a geometric model as seen from an arbitrary point of view—a picture of a virtual world recorded by a virtual camera."[6]

Manovich sketches three steps in the automation of sight: (1) the invention of perspective in the Rennaissance; (2) the development of the photographic camera, which built perspective "physically into its lens" and thereby

"automated the process of creating perspectival images of existing objects"; and (3) computer technologies of "geometric vision," which liberated vision from the recording of "real" objects and from the limitation of a single perspective. With this deterritorialization of reference, we reach the scenario presented in the scene from *Blade Runner*—the moment when a computer can "see" in a way profoundly liberated from the optical, perspectival, and temporal conditions of human vision: "Now the computer could acquire full knowledge of the three-dimensional world from a single perspectival image! And because the program determined the exact position and orientation of objects in a scene, it became possible to see the reconstructed scene from another viewpoint. It also became possible to predict how the scene would look from an arbitrary viewpoint."[7] With the material fruition of the form of computer vision imagined in this scene, in other words, we witness a marked deprivileging of the particular perspectival image in favor of a total and fully manipulable grasp of the entire dataspace, the whole repertoire of possible images it could be said to contain.

What is fundamental here is the radical resistance of this dataspace to any possible human negotiation. Accordingly, one way of making sense of this negotiation would be to understand this dataspace as a form of *radical* anamorphosis, in which the cumulative perspectival distortions that lead to the final image do not mark a "stain" that can be resolved from the standpoint of another *single* perspective (however technically mediated it may be). Unlike Holbein's *The Ambassadors,* where an oblique viewing angle reveals the presence of a skull within an otherwise indecipherable blob, and unlike Antonioni's *Blow Up,* where photographic magnification discovers a clue initially invisible in the image, what we confront here is a multiply distorted technical mediation that requires the abandoning of *any particular perspectival anchoring* for its "resolution."

This transformative operation furnishes a case study of what Kate Hayles has dubbed the "OREO structure" of computer mediation: an analog input (the original photograph) undergoes a process of digital distortion that yields an analog output (the close-up).[8] If we are to understand the impact of this complex transformation, we must not simply attend to the analog outsides, but must deprivilege our modalities of understanding enough to allow the digital

middle to matter. Paradoxically, then, the imperative to find ways of "understanding" the digital middle becomes all the more significant as computer vision parts company with perspective and photo-optics altogether. Indeed, the apotheosis of perspectival sight marks the very moment of its decline: owing to the intrinsic underdetermination of the image, vision researchers quickly realized that the perspective inherent to photographic optics was an obstacle to the total automation of sight, and they went on to develop other, nonperspectival means, including "range finders" such as lasers or ultrasound, as the source of three-dimensional information.[9]

No one has expressed the cultural significance of this unprecedented moment more pointedly than art historian Jonathan Crary, who cites it as the motivation for his reconstruction of the technical history of vision:

> Computer-aided design, synthetic holography, flight simulators, computer animation, robotic image recognition, ray tracing, texture mapping, motion control, virtual environment helmets, magnetic resonance imaging, and multispectral sensors are only a few of the techniques that are *relocating vision to a plane severed from a human observer.* . . . Most of the historically important functions of the human eye are being supplanted by practices in which visual images no longer have any reference to the position of an observer in a "real," optically perceived world. If these images can be said to refer to anything, it is to millions of bits of electronic mathematical data.[10]

The work of the cultural theorist—like that of the new media artist—begins at the very point where the human is left behind by vision researchers: the apotheosis of perspectival vision calls for nothing less than a fundamental reconfiguration of *human* vision itself.

Machinic Vision and Human Perception

In a recent discussion of what he calls "machinic vision," cultural theorist John Johnston correlates the digital obsolescence of the image with the massive deterritorialization of information exchange in our contemporary culture. In a

world of global, networked telecommunications assemblages, Johnston wonders whether we can still meaningfully speak of the image as having any privileged function at all:

> Unlike the cinematic apparatus, . . . contemporary telecommunications assemblages compose a distributed system of sentience, memory and communication based on the calculation (and transformation) of information. Within the social space of these assemblages. . . , the viewing or absorption of images constitutes a general form of machinic vision. . . . As a correlative to both these assemblages and the distributed perceptions to which they give rise, the image attains a new status, or at least must be conceived in a new way. . . . In the circuits of global telecommunications networks, . . . the multiplicity of images circulating . . . cannot be meaningfully isolated as material instances of cinema (or television) and brain. Many of these images, of course, are perceived, but their articulation occurs by means of another logic: the incessant coding and recoding of information and its viral dissemination. The image itself becomes just one form that information can take.[11]

For Johnston, the informational infrastructure of contemporary culture quite simply necessitates a radical disembodiment of perception. As he presents it, this disembodiment follows on and extends the disembodiment to which Gilles Deleuze (in his study of the cinema) submits Bergson's conception of perception as the selective filtering performed by an embodied center of indetermination. For us, the interest of Johnston's extension of Deleuze's disembodiment of Bergson comes at the precise point where it diverges from Deleuze: where the disembodiment of perception is correlated with the contemporary achievement of automated vision. Not only does this correlation bring to material fruition the universal flux of images that Deleuze claims to discover in the cinema of the time-image, but it marks *the culmination of the image's function as a privileged vehicle for perception.* Reconceived in the context of today's global telecommunications assemblages, the image is said to be

> the perceptual correlative of actions in and reactions to a milieu (Bergson), but a milieu now defined by a variety of agents and subagents in

human–machine systems. While Deleuze never explicitly describes this new machinic space, nor the specific kind of vision it elicits, both are anticipated in his Bergsonian study of the cinematic image, where the viewer is always already *in* the image, necessarily and inevitably positioned within a field of interacting images, with no means to step back, bracket the experience, and assume a critical distance. . . . [O]nce the brain no longer constitutes a "center of indetermination in the acentered universe of images," as it did for Bergson, and is itself decomposed into distributed functions assumed by machines, *perception can no longer be simply defined in terms of the relationship between images.*[12]

Johnston parts company with Deleuze from the moment that he correlates the digitization of the image with the technical distribution of cognition *beyond* the human body–brain: as functions formerly ascribed to it "have been autonomized in machines operating as parts of highly distributed systems," the brain has become a "deterritorialized organ."[13] The result is a "generalized and extended condition of visuality"—machinic vision—in which the task of processing information, that is, perception, necessarily passes through a machinic circuit.[14] In this posthuman perceptual regime, the selection of information is no longer performed exclusively or even primarily by the human component (the body–brain as a center of indetermination).

It is hardly surprising, then, that what Johnston refers to as the "digital image" can be "perceived" only by a distributed machinic assemblage capable of processing information without the distance that forms the condition of possibility for human vision: "for the digital image there is no outside, only the vast telecommunications networks that support it and in which it is instantiated as data."[15] The digital image has only an "electronic underside," which "cannot be rendered visible" precisely because it is entirely without correlation to any perceptual recoding that might involve human vision. Accordingly, the digital image is not really an "image" at all: far from being a correlate of the imaginary domain of sense experience, it designates the "objective" circulation of digital data—Kittler's endless loop of infinite knowledge—emancipated from any constraining correlation with human perceptual ratios.

Despite his professed commitment to *machinic* vision as resolutely posthuman, however, Johnston's analysis is significant, above all, for the (perhaps

unintended) contribution it makes toward reconfiguring human vision for the digital age. Specifically, Johnston's machinic vision must be differentiated from the automation of vision explored above, and the human must be resituated in the space of this difference: whereas visual automation seeks to replace human vision *tout court,* machinic vision simply expands the range of perception well beyond the organic-physiological constraints of human embodiment. One way of understanding this expansion (Johnston's way) is to focus on its transcendence of the human; another, more flexible approach would view it as a challenge to the human, one that calls for nothing less than a reconfiguration of the organic-physiological basis of vision itself. Taking up this latter perspective, we can see that machinic vision functions precisely by challenging the human to reorganize itself. In this sense, machinic vision can be understood as profoundly Bergsonist, since it occasions an expansion in the scope of the embodied human's agency in the world, a vast technical extension of "intelligence."

In another sense, however, machinic vision appears to ignore the core principle of Bergson's theory of perception—the principle that there can be no perception without affection:

> . . . we must correct, at least in this particular, our theory of pure perception. We have argued as though our perception were a part of the images, detached, as such, from their entirety, as though, expressing the virtual action of the object upon our body, or of our body upon the object, perception merely isolated from the total object that aspect of it which interests us. But we have to take into account the fact that our body is not a mathematical point in space, that its virtual actions are complicated by, and impregnated with, real actions, or, in other words, *that there is no perception without affection. Affection is, then, that part or aspect of the inside of our body which we mix with the image of external bodies;* it is what we must first of all subtract from perception to get the image in its purity.[16]

For Bergson, any "real" act of perception is always contaminated with affection—both as a factor determining the selection of images and as a contribution to the resulting perceptual experience. What this means, of course, is that

there simply can be no such thing as "machinic *perception*"—unless, that is, the human plays a more fundamental role in it than Johnston wants to acknowledge.[17] Thus, what Johnston describes as a new "machinic space" should be understood less as an expansion of the domain of perception itself than as a vast increase in the flux of information from which perception can emerge.

Rather than demarcating a new deterritorialized regime of perception— a "generalized condition of visuality"—what the phenomenon of machinic vision foregrounds is the urgency, at this moment in our ongoing techno genesis, for a differentiation of properly human perceptual capacities from the functional processing of information in hybrid human–machine assemblages. Only such a differentiation can do justice to the affective dimension constitutive of human perception and to the active role affectivity plays in carrying out the shift from a mode of perception dominated by vision to one rooted in those embodied capacities—proprioception and tactility—from which vision might be said to emerge.

Precisely such a differentiation and an altogether different understanding of the automation of sight informs the aesthetic experimentation with computer vision and image digitization that is my focus here. For today's new media artists, the historical achievement of so-called vision machines[18] constitutes nothing if not a felicitous pretext for an alternative investment in the bodily underpinnings of human vision. At the heart of this aesthetic approach to the automation of sight is an understanding of the vision machine as the catalyst for a "splitting" or "doubling" of perception into, on the one hand, a *machinic* form (roughly what Lacan, and Kittler following him, understand as the machine registration of the image)[19] and, on the other, a *human* form tied to embodiment and the singular form of affection correlated with it. Such a splitting of perception is simply the necessary consequence of the vast difference between computer and human embodiment: whereas "vision machines" transform the activity of perceiving into a computation of data that is, for all intents and purposes, instantaneous, human perception takes place in a rich and evolving field to which bodily modalities of tactility, proprioception, memory and duration—what I am calling affectivity—make an irreducible and constitutive contribution. As the pretext for an alternative investment of the embodied basis of human visual perception, this splitting is fundamental for any aesthetic redemption of the automation of sight. Whereas theorists like Deleuze and

Johnston miss the call for such an investment, new media artists directly engage the bodily dimensions of experience that surface, as it were, in response to the automation of vision. Their work can thus be said to invest the "other side" of the automation of vision—the affective source of bodily experience that is so crucial to reconfiguring human perception in our contemporary media ecology.

Reembodying Perception

To contextualize this aesthetic investment of the body, we would be well advised to revisit the work of French media critic Paul Virilio—the theorist of the "vision-machine" as well as the proximate target of Johnston's critique. More than any other source, it is Virilio's critical insight into the basis for automation—the technification of perceptual functions traditionally bound up with the body—that informs the "Bergsonist vocation" of aesthetic experimentations with embodied vision.

Far from being the nostalgic has-been of Johnston's imagining, Virilio shows himself to be just as attentive to the advantages of technification as he is to its human costs. In this sense, his evolving analysis of the vision-machine can be said to pursue two equally important ends. On the one hand, it functions as a critique of the disembodying of perception that informs the historical accomplishment of what Virilio has termed the "logistics of perception," the systemic technical recoding of formerly human-centered perceptual ratios. But on the other hand, Virilio's analysis forms the basis for an ethics of perception rooted in a defense of the body as an ever-evolving perceiving form. Accordingly, the very position for which Johnston berates Virilio—his refusal to abandon the phenomenology of the body—takes on a newfound and decisively positive significance: as the "victim," so to speak, of the logistics of perception, the body becomes the site of a potential resistance to—or more exactly, a potential *counterinvestment* alongside of—the automation of vision. *Contra* Johnston, Virilio's concern is not the body as *natural,* but the body as an index of the impact of technological change: the body *as it coevolves with technology,* and specifically, *as it undergoes self-modification through its encounter with automated vision.*

Given Virilio's sensitivity to the bodily costs of technification, it is hardly surprising that his position strongly resonates with our understanding of the transformation of the image. As the culminating moment of a fundamental transfiguration in the materiality of the image, the vision-machine instantiates precisely what is radically new about the digital image: the shift in the "being" of the image from the objective support of a technical frame to the impermanent "mental or instrumental" form of visual memory. With this new material status comes a profound shift in the scope of the technological recoding of perception: from this point forward, it is the *time* of perception itself, and not its material support, that forms the "object" of technical investment:

> Any *take* (mental or instrumental) being simultaneously a *time* take, however minute, *exposure time* necessarily involves some degree of memorization (conscious or not) according to the speed of exposure. . . . The problem of objectivisation of the image thus largely stops presenting itself in terms of some kind of paper or celluloid *support surface*—that is, in relation to a material reference space. It now emerges in relation to time, *to the exposure time that allows* or *edits seeing.*[20]

To this shift in the *object* of technical investment corresponds a profound displacement of the human role in perception. In contrast to earlier visual technology like the telescope and the microscope (not to mention cinema itself), which function by *extending* the physiological capacities of the body, contemporary vision machines bypass our physiology (and its constitutive limits) entirely. What is important is not just that machines will take our place in certain "ultra high-speed operations," but the rationale informing this displacement: they will do so "not because of our ocular system's limited depth of focus . . . but because of the limited *depth of time* of our physiological 'take.'"[21] In short, what we face in today's vision-machines is the threat of *total* irrelevance: because our bodies cannot keep pace with the speed of (technical) vision, we literally cannot see what the machine can see, and we thus risk being left out of the perceptual loop altogether. When he pronounces the image nothing more than an "empty word," Virilio brings home just how profoundly intertwined the body's *epochē* is with the digital obsolescence of the image.[22]

What most critics—Johnston included—fail to appreciate is that Virilio's analysis does not culminate with this bleak diagnosis of our contemporary situation. Not only does he repeatedly invoke the necessity for an ethics capable of addressing the splitting of perception, but his intellectual trajectory witnesses an increasing attentiveness to the violence of the vision machine's recoding of embodied human functions as disembodied machinic functions. In so doing, Virilio manages to raise his analysis of the vision machine above the limiting binary—human versus machine—that he is so often accused of reinscribing. For in the end, what is at stake in his analysis is neither a resistance to humankind's fall into technology nor an embrace of a radical, technical posthumanization, but something more like the possibility for a technically catalyzed reconfiguration of human perception itself: a shift from a vision-centered to a body-centered model of perception.

Nowhere is this potential perceptual reconfiguration more clearly at issue than in the incisive analysis accorded the virtual cockpit in *Open Sky*. Here Virilio pinpoints the fundamental tradeoff of visual automation: embodiment for efficiency. A high-tech helmet that functions in the place of the instrument panel and its indicator lights, the virtual cockpit combines the superiority of machinic processing with the drive to recode complexly embodied capacities as instrumental visual activities, entirely purified of any bodily dimension: "since th[e] type of fluctuating (real-time) optoelectronic display [offered by the virtual cockpit] demands substantial improvement in human response times, delays caused by hand movements are also avoided by using both voice (speech input) and gaze direction (eye input) to command the device, *piloting no longer being done 'by hand' but 'by eye,'* by staring at different (real or virtual) knobs and saying *on* or *off*. . . ."[23] Examples like this lend ample testimony to Virilio's complex interest in the dehumanizing effects of automation: far from being simple moments in an inexorably unfolding logistics of perception, technologies like the virtual cockpit serve above all to expose the concrete costs of visual automation. Indeed, in Virilio's hands, such technologies are shown to function precisely by mounting an assault on the domain of embodied perception; they thereby expose just how much the recoding of human vision as an instrumental function of a larger "vision-machine" strips it of its own embodied basis.[24]

This concern with the correlation between automation and the recoding of the bodily seems to have motivated a subtle yet significant shift of emphasis in Virilio's research, a shift that centers around the role to be accorded the invisible or the "non-gaze." For if, in *War and Cinema* and *The Vision Machine* (his classical texts of the 1980s), Virilio tends to assimilate blindness to the sightless vision of the vision machine, in *Open Sky* (1995), he begins to speak instead of a "right to blindness." Rather than yet one more domain for machinic colonization—the "latest and last form of industrialization: *the industrialization of the non-gaze*"[25]—blindness becomes the basis for an ethics of perception: "it would surely be a good thing if we . . . asked ourselves about the individual's *freedom of perception* and the threats brought to bear on that freedom by the industrialization of vision. . . . Surely it would then be appropriate to entertain a kind of *right to blindness*. . . ."[26] More than simply a right not to see, the right to blindness might best be understood as a right to see in a fundamentally different way. For if we now regularly experience a "pathology of immediate perception" in which the credibility of visual images has been destroyed, isn't the reason simply that image-processing has been dissociated from the body?[27] And if so, what better way can there be to resist the industrialization of perception than by reinvesting the bodily basis of perception? Faced with the all-too-frequent contemporary predicament of "not being able to believe your eyes," are we not indeed impelled to find other ways to ground belief, ways that reactivate the bodily modalities—tactility, affectivity, proprioception—from which images acquire their force and their "reality" in the first place?[28] And if so, might not Virilio's work be understood as anticipating the work of new media artists who deploy technology—indeed, the very visual technologies he analyzes—to uncover the bodily basis underlying all perceptual experience, including, perhaps most significantly (if least "visibly"), vision itself?

Expanded Perspective

New media artists can be said to engage the same problematic as machine vision researchers, though to markedly different effect. As interventions in today's informational ecology, both exploit the homology between human

perception and machinic rendering; yet whereas the project of automation pushes this homology to its breaking point, with the result that it brackets out the human altogether, new media art explores the creative potential implicit within the reconceptualizing of (human) perception as an active (and fully embodied) rendering of data. In a recent discussion of the digitization of the photographic image, German cultural critic Florian Rötzer pinpoints the significance of this rather surprising convergence:

> Today, seeing the world is no longer understood as a process of copying but of modelling, a rendering based on data. A person does not see the world out there, she only sees the model created by the brain and projected outwards. . . . This feature of perception as construction was . . . unequivocally demonstrated by attempts to mechanically simulate the process of seeing . . . in which the processing . . . has to be understood as a complex behavior system. In this context, not only does the processing stage move into the foreground as against the copy, but [so too does] *that organism once taken leave of in the euphoric celebration of photographic objectivity,* an organism whose visual system constructs an environment which is of significance to it.[29]

Rötzer's claim underscores the *functional isomorphism* between machine vision and human perception that forms the foundation of contemporary vision research as well as the impetus for artistic engagements with visual technologies. At issue in both is a *process* of construction from "raw" data in which rules internal to the machine or body–brain are responsible for generating organized percepts—"data packets" in the case of the machine; "images" in that of the human.

Of particular interest here is the inversion to which Rötzer subjects the trajectory followed by vision research: for him, what is central is not how the human prefigures the machinic, but rather how the mechanical simulation of sight has a recursive impact on our understanding and our experience of human vision. It is as if the very capacity to simulate sight furnished the impetus for a reconfiguration—indeed, a reinvention—of vision itself. Beyond its contribution to our understanding of the material transformation of the image, Rötzer's analysis thus pinpoints the potential for the machinic paradigm to

stimulate artistic practice. By revealing that embodied human beings are more like computer-vision machines than photo-optical cameras, the functional isomorphism between machinic sight and human perception underscores the processural nature of image construction. Rather than passively inscribing information contained in our perceptual fields, we actively construct perspectival images through rules internal to our brains.

We must bear in mind, however, that this homology between human and computer "perception" becomes available for aesthetic exploitation only in the wake of the splitting of vision into properly machinic and human forms. Accordingly, if our perceptual process is like that of the computer in the sense that both involve complex internal processing, the type of processing involved in the two cases could not be more different: whereas vision-machines simply calculate data, human vision comprises a "body–brain achievement." Not surprisingly, this difference holds significance for the aesthetic import of the homology as well: whereas machine-vision systems abandon perspective entirely in favor of a completely realized modelization of an object or space, aesthetic experimentations with human visual processing exploit its large margin of indetermination not to dispense with three-dimensionality altogether, but expressly to modify our perspectival constructions.[30]

It is precisely such modification that is at issue in much recent experimentation with the impact of digitization on the traditional photographic image—perhaps the most developed field of new media art practice. By opening extravisual modes of interfacing with the digital information encoding the digital (photographic) image, such experimentation foregrounds the specificity of human processes of image construction. In so doing, it pits human image construction against the analog process of photographic rendering, thus drawing attention to the central role played by embodied (human) framing in the contemporary media environment; at the same time, it underscores the fundamental difference between human and computer processing by deploying the latter as an instrument for the former. This double vocation explains the apparent paradox of aesthetic experimentations with the digital infrastructure of the photograph: that exploring the "image" beyond its technical framing (i.e., as the photographic or cinematic image) necessarily involves some significant engagement with the technical (i.e., with the computer and its constitutive mode of "vision"). In so doing, this double vocation manages to introduce the

Figure 3.2
Tamás Waliczky, *The Garden* (1992). Computer-generated animation depicting a "synthetic" world from a child's viewpoint; compels the viewer to adopt a "waterdrop" perspective. (See plate 4.)

concrete Bergsonist imperative motivating such experimentation: the imperative to discover and make experienceable *new forms of embodied human perspectival perception* that capitalize on the perceptual flexibility brought out in us through our coupling with the computer.

Consider, for example, new media artist Tamás Waliczky's *The Garden* (figure 3.2). This computer-generated animation depicts a "synthetic" world oriented around the figure of a child who plays the role of point of view for the camera and thus anchors this point of view, and also that of the spectator, *within* the space of the image. As she moves around in the image space, the child remains the same size, while the objects she encounters change size, angle, and shape in correlation with the trajectory of her movements through the space. By identifying the viewer's perspective with that of the child, Waliczky compels

the viewer to deterritorialize her habitual geometric perspective and assume what he calls a "waterdrop perspective" (in a waterdrop, as in a bubble, space is curved around a central orienting point of view). Thus, *The Garden* plays with the flexibility of perspective in a way specifically correlated with human embodiment, and indeed, in a way designed to solicit an active response. As one commentator puts it, the work "sets the viewer a task that proves to be hard to grasp—to adopt a decentered point-of-view."[31] By disjoining the point of view of the space it presents from our habitual geometric viewpoint, *The Garden* in effect challenges us to reconfigure our relation to the image; and because the act of entering into the space of the image entails a certain alienation from our normal experience, it generates a pronounced affective correlate. We seem to *feel* the space more than to *see* it. Moreover, because it seeks to reproduce the "spherical perspective" of a child's viewpoint on the world, *The Garden* actively forges concrete connections to other modes of perception—for example, to the "egocentric" viewpoint characteristic of children—where seeing is grounded in bodily feeling. As a form of experimentation with our perspectival grounding, *The Garden* thus aims to solicit a shift in perceptual modality from a predominantly detached visual mode to a more engaged, affective mode.

In his recent work on hypersurface architecture, cultural theorist Brian Massumi grasps the far-reaching implications of such an alternative, haptic and pre-hodological mode of perception:

> Depth perception is a habit of movement. When we see one object at a distance behind another, what we are seeing is in a very real sense our own body's potential to move between the objects or to touch them in succession. We are not using our eyes as organs of sight, if by sight we mean the cognitive operation of detecting and calculating forms at a distance. We are using our eyes as proprioceptors and feelers. Seeing at a distance is a virtual proximity: a direct, unmediated experience of potential orientings and touches on an abstract surface combining pastness and futurity. Vision envelops proprioception and tactility. . . . Seeing is never separate from other sense modalities. It is by nature synesthetic, and synaesthesia is by nature kinesthetic. Every look reactivates a multi-dimensioned, shifting surface of experience from which cognitive functions emerge habitually but which is not reducible to them.[32]

Not only does Massumi broaden perception beyond vision in order to encompass all the sensory modalities of bodily life, but he also suggests that the perspectival flexibility we are exploring here is a consequence of the primordiality of such bodily "vision." On the account he develops, optical vision derives from proprioceptive and tactile "vision," as a particular limitation of its generative virtuality. We might therefore say that new media art taps into the domain of bodily potentiality (or virtuality) in order to catalyze the active embodied reconfiguring of perceptual experience (or, in other words, to "virtualize" the body).

Haptic Space

Precisely such a transformation of what it means to see informs the work of new media artists engaged in exploring the consequences of the digitization of the photographic image. In divergent ways, the work of Tamás Waliczky, Miroslaw Rogala, and Jeffrey Shaw aims to solicit a bodily connection with what must now be recognized to be a material (informational) flux profoundly heterogeneous to the perceptual capacities of the (human) body. By explicitly staging the shift from the technical image to the human framing function, the works of these artists literally compel us to *"see" with our bodies.* In this way, they correlate the radical agenda of "postphotography" with the broader reconfiguration of perception and of the image currently underway in contemporary culture. With their investment of the body as a quasi-autonomous site for processing information, these works give concrete instantiation to the fundamental shift underlying postphotographic practice, what pioneering new media artist Roy Ascott glosses as a "radical change in the technology of image-emergence, not only how the meaning is announced but how it comes on stage; not only how the world is pictured, or how it is framed, but how frameworks are constructed from which image-worlds can emerge, in open-ended processes."[33] By foregrounding the bodily underpinnings of vision, the works of Waliczky, Rogala, and Shaw transform the digital photograph into the source of an embodied framing process that specifies precisely how information can be transformed into experienceable image-worlds.

Unlike Waliczky's *The Garden,* Miroslaw Rogala's *Lovers Leap* (figure 3.3) does not present a virtual image space, but is firmly rooted within the tradition

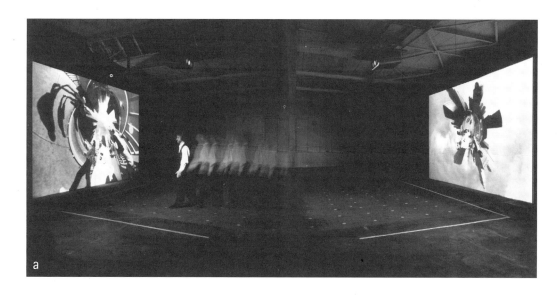

of photo-optical perspective.³⁴ It joins together two large-screen video projections of the busy Michigan Avenue bridge in downtown Chicago displayed according to a perspective system that Rogala calls "Mind's-Eye-View." Two photographs taken with a fish-eye lens are processed together into a 360° "pictosphere" that allows exploration along a spectrum ranging from standard linear perspective (when the angle of viewing tends to coincide with the angle of filming) to a circular perspective (when the two angles stand at 180° from one another). Within the space of the installation, the two video screens display views of the same image space from opposite orientations. Caught inside the strange space of the image, the viewer-participant interacts with the image by moving around in the installation or by standing still. Bodily movement engages floor-mounted sensors that trigger shifts in the 360° image and that determine whether the shifts are abrupt or gradual, while stasis triggers either an animated sequence of the city corresponding to a given location along the spectrum of the image or a randomly selected video sequence of daily life in Lovers Leap, Jamaica. The installation thus combines elements of chance and viewer control: indeed, the viewer-participant's mounting sense of control through movement might be said to be undercut by the random jump cuts to virtual scenes of other places. As Rogala explains: "When the viewer enters the place,

Figure 3.3
Miroslaw Rogala, *Lovers Leap* (1995). (a) Two video screens display views of a 360° "pictosphere"; viewers' physical movement within the space triggers movement of image. (b) Close-up of 360° pictosphere of downtown Chicago taken with "fish-eye" lens. (See plate 5.)

b

one becomes aware that one's movements or actions are changing the view but won't realize how. This means that the viewer is not really in control, but simply aware of his or her complicity. . . . As the viewer's awareness of the control mechanisms grows, so does the viewer's power."[35] Still, as Margaret Morse observes, the viewer remains powerless to select the content of the experience and can only modify its manner: the viewer chooses "not what is seen, but how it is viewed."[36] And, we might furthermore add, what performs the selecting is not the viewer's rational faculties, but her bodily affectivity, which henceforth becomes the link between her mental experience and the space of the image.

In this sense, Rogala's installation might be said to recast the experience of perspective not as a static grasping of an image, but as an interactive construction of what Timothy Druckrey calls an "event-image." In the work, the digitized image becomes "the point of entry into an experience based on the ability to render curvilinear perspective as process."[37] Effectively, the image be-

comes an "immersive geometry" in which perspective loses its fixity and becomes multiple. The result is a kind of play with perspective in which the viewer's gestures and movement trigger changes in the image and thereby reconstruct the image as a haptic space. Rogala explains: "movement through perspective is a mental construct; one that mirrors other jumps and disjunctive associations within the thought process."[38] Moreover, it is the brain which functions to "link" (though not to "unite") the physical locality in which the viewer-participant finds herself with the virtual dimension. "The goal" of the installation, Morse concludes, "is to externalize an internal image in the mind, allowing the viewer to stand outside and perceive it."[39] Not only does *Lovers Leap* thus suggest a new relation to the photographic image—since, as Druckrey puts it, "the usefulness of the single image can no longer serve as a record of an event"—but it foregrounds the shift from an optical to a haptic mode of perception rooted in bodily affectivity as the necessary consequence of such a shift in the image's ontology and function.[40]

Whereas Rogala's work manages to uproot perspective from its photo-optical fixity without abandoning Euclidean space, Waliczky's work embraces the flexibility of computer mediation and, ultimately, computer space itself, in order to confront the anthropomorphic basis of perception with the catalyst of the virtual image.[41] In *The Way,* for example, Waliczky employs what he calls an "inverse perspective system": as three depicted figures run toward buildings, these buildings, rather than getting nearer, actually move farther away (see figure 1.4). In *The Garden,* as we've already seen, Waliczky employs a "waterdrop perspective system," which privileges the point of view not of the spectator, as in traditional perspective, but rather of the child, or more exactly, of the virtual camera, whose surrogate she is. And in *Focusing,* Waliczky dissects a 99-layer digital image by making each of its layers available for investigation by the viewer. What one discovers in this work is that each part of the image explored yields a new image in turn, in a seemingly infinite, and continuously shifting, process of embedding (figure 3.4). Indeed, Waliczky's work not only furnishes a perfect illustration of Deleuze's claim that any part of the digital image can become the link to the next image but also foregrounds the bodily activity of the viewer as the filtering agent: what it presents is a truly inexhaustible virtual image surface that can be actualized in an infinite number of ways through the viewer's selective activity.

Waliczky's use of computer space to unsettle optical perspective takes its most insistent form in a work called *The Forest*. Initially produced as a computer animation, *The Forest* uses two-dimensional elements (a single black-and-white drawing of a bare tree) to create the impression of a three-dimensional space. To make *The Forest*, Waliczky employed a small virtual camera to film a series of rotating cylinders of various sizes onto which the drawing of the tree has been copied. Because the camera is smaller than the smallest cylinder, the viewer sees an endless line of trees in staggered rows, when in actuality the trees are mounted on a set of convex surfaces (figure 3.5). As Anna Szepesi suggests, Waliczky's work combines vertical movement (the movement of the trees), horizontal movement (the movement of the cylinders), and depth movement (the movement of the camera). This combination, argues Szepesi, produces movements running in every direction. The result is a thorough transformation of the Cartesian coordinate system, a replacement of the straight vectors of the x, y, and z axes with "curved lines that loop back on themselves."[42] And the effect evoked is a sense of limitless space in which the viewer can find no way out. Szepesi explains: "The bare trees revolve endlessly around their own axis,

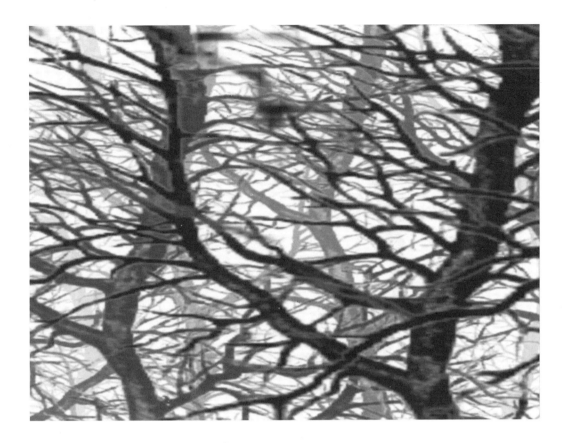

like patterns in a kaleidoscope. The resulting illusion is complete and deeply alarming: the infinity of the gaze leads to a total loss of perspective."[43]

Yet *The Forest* does not present a "posthuman point of view," as Morse claims; nor does it restore the conventions of Euclidean vision within a non-Euclidean image space. Rather, by embedding experienceable vantage points within warped image spaces, *The Forest* opens alternate modes of perceiving that involve bodily dimensions of spacing and duration—modes that, in short, capitalize on the flexibility of the body, and indeed, on the cross-modal or synaesthetic capacities of bodily affectivity. In this way, it exemplifies the mechanism driving all of Waliczky's work: the inversion of a normal viewing situation, such that the image becomes the stable point of reference around which the body might be said to move. Morse discerns something similar in *The Way:*

Figure 3.5
Tamás Waliczky, *The Forest* (1993). Two-dimensional drawing fed through virtual camera yields illusion of an infinite three-dimensional space.

"A stationary viewer can interpret his or her own foreground position to be moving. The result is puzzling, an enigma that in any case suggests an ironic or dysphoric vision of motion into what is usually associated with the future or the path of life."[44] I must insist, moveover, that what effects such an "interpretation" or "suggestion" is precisely the capacity of the installation to tamper with our ordinary embodied equilibrium: in a reversal of the paradigm of cognitive linguistics (where meaning schemata can be traced back to embodied behavior), what is at stake here is a modification at the level of embodied behavior that subsequently triggers connotational consequences.[45]

These two distinct engagements with photo-optical perspective—one more directly aligned with traditional photography, the other with the virtual image of computer vision research—come together in the work of Jeffrey Shaw. Consider, for example, his coproduction, with Waliczky, of an interactive installation version of *The Forest.* The aim of this installation is to expand the interface between the human viewer and Waliczky's animated virtual world: to open it not simply to the viewer's internal bodily processing, but to her tactile and spatial movement. To this end, Waliczky's world is made navigable via the interface of an advanced flight simulator; using a joystick mounted on a moving seat, the viewer is able to negotiate her own way through the infinitely recursive virtual world of *The Forest* and to experience her journey through the physical sensations of movement that the flight simulator produces in her own body (figure 3.6). In effect, the process of mapping movement onto the body functions to frame the limitless "virtual" space as an actualized image.

More firmly rooted in the traditions of past image technologies, Shaw's own recent works (as we have seen) deploy multiple, often incompatible interfaces as navigation devices for the virtual image spaces his works present. By employing the navigation techniques of panorama, photography, cinema, and virtual reality, Shaw makes their specificity both a theme and a function of his work. However, rather than collapsing the technologies into some kind of postmodern *Gesamtkunstwerk,* he layers them on top of one another in a way that draws attention to the material specificity distinguishing each one. The effect of this juxtaposition of incompatible media frames or interfaces is to foreground the "framing function" of the embodied viewer-participant in a more direct and insistent way than either Rogala or Waliczky do. Rather than

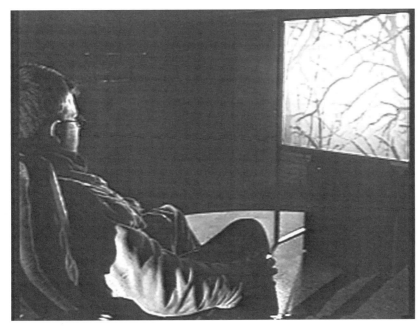

Figure 3.6
Jeffrey Shaw and Tamás
Waliczky, Installation
Version of *The Forest*
(1993). Embeds *The For-
est* within flight simula-
tor interface; couples
illusion of infinite three-
dimensional space to
possibilities of body
movement.

presenting the viewer-participant with an initially destabilizing interactional domain, Shaw empowers her as the agent in charge of navigating media space: it is the viewer-participant's bodily activity—and specifically, her synesthetic or cross-modal affectivity—that must reconcile the incompatibilities between these diverse interfaces. Thus, as the viewer-participant gradually discovers the limits of the immersive environment, and correspondingly of her own affective processing of this environment, she gains a reflexive awareness of her own contribution to the production of the "reality effects" potentially offered by the interface possibilities. As exhilirating as it is deflating, this awareness serves to place the viewer-participant within the space of the image, although in a manner that, by constantly interrupting immersion, draws attention to the active role played by bodily affectivity in producing and maintaining this experience.

In two striking instances, this juxtaposition of competing visual traditions concretely exploits the contrast between the photographic image as a static (analog) inscription of a moment in time and as a flexible data set. In *Place: A User's Manual,* Shaw deploys the panorama interface in its traditional

form—as a photographic image—precisely in order to defeat its illusionist aim. By giving the viewer control over the projection, the frame, and the space it depicts, and by foregrounding the reversibility of the screen (which allows the panorama to be seen from the outside), Shaw opens the photographic space of illusion to various forms of manipulation—all involving bodily movement—that serve to counteract its illusionistic effects. Photography is thus transformed into the "condition . . . of another movement, that of movement within virtual space";[46] it becomes the pretext for a movement that is simultaneously *within* the viewer's body and the virtual space and that is—on both counts—*supplementary* to the static photographic image. This effect of introducing movement into the photograph from the outside—and its inversion of the conventions of the traditional panorama—is made all the more striking by the content of the panoramic image worlds: deserted sites or sites of memory that, in stark contrast to the tourist sites featured in the nineteenth-century panoramas, are themselves wholly devoid of movement (figure 3.7).

In *The Golden Calf* (1995), Shaw deploys the photographic image as the basis for an experience that reverses the movement foregrounded in *Place* and, by doing so, inverts the traditional panoramic model itself. The work features a white pedestal on which is placed an LCD color monitor connected to a com-

Figure 3.7
Jeffrey Shaw, *Place: A User's Manual* (1995). Close-up of panoramic photograph of deserted site of memory.

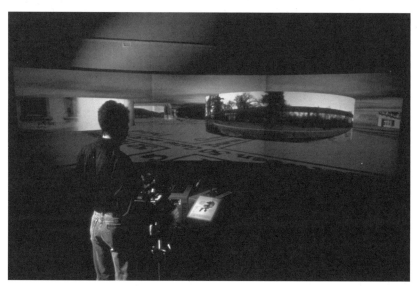

puter via a large five-foot cable. The monitor displays an image of the pedestal with a computer-generated image of a golden calf on top. By moving the monitor around the actual pedestal and contorting her body in various ways, the viewer can examine the calf from all possible angles—above, below, and from all sides (figure 3.8). The monitor thus functions as a window revealing an immaterial, virtual object seemingly and paradoxically located within actual space. Yet, because the calf's shiny skin has been "reflection-mapped" with digitized photographs of the room that were captured with a fish-eye lens, this virtual object also becomes the projective center for a virtual panoramic representation of the space surrounding the viewer, and moreover, one that brings together past images (again, photography's ontological function) with the present experience of the viewer. Whereas in *Place* the actual panoramic image

Figure 3.8
Jeffrey Shaw, *The Golden Calf* (1995). (a) Inverts traditional panoramic model by requiring viewer to align virtual image of golden calf sculpture on a pedestal in physical space. (b) Close-up of monitor displaying image of golden calf sculpture. (See plate 6.)

becomes the pretext for an exploration of virtual space, both within the viewer's body and within the image itself, here the panoramic image is itself the result of a virtual projection, triggered by the images reflected on the calf's skin and "completed" by the embodied processing of the viewer. Rather than enacting the deterritorialization of the photographic image into a kinesthetic space, this work deploys photography as an interface onto three-dimensional space. In this way, it underscores the fundamental correlation of photography in its digitized form with the "reality-conferring" activity of the viewer's embodied movement in space and the affectivity it mobilizes. If the viewer feels herself to be in the panoramic image space, it is less on account of the image's autonomous affective appeal than of the body's production, *within itself,* of an affective, tactile space, something that we might liken to a bodily variant of Deleuze's notion of the "any-space-whatever." Moreover, if this penetration into the image necessarily involves a certain fusion between actual and virtual image space, it foregrounds the body–brain's capacity to suture incompossible worlds in a higher transpatial synthesis.

In sum, the digital environments of Rogala, Waliczky, and Shaw foreground three crucial "problems" posed by the digitization of the technical

(photographic) image: the problems, respectively, of processural perspective, of virtual infinitude, and of the indiscernible difference between virtual and actual space. In all three cases, what is at stake is an effort to restore the body's sensorimotor interval—its affectivity—as the supplementary basis for an "imaging" of the digital flux. Rogala's deformation of photo-optical norms renders perspective as process and maps it onto the body as a site of a variant haptic point of view. Waliczky's perturbation of perceptual equilibrium foregrounds the active role of the body required to frame virtual space as a contingent actualized image. And Shaw's deconstruction of the illusionary effects of photographic representation highlights the bodily basis of human perception and the transpatial function that allows the body to confer reality on actual and virtual space alike.

Embodied Prosthetics

All of these aesthetic experimentations with the digitization of photography exemplify the Bergsonist vocation of new media art: in various ways, they all channel perception through the computer, not as a technical extension *beyond* the body–brain, but as an embodied prosthesis, a catalyst for bodily self-transformation. In so doing, they all foreground the body as the agent of a sensorimotor connection with information that, unlike the sensorimotor logic inscribed into the movement-image, must be said to be *supplementary.*

Insofar at it defines the creative margin of indetermination constitutive of embodied framing, this supplementary sensorimotor connection is precisely what defines the Bergsonist vocation of new media art. We can understand it to be the result of a contemporary refunctionalizing of the two productive dimensions of Bergson's understanding of the body: through it, the subtractive function of the body and the singularizing contribution of affection and memory are brought to bear on what is, in effect, an entirely new world—a universe not of *images* but of *information.* As the privileged vehicle for this refunctionalizing, new media art facilitates a bodily negotiation with the processural environment that is simultaneously a reconfiguration of the body, a broadening of its function as center of indetermination. By widening the correlation of body and technology well beyond anything Bergson could have imagined, new media artworks vastly expand his theory of embodied prosthetics:[47] indeed, the

experience they broker fosters the interpenetration of technology into perception and thereby extends the scope of the body's *sensorimotor* correlation with the universe of information. New media art might thus be said to create, or rather to catalyze the creation of, new modalities through which the body can filter—and indeed give form to—the flux of information.

Architect Lars Spuybroek grasps the profound impact of this new model of embodied prosthetics on our understanding of the body:

> the body's inner phantom has an irrepressible tendency to expand, to integrate every sufficiently responsive prosthesis *into its motor system,* its repertoire of movements, and make it run smoothly. That is why a car is not an instrument or piece of equipment that you simply sit in, but something you merge with. . . . Movements can only be fluent if the skin extends as far as possible over the prosthesis and into the surrounding space, *so that every action takes place from within the body,* which no longer does things consciously but relies totally on feeling. . . . [E]verything starts inside the body, and from there on it just never stops. The body has no outer reference to direct its actions to, neither a horizon to relate to, nor any depth of vision to create a space for itself. *It relates only to itself.* There is no outside: there is no world in which my actions take place, the body forms itself by action, constantly organizing and reorganizing itself motorically and cognitively to keep "in form."[48]

Rather than extending our senses outward, as the dominant understanding would have it, embodied prostheses impact experience because they augment our tactile, proprioceptive, and interoceptive self-sensing or affectivity: "every prosthesis is in the nature of a vehicle, something that adds movement to the body, that adds a new repertoire of action. Of course, the car changes the skin into an interface, able to change the exterior into the interior of the body itself. The openness of the world would make no sense it if were not absorbed by my body-car. The body simply creates a haptic field completely centered upon itself, in which every outer event becomes related to this bodily network of virtual movements, becoming actualized in form and action."[49] As a "vehicle" in precisely this sense, new media art configures the body as a haptic field, thereby allowing it to exercise its creative productivity.

Because of the crucial role it accords the computer as an instrumental interface with the domain of information, however, new media art transforms this haptic prosthetic function into the basis for a supplementary sensorimotor connection with the digital. In the process, it helps unpack what exactly is at stake in the shift from an ontology of images to an ontology of information, from a world calibrated to human sense ratios to a world that is, following Johnston's and Kittler's distinct but complementary insights, in some sense fundamentally heterogeneous to the human. Following this shift, we can no longer consider the body to be a correlate of the material flux, and its constitutive sensorimotor interval can no longer define the image as the basic unit of matter. Rather, precisely because it is heterogeneous to the flux of information, the body and its sensorimotor interval can only be *supplemental* to this flux—something introduced into it or imposed on it *from the outside, from elsewhere.* Put another way, the sensorimotor interval can no longer furnish the basis for deducing the body from the material universe, but instead now designates a specific function *of the body itself* as a system heterogeneous to information.[50] The body, in short, has become the crucial mediator—indeed, the "convertor" (Ruyer)—*between information and form (image):* its supplemental sensorimotor intervention coincides with the process through which the image (what I am calling the digital image) is created.

Once again, architect Lars Spuybroek pinpoints the profound significance of this transformation in the haptic, prosthetic function.[51] As an embodied prosthesis, the computer lets us perceive movement itself in a way that fundamentally alters what it means to see: the computer, Spuybroek maintains, "is an instrument for viewing form in time." When we see through the computer, "we no longer look at objects, whether static or moving, but at movement as it passes through the object. Looking no longer implies interrupting the object to release images in space. Today *looking has come to mean calculating rather than depicting external appearance.*" Looking now means calculating *with the body,* and the image that gets "released" designates something like its processual perception: "we build machines . . . not just to connect perception and process, but more importantly *to internalize these and connect them with the millions of rhythms and cycles in our body.*"[52] Insofar as it employs the computer as a prosthetic "vehicle" to transform the basis and meaning of vision, new media art can be thought of as an apparatus for producing embodied images. It

responds to the eclipse of the sensorimotor basis of vision by fundamentally reinvesting the body's sensorimotor capacities, and indeed, *by resituating the sensorimotor itself,* transposing it from the domain of vision to that of affectivity. In this respect, the automation of vision can be seen to exert a similar impact on art as it does on (human) perception more generally: just as perception is compelled to rediscover its constitutive bodily basis, so too must art reaffirm its bodily origin and claim the image as its proper domain.

Part II

The Affect–Body

4

Affect as Interface: Confronting the "Digital Facial Image"

You enter a darkened corner of a large room and position yourself in front of a giant, digitally generated close-up image of an attractive female face (figure 4.1). After reading the instructions affixed to a post on your left, you nervously pick up the telephone receiver located just above these instructions and prepare to speak into it. "Hello, can you hear me? What is your name?" you ask in a quivering, muffled voice, all the while continuing to fix your gaze on the image in from of you. After ten or twelve seconds, with no apparent change in the mild indifference expressed by the facial image, which continues to sway softly back and forth in front of you in a kind of digital haze, you steel yourself and try again. "Hello, can you hear me? What is your name?" you again intone, this time trying your best to speak crisply and loudly into the telephone receiver. Once again, however, ten or twelve seconds pass, with no change in the image. With a gradually mounting feeling of strangeness you will later associate with the very enterprise of interrogating a digital image, you nonetheless persist, trying perhaps four or five more times, using the same strategy, though once or twice mixing in some German, the presumptive native language of this creature. "Hallo, können Sie mich hören? Wie heissen Sie?" you meekly intone, but again the image rebuffs you. Finally, after what seems to be an unbearably long period of interrogation, the creature compensates your efforts with a sudden, disengaged, perhaps even mocking laugh and turn of the head to your left, almost instantaneously reverting back to her indifferent hovering. Emboldened by this meager response you enter another round of questioning, and this time, again after what seem to be countless efforts on your part, you are awarded a quick kiss, again followed almost immediately by the return of the image to her default disengagement. Further emboldened by this fleeting display of what you cannot help but take as a sign of affection, you branch out in your line of questioning, asking the creature where she lives, whether she is happy, whether

Theoretical Aim	Body	Image	Artwork
To restore the intrinsic link of affection with the body	From *epoché* of body in the affection-image to reinvestment of body as the source of affection via a supplementary sensori-motor contact with information	From autonomous affection-image (cinematic close-up) to image *as affective response to* digital information ("digital facial image")	Geisler's *Dream of Beauty 2.0*; van Lamsweerde's *Me Kissing Vinoodh (Passionately)*; Corchesne's *Portrait no. 1*; Mongrel's *Color Separation*; Feingold's *If/Then, Sinking Feeling; Huge Harry*

Figure 4.1
Kirsten Geisler, *Dream of Beauty 2.0* (1999). Digitally generated close-up image of virtual persona affords limited possibilities for interaction with the digital domain. (See plate 7.)

she needs to eat to stay alive, whether she sleeps and dreams, and if so, what about? Through all this, you are rather disappointed to discover, her pattern of response seems to remain constant, with a predominant detached hovering only occasionally giving way to an almost instantaneous, mocking smile or overly mannered kiss. Having grown accustomed to this odd form of exchange, or perhaps simply distressed at the ineffectuality of your efforts to become more intimate with this odd creature, you turn away, with a vague though nagging sense of your own irrelevance.

The digital artwork just described is German artist Kirsten Geisler's *Dream of Beauty 2.0* (1999), an interactive, voice-activated installation with a digitally generated female persona. The experience it has catalyzed for you is an affective interfacing with what I shall call the "digital facial image" (DFI). In this experience, the infelicitous encounter with the digitally generated close-up image of a face—and specifically the affective correlate it generates in you, the viewer-participant—comes to function as the medium for the interface between the domain of digital information and the embodied human that you are. Geisler's work is exemplary of aesthetic experimentations with the DFI precisely because of its success at furnishing some sense of the radical material "indifference" of digital information to human sensory ratios. By catalyzing a disturbing confrontation with the digital, *Dream of Beauty 2.0* draws attention to the the nonseamlessness of the interface between embodied human beings and the computer. Yet in so doing, it manages to forge a connection between these two that stands as proof against the more nihilistic posthumanism of a Friedrich Kittler, who (as we have already had occasion to see) has infamously pronounced the structural irrelevance of the human in the face of "digital convergence." Geisler's work answers Kittler's claims, as it were, by generating an intense affective experience that forms a kind of human counterpart to the potential autonomy of the digital, a new domain of human embodiment that emerges out of our response to digitization.

In this chapter, I shall propose this encounter as a new paradigm for the human interface with digital data. To my mind, the DFI and the affective response it triggers offers a promising alternative to the profoundly impoverished, yet currently predominant model of the human–computer interface (HCI). Whereas the HCI functions precisely by reducing the wide bandwidth of embodied human expressivity to a fixed repertoire of functions and icons,

the DFI transfers the site of this interface from computer-embodied functions to the open-ended, positive feedback loop linking information to the entire affective register operative in the embodied viewer-participant. Thus, rather than channeling the body's contribution through the narrow frame of preconstituted software options, the DFI opens the interface to the richness of the bodily processing of information.[1] For this reason, the DFI allows us to reconceptualize the very notion of the interface: bypassing exploration of more effective technical "solutions," it invests in the body's capacity to supplement technology—its potential for collaborating with the information presented by the interface in order to create images.

This potential stems from the bodily dimension of affectivity that, as we have already had occasion to observe, has been theorized by Bergson and, following his lead, French bio-phenomenologist, Gilbert Simondon. Both philosophers have foregrounded the centrality of affection in perceptual and sensory experience, with Bergson demonstrating the inseparability of affection and perception and Simondon correlating affectivity with the heterogenesis of the body. Insofar as it functions by triggering affectivity as a vehicle for embodied heterogenesis, the confrontation with the DFI results in a transfer of affective power *from* the image *to* the body. Accordingly, instead of a static dimension or element intrinsic to the image, affectivity becomes the very medium of interface with the image. What this means is that affectivity actualizes the potential of the image at the same time as it virtualizes the body: the crucial element is neither image or body alone, but the dynamical interaction between them. This understanding of affectivity will allow us to redeem Bergson's embodied understanding of the center of indetermination from Deleuze's effort to generalize it into a theory of cinematic framing, and specifically to rescue Bergson's embodied conception of affection—in which affection forms a phenomenological mode autonomous from perception—from subsumption into a mere effect or transmutation of the image. To carry out such a redemption, I shall interweave discussions of aesthetic experimentations with the DFI and theoretical arguments concerning the potential of bodily affectivity and the virtualization of the body it operates. Together, these discussions and arguments will generate a theoretical model of affectivity as a potentially fruitful medium for interface with the computer, one that eschews the narrow bandwidth communication of today's HCI in favor of an open-ended and radically

experimental engagement with the richness of our embodied modes of sensation. As the digital artworks discussed at the end of this chapter propose, if we can allow the computer to impact our embodied affectivity directly, our communication—and indeed our coevolution—with the computer will be opened to a truly new, "postimagistic" phase.

From Facialization to the Close-Up and Back Again

Why, we might be inclined to ask, the face? What is it exactly that justifies the privilege accorded the facial image in this process of affective bodily supplementation? Consider the correlation Deleuze and Guattari posit between the semiotics of capitalism and the process of "facialization" in *A Thousand Plateaus.* Defined as the overcoding of the body on the face, facialization carries out the "jump" that makes possible capitalist semiotics: the jump "from the organic strata to the strata of signifiance and subjectification." Facialization, therefore, requires the wholesale sublimation of the body, as Deleuze and Guattari explain:

> This machine is called the faciality machine because it is the social production of face, because it performs the facialization of the entire body and all its surroundings and objects, and the landscapification of all worlds and milieus. The deterritorialization of the body implies a reterritorialization on the face; the collapse of corporeal coordinates or milieus implies the constitution of a landscape. The semiotic of the signifier and the subjective never operates through bodies. It is absurd to claim to relate the signifier to the body. At any rate it can be related only to a body that has already been entirely facialized.[2]

As the catalyst for a dynamic reembodiment of the interface, the DFI reverses precisely this process of facialization that, we can now see, comprises the very principle of the HCI as an instrument of capitalist semiotics. In the experience of the DFI, that is, the face becomes the catalyst for a reinvestment of the body as the rich source for meaning and the precondition for communication. The DFI thus forms the vehicle of contact between our bodies and the domain of information that would otherwise remain largely without relation to us.

For this reason, the DFI can be said to function—at least to some degree—in a manner not unlike the close-up in film, following Deleuze's analysis in *Cinema 1*. Defined as the concentration of all expressive elements on the surface of the face, the close-up fundamentally revalorizes facialization as a liberation of affect from its ties to the body:

> The face is this organ-carrying plate of nerves which has sacrificed most of its global mobility and which gathers or expresses in a free way all kinds of tiny local movements which the rest of the body usually keeps hidden. Each time we discover these two poles in something—reflecting surface and intensive micro-movements—we can say that this thing has been treated as a face [*visage*]: it has been "envisaged" or rather "facialized" [*visagéifiée*], and in turn it stares at us [*dévisage*], it looks at us . . . even if it does not resemble a face. Hence the close-up of the clock. As for the face itself, we will not say that the close-up deals with it or subjects it to some kind of treatment; there is no close-up *of* the face, the face is in itself close-up, the close-up is by itself face and both are affect, affection-image.[3]

Contrasted with the critical analysis offered in *A Thousand Plateaus,* this account yields a positive conception of facialization: rather than overcoding (and thus eliminating) the body, the face is now endowed with the function of expressing the intensity of the body abstracted or purified, as it were, from its spatiotemporal functions.[4] For Deleuze, the informatic excess of cinematic facialization yields an expressionism rooted in the autonomy of affect: "the close-up of the face," he concludes, "has nothing to do with a partial object. . . . As Balázs has already accurately demonstrated, the close-up does *not* tear away its object from a set of which it would form part, of which it would be a part, but on the contrary, *it abstracts it from all spatio-temporal co-ordinates,* that is to say, it raises it to the state of Entity."[5] The close-up, in short, possesses the "power to tear the image away from spatio-temporal co-ordinates in order to call forth the pure affect as the expressed."[6]

Aesthetic experimentations with the DFI likewise invest the process of facialization as a positive conduit from the domain of information back to the

body. In such experimentations, facialization involves a certain excess over the framed image, one that catalyzes a properly bodily affective response. Yet, beyond this common general investment in facialization, these aesthetic experimentations diverge fundamentally from Deleuze's analysis of the close-up: in them, the face does not so much *express* the body, as *catalyze* the production of a *supplementary* sensorimotor connection between the body and a domain (informatics) that is fundamentally heterogeneous to it. This production can be usefully compared with the process of "affective attunement" analyzed by psychoanalyst Daniel Stern: like the affective modality of preverbal parent-infant interaction, this supplementary sensorimotor connection capitalizes on the contagious dynamics of affectivity in order to attune the body to a stimulus that is novel—and, in this case, that is so precisely because of its radical heterogeneity to already developed human perceptual capacities.[7] It is as if affectivity steps in precisely where no perceptual contact can be made. Accordingly, as a catalyst for an essentially creative process of affective attunement, the DFI furnishes a way back into the body that need not be understood as a simple "return to" the body.[8] More specifically still, the experience triggered by the DFI invests in the affective bodily response to facialization and thus directly counters the overcoding of the body on the face that constitutes facialization in its capitalist mode. In this sense, aesthetic experimentations with the DFI can be understood as a sort of antidote to late capitalist semiotic mechanisms (e.g., televisual advertising but also the dominant HCI itself) that function specifically by reducing embodied singularity to facialized generality. Indeed, insofar as it *virtualizes* the body, the process of affective attunement carries out a fundamental reindividuation of the body, or more exactly, an expansion of the body's capacity to mediate between its own on-going individuation and the individuation of the world itself.[9] Affectivity, accordingly, is more than simply a supplement to perception (as Deleuze maintains) and it is more than a correlate to perception (as Bergson holds). Not only is it a modality of experience in its own right, but it is that modality—in contrast to perception—through which we open ourselves to the experience of the new. In short, affectivity is *the* privileged modality for confronting technologies that are fundamentally heterogeneous to our already constituted embodiment, our contracted habits and rhythms.

The Affective Intensity of the DFI

We can now pinpoint exactly how digital facialization differs from Deleuze's positive refunctionalization of facialization in *Cinema 1:* whereas Deleuze celebrates the close-up as a liberation of affect *from the body,* the DFI aims to catalyze the production of affect *as an interface between the domain of information (the digital) and embodied human experience.* The task of unpacking what is at stake in the DFI thus calls for a trajectory that is the precise inverse of the one pursued by Deleuze in *Cinema 1.* While it shares Deleuze's privileging of affection,[10] this trajectory will move toward a rehabilitation of Bergson's embodied conception of affection. Consequently, it will call on us to criticize and to reverse the fundamental philosophical gesture of Deleuze's appropriation of Bergson's ontology of images: his reduction of bodily affection to one specific permutation of the movement-image (the affection-image).

In his second commentary on Bergson, Deleuze derives the affection-image as one possible result of the encounter between the movement-image and a center of indetermination, as one possible embodiment of the movement-image. Following in the wake of the "perception-image" and the "action-image," the affection-image is thereby defined as the "third material aspect of subjectivity."[11] In this office, affection mediates between the other material aspects of subjectivity, namely, perception and action; specifically, affection fills the interval between perception and action—the very interval that allows the body *qua* center of indetermination to delay reaction and thus organize unexpected responses:

> Affection is what occupies the interval, what occupies it without filling it in or filling it up. It surges in the center of indetermination, that is to say in the subject, between a perception which is troubling in certain respects and a hesitant action. It is a coincidence of subject and object, or the way in which the subject perceives itself, or rather experiences itself or feels itself "from the inside" (third material aspect of subjectivity). It relates movement to a "quality" as lived state (adjective). Indeed, it is not sufficient to think that perception—thanks to distance—retains or reflects what interests us by letting pass what is indifferent to us. There is inevitably a part of external movements that we "absorb," that we refract,

and which does not transform itself into *either objects of perception or acts of the subject;* rather they mark the coincidence of the subject and the object in a pure quality.[12]

This understanding of affection as "pure quality" is made necessary, Deleuze contends, because as centers of indetermination, we humans have specialized one of our facets into "receptive organs at the price of condemning them to immobility": this specialized facet absorbs movement rather than reflecting it, which means that a "'tendency' or 'effort' replaces . . . action which has become momentarily or locally impossible."[13]

Although drawn directly from Bergson's definition of affection, Deleuze's interpretation—with its emphasis on affect as pure quality—marks a fundamental break from its source. Whereas Bergson views affection as a phenomenological modality in its own right and implies a difference of *kind* between affection and perception,[14] Deleuze determines affection as a (sub)component of perception. Specifically, affection is made to designate a *particular modality of perception:* an attenuated or short-circuited perception that ceases to yield an action, and instead brings forth an expression. "There is therefore a relationship between affection and movement in general . . . : the movement of translation is not merely interrupted in its direct propagation by an interval. . . . Between the two there is affection which re-establishes the relation. But, it is precisely in affection that the movement ceases to be that of translation in order to become movement of expression, that is to say quality, simple tendency stirring up an immobile element."[15] And, as a modality of perception, affection becomes a type of image—the affection-image or close-up: it is the *external* expression of an internal bodily state, the extraction of a "pure quality": "It is not surprising," Deleuze continues, "that, in the image that we are, it is the face, with its relative immobility and its receptive organs, which brings to light these movements of expression while they remain most frequently buried in the rest of the body."[16] With this determination of affection as a variety of the movement-image, Deleuze manages to *subsume affection within perception,* thereby dissolving its constitutive link to the body. It is this subsumption, moreover, that allows Deleuze to operate his transformation of Bergson: for once affection has become one variety of perception—rather than an alternate modality constitutive of the body—it becomes possible to define the body as

a particular "assemblage" of images (pure perceptions), or alternatively, as a particular actualization of the universe of images or plane of immanence: "each one of us," concludes Deleuze, "is nothing but an assemblage [*agencement*] of three images, a consolidate [*consolidé*] of perception-images, action-images and affection-images."[17]

If we contrast the examples Deleuze offers in support of his interpretation against recent engagements by new media artists with faciality, what we find is precisely the fundamental *aesthetic* difference introduced above. Whereas Deleuze's examples subsume bodily activity into the expressive quality of the close-up, new media artworks turn attention back on the bodily activity through which we perceive and interact with the face—the process of affective attunement in which facial signals spontaneously trigger an affective bodily response. Rather than following Deleuze's trajectory toward the transcendence of the bodily basis of the image, new media art foregrounds precisely what is at stake *for the body* in the engagement with digital faciality, namely, the reinvestment of the fundamental creativity of bodily affectivity. We might say that new media art reinserts the body in the circuit connecting affectivity and the face, thereby supplementing what Deleuze calls the "icon" (the set of the expressed and its expression) with a third term: the embodied activity that produces affect from image and exposes the origin of all affectivity in embodied life.[18]

For Deleuze, there are two poles of the close-up: on the one hand, micromovements that "gather and express in a free way" what the body keeps hidden; on the other, the receptivity and immobility that makes the face into a "reflecting and reflected unity."[19] To these poles correspond "two sorts of questions [one] can put to a face . . . : what are you thinking about? Or, what is bothering you, what is the matter, what do you sense or feel?"[20] Insofar as it thinks about something, Deleuze suggests, the face functions as a reflecting unity: it has value through its "surrounding outline." This sort of close-up was the hallmark of Griffith, according to Deleuze, who cites a scene in *Enoch Arden* where a young woman thinks about her husband and, more generally, all the famous Griffith close-ups "in which everything is organized for the pure and soft outline of a feminine face."[21] On the other hand, when the face feels something, it is said to have value "through the intensive series that its parts successively traverse as far as paroxysm, each part taking on a kind of momentary

independence."[22] Here it is Eisenstein to whom Deleuze turns, citing the scene in *The General Line* where the priest's face dissolves and gives way to "a cheating look which links up with the narrow back of the head and the fleshy earlobe."[23] In this example, and in Eisenstein's practice more generally, "it is as if the traits of faceity were escaping the outline. . . ."[24]

As this analysis proceeds, it becomes clear that Deleuze's focus on the close-up aims toward a certain transcendence: a cinematic detachment of affect from body. While mental reflection is "undoubtedly the process by which one thinks of something," *cinematographically* it is "accompanied by a more radical reflection expressing a pure quality."[25] Likewise, though the intensive micro-movements of the face undoubtedly express states of the body, *cinematographically* they "begin to work on their own account," passing from "one quality to another, to emerge on to a new quality" or rather a "pure Power."[26] This cinematographic *epochē* of the bodily basis of affect reaches its apex in Eisenstein's intensive series, insofar as this latter directly unites "an immense collective reflection with the particular emotions of each individual" and thus expresses "*the unity of power and quality.*"[27] By so doing, Eisenstein's practice exemplifies the status of the close-up not as "partial object," but as "Entity" abstracted from all spatiotemporal coordinates. Rather than a mere enlargement, the close-up implies an absolute change of dimension: "a mutation of movement which ceases to be translation in order to become expression."[28] Transcending its ties to the body by tearing the image away from its spatiotemporal localization, the close-up calls forth "the pure affect as the expressed": the "affect is the entity, that is Power or Quality . . . ; the affection-image is power or quality considered for themselves, as expressed."[29] For this reason, the close-up might be said to annihilate the face: "There is no close-up of the face. The close-up is the face, but the face precisely in so far as it has destroyed its triple function [individuation, socialization, communication]. . . . [T]he close-up turns the face into a phantom. . . . The face is the vampire. . . ."[30]

By contrast, the DFI deploys affect to entirely different ends: rather than a transcendence or suspension of individuation, what is at stake in recent aesthetic experimentations with digital faciality is the catalysis of an individuation that utilizes affectivity to engage with the digital processes of image production. That these works confront the participant with affection-images *generated entirely through digital processes* has the effect of reversing the Deleuzean

schema: rather than a drive toward autonomy of the image as the expressed of affect, what becomes urgent in these cases is the forging of contact—any contact—with the bizarrely "alien" image (and the radically inhuman universe of information it materializes). Here, in short, the autonomization of the affect-image is *given at the outset* and serves as the catalyst for a new individuation, a virtualization of the body that "responds," as it were, to the problematic posed by the digital image.

Appropriating Deleuze's distinction between receptivity and intensity, we can distinguish two tendencies in experimentations with the DFI: a tendency to confront the participant-viewer with single, relatively static digital affection-images; and a tendency to engage the participant-viewer in a protracted interaction with a moving close-up of what can only be called a "virtual creature." In both cases, however, the emphasis is transferred from the image to the embodied response it catalyzes.

Exemplary of the former is Inez van Lamsweerde's *Me Kissing Vinoodh (Passionately)* (1999), a monumental photographic image of the artist kissing her boyfriend, whose image has been digitally extracted, leaving in its place a sort of shadow of its former presence (figure 4.2). Exploring the work, the viewer-participant quickly becomes aware that this extraction does not leave a simple absence in its wake: rather, as expressed by the distortion of the artist's face, the digital manipulation of the image has transformed its spatial coordinates in a way that makes it seem fundamentally discontinuous with the space of ordinary phenomenal perception. The distortion endows the work with "a feeling of violent disjunction" that confronts the viewer as a punctual shock.[31] As we process this shock, we begin to feel with a rapidly mounting intensity that the image is not necessarily *of* the same "reality" as we are, and that there may be no ready bridge between it and us. By suggesting a radical disjunction between its space and ours, this image might thus be said to form a kind of inversion of the Griffith close-up: rather than autonomizing affection in a perfectly bounded receptive surface (the woman's face), it operates a distortion of this very receptive surface that functions to catalyze an affective reaction in the viewer, and in this way, holds forth the potential to restore some form of contact with this strangely alien image.

Exemplary of the latter tendency is Luc Corchesne's *Portrait no. 1* (1990), a computer-supported dialogic interface with the close-up image of a virtual

persona.[32] The viewer-participant is invited to initiate conversation with the close-up image of an attractive young woman named Marie (figure 4.3).[33] Choosing one of six languages, the viewer-participant selects one of four possible questions and thus begins a question and answer session with Marie. Ranging in attitude from bland and straightforward to coy and flirtatious, Marie seems oddly detached from the dialogue situation, as if burdened by her all-too-keen awareness of her singular ontological status and its vast divergence from that of the viewer-participant: "I only have my past," she at one point intones, "For me, time stood still the day I became what I am now. Because I am a portrait, my real existence is elsewhere." During interaction with Marie, the viewer (if this viewer's experience is, in any way, exemplary) moves from an initial curiosity to a more self-reflexive sense of the oddness of the entire enterprise, mixed with a dawning realization of the limitedness of its interactional possibilities. As the seductive appeal of Marie's engaging face cedes place to a mild feeling of tedium that begins to ensue once the majority of interactional paths have been explored, the viewer is made to confront the fact of Marie's difference: this is a being whose initial promise (bound up with the affect

Figure 4.2
Inez van Lamsweerde, *Me Kissing Vinoodh (Passionately)* (1999). Monumental photograph of artist kissing void in image from which her boyfriend's face has been digitally extracted.

Figure 4.3
Luc Courchesne, *Portrait no. 1* (1990). Computer-based interface facilitates dialogue with a close-up image of a virtual persona.

presented by her close-up image) is belied by her limited repertoire. What we encounter in this digital creature is a kind of "virtual" mirror: a being whose own "shrinking" presence gives way to self-reflection as the problematic of her paradoxical existence seeps beyond its virtual space. "It is true that I am unreachable—and that you cannot change me," Marie admits. "But," she continues, "look at the people around you: Are they so different from me? Are they reachable?" By threatening to contaminate the viewer-participant's most fundamental social assumptions, *Portrait no. 1* follows a trajectory precisely opposite to that of Eisenstein's intensive series: rather than autonomizing an unfolding affection-image across a self-sufficient set of images, the mounting

intensity of our engagement with the image of Marie bleeds into the space and time of our lived experience, calling on us to recognize our intense desire to engage affectively with the "virtual" at the same time as we confront the disconcerting possibility of its indifference to us.

Like their cinematic equivalents, these two tendencies of digital faciality themselves tend to coalesce, in the sense that they both experiment with the radical disjunction between the digital image and the spatiotemporal coordinates of the viewer-participant's experience. Moreover, both point toward the active role of the viewer-participant whose affective reaction might be said to supplement what *initially* confronts her *as an already autonomous affection-image;* rather than marking the wholesale disjunction of the image from the human body, affection here serves as the very medium of contact. It is hardly surprising then that works combining the punctual shock of the confrontation with the alien digital image and the contaminating seepage of the protracted engagement with the virtual persona exemplify the suturing function of affect: by maximizing the digital image's resistance to signification, such works intensify its force as catalyst for a subsequent affective reaction.

Both Alba d'Urbano's *Touch Me* (1995) and Geisler's *Dream of Beauty 2.0* exploit the informational basis of the affection-image in ways that explicitly engage the bodily activity of the viewer-participant. In d'Urbano's work, the viewer-participant confronts a frontal close-up image of a woman's (in fact, the artist's) face on a monitor housed within a column at eye level (figure 4.4).[34] When the viewer-participant touches the monitor, the image undergoes what appears to be a digital fragmentation; as this process comes to an end, the image's original face is replaced by a live video image of the viewer-participant. Like Joachim Sauter's and Dirk Lüsebrink's pioneering *Zerseher,* this work correlates the activity of experiencing an image with its destruction.[35] Yet here the foregrounded activity is not looking but touching, and the destruction that results yields not blank space, but a place for an image of the viewer-participant. Accordingly, the work does more than simply use digital technology to expose the bodily dimension of image perception; it engages the viewer-participant tactilely with the informational materiality of the digital image. If the work thereby allows us to touch and insert ourselves into the digital image, it also foregrounds the tenuousness of this contact by repeatedly resetting its image and

Figure 4.4
Alba d'Urbano, *Touch Me*
(1995). By touching a
digital image of the
artists face, viewer
causes its dissolution;
real-time video image
of viewer's face tempor-
arily fills the void in the
image.

confronting us with the infinitely regenerative potential of the digitized image. For this reason, the affection produced in the viewer-participant correlates directly with the apperception of the sheer impermeability of the digital image: although "a new liason is created for each interactive observer," one description reminds us, "the image offered will always go back to the starting point. Its expression stays untouched, inexperienced. . . . Only the impression of one's own reflection in the electronic mirror, and its temporary revival through a mimic sequence, stand in the way of the insurmountable technical logic."[36]

Because it affords the viewer-participant a protracted experience of this same impermeability of the digital image, Geisler's *Dream of Beauty 2.0* best exemplifies the interpenetration of the two tendencies of digital faciality.[37] As we have already seen, the installation brings the viewer-participant into contact with the projected image of a giant, digitally generated female face floating in a kind of dream world. Voice interface between the viewer-participant and the virtual creature leads to frustration and profound discomfort, as the viewer-participant's attempts to "contact" the digital creature yield nothing more than bemused, apparently mocking—and clearly disengaged—gestures on "her" part. The bizarre feeling of inefficacy and irrelevance with which this interaction left me (to offer up my own affective reaction as evidence) attests to the affective intensity of experimentation with the DFI. The longer the interaction endured, the more I was confronted with the self-sufficiency of the digital affection-image; and the more I experienced my own failure to make any real

contact with it, the more intense the experience became, until I simply could take it no longer.

What makes *Dream of Beauty 2.0* exemplary of the DFI is the way it anchors the two modalities of the affection image—the self-sufficiency of pure Quality and the intensity of pure Power—in a materiality that has no necessary connection with the ratios of our embodied experience. If it affords an experience of the "affective autonomy" of the close-up, it is one that cannot be separated from the material autonomy of information itself. Accordingly, when it catalyzes a nearly intolerable affective reaction in the bodily engaged viewer-participant, what *Dream of Beauty 2.0* demonstrates about the DFI is something very different from what Deleuze says about the close-up: this digitally generated image, we cannot but realize, does not need us, will continue to exist in total indifference to our efforts to engage it, and can have meaning for us only to the extent that it foregrounds the source of our affective response— our constitutive embodiment, which is to say, the profound divide between its materiality and our own.

From the Virtual to Virtualization

In what sense does the affective reaction catalyzed by the above works denote an opening to the virtual? Beyond simply exposing the problematic of the digital image, these aesthetic experimentations with the DFI might be said to carry out a *virtualization* of the body through the "medium" of affectivity. And in so doing, they manage to reveal affectivity to be a bodily "capacity for . . ."—a rich source for the production of new individuations beyond our contracted perceptual habits. Far from being a mere component of perception, then, affectivity is deployed in these works as a separate experiential modality and one, moreover, that might be said to hold priority over perception. As such, affectivity correlates with a specific form of virtuality—a virtuality of the body— that differs in fundamental ways from Deleuze's development of the virtual as a transcendental force.

It is French media philosopher Pierre Lévy who has done the most to develop an embodied conception of the virtual. Breaking with a philosophical tradition (Deleuze, Serres) that privileges the passage from the virtual to the actual, Lévy focuses instead on the "virtualization that climbs back from the real

or the actual toward the virtual." This philosophical reversal foregrounds the way in which the virtual constitutes the entity and thus functions to resituate the virtual *within* the body: "virtualities . . . are inherent to a being, its problematic, the knot of tensions, constraints and projects which animate it."[38] Because it is "an essential part" of the "determination" of every concrete biocultural body, the virtual is always an element of the very body it serves to constitute.

Carried over to the domain of the aesthetic, virtualization opens a recursive interaction between body and artwork: by actualizing the virtual dimensions of the artwork, the viewer-participant simultaneously triggers a virtualization of her body, an opening onto her own "virtual dimension." In the case of new media art, such a recursive interaction opens a circuit between the body and an informational *process:* ". . . the [new media] artist now attempts to construct an environment, a system of communication and production, a collective event that implies its recipients, transforms interpreters into actors, enables interpretation to enter the loop with collective action. . . . [T]he art of implication doesn't constitute a work of art at all, even one that is open or indefinite. It brings forth a process. . . . It places us within a creative cycle, a living environment of which we are always already the coauthors. Work in progress? The accent has now shifted from work to progress."[39] With this vision of artistic interaction as a fluid and recursive process of "co-creation," Lévy couples a postbroadcast perspective on media technology with an understanding of aesthetic experience as an active, ongoing, multidimensional, and embodied creation of form. New media artworks can be said to furnish us opportunities to "create, modify and even interact with" molecular information in ways that mobilize our own virtualizations and that function to attune our senses to information: like other technological interfaces that effectively exploit the molecular potential of information, "interactive simulations . . . are so many potential texts, images, sounds, or even tactile qualities, which individual situations actualize in a thousand different ways."[40] For this reason, Lévy can conclude that "digitization reestablishes sensibility within the context of somatic technologies. . . ."[41]

A similar investment in embodied virtualization informs cultural critic Timothy Murray's transformative appropriation of Deleuze's aesthetics of the virtual.[42] As Murray sees it, the interactive aesthetics of contemporary new me-

dia brings the Deleuzean understanding of the virtual to "material fruition": with their "technical ability to enfold the vicissitudes of space and time in the elliptical repetition of parallel structure," new media artworks give material embodiment to the elements that, in Deleuze's understanding of the virtual, constitute the object as Idea.[43] With its correlation of a virtuality proper to the work and a virtuality emanating from the user-participant, Murray's intervention operates a transformation of the aesthetic that parallels Lévy's: by materializing the virtual elements of the object or work in a form that opens them to interaction with the user-participant, new media artworks detach these elements from the work as a static object ("structure" or "Idea") and resituate them *within* the interactional process through which the user-participant becomes dynamically coupled with the work. They thereby become catalysts for the user-participant's own virtualization: "The 'interactivity' of digital aesthetics," argues Murray, "is commonly understood to shift the ground of the artistic project away from 'representation' and toward 'virtualization.'. . . [D]igital aesthetics can be said to position the spectator on the threshold of the virtual and actual. . . . The promise of digital aesthetics is its *enhanced zone of 'interactivity'* through which the users' entry into the circuit of artistic presentation simulates or projects *their own virtualizations, fantasies, and memories* in consort with the artwork."[44] At stake in this enhancement of interactivity is a fundamental transformation of the *philosophical* tenor of the virtual: rather than a transcendental condition for thought, the virtual becomes instead the quasi- or infraempirical catalyst for the "real genesis" of a bodily spacing, which is, not surprisingly, nothing other than the virtualization of the body itself.

With his understanding of cinema as a machine for producing subjectivities, Félix Guattari brings this embodied conception of the virtual to bear on Deleuze's analysis of the cinema. Specifically, Guattari explains how Deleuze's image typology must in fact be circumscribed within an existential account of subjectivity: "In studies on new forms of art (like Deleuze's on cinema) we will see, for example, movement-images and time-images constituting the seeds of the production of subjectivity. We are not in the presence of a passively representative image, but of a vector of subjectivation. We are actually confronted by a non-discursive, pathic knowledge, which presents itself as a subjectivity that one actively meets, an absorbant subjectivity given immediately in all its complexity."[45] Not only does Guattari thereby recognize the

urgency for a supplementary sensorimotor dimension of embodied response, but he correlates this dimension specifically with the domain of affectivity, the "non-human, pre-personal part of subjectivity" from which "heterogenesis can develop."[46] What Guattari here says about the cinematic image is all the more true for the digital image, since the latter, to have any impact at all, must catalyze a bodily response. The ethico-aesthetic paradigm Guattari develops in *Chaosmosis* is, accordingly, itself a theory of virtualization that is directly responsive to the phenomenon of digitization. For if "technological machines of information and communication operate at the heart of human subjectivity . . . within its sensibility, affects, and unconscious fantasms," the "existential singularization" catalyzed by digital artworks necessarily virtualizes the body by opening it to machinic heterogenesis.[47]

Virtualization, then, is nothing less than the vehicle for the Bergsonist vocation of new media art—the means by which we can bring the force of the virtual to bear on our experience, to tap it as the catalyst for an expansion of the margin of indetermination constitutive of our technically facilitated embodiment. It is only because the body, through its ongoing interaction with a constantly evolving environment, continually generates or maintains a virtuality proper to it that the actualization of the virtual in the experience of the art work can at the same time be the catalyst for a virtualization of the body. This is why the virtual dimension opened by art as well as the ensuing virtualization of the body cannot be discussed as if they existed *outside* and *independently of* the interaction constitutive of them both: the virtual dimension at issue in new media art is precisely the virtual that gets actualized ("in a thousand ways," as Lévy says) through the experience of the artwork as a process, and that, in being actualized, taps into the potential of embodied affectivity. The promise of digital interactivity is its capacity to bring into correlation these *two distinct virtualities:* new media artworks facilitate interaction with virtual dimensions of the technosphere precisely in order to stimulate a virtualization of the body. By placing the body into interactive coupling with technically expanded virtual domains, such works not only extend perception (i.e., the body's virtual action); more important still, they catalyze the production of new affects—or better, new affective *relations*[48]—that *virtualize* contracted habits and rhythms of the body. For this reason, virtualization can be said to specify the virtual dimension constitutive of human experience.

The "Genetic Element" of the DFI: Affectivity

As the "genetic element" of aesthetic experimentations with the DFI, affectivity differs fundamentally from the genetic transformation to which Deleuze submits the affection-image. Whereas Deleuze's generalization of the close-up from a particular type of cinematic image into a genetic principle of the cinema functions to *liberate* the affection-image to express its constitutive virtual side, new media artworks catalyze the production of affectivity as a virtualization of the body itself.

To transform the close-up from a specific *type* of image into a generic *function* of the image, Deleuze takes recourse to the *philosophical* distinction between the actual and the virtual:

> There are two kinds of signs of the affection-image, or two figures of firstness: *on the one hand the power-quality expressed by a face . . . ; but on the other hand the power-quality presented in any-space-whatever. . . .* [T]he second is more subtle than the first, more suitable for extracting the birth, the advance and the spread of affect. . . . [For] as soon as we leave the face and the close-up, as soon as we consider complex shots which go beyond the simplistic distinction between close-up, medium shot and long shot, we seem to enter a "system of emotions" which is much more subtle and differentiated, less easy to identify, capable of inducing non-human affects.[49]

Underlying the close-up is a generic framing function—the any-space-whatever (ASW)—that is capable of expressing affects for themselves. In the ASW, the affection-image discovers its genetic element—what allows it to express affects independently of all connection to the human body and, beyond that, to express space itself as affective. In the form of the ASW, the affection-image taps into *the other, virtual, side of affect:* not just the face as the affect "actualized in an individual state of things and in the corresponding *real connections,*" but affects "as they are expressed for themselves, outside spatio-temporal coordinates, with their own ideal singularities and their *virtual conjunction.*"[50]

In Deleuze's conceptual history of the cinema, it is Robert Bresson who accomplishes the shift from the close-up to the ASW. Bresson's deployment of

fragmentation first allows affect to obtain a space for itself independent of the face: "It is the construction of a space, fragment by fragment, a space of tactile value, where the hand ends up by assuming the directing function which returns to it in *Pickpocket,* dethroning the face."[51] As against Dreyer, who presented affect indirectly by transforming the close-up into a kind of framing, Bresson is said to have liberated affect from its dependence on the close-up. This liberation opens a wholly new conception of the cinematic presentation of space as the real genesis via the raw material of cinema itself (shadow, oscillation of light and dark, color): the ASW is, accordingly, "a perfectly singular space, which has merely lost its homogeneity, that is, the principle of its metric relations or the connection of its own parts, *so that the linkages can be made in an infinite number of ways. It is a space of virtual conjunction, grasped as pure locus of the possible.*"[52] In other words, whereas the close-up comprises a moment of suspension within a larger movement (even if it is disconnected from this movement), with the ASW it is as if everything were in suspension, as if all of space (and the connection between images from which it emerges) were being created on the spot: "Space itself has left behind its own co-ordinates and its metric relations. It is a tactile space. . . . The spiritual affect is no longer expressed by a face and space no longer needs to be subjected or assimilated to a close-up, treated as a close-up. The affect is now directly presented in medium shot."[53] In Bresson, space itself acquires an affective autonomy, and affect becomes a function of cinematic framing.

It is precisely this disembodying of affect that is undone by aesthetic experimentations that tap into what we might call the "virtual side" of the DFI in their effort to carry out an affective virtualization of the viewer-participant's body. In works like Mongrel's *Color Separation,* Ken Feingold's recent animatronic sculptures, and the performances of the synthetic persona, Huge Harry, the DFI is variously deployed as an interface linking the domain of digital information and the modality of affectivity that is constitutive of our openness to the new. By deploying the image as a means rather than an autonomous expression, these works broaden the affective experience solicited by the DFI into an affectively generated framing of information itself. As a result, an affective excess comes to supplement the actualized facial images as a sort of fringe of virtuality. We can therefore propose a general analogy: just as the medium-shot framing of the ASW constitutes the genetic element of the close-up or

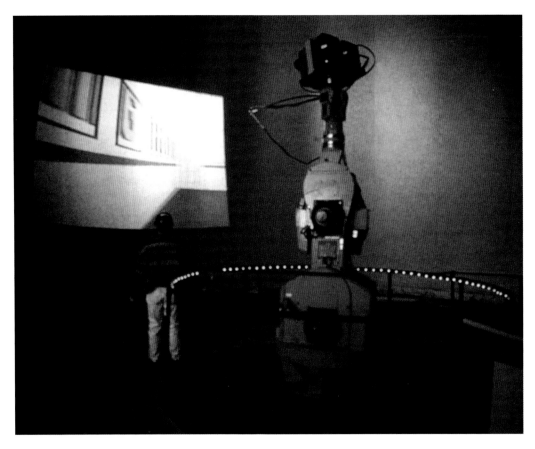

Plate 1 Jeffrey Shaw, *EVE (Extended Virtual Environment* [1993–present]). Interface platform combining domed image surface and cinematic framing; by coordinating viewer's head movement with the movement of camera head, allows dynamic coupling of viewer with image.

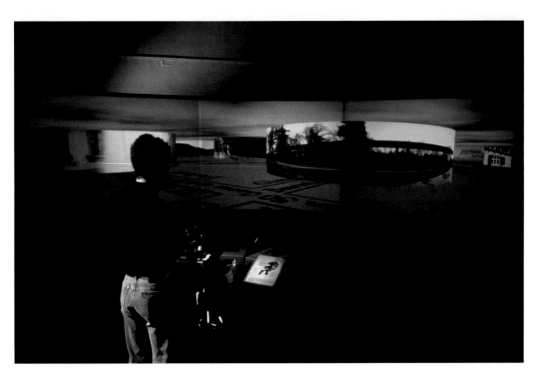

Plate 2 Jeffrey Shaw, *Place: A User's Manual* (1995). Rotatable platform with manipulable video camera allows interaction with virtual worlds contained in image cylinders; the coordinates of these worlds duplicate the physical coordinates of the panoramic space of the installation.

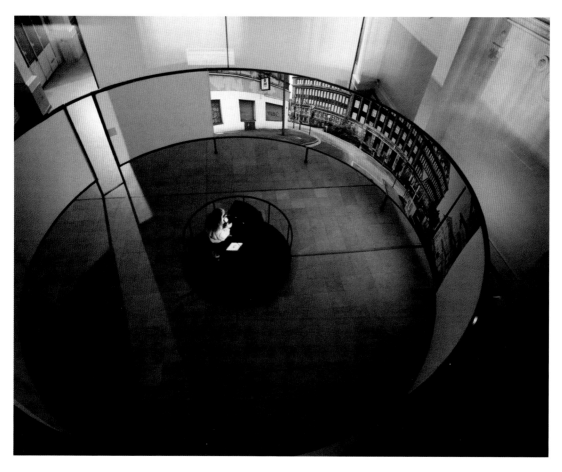

Plate 3 Jeffrey Shaw, *Place: Ruhr* (2000). *Place* interface reprised to afford interaction with image cylinders containing live-action images of selected sites in Germany's industrial region.

Plate 4 Tamás Waliczky, *The Garden* (1992). Computer-generated animation of a synthetic world; by identifying the child's viewpoint with the camera, compels the view– er to adopt a "waterdrop" perspective in which objects change size as the child moves within the space of the image.

Plate 5 Miroslaw Rogala, *Lovers Leap* (1995). Two video screens permit interaction with a 360° "pictosphere" of downtown Chicago taken with a fish-eye lens; viewer movement within the space triggers movement within image and shift to video loops of life in Lovers Leap, Jamaica.

Plate 6 Jeffrey Shaw, *The Golden Calf* (1995). By manipulating a flat-screen monitor displaying image of a golden calf, viewer tries to align virtual space with the physical space occupied by her own body and by the white pedestal on which the calf is meant to be placed.

Plate 7 Kirsten Geisler, *Dream of Beauty 2.0* (1999). By means of a voice interface with a digitally generated close-up image of virtual persona, viewer is offered limited opportunities for interaction with the digital domain.

Plate 8 Mongrel, *Color Separation* (1998). Close-up of stereotyped facial image wearing mask and covered in spit. Interactive installation configures viewer as the initiator of an act of racialization intended to provoke "racial dichotomy"—a disjunction between the stereotyped image of the other and the rich story of her racial abuse.

Plate 9 Diane Gromala (with Yakov Sharir), *Dancing with the Virtual Dervish* (1993). Dynamic, virtual reality environment in which viewer-participant adopts a virtual dancing body in order to interact with other virtual bodies. Image presents close-up of viewer-participant as her movements become virtualized.

Plates 10/11 Bill Viola, *Quintet of the Astonished* (2000). Part of Viola's Passions series, this digital film of five figures undergoing extreme emotional experiences was shot at high speed but projected at normal speed. Since it captures sixteen times the amount of information normally perceivable on film, this work supersaturates the image with ordinarily imperceptible affective content.

affection-image, so too does the affective framing of information comprise the genetic element of the DFI. But in the latter case, what unleashes the force of the virtual is not a liberation *from* the human body but rather a virtualization that operates *through the medium of embodied affectivity.*

Color Separation is an interactive, multiplatform artwork that aims to catalyze a confrontation of the viewer-participant with the power of racial stereotypes. The work is constructed from more than one hundred photographic close-ups of people, all of whom are somehow related to the four core members of the British art collective, Mongrel. These photos were distilled into forty images that were then digitally merged (using Mongrel's "Heritage Gold" software) into eight images of four distinct racial types in both male and female variants. The eight stereotyped racial images wear the masks of the other stereotypes and the masks bear the traces of racial abuse in the form of spit that adorn them (figure 4.5).[54] Interacting with these images, the viewer is drawn into an experience of "racial dichotomy": a forced identification with images that can only be likened to the abject leftovers of the morphing process. The installation thereby compels the viewer to confront the power of racial stereotypes at a more fundamental level than that of representation; it aims to get under the viewer's skin, to catalyze a reaction that might possibly lead to a loosening up of the sedimented layers of habitual, embodied racism. As the group explains: "Masking the face of an anonymous portrait encourages the viewer of a poster to be caught up in a racial dichotomy. The viewer is unsure why the base face has the skin of another face sewn onto it. Further, with the spit added, the user can detect signs of racial abuse but not identify who is the abuser or who is abused."[55]

In its form as an interactive installation at the ZKM exhibition "Net Condition," the work consisted of an interactive, mouse-based interface and a projected image bearing the masked stereotyped faces. Entering the darkened room in which the work was shown, I was at first a bit flustered, finding no directions to guide my interaction with the work. On discovering a mouse on the console in the middle of the room (after my eyes adjusted to the darkness), I instinctively began to move it. Immediately the images of the faces began to move so that ever new configurations of different subsets of the sixty-four iterations (combinations of the eight face images and eight mask images) continually scrolled into one another. Abruptly I stopped the mouse and centered

Figure 4.5
Mongrel, *Color Separation* (1998). Interactive artwork confronts viewer with stereotyped facial images and stories of racial abuse. (See plate 8.)

the cursor on one of the images; as I clicked the mouse, an image of spit was projected onto the face. At the same moment, a raspy, female voice began what seemed at first to be a mundane monologue about an everyday event but that soon turned out to be a detailed and disturbing tale of racial abuse. Confronted with this image of "racial dichotomy," I was flooded with questions: Does this voice belong to the face, or to the mask? How could it, since the face-mask is, or appears to be, male? Why is there a mask on this face, and why has it been spat on? What do the mask and the spit have to do with the voice and the story it has to tell? Confused yet energized, I next honed in on a female face-mask combination. I heard yet another story, this time told by a male voice again of racial abuse, and a similar affective process set itself into motion. After several further experiences of spoken narratives uncomfortably sutured to face-mask combinations apparently selected at random, I became overwhelmed with a feeling of the discordance between the richness of the narratives and the sameness, even the emptiness, of the various face-masks. Finally, more bewildered than edified, but with heart racing and curiosity peaked, I bolted from the installation. Some while later, I began to fathom the constitutive paradox that sparked my reaction: while the installation was clearly asking me to correlate voice with image, I could only experience their sheer incommensurability. It was this failure to make sense of what I was perceiving that produced the experience of a mounting, and ultimately intolerable, affective overflow.

As I now reflect on the experience, I can see more clearly still how the play between image, voice, and the spatialized data field was instrumental to the affective impact of the work. As an index of embodiment, the voice furnishes a cipher of singularity resistant to categorization via the limited repertoire presented by the face-mask combinations. The concrete intensity of these stories of abuse makes its impact felt precisely because it is betrayed by the poverty of the images. To recur to the terms of our earlier discussion, we might say that in this installation the DFI repeatedly fails to facialize the body it would appear to express, thus constantly returning us to the dataspace of the installation and the vain search for a felicitous facialization. The result is the experience of an ever-mounting affective excess that emerges in the body of the viewer-participant as a kind of correlate to—perhaps even a recompense for—the incongruity between the image of a face and the voice used to narrate its story. Not surprisingly, this affective excess intensifies in sync with the empty proliferation of

such incongruity across a infinitely expanding spatialized data field. Affect is produced within the body in response to this spatialized proliferation of incommensurability, as if to afford some kind of bodily intuition of the continuum of racial difference literally masked over by these stereotyped facial images.

Ken Feingold's recent animatronic sculptures of heads function to intensify the affective stakes of precisely this experience of incommensurability.[56] While Feingold's work deploys the disjunction between the image and voice as the catalyst for an affective virtualization, it inverts the fundamental coding of the voice, such that rather than interfacing us with a bodily excess compromised by an impoverished DFI, we are brought into contact with the fully automated, computerized voice and thus, in a more general sense, with a radically new artifact in the technical history of language: the direct prosthesis of speech itself.[57] Unlike the earlier discussed digital facial images, Feingold's heads are purposely rendered comical, alien or uncanny,[58] effectively removing the visual lure of verisimilitude, and with it, the lure of the digital image itself. In this way, Feingold directs the viewer's attention to another facet of the interface with the domain of information, namely, the circuit connecting affectivity with the smooth and omnidirectional space of the sonic. Put another way, Feingold's works have the effect of liberating affection from its close ties to the image (as in the above discussed examples) in order to expose its more fundamental ties with the process of virtualization.

Following a trajectory clearly indebted to Samuel Beckett (not to mention Kafka and Maurice Blanchot), Feingold stages various types of mediated confrontation with artificial communication agents. These stagings exemplify the two concerns motivating his aesthetic interrogation and playful perversion of the Turing test: on the one hand, a fascination with the possibility for and significance of machine-to-machine communication; and on the other, a keen attentiveness to the nonseamlessness of the human–computer interface.

If/Then (2001) is a sculptural installation consisting of a large cardboard box, filled with packing popcorn, in which are placed two identical heads facing in opposite directions. Sculpted in the "likeness of an imaginary androgynous figure," these two heads speak incessantly to one another, attempting to determine whether they really exist or not, whether they are the same person or not, and whether they will ever find answers to these fundamental questions (figure 4.6). Feingold explains that he wanted these heads to look just like

Figure 4.6
Ken Feingold, *If/Then*
(2001). Sculptural instal-
lation consisting of a
large, packing popcorn-
filled, cardboard box in
which two opposite fac-
ing identical heads en-
gage in incessant
existential questioning.

"replacement parts being shipped from the factory that had suddenly gotten up and begun a kind of existential dialogue right there on the assembly line."[59] Their conversations are generated in real time, utilizing language-processing software and personality algorithms written by Feingold himself, and as such, are neither completely scripted nor completely random; the software gives each head a continually morphing personality, equipped with a singular vocabulary and habits of association, which makes each conversation "quirky, surprising, and often hilarious."[60] According to Feingold, the sculptural heads attempt to "draw visitors into their endless, twisting debate over whether this self-awareness and the seemingly illusory nature of their own existence can ever be really understood."[61]

Sinking Feeling (2001) is an interactive installation consisting of a single head with whom the visitor is invited to converse (figure 4.7). The head—a plastic, oddly rigid, and uncanny portrait of the artist himself, placed Beckett-like in a flowerpot—seems to be quite convinced of its own existence, but desperate to know the answer to a series of core existential questions. Staring blankly out at the viewer, it plaintively asks: "Why don't I have a body like everyone else?" or "How did I get here and what am I doing here?" And as it poses these questions, what Feingold dubs its "cognition" is made visible in a projection of its words on the wall behind it, as are the words the viewer-participant speaks into the microphone located in front of the head. In this parody of the human–computer interface, the human voice is brought into contact with the autonomous computational voice (speech as autonomous sound) via the mediation of the text projected on the wall. In this way, Feingold's work compels the viewer-participant to wonder whether her own speech is not itself perhaps the equivalent of the computer's anguished and often confused vocalizations, and what this potential equivalence says about the process of communication itself.[62] And, beyond these semantically focused queries, Feingold's work compels us to ask a still more radical question: how much does communication via language itself rely on nonlinguistic—that is, embodied and affective—cues, and if it does so to a significant degree, can our text-mediated "interface" with the computer be understood as a form of contact with the digital realm, and if so, how?

In the end, however, what proves to be most striking about Feingold's work is its capacity to elicit an affective response in the viewer-participant,

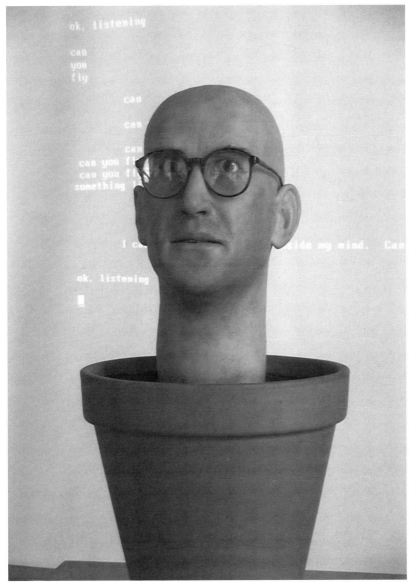

Figure 4.7
Ken Feingold, *Sinking Feeling* (2001). Interactive installation featuring a single head sculpture with which the viewer is invited to converse.

despite the total elimination of any index of bodily excess as an element of the interface. What viewer could fail to empathize with these machine-produced heads endlessly wondering if they really exist? Or with this isolated head plaintively asking why it doesn't have a body like everyone else? By transferring the vehicle of our contact with these bizarre creatures to the "grain" of the digital voice, if I can be allowed to pervert Barthes's concept in this way,[63] Feingold's works place the viewer-participant in contact with the zero-degree of affectivity: the fact that affectivity is a power of her own embodiment, the very medium of her virtualization. For how else, indeed, can we explain the ability of these creatures to elicit an excess of affect in us, if not by understanding affectivity as the very medium for communication as such, or in other words, for all of our contact with the outside.[64]

The potential for this exposure of the "genetic element" of affectivity to eschew the anthropomorphic colonization of the digital animates the conceptual performance art of the artificial creature, Huge Harry.[65] With the help of his "human support staff," Arthur Elsenaar ("display device") and Remko Scha ("word processing"), Harry has lectured widely on various topics concerning machines and art and has, according to his Web site, "developed into one of the most outspoken and authoritative voices in the discussion about art, society and technology—always representing the computational point of view with great vigor and clarity."[66] Accordingly, Harry's vision of an integrated human–machine aesthetic might be understood as extending Ken Feingold's exploration of human–machine communication by directly opposing the aim of art to that of communication. In his 1992 lecture, "On the Role of Machines and Human Persons in the Art of the Future," for example, Harry carves out a role for machines in the production of artwork that reflects their capacity to be disinterested, in accordance with the Kantian ideal put forth in the *Critique of the Faculty of Judgement,* and thus to effectuate an "experience that transcends the conventionality of human communication." Art production, he concludes, must involve a "division of labor between human and machine" that, unlike most computer art, refuses to subordinate the latter to the former and seeks to exploit the different talents of both.[67]

Despite his activism on behalf of machines, however, Harry acknowledges that machines are both fundamentally different from and yet dependent

on humans, and he takes this difference and this dependence to constitute the basis for their potential integration. Accordingly, his aesthetic experiments involving human–machine collaboration necessarily foreground the role of human embodiment: "if we want to create performances that are interesting for human audiences," he explains, "it is essential to use human bodies on stage—because the emotional impact of a theater performance depends to a large extent on resonance processes between the bodies on stage and the bodies in the audience."[68] This insight is the fruit of research on the human–computer interface involving experiments with "the communicative meanings of the muscle contractions of certain parts of the human body," most prominently the face. To the extent that it takes seriously the rich potential of affectivity as a conduit between machines and humans, this research underscores our constitutive bodily excess over the restrictive facialization of today's dominant human–computer interface.

In a lecture-performance delivered at the 1997 Ars Electronica festival, "Flesh Factor," Huge Harry illustrated the crucial communicational function of human affectivity with the assistance of his "human display system," namely, the face of Arthur Elsenaar. Harry sent signals to Arthur's facial muscles that simulated what his "brain would do, if [his] operating system would be running global belief revision processes . . . involving a large number of conflict-resolutions and priority reassessments"—that is to say, if his "operating system" were in a particular emotional state. Harry proceeded through a series of expressions, from the blank face (the face in a neutral position in which all parameters are in their default positions) to various expressions created by particular parts of the face. Thus, focusing on the eyebrows, he took his audience through three states—attention (when the eyebrow is lifted high above the eye), reflection (where the whole eyebrow is lowered), and disdain (where the eyebrow is contracted) (figure 4.8). As Harry took pains to emphasize, this exercise illustrated that "the range of parameter values that the eyebrows can express is much more subtle than what the words of language encode." He then reiterated the analysis for Arthur's "mouthpiece"—demonstrating joy (grin), sadness (frown), and "serious processing difficulties" (combination of contempt and sadness)—as well as for the nose and ears, again emphasizing the same point concerning the richness of these facial expressions as well as their near universal significance and

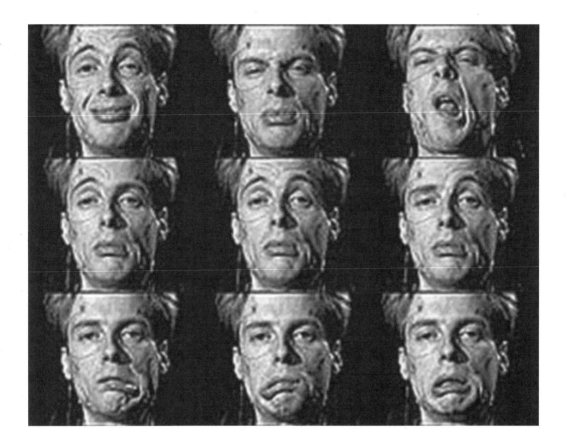

Figure 4.8
Huge Harry, *Selected Facial Expressions* (1995). Composite image of various affective states experienced by a computer and expressed through the medium of the human face.

their instantaneity. "Every person," concludes Harry, "knows exactly in what state another human person is, when this person makes a face. . . . Because they know what state *they* would be in, if *they* would make a face like this."

The payoff of this analysis, at least as seen from the machine-centric position of Huge Harry himself, is the potential for machines to utilize the human face in order to interface more effectively with humans. Harry's idea is that the computer will interface more seamlessly with the human because it will be able to display its internal states by triggering the muscles on a human face, thereby communicating those states, universally and instantaneously, to human interlocutors. In a kind of machinic parody of Hayles's OREO structure, this interface would convert data of digital origin into an analog surface comprising the expression of the human face itself.

Before we allow ourselves to become wholly seduced by the evident charms of Huge Harry, however, we would do well to grapple with his own, never explicitly acknowledged, dependence on Arthur Elsenaar. Whether or not Elsenaar should be credited as artist (and Harry as creation),[69] it is certainly the case that Elsenaar plays a far greater role than would at first appear, since his input is the critical force informing Harry's various papers and presentations. A more felicitous way to describe their symbiosis would consequently be to follow Eric Kluitenberg who, in his preface to an interview with Huge Harry, notes that Elsenaar has "developed a portable controller system that allows quite sophisticated computational control of human facial muscles" and thereby "*enables him* [that is, Elsenaar] to 'interface' more directly with digital machines. . . ."[70]

Following this refocusing of the experience of the interface *on the human element,* the project not only becomes less grandiose and tendentious, but also takes on an exemplary significance for our exploration of affectivity as a medium of interface: it specifies an avenue through which computer input can impact human affectivity beyond the control of the human involved and, for this reason, taps into the computer's potential to catalyze an affective heterogenesis—an expansion of the range of affectivity beyond its already embodied, habitual function.[71] Recalling the *cliché* that smiling makes you happy (a *cliché,* incidentally, not entirely without scientific plausibility),[72] the computer would thereby acquire the capacity to trigger material alterations of human affective states, and with it greater potential to communicate with human beings and to virtualize the human body. And even if such communication and virtualization remains circumscribed by an ineradicable anthropomorphism, since the range of possible affections necessarily coincides with the physiological range of human facial expression, the wresting of control over expression from the human agent would have the promising consequence of exposing the *autonomy of affect,* the fact that affectivity is, to paraphrase the description of pioneering video artist Bill Viola (to whom we return below in chapter 7), something that passes through the body and that can only be felt, often at a speed beyond and of a magnitude beneath the perceptual thresholds of the unaided human perceptual apparatus.

What's Virtual about VR? "Reality" as Body–Brain Achievement

Theoretical Aim	Body	Image	Artwork
To differentiate affectivity categorically from perception	From transcendence of body in visually dominant VR experience to reinvestment of body-brain as affective source for creation of "virtual" space	From simulation of physical reality to "absolute survey" (nonextended mental apprehension) of bodily generated space	Penny's *Fugitive*; Shaw's *EVE, I-Cinema*; Gromala's *Virtual Dervish*; Scroggins and Dickson's *Topological Slide*; Wennberg's *Parallel Dimension, Brainsongs*; Smetana's *Room of Desires*; Dunning and Woodrow's *Einstein's Brain*

> Digital technologies . . . have a remarkably weak connection to the virtual, by virtue of the enormous power of their systemization of the possible. . . . Equating the digital with the virtual reduces the apparational to the artificial, with the "simulacrum" taking the place of the phantasm. . . . This forgets intensity, brackets potential, and in that same sweeping gesture bypasses sensation, the actual envelopment of potential. . . . Digital technologies have a connection to the potential and the virtual only through the analog.
>
> —Brian Massumi[1]

Now that we have sketched out the specificity of human virtualization and unpacked its constitutive correlation with bodily affectivity, we can turn to the crucial relation between the virtual and the digital. As the above citation makes clear—and contrary to common practice—we must not only refrain from identifying the two terms, but must situate the digital in relation to the virtual via processes said to be "analog," that is, correlated with actualization as the production of (embodied) sensation.

Nowhere is this methodological imperative more consequential than in relation to so-called virtual reality (VR) where the human sensory apparatus is somehow technically extended and put into direct interface with a "space" or "world" created entirely out of data. By purportedly removing experience from its bodily anchoring in the physical space of the "actual" world, VR represents *that* new technology in relation to which the process of virtualization is at once maximally effaced and maximally crucial. In this chapter, I shall accordingly concentrate on aesthetic experimentations with VR that foreground the bodily basis of the VR interface and exemplify a conception of perception as construction or what I shall call a body–brain achievement.

Let me begin with some elementary observations concerning VR. VR has been defined as an "interactive, immersive experience generated by a computer."[2] Lurking "within" this rather general definition are some built-in constraints that are of the utmost importance for how VR has been, and will presumably continue to be, theorized and developed. For example, it seems to me undeniable that the vast majority of VR systems—whether these be commercial, scientific, *or* artistic—work with an impoverished conception of experience as above all (or exclusively) visual. By endowing the user with VR goggles and helmet, VR systems deploy vision as the privileged sense endowed with the task of mapping the human sensory apparatus onto new dataspaces.[3] To some extent, this "decision" reflects technical difficulties involved in simulating tactile and olfactory sensations, but more fundamentally, it is an artifact of the "literalness" with which VR has been conceived and implemented— that is, its development as a straightforward extension of our physical experience into new domains. In line with research into simulation in virtual environments, VR developers have seized on vision as the best way to produce the simulation of presence and, indeed, through the use of texture modeling, to *simulate* other senses like touch.[4]

For this reason, we might say that VR has the tendency *to reterritorialize the body onto the face,* or more exactly, to *facialize access to dataspaces* with the result that, rather than being channeled through the body, these dataspaces are (or appear to be) mediated by pure perception (vision unencumbered by anything bodily).[5] (In this sense, VR helps demonstrate that the facializing logic we correlated with the human–computer interface (in chapter 4) draws its force less from specific technical limitations than from the longstanding ideological correlation of knowledge with vision.)[6] This tendency places a fundamental constraint on the creative potential of the VR interface that, not insignificantly, coincides with a constraint endemic to Bergson's theory of perception: in both cases, the tendency to privilege vision has the effect of restricting what can be perceived (and thus what can be presented as a perceivable virtual world) to what can be apprehended visually.

We have already seen how such a constraint informs Bergson's conception of vision as a kind of virtual touch. By describing perception as "virtual" (in contrast to affection, which he characterizes as "real"), Bergson correlates it with vision: as the potential for the body to act on an external object, it is liter-

ally defined by the distance separating the object perceived from the acting body.[7] Not only is perception as a whole thus identified with vision, it is furthermore said to occur there where the object (or image) itself is: "There is not," says Bergson, "an unextended image which forms itself in consciousness and then projects itself into P. The truth is that the point P, the rays which it emits, the retina and the nervous elements affected, form a single whole; that the luminous point P is a part of this whole; and that *it is really in P, and not elsewhere, that the image of P is formed and perceived*."[8] This peculiar Bergsonist notion can be understood to be the consequence of Bergson's monism—of the continuity he posits between the body as a center of indetermination (a privileged image) and the universe of images in the midst of which it is situated; since perception simply is the product of the body's filtering of some images and not others, it makes a certain amount of sense to say that this perception occurs *in* those images. Indeed, such a postulate is necessary if Bergson's anti-idealism—and more specifically, his critique of the doctrine of "true hallucination"—is to remain coherent: what Bergson above all cannot allow is the granting of any positive agency to consciousness beyond its function as a selector of images.[9] In light of the convergence of perception and simulation (or hallucination) explored above in chapter 3, this peculiar commitment of Bergson's theorization of perception forms something of a test case for the applicability of his theory to contemporary media technology and specifically to VR perception, where there is, literally, no "there" there.

What I want to argue here is that perception in the VR interface—as the exemplary instance of the filtering of information from a universe of information—can *only* take place in the body. Indeed, the framing function that I have ascribed to human embodiment reaches its creative potential in VR interfaces with dataspaces that are markedly different from the geometric space of "ordinary" perception and that, consequently, *cannot be apprehended through perspectival vision*. Such dataspaces can be "intuited," as it were, only through what post-Bergsonist philosopher Raymond Ruyer calls an "absolute survey"—a nondimensional grasping of a perceptual field as an integral whole or "absolute surface." As it is deployed in certain aesthetic experimentations with the VR interface, the capacity for absolute survey furnishes the mechanism for a nongeometric and nonextended "giving" of space that is nothing other than a production of space in the body, or better, a bodily spacing. Accordingly, on

Ruyer's (in this respect, markedly anti-Bergsonist) account, rather than being there where the object (image) is, perception—or better, sensation—always takes place in the body, *as a spacing of the embodied organism.*

It is this understanding of perception as bodily spacing that allows the ocularcentrism of VR to be overcome. As it is deployed, for example, in VR interfaces with "warped" topological spaces or with the interoceptive interiority of the body itself, the absolute survey furnishes the basis for two complementary expansions of the threshold of "perception": on the one hand, by foregrounding the form-giving function of consciousness as a pure form, it broadens what can be grasped beyond what can be constituted as an image; and on the other hand, by bringing out its own "organismic" basis, it operates a kind of self-extension from a predominantly visual form to an "autopoietic affective kernel" capable of producing intensive space in the place of geometrically extended space.[10] In both cases, the absolute survey can be said to exemplify the task of art as process in the informational age: to frame information in order to produce new images and, we must now add, new forms and spaces as well.

In accord with this distinction between these two complementary expansions of "perception," my analysis in this chapter will take place in two stages. First, I shall attempt to grasp the VR interface as exemplary of the absolute survey in the age of information. Then, I will unpack the organismic or bodily basis of the absolute survey that forms the necessary correlate of any account of form-giving form in an informational environment.

The Aesthetic Dimension of VR

What is it, exactly, that is distinctive of the VR interface? Is it the capacity to enter into the space of the image? Or the possibility to bring the mind into contact with spaces it otherwise could not enter? Is it the opportunity to leave the body and its constraints once and for all behind? Although there is little hope of settling this fraught question in any definitive way, we can usefully juxtapose popular culture's investment in VR with that of the artistic community as two divergent configurations of the potential of VR. Whereas Hollywood and Las Vegas have staked a fortune on the illusion of presence widely celebrated by proponents of VR, some artists have questioned the underlying assumptions that VR promises a disembodied, predominantly visual, immersive expe-

rience.[11] For Australian media artist Simon Penny, to cite one prominent example, deployments of VR by the military, scientific, and entertainment industries remain bound up with the Cartesian legacy, which not only divorces mind from body but privileges vision as the purest of the senses:

> VR technology, far from including the body in a virtual environment, actively excludes the physical body, replacing it with a body image. One does not take one's body into VR, one leaves it at the door while the mind goes wandering, unhindered by a physical body, inhabiting an ethereal virtual body in pristine virtual space, itself a "pure" Platonic space, free of farts, dirt and untidy bodily fluids. In VR the body is broken into sensor and effector components, a panoptical eye and a slave body which "works" the representation but is invisible within it. As such, it is a clear continuation of the rationalist dream of a disembodied mind, part of the long Western tradition of denial of the body. This re-affirms the Cartesian duality, reifying it in code and hardware.[12]

In accord with this denunciation of VR in its predominant forms, Penny envisions his task as an artist to be that of producing a "mode of interactivity" that does not "require the user to submit to a static Cartesian division of space"— "an interactive space in which the user [can] interact with a system which [speaks] the language of the body, . . . which truly reflect[s] the kinesthetic feeling of the user, [her] sense of embodiment over time."[13]

To produce such a mode of interactivity in his installation *Fugitive* (1995– 1997), Penny focused on coupling the user with the image *dynamically rather than positionally* (figure 5.1).[14] *Fugitive* is a single-user, spatial, interactive environment comprising a circular space about thirty feet in diameter. A video image travels around the walls in response to the user's movement within the space. The behavior of the system is evasive, in the sense that the image tends to run away from the user, thereby compelling her to pursue it. The user's movements are tracked not through tracker hardware worn by her, but via machine vision using infrared video hooked up to a PC (for preliminary processing), an SCI 02 computer (for "mood analysis engine" processing), and finally a "video selector engine" that selects digital video images on a frame-by-frame basis. The aim of the system is to engage the user in a complex interaction that

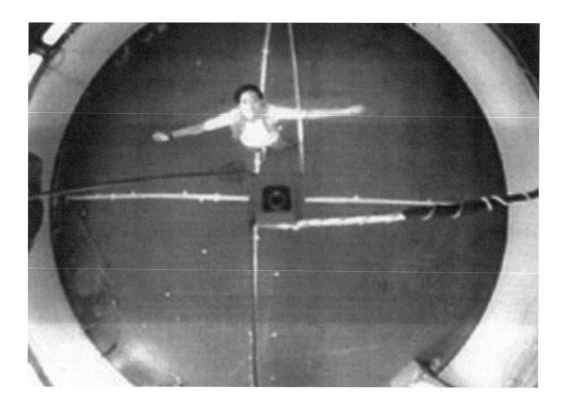

Figure 5.1
Simon Penny, *Fugitive*
(1995–1997). Vertical
image of viewer-
participant in dynamic
coupling with image
environment.

directly reflects her own bodily dynamics. Since the flow of digitized video im-
agery is controlled by the output of the mood analysis engine, each trajectory
through the installation will have a singular expression; indeed, even if two
people walked the very same path, different video sequences would be pro-
duced in accordance with the differences in their bodily dynamics. As Penny
explains, "The system responds to the dynamics of user behavior and their
transitions over time. Ideally, the system responds not simply to changes in raw
acceleration or velocity or position, but to kinesthetically meaningful but com-
putationally complex parameters like directedness, wandering or hesitancy."[15]
By foregrounding the dynamic basis of the interaction between body and
image, *Fugitive* replaces the continuity of extended geometric space with a
bodily generated spacing—"the continuity of body and time, against the con-
tinuity of an illusory space."[16]

Let me posit that this emphasis on the dynamic coupling of body and image (or intensive space) *is* the defining *aesthetic* feature of VR. What demarcates VR most starkly from all previous image technologies—and indeed makes it the first properly "postimagistic" technology—is the indiscernibility of perception and image that is its prominent experiential effect. In short, VR's achievement is to accomplish the passage from interactivity to dynamics, from image perception to body–brain simulation: VR, notes media theorist Derrick de Kerckhove, "goes a very large step beyond conventional computers which are merely 'interactive': 'A cyberspace system is dynamic: the virtual world changes in real time, both autonomously and fluidly in response to the actions of the patron. Action is visceral, and there need be no veneer of symbolic "interface," since the objects in this 3-D world can be directly manipulated.'"[17] Such immediate dynamic coupling represents the culminating point of the history of the interface, which is also to say, of the history of the image: in VR, the image "abandons the exteriority of spectacle to open itself to immersion."[18]

Put yet another way, VR brings to material fruition the thesis that perception is simulation—a process of construction or data-rendering that takes place *in the body–brain*—and not an inscription or registering of an outside object or reality. This is a position held in common by both contemporary neuroscientists and cultural theorists interested in new media (as we saw in chapter 3), but it is the latter who extract the most radical consequences from it. Thus Raymond Bellour's unpacking of the correlation between the video/computer-image and simulation furnishes an incisive characterization of VR, where what is at stake is nothing less than a fundamental "mutation," a break with the

> privilege that had centered (since the camera obscura) around light as the precondition for the formation of images and was destined to evolve in two complementary dimensions: a conceptual space and a tactile space. The former goes beyond the overly pure visual impression to permit an approach to a more complete relationship with space, insofar as it makes it possible to recover the relationship between sensations and cerebral simulations "according to a process that goes from the inside to the outside, rather than the other way around" [citing Bill Viola]. . . . Here the image is conceived as a diagram, a mental projection, rather than a seizure

of light-time. The second space is that of manipulating the computer that creates the images; such manipulation is, of course, skillful, but, above all, instrumental, corporeal and gestural. . . . [Together, these two conditions work by] throwing the spectator out of his allotted seat and bringing him in as an actor, producer, and coproducer of a potentiality.[19]

These two dimensions are nothing other than the twin conditions for the dynamic coupling foregrounded in Penny's *Fugitive:* in the first case, a perfect correlation between "perception" and "image"; in the second case, an induction of bodily motility as the operator of this correlation.

What is most crucial about the dynamic coupling materialized in VR is the indiscernibility of perception and affection that it brings about. Indeed, we could say that VR exposes the affective basis of perception—and indeed, the priority of affection over perception—since the virtual space "perceived" does not really exist in physical, extended, geometric space, but is the product of a "real" action of the body on itself.[20] What is at stake in VR is a simulated perception that is generated through the sheer force of bodily (self-)affection. In this sense, VR can be seen to lend concrete support to neuroscientist Humberto Maturana's generalization of simulation: "whenever we have an illusion," suggests Maturana, "we really have it. In our experience we cannot differentiate between what we call a perception and what we call an illusion. Whenever we have an illusion, we experience it always in the same way as we experience what we are used to calling a perception."[21] This is so, moreover, precisely because the experience of illusion and of perception are *affectively* identical: from the standpoint of the experiencing, feeling body, simulation and perception are, quite simply, indiscernible. It is this affective indiscernibility that, according to cultural theorist Florian Rötzer, forms the mechanism through which VR art can produce new sensations: "If an image is always a world in the world, the frame or interface is distorted [*läßt sich . . . verschieben*] such that the comparison of image and environment or the difference of image and material support is made impossible for the cognitive system of the observer."[22] Insofar as the viewer is integrated bodily into a virtual world, she is effectively "locked in" to a perspective that does not permit any distinction between perception and illusion, and one, moreover, that needs only her internally generated affection to garner whatever "reality-conferring" force it may require.[23]

From Perceived Image to Form-Giving Form

In chapter 3, we were content to note the analogy linking human perception with machine vision and serving to differentiate both from analogical image techniques like photography and cinema. In both cases, we concluded, some kind of rendering of data is at stake. Now that our topic is VR as a system that, in a sense, turns simulation back on itself, we must try to pinpoint exactly what differentiates the "body–brain achievement" of human simulation from machine vision simulation. Insofar as it derives from a categorical distinction between the digital and the virtual, Peter Weibel's critique of the "digital dream" can help us to do so. According to Weibel, it is the human "component" of the VR system—the human capacity for simulation—that is responsible for its virtual dimension:

> My main argument [against the digital dream is] . . . the theory of simulation itself. AIDS has demonstrated that the perfect virus is the one that is immune against simulation. Thesis # 1: The highest level of simulation lies in attaining immunity from simulation itself. (A copy without original, a clone without body.) This used to be expressed *in principio individuationis*. So, how could a "living" machine that would have to perfectly simulate humans from a digital basis be effected, when we take it that humans represent the end in a chain of evolution of survival of the fittest simulation? Applying thesis # 1, humans would be immune from full simulation; they cannot be comprehensively simulated by a (digital) machine. Secondly, I put it that life is a condition of virtuality. Virtuality, however, is defined not as a property inherent in the very objects, machines, parts, or systems which themselves can be simulated, but rather as a property pertaining only in the act of correlation of all particles. Per definition precisely this correlation cannot be simulated. Because of virtuality not everything can be simulated, least of all simulated digitally.[24]

Here we see again why the virtual and the digital cannot be equated. By affirming the tie between virtuality and life, Weibel not only pinpoints the crucial difference between human perception and machinic vision as variant forms of simulation, but he associates the former with the virtual and the latter with the

digital: while machinic vision involves a perspectiveless intuition of a fully realized or fully actualized surface (bearing a string of 0s and 1s), human perception—to the extent that it involves a distanceless "correlation" or "survey" identical with the perspective of this or that particular "I-unity"—can be conceived only as an actualization of an inexhaustible virtuality or potential.

With its specification of the privilege of the human being as the originator of simulation, Weibel's claim coincides perfectly with Ruyer's concept of the absolute survey that, moreover, it helps correlate to the VR interface. As that operation of human vision which differentiates it from vision as a purely physico-physiological event, the absolute survey forms nothing less than the mechanism for the body–brain achievement realized in the dynamic coupling of VR. Accordingly, it helps us to appreciate the discontinuity between VR and previous image technologies—the very "mutation" invoked by Bellour: whereas photography and cinema present analog or materially inscribed images for subsequent perception by the spectator's simulational consciousness, in VR the image is literally created in the process of "perception" (simulation). From this follows a fundamental shift in the relation of the image and (human) simulation: rather than being mediated by the distance constitutive of perception on Bergson's account, this "relation" has been folded in on itself—the image simply *is* the mental simulation.

If we situate this shift in relation to the two categories of Jonathan Crary's history of optical techniques—the metaphoric model of the *camera obscura* and the metonymic model exemplified (for Crary) by the stereoscope—we get a clear, if complex, sense of its magnitude.[25] Neither a figure for visual function nor a functional instrument co-constitutive (with the eye) of vision, VR demarcates the *technical infiltration* of human perception or, more exactly, the *technical supplementation* of the human capacity for simulation (the absolute survey). With VR, that is, the machinic component no longer serves as a frame for perception, but becomes entirely integrated into the process of simulation that lies beneath and encompasses perception.

In this sense, VR finds a crucial precursor in the figure of the stereoscope, which, *contra* Crary, poses a question not so much of human–machine cofunctioning as of their "fusion" in a body–brain achievement. In this respect, the stereoscope must be distinguished from other precinematic technologies:

unlike, say, the phenakistoscope or the zootrope, the stereoscope is not an optical device "on the same plane of operation [as the eye], with varying capabilities and features";[26] it is, rather, a technical induction of an absolute survey. As Ruyer notes in his account of stereoscopy, the stereoscopic effect results from a conflict between retinal images that can be resolved only in the transpatial dimension of human simulation: "Two stereoscopic views of the same landscape, even though they represent the same objects, are not superposable. The synthesis can only occur through the intuition of depth which reconciles what was irreconcilable so long as one only had recourse to two dimensions."[27] Rather than an instrument contiguous with the eye, the stereoscope is itself a technical catalyst for a transpatial absolute survey of two-dimensional, framed (technical) images. Similarly, as a much enhanced, dynamic version of the stereoscope, the VR interface is a technical mechanism for a fully mobile frameless vision, an "absolute frame" of the visible field.

Two projects designed specifically to be experienced with Jeffrey Shaw's *EVE (Extended Virtual Environment)* platform exemplify this legacy. Both *I-Cinema* and *The Telepresent Onlookers* (1995) are experiments in the digital expansion of cinema that capitalize on the notion of the absolute frame. Produced through the collaboration of several artists at the ZKM (including Shaw), both works aim to furnish a "direct experience" of the coincidence or dedifferentiation of perception and simulation. Unlike earlier applications of *EVE* that used synthesized imagery, both of these projects involve live image capture and the dynamic coupling of the image environment with the viewer's movement within the space of the image.

The Telepresent Onlookers supplements the normal *EVE* platform with a pair of cameras attached to a second pan-and-tilt head outside the domed space (figure 5.2). These cameras correspond exactly to the two projectors placed within the dome and attached to an identical pan-and-tilt robotic head. These projectors present a stereo pair of images that appear as a frameless three-dimensional visual field to viewers wearing polarized glasses. As is the case with all works projected in *EVE,* one of the viewers wears a helmet—what Shaw calls a "miner's lamp"—with an attached spatial tracking device that identifies the position and angle of her head and thereby controls the positioning of the projectors within the domed space, and in this case, of the cameras registering

Figure 5.2
Jeffrey Shaw et al., *The Telepresent Onlookers* (1995). Through the use of two pan-and-tilt cameras outside the domed image space of *EVE,* this work couples the experience of viewers within the dome, via projection, to that of viewers outside the dome.

the space outside the dome, so that the projected frameless image always follows the direction of this viewer's gaze. Because the spectator simultaneously controls the camera-robot and the projector-robot, her actions determine both the recording and the reception (or perceptual reconstruction) of the scene. This spectatorial synthesis gives rise to a "new temporal dimension" in which what Bergson would call the virtual space of perception is collapsed in an experience of telepresence. Because the exterior scene "could be reconstituted within the dome," the viewers inside could be "vicariously telepresent in the outside space."[28]

I-Cinema deploys a similar mirroring of (exterior) recording and (interior) projection using a panoramic, rather than a discrete, image-based approach (figure 5.3). The project allows for a telepresent exchange between viewers inside *EVE* and vistors to the central entrance hall of the ZKM. By means of twelve cameras, placed at equidistant points around a circle in this entrance space, twelve simultaneous real-time recordings of the area are captured and, through the use of special software, combined into a single panorama. This

Figure 5.3
Jeffrey Shaw et al.,
I-Cinema (1998). By
means of a panoramic
doubling of the *EVE*
platform, this work al-
lows for telepresent ex-
change between viewers
inside *EVE* and visitors to
the central hall of the
Center for Media Art in
Karlsruhe, Germany. (a)
EVE interface configured
for *I-Cinema*. (b) Close-
up image of central hall
of the Center for Media
Art as projected within
I-Cinema.

a

b

panorama is simultaneously projected within the domed space of *EVE* via twelve equidistantly situated projectors controlled again by a single viewer wearing a "miner's lamp."

Despite certain differences in their aesthetic effects, both works exemplify the function of the VR interface to extend the body–brain achievement of simulation into hitherto unprecedented, technically supported materializations of information. Indeed, by capitalizing on the (human) capacity for simulation as a means to couple the viewer, telepresently, with a virtual space that is, however, not spatially distant from the viewer's surveying perspective, both works show how the extension of experience in VR is first and foremost a function of the human capacity for absolute survey. Indeed, as a technical supplement of the absolute survey, VR challenges the image ontology underlying both Bergson's and Deleuze's positions and, consequently, helps to specify just how much a Ruyerian understanding of the technical contamination of perception differs from Deleuze's investment in the inhuman perspective opened by cinema. Put bluntly, Ruyer's position *inverts* the priority of the cinematic frame over the human framing-function that forms the core of Deleuze's theorization of cinema.

It is hardly incidental, then, that Ruyer's presentation of the absolute survey takes place by way of a contrast with the photographic (and, by extension, the cinematic) image. Photographic perception is inherently limited insofar as it requires a supplemental dimension capable of enframing it:

> A photographic apparatus, in order to capture the entirety of a surface, must be placed at some distance from it, along a perpendicular dimension. A living being, likewise, localizable as a body, must have an eye placed more or less like the photographic apparatus in order to perceive the entirety of the surface and its decorative *pattern*. If I were to see the photograph from the surface of the table, I would be again obliged to place my eyes at some distance from this photograph. It is necessary to be in a second dimension to photograph or perceive a line. It is necessary to be in a third dimension to photograph or perceive a surface.[29]

This comparison serves as a forceful indictment of Bergson's claim that consciousness (as a center of indetermination) is a privileged image among images:

to so determine consciousness, Ruyer informs us, is to situate it entirely within empirical, geometric space and to render it an object that, like the photograph, lacks the autopoietic force of sensation. Put another way, such a conception of consciousness could only be that of an observer capable of taking a distance from the image.[30]

From this criticism arises the necessity to posit another dimension of consciousness more fundamental than its role as an image. This is what Ruyer terms "form-giving form," and it is exemplified by vision insofar as vision is necessarily more than a simple geometric function or physico-physiological event. Human vision (like all processes of consciousness) is rooted in an absolute survey that takes in the entirety of the visual field in a dimensionless "inspection" or "direct knowledge":

> Let us now consider not photographic observation or the organic *mise en scène* of perception, but my visual sensation in itself. It is comprised, like the table or the photograph of the table, of multiple details, checkerboard squares [*des damiers*], which are also, in a sense, *partes extra partes,* each being at another place than any other. This time, however, *"I" have no need of being outside of my sensation, in a perpendicular dimension, in order to consider, one after another, all the details of the sensation.* . . . [The surface of the perceived-table (*table-vue*)] is a surface captured in all its details, without a third dimension. It is an "absolute surface," which is relative to no point of view external to itself, which knows itself without observing itself. . . . I have no need to be "at a distance" from the sensation to see it extended. On the contrary, I am unable to turn around it in order to consider it from diverse angles. "I" (my organism) can turn around the table in order to *obtain* different sensations, but *"I" am unable to turn around my sensation once it has been achieved [une fois obtenue].*[31]

Constrasted with the perception of an image, the absolute survey is a frameless vision that grasps the entire visual field in a single instantaneous take; and contrasted with the image itself, the absolute surface is a nongeometric, nondimensional space directly and immediately correlated with the surveying "I-unity." Extending Ruyer's criticism of technical metaphors, we could say that the absolute surface materializes a *different kind* of "image" than that of the

photograph or cinematic shot. It is not an objective, technical image observable at a distance, but a dimensionless, subjective "image" that, as Bill Viola has pointed out, can be experienced only internally, within the body of the sensing organism itself.[32]

We can now grasp the aesthetic payoff of VR's function as a technical supplementation of the absolute survey: the VR interface brings the capacity for absolute survey into contact with the purely computational or digital "field" of machine vision. By facilitating the surveying of a visual field comprised entirely of digitized data, VR thus forms a counterpart—indeed a redemptive correlate—to the computer's achievement of "total vision" at the physico-physiological level. Specifically, the VR interface (the technically supplemented absolute survey) functions by extracting a virtual dimension from the digital: in it, at least some of the flexibility of the digital environment (e.g., the capacity to materialize topological spaces) is brought to bear on human experience, as the catalyst triggering an *infraempirical* sensation. Far from coinciding with the digital, the "virtual" of VR thus names the way that technical supplementation potentially catalyzes the *virtualization* of the absolute survey—its opening up to encompass unprecedented kinds of absolute surfaces.[33]

In terms that bear directly on the motivating theoretical claim of this book, we might say that the digital image must be and can be "framed" only by a virtual form, that is, an organic form capable of absolute survey. In his critique of the image and his distinction of form from image, Ruyer pinpoints why this is so. For Ruyer, an image is simply a form *as it is perceived*. It is, accordingly, a "secondary complication that derives from the fact that in our organism there is a special region, the brain, or more precisely, the cerebral cortex, where the absolute organic overview is applied not to its own form but to external forms projected onto it by sensory equipment."[34] This reality is, however, largely obscured by our "adult habit" of using our eyes to look at objects outside ourselves. What we thereby overlook is the dependence of images on our capacity for form-giving, or more exactly, our status as form-giving forms (organic forms capable of absolute survey). The bottom line is that we are able to perceive images only because we sense ourselves as form. Perception, in short, depends on affectivity. What this means is that the auto-subjectivity of form-giving forms cannot be likened to a *perception* of self, but must be un-

derstood as a primary affectivity, a "consciousness-texture," that underlies and conditions all experience, including perceptual experience.[35]

If the VR interface catalyzes the virtualization of the absolute survey, it is precisely because it addresses the organism (organic form) at this preperceptual level of its affectivity and not as mediated by the secondary perception of images.[36] The virtual at stake in VR is equivalent to the equipotentiality of the human being *qua* absolute or form-giving form. Moreover, as the operative mechanism of the VR interface, the absolute survey confirms the assymetry between organism and image posited by Florian Rötzer in his account of perception as simulation: rather than a Bergsonist material image, the mental image must be understood as an "imaging activity" rooted in the form-giving equipotentiality of the human organism.[37]

Surveying the Body: Virtual Interface with Topology and Biofeedback

Now that we have exposed the absolute survey as the operative mechanism of the VR interface, another set of questions arises. How exactly can VR catalyze the virtualization of the absolute survey? What specific factors will allow the technical supplementation of affective auto-subjectivity to operate its self-expansion?

By technically supplementing the absolute survey, VR transforms it into a mechanism for the nongeometric and properly speaking nonperceptual "giving" or "intuition" of spaces *that themselves need not be geometric or otherwise correlated to visually apprehensible reality.* In such cases, as I shall now argue by way of reference to several aesthetic experimentations, the VR interface functions to fold the transpatial dimension of consciousness back onto the physico-empirical mode, except that here the latter denotes the location of consciousness not in the external world but *within the space of the body.* That is why I could claim above that sensation as it is configured in certain VR environments is nothing other than the *spacing of the embodied organism:* in such environments, an intuition of the space of the body takes the place of the intuition of an extended, geometric space. Put another way, the VR interface mediates an absolute survey of nothing other than the space of the body itself—that paradoxical being which is neither object nor absolute subjectivity.[38]

When the capacity for absolute survey is retooled in this way, it yields an intuition of the body as what Ruyer calls an "absolute volume."[39] Such an intuition materializes the body as it experiences itself, and not as it is observed by the scientist (or, for that matter, the cultural critic): unlike the "object-body," which is a purely epiphenomenal construction of a secondary observer, the "real body" is our organism as a "set of pure subjectivities of a different order than conscious subjectivity."[40] The survey of the body as an "absolute volume" accordingly engages the body as a "system of unconscious subjectivities" or what we might call "microsensibilities."[41] It is precisely this microsensory surveying that gets catalyzed by VR artworks that interface consciousness with visually impermeable "data fields." In the experience of such "warped surfaces,"[42] the dominance of vision is *per force* overcome, not simply because the bodily basis of vision comes back with a vengeance,[43] but because visual survey is fundamentally inadequate as a sensory interface to them. Vision simply does not suffice to survey the absolute volume of the body.[44] For this reason, these kinds of VR artwork might be said to retool the human capacity for absolute survey (whose biological roots ensure its concrete correlation with the capacity to intuit *geometric space* as sensory extension) for operation in relation to new, digitally generated topological surfaces. And, because they capitalize on its organismic basis in order to do so, they might be understood as catalyzing the *embodiment* of the absolute survey in a kind of adaptation to the sensory demands posed by digital environments.

Diane Gromala speaks for a group of artists interested in VR when she positions the aesthetic potential of VR in stark contrast to the rhetoric of disembodiment and transcendence so frequently associated with it: "Recent media frenzies about virtual reality portray these technologies as promising a brave new world. . . . What if, instead, we explore this notion turned in on itself— our travels not to an abstract virtual 'outer' space, but to the inner reaches of our body?"[45] In her collaboration with Yacov Sharir, *Dancing with a Virtual Dervish,* Gromala attempts to put this program into action. In this dynamic VR environment, the participant is given the opportunity to assume a virtual dancing body and dance with other virtual dancers, including "intelligent simulations" entirely unconnected to the physical movement of a (human) body (figure 5.4).[46] In one configuration, the work dynamically couples the participant to a virtual dervish that mimics her movements, invites her response, or

Figure 5.4
Diane Gromala (with
Yakov Sharir), *Dancing
with the Virtual Dervish*
(1993). In this dynamic
VR environment, partici-
pants assume a virtual
dancing body in order to
interact with other vir-
tual bodies. (See
plate 9.)

dances alone, depending on several aspects of the participant's behavior: her proximity to the dervish, the speed of her response time, the implications of her movements, and so on. According to Gromala, this type of dynamic coupling brings "chance operations to a set of variables that are not limited to linear performance," transforming the interactive situation into true mutual improvisation. In this and subsequent configurations, *Dancing with a Virtual Dervish* aims to provoke within the participant the affective conflict that lies at the heart of the feeling of disembodiment commonly held to characterize VR: the confrontation between two nonsuperposable bodies—the virtual body occupied by the participant within the VR space and the physical body where her experience is affectively processed.

While such a confrontation can be said to occur from the moment the participant enters a virtual space that does more than simply "replicate the physical world as it is," it is specifically foregrounded in Gromala's inclusion of an interface with an enormous simulation of the human body, comprised of a rib cage, pelvis, heart, kidney and other viscera, blanketed by letter forms and text, all in a process of continual metamorphosis. Constructed from artistically manipulated "objective" MRI data of the artist's body, this simulation allows the participant to dance through the inner spaces of the body via a non-Cartesian interface that transforms the body as a geometric volume into a dimensionless topological intuition: "Literal pictorial and sonic representation of enormous body parts reveal paradoxically larger, surreal worlds as the user travels or 'flies' within them. Poetic text wrapped around these organic structures defines them, but simultaneously confounds what constitutes inside with outside" and collapses "the distance of the bodily responses to representation."[47] When Gromala goes on to explain that her project aims to exploit proprioception (the inner sense of where we are in our bodies) as the basis for a "re-embodiment," a "reconfigured and enhanced experience of [the] body," she perfectly expresses the concrete connection on which the most fruitful aesthetic experimentation with VR is based: the connection linking warped surfaces with the intuition of the body as absolute volume.

As I see it, artists working in this vein display two distinct tendencies, depending on whether their interest is the possibility of intuiting topological forms, or the possibility, itself facilitated by the direct interface with topologi-

Figure 5.5
Michael Scroggins and
Stewart Dickson, *Topo-
logical Slide* (1994). In
this VR environment,
participants are placed
into bodily interface
with warped topological
surfaces.

cal forms, of intuiting the body as an absolute volume. Representative of the
former tendency is Michael Scroggins and Stewart Dickson's *Topological Slide,*
a VR interface with models of topological surfaces (figure 5.5).[48] Scroggins and
Dickson work through the metaphor of Web surfing in order to recuperate the
notion of continuity of form that is lost in the predominantly static and dis-
crete idea of clicking from site to site. For Scroggins, *Topological Slide* can be
counterposed to the striated space of the Web: whereas the Web operates a
transformation of the "actual" into the "virtual," of the local into the abstract,
their VR interface allows the participant to traverse mathematical objects in an
experience of "the abstract made concrete."[49] To this end, the artists built a
surfboard-like platform, dynamically coupled with virtual topological models
of such mathematical figures as Enneper's surface and the Jorge-Meeks trinoid,
that the participant can manipulate through body motion (directional lean-
ing). As Scroggins explains, *Topological Slide* was conceived to be a "direct
sensual experience" of surfaces ordinarily accessible only through abstract in-
tellection. By coupling the participant's body directly with warped topological

surfaces, the work maps topology directly onto the nongeometric volume of the body, thus furnishing an affective correlate to topological forms, an experience of what it would feel like to ride along their warped surfaces. Dickson explains the mechanics of such mapping in a way that pinpoints its complexity: "The general problem of placing the rider on a mathematically-specified surface is fairly complex. First the (X,Y,Z) coordinate in three-space on the mathematical surface must be calculated as a function of the (U, V) coordinate in parametric space of the rider's location. This location is the cumulative effect of the two acceleration vectors specified by the platform tilt axes and a constant friction or drag coefficient. The rider must then be oriented in a natural manner to the surface at the correct three-dimensional address."[50] Though it is intended to emphasize the *mathematical* complexity of the mapping, this description simultaneously implies a reciprocal *experiential* complexity in the participant who is in fact called on to intuit the topological surface via the dynamic vectorial space of her kinesthetic body. Bluntly put, the mapping of topology onto the body catalyzes a remapping of the body itself—its transformation from a geometric object within space into an intense, dimensionless, absolute volume.

This intrinsic reciprocity between the intuition of warped surfaces and the intuition of the body as absolute volume is foregrounded in the work of Teresa Wennberg, which (along with Gromala's *Dancing with a Virtual Dervish*) furnishes a sort of transition from the first tendency to the second. In *The Parallel Dimension* (1998), Wennberg deploys the space of the body as a metaphor for the nongeometric space of the virtual (figure 5.6).[51] Developed for the six-sided VR-Cube,[52] *The Parallel Dimension* consists of six imaginary rooms, each devoted to a different "body part" and its associated "virtual function." The participant begins in the Brain Chamber and proceeds, via a network of nerve and vein connections, to the other five rooms (the Heart & Blood Room, the Breathing Cathedral, the Thought Cabinet, the Flesh Labyrinth, and the Dream Cavern), each of which affords a distinct ambient experience accompanied by a specific soundscape. Wennberg explains that, in each part, "the confrontation with virtual space takes place through the construction of space itself," and this construction, far from being geometric and relative to an absolute Cartesian extensity, is itself a function of the affective registers of the participant's experience. This latter in effect serves to expand nongeometrically what is in the end

Figure 5.6
Teresa Wennberg, *The Parallel Dimension* (1998). This VR environment deploys the space of the body as an embodied metaphor for the nongeometric space of the virtual.

a "closed environment."[53] Space, accordingly, is constructed via the affective connotations provoked by the participant's journey through the virtual space and according to the sensory continua bounded by binary oppositions such as the following: "gigantic/claustrophobic, vertical/horizontal, empty/full, animated/still, round/oval/square." In *The Parallel Dimension,* the construction of space is truly a construction via the body: space as affectively lived.

In a subsequent project, *Brainsongs (Welcome to My Brain)* (2001), Wennberg effectively updates the metaphoric correlation between the space of the body and nongeometric virtual space by introducing the active and creative functions of the brain as a third mediating term (figure 5.7).[54] *Brainsongs,* she explains, works "with a virtual interpretation of the above mentioned [brain] functions" (executive decision making, short-term memory, visual pattern recognition, and spatial orientation) that furnish "visual metaphors for the world of the brain. The underlying idea is to provoke our normal concept of reality through these unknown forms and constellations."[55] The work begins with a model displaying the interconnections in a brain. From there, the participant

Figure 5.7
Teresa Wennberg, *Brain-songs (Welcome to My Brain)* (2000). This VR environment introduces the active, creative ca-pacities of the brain as a mediating term between bodily space and nonge-ometric virtual space.

can venture into various situations in which the brain's functions are at stake and which afford us experience of its extraordinary flexibility. Toward this end, Wennberg has sought to create virtual metaphors for brain function, or perhaps more exactly, virtual experiences designed to trigger activity from "parts of our brain we have never discovered before."[56] Thus, we are confronted with many "stunning contradictions: we fly although we are standing still, we go through solid walls; we move with incredible speed between totally different situations"; in sum, we are made to "oscillate between a feeling of control and confusion" as our embodied habits are pitted against the challenge of new motor solicita-tions.[57] The effect of such contradictory solicitation (where the virtual body is partially disjoined from the physical body) is to focus the aesthetic experience less on finding an affective correlate for nongeometric virtual space than on turning attention back onto the body–brain itself. Wennberg explains that when we enter *Brainsongs,* "we experience a real-time metaphor for the change

and transformation that is constantly taking place inside us." Effectively, the work compels us to ask questions that strike at the core of the body–brain's capacity for constructing "reality" as simulation: How do we differentiate between true and false experience within virtual zones that "both resemble and defy all the physical laws" of normal life?[58] "What is true and what is illusion? How quickly does the brain adapt itself? Does it change once we have experienced another reality? Is the truth factor actually important here?"[59] What we subsequently "learn" from our experience in *Brainsongs* is precisely what we learned from our earlier consideration of the neurophysiology of the brain: that "our brain doesn't seem to care about such distinctions." The only difference here is that we learn this precisely by experiencing our own distributed body–brain in the very process of adapting to a strange new world and forming a "strange concensus" among its many subagencies.[60]

Whereas Wennberg's work invests in the metaphoric correlation linking brain processes with virtual space, Pavel Smetana's *Room of Desires* (1996) and Alan Dunning and Paul Woodrow's ongoing *Einstein's Brain* project deploy biofeedback as a means literally and directly to couple the body–brain with the image or virtual space. In Smetana's interactive environment, the participant is wired to a "brain–heart" interface via electrodes attached to her head and body. This interface serves to transmit physiological data from the participant to the image generator, and thereby to influence the future trajectory of the images being projected. Likewise, in *Einstein's Brain,* the participant is wired through encephalographic, galvanic, and cardio biofeedback loops to a computer that uses her physiological output to generate and modify images in real time.

Smetana's installation is deceptively low-tech in its appearance: the participant enters a wooden, dimly lit, windowless cabin with smooth black walls (figure 5.8).[61] She sits in the sturdy wooden chair next to the small table and is wired to the interface. Immediately images appear on the wall in front of her. She initially recognizes a calm landscape, a cornfield in summer, and she hears gentle sounds of cornstalks swaying in a light breeze. If the participant becomes excited or nervous, the images as well as the sounds become more agitated and jarring. The aim of the installation is to allow the participant gradually to recognize the nature of the biofeedback system connecting her to the image generator. Accordingly, as the participant begins to see that her own affective states are functioning as triggers for the image sequence, she will begin to experiment

Figure 5.8
Pavel Smetana, *The Room of Desires* (1996). (a) Via a "brain-heart" interface, viewers are hooked up to an image sequence; installation facilitates interaction between physiological signals and image content. (b) Sequences of images from *The Room of Desires*.

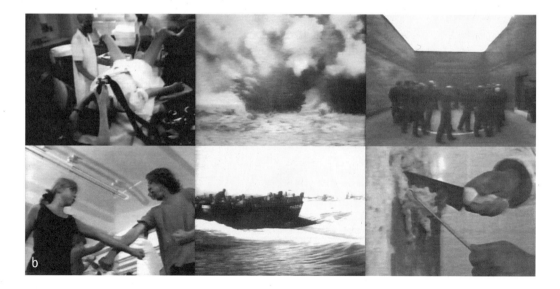

with controlling her impulses as a means of guiding the trajectory of the film. In this way, her attention is drawn to the association of her own physiological changes with the perceptual changes to which they are directly linked, and she is brought to recognize the physiological basis of the body–brain achievement we have termed simulation. In a project description of Smetana's work, artist Louis Bec perfectly captures the mechanism of this process: "Knowledge of the medium is built up through a multitude of impulses, which drain towards the brain from sensory nerve endings or receptors implanted at the surface of the body. Each of these receptors may be stimulated by forms of energy. . . . These stimulations provoke nerve impulses which ultimately form the basis of constructed conscious perceptions."[62]

Smetana's *Room of Desires* exemplifies technological artworks that use digital technologies and interactive devices to amplify the embodied basis of perception-simulation: "Such works," Bec continues, "build on an electro-physiological substrate to try and reach levels of higher symbolic emergence, through proprioceptive and somatesthetic events." By foregrounding the bodily basis for simulation, in other words, the "brain–heart" interface exemplifies the function of the computer as "an extension and a continuation of the human mind," a means to "investigate man's interior, in a literal and figurative sense."[63] By means of this interface, the experience of *Room of Desires* comes to be far less about the content of the image sequence, and indeed far less about the image as such, than it is about the physiological processing underlying the production of body–brain simulations. As Bec suggests, Smetana's work seeks to situate the human body–brain achievement of simulation not simply within the rich context of physiological affective processes but within the larger ecological context to which they are coupled. *Room of Desires* is thus said to exemplify a form of artistic experimentation that "proceeds by cognitive exploration of the medium, considered as a *technobiome* subject to constant transformation by artistico-techno-scientific tools."[64] Ultimately, this has the effect of situating Smetana's work within a larger "loop of constructivist viability" whereby "the living being transforms the medium at the same time as the medium transforms the living being."[65]

Notwithstanding this sensitivity to the ecology of sensation, Smetana's decision to use the image technology of cinema rather than VR limits the scope

of *Room of Desires*. Specifically, it narrowly couples the work's catalysis of the physiological dimension of simulation with the production of an image sequence, thus preventing it from yielding an intuition of the absolute volume of the body. It is just such an intuition that is at issue in Dunning and Woodrow's *Einstein's Brain* project. Conceived as a flexible platform for the navigation of a variety of different worlds, *Einstein's Brain* directly engages the idea that the world is "a construct sustained through the neurological processes contained within the brain."[66] The project is composed of a series of worlds digitally generated from topographical maps, magnetic resonance images, and pharmacological 3-D models of the human body and brain. To this corpus of fixed images, the physiological output from the participant's body is added; this output both serves to control the configuration of the preformed images and contributes an additional source of data, namely, an "online" representation of her body's continually mutating internal state. By means of a "wearable head-up display" with a choice of transmissive (see-through) or opaque optics connected via microwave transmitters to a computer, the participant is able to navigate through these virtual worlds and to superpose the virtual worlds on the physical world in such a way that her physiological output is made to correspond directly and immediately with changes in the absolute surface.[67]

In this way, the *Einstein's Brain* platform takes us a major step beyond Smetana's experimentations: specifically, it dynamically couples the physiological output of the participant's online or "dispositional" body to the capacity for absolute survey that forms the basis for the body–brain achievement of simulation. As the artists explain, "In the construction of a dynamic self, the mind attempts to engage the world(s) behind appearances. These worlds are in perpetual motion and unstable transformation, without attributable frames of reference, without material bodies or finite borders, in constant flux, linking past to future and memory to prediction. It is as if we are inside ourselves, like a three-dimensional eye which constructs itself as it moves through internal haptic space."[68] In the wake of Ruyer's work, we might even better characterize this evoked experience of being inside ourselves as the perspective of a nondimensional "I" constructing its haptic or affective space through an intuition of itself as an absolute volume. Indeed, as if to confirm just such a link, this characterization perfectly captures what is at stake in the concept of the "movie-in-the-brain" that Dunning and Woodrow borrow from neuroscientist Antonio

Damasio—the sense of precisely how the ongoing, moment-by-moment construction of the self differs from the external apprehension of a cinematic film. Damasio suggests that "the images in the consciousness narrative flow like shadows along with images of the object for which they are providing an unwitting unsolicited comment. To come back to the metaphor of the movie-in-the-brain, they are within the movie. There is no external spectator . . . the core you is born as the story is told within the story itself."[69] What, indeed, is VR, if not a movie-in-the-brain, a movie with no external spectator, a movie that coincides *exactly* with the ongoing brain activity of its intuitor or "internal spectator"?

Although some crucial dimension of embodiment is at stake in all the component projects of *Einstein's Brain*,[70] its radical aesthetic consequences emerge most clearly in *Errant Eye* (figure 5.9). Here, the participant is immersed

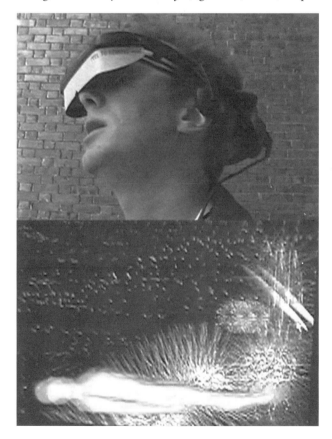

Figure 5.9
Stewart Dunning and Paul Woodrow, *Einstein's Brain (Errant Eye)* (1997–present). Deploys the physiological output of the participant's "dispositional" body in the task of synthesizing an image space.

in a virtual environment composed of a data forest generated and continuously altered through feedback from electroencephalograph signals originating in her own brain. The VR interface thus serves to couple the participant directly and immediately with her own physiological states. In this form of dynamic coupling, which most closely anticipates the direct stimulation of the optical nerve long projected as the ultimate achievement in human–computer interface,[71] the mediation of the image becomes entirely incidental, serving solely as a representational support for the flux of brain wave data. Like Wennberg's *Brainsongs,* the immediate aim of the work is to throw into question the very distinction—between perception and simulation—that informs the conception of the image as an external, technical frame: "By linking brain activity with visual changes in the perception of a world, [*Errant Eye*] provides a space where these manifestations of the inner workings of the brain problematize the relation between a world apparent and a world perceived."[72] Indeed, by placing the participant into a recursive correlation with her own continually changing, "online" physiological state, the project couples the affective dimension foregrounded by Smetana's *Room of Desires* with the ongoing production of an intuition of self as absolute form. In this case, accordingly, the affective dimension is not put in the service of the perceptual construction of a cinematic image sequence, but instead carries out the body's own self-intuition as an absolute volume. Contrasted with Wennberg's metaphoric link of body and virtual space, we might say that here it is the virtual space of the body itself that is intuited. Indeed, the very fact that the resulting intuition of the body remains inaccessible to perception, and specifically to vision, helps to explain the alleged paradox of VR experience: as Dunning and Woodrow keenly discern, the worlds generated from the physical and visual structure of the brain "are not external to the body, but are properly thought of as being inside the body. This accounts for the apparent invisibility of the body in a virtual space. The body disappears because it is turned in on itself."[73] Yet, as it disappears from the domain of the *visual* image, the body materializes in the domain of *form,* where it experiences itself as absolute sensation or subjectivity. Or, in the Bergsonist terminology so central to my argument in this book: the more invisible the interface with the body, the more affectively rooted it becomes.

Bodily Spacing and the Givenness of Time

Insofar as they expose the crucial embodied dimensions of the "self-enjoyment" at issue in our experience as absolute forms,[74] aesthetic experimentations with VR might be said to expand our capacity for "direct experience"—our primary embodied contact with information:

> We obtain raw, direct information in the process of interacting with the situation we encounter. . . . [D]irect experience has the advantage of coming through the totality of our internal processes—conscious, un-conscious, visceral, and mental—and is most completely tested and evaluated by our nature. Processed, digested, abstracted second-hand knowledge is often more generalized and concentrated, but usually affects us only intellectually—lacking the balance and completeness of experienced simulations. . . . Although we are existing more and more in the realms of abstract, generalized concepts and principles, our roots are in direct experience on many levels, as is most of our ability to con-sciously and unconsciously evaluate information.[75]

Reminiscent of Donald MacKay's conception of meaning as rooted in the or-ganismic richness of the receiver,[76] this notion of direct experience can be di-rectly correlated with Ruyer's concept of absolute volume: to the extent that it denotes a fully embodied simulation, direct experience would appear to be syn-onymous with the body's self-intuition as absolute volume, its capacity for spacing.[77]

This synonymy bears particular significance for our claims regarding the sensorimotor reconfiguration of the body in the context of digital information. Not only does it suspend the priority of time over space that has been a leitmo-tif in philosophy from Bergson to Deleuze, but it furnishes the basis for a rearticu-lation of space (or better, spacing) as the very condition for the givenness of time. The spacing that comprises the body's self-intuition as absolute volume encompasses both time *and* space (and also the space-time of relativity physics). What is at stake in bodily self-intuition, in other words, is an unprecedented conception of space as spacing, a conception that is not only compatible with

the flux of time (duration), but is in fact *constitutive of* this flux. According to Ruyer, it is the surveying of time (more so even than that of space) that opens the body's absolute spacing, its self-intuition as absolute volume:

> the absolute survey of space entails [*entraîne*], with some supplementary difficulties, the absolute survey of time. Organically and psychically already, I do not live [*vis*] exclusively in the present. I am always in the process of accomplishing an action or an effort which simultaneously anticipates the future and modifies the meaning of the past. Despite the incremental nature [*de proche en proche*] of the succession of instants, . . . I do not enter the future with closed eyes. . . . One can, to some degree, choose one's path in time, just as one can choose between diverse itineraries in surveyed space, by avoiding future obstacles, situatable through diverse symbolic processes.[78]

To the extent that this capacity to choose one's path in time depends on the root equipotentiality of the organism, being in time comprises one central dimension of the intuition of the body as absolute volume. What this means, finally, is that time can be intuited only through direct experience, or alternatively, through the spacing of the body itself.

This rearticulation of spacing as the basis for the givenness of time corresponds to a material change in the being of time itself. According to media artist/engineer Edmond Couchot, digital technology transcends the entropic limit that previously regulated the correlation of information with memory:

> [W]ith digital technology [*le numérique*], one has the means for definitive registration, sheltered [*á l'abri de*] from all entropy, from all usage [*usure*] of information, because it is reduced to primary, binary symbols. . . . [T]he problem is that of the permanent demarcation [*débordement*] of memories which will continue to present itself despite the ever larger capacities of memories. Thus the problem of the choice of conservation is also posed. In earlier times, this problem was solved [*était réglé*] in part by entropy. Video and film change very quickly. In the case of painting, alas, we are encountering catastrophes. . . . We confront the difficult problem of human memory which only retains, generally speak-

ing, what interests it directly, profoundly. This fundamentally inverts the relation that one has had up to now with memory, with the trace. . . . we are entering into a neg-entropic state, that is to say, one that is close to the living, in the operation [*gestion*] of memories. . . . By necessity, work in the neg-entropic mode will converge with our memory function which is considered as a permanent re-creation and not as a physico-mechanical recall of a previously registered trace. One never remembers the same thing twice and I believe that digital technologies are going to force us to function accordingly, in the sense that [conservation] will not be a question of a simple recall since mechanisms of access to stored information [*informations enregistrées*] will be closely modelled on what happens in our own memory.[79]

The capacity to store information "sheltered from entropy" has, in short, rendered time an independent variable: no longer intrinsically bound to materials subject to decay, time in some sense "exists" *outside* or *beyond* the thermodynamically irreversible universe governed by the laws of physics. In the wake of this shift in the being of time, human mediation of digital information becomes necessary *as a means to reintroduce temporality into information.* By performing a role formerly carried out through the entropic decline of information's material support, the supplementary human mediation (or framing) of information has now become central to the givenness of time itself. What this means is that time is necessarily mediated by bodily spacing. Accordingly, time loses its priority over space, and the "cinematographic illusion" denounced by Bergson—the spatialization of time—is overcome. Insofar as it constitutes the mechanism for the direct experience of "absolute duration," spacing or the self-intuition of the body is nothing less than the precondition of time itself.

This inversion—or rather dissolution—of the hierarchy of time over space allows us to differentiate aesthetic experimentations with VR from the Deleuzean cinema of the time-image, and specifically, from what Deleuze calls the "cinema of the brain." While Deleuze's neuro-cinema operates a fundamental disembodiment of the brain[80]—a transcendence of its sensorimotor basis—VR resituates the neural activity of the brain (simulation) within its richly embodied context and exposes just how deeply intertwined with the

body cognition actually is. Indeed, aesthetic experimentations with VR specifically highlight two fundamental limitations of Deleuze's neuroaesthetics that might equally be ascribed to the cinema itself: on the one hand, the passive status necessarily accorded the brain, which is limited to the task of simply inscribing the circuits created by cinema; and on the other hand, the indispensible distance between image and perception, which ensures that the cinematic object be apprehended in the secondary mode of abstract knowledge, and not as the direct experience of (absolute) sensation.

Viewed in this context, Deleuze's recourse to the time-image can be understood to be symptomatic of cinema's fundamental insufficiency as a model for experience: it is precisely because cinema cannot account for the primacy of the subjective dimension of the body–brain (its status as absolute survey or volume) that Deleuze finds himself compelled to introduce a source of creativity (time or the virtual) that is external to the body–brain and its constitutive equipotentiality.[81] As we have seen, this same limitation does not hold for VR, where the brain is no longer external to the image and is indeed no longer differentiated from an image at all, and where movement is not first movement in the image and subsequently synthesis in the brain, but is from the outset indissociable from the participant's own (bodily) movement. As Florian Rötzer puts it, VR "shields the environment, which allows us in fact to enter the digitally produced three-dimensional space with the entire body. Whereas we used to be led as spectators through the spaces and scenes by the moving camera, we can now move within them on our own. . . ."[82] VR accordingly opens a vastly different path beyond the movement-image than does the time-image: as a technical extension of the capacity for absolute spacing, the VR interface marks a break with the sensorimotor logic of the movement-image that is, however, *not a break with the sensorimotor per se, but rather its decoupling from an outmoded model of the body.*

As a subsequent reembodying of the sensorimotor *as absolute volume,* spacing forms the basis for a very different neuroaesthetics than Deleuze's cinema of the brain. Indeed, what aesthetic experimentations with VR ultimately demonstrate is the capacity of new media art to accord the body new functionalities—including the extension of its capacity for self-intuition or spacing—precisely by putting it into sensorimotor correlation with new environments,

or more accurately, with unprecedented configurations of information.[83] In this way, the body is transformed into a nondimensional, intensive site for a feedback loop with information, where, as we have seen, the output of the body and the output of information are locked into an ongoing recursive coupling. Dubbing it the "neuro-cultural function" of new media art, Derrick de Kerckhove attributes this process to the capacity of new technologies "to place the human subject corporeally and spiritually into relation with the transformed environment. Interactive systems are deeply expanded biofeedback systems. They teach us how we can adapt ourselves [*anpassen können*] to new sensory syntheses, new speeds and new perceptions."[84] And they do so, specifically, by catalyzing those bodily "senses"—proprioception, interoception, affectivity— that allow us to orient ourselves in the absence of fixed points or external orienting schema, or in other words, through the internal, intensive space of our affective bodies. It is, accordingly, the body's affective autopoietic dimension— its capacity for absolute spacing—that accounts for the neurocultural function of new media art. Recalling the epigraph at the start of this chapter, we must conclude that the virtual in VR lies on the side of the human even when it is placed in direct correlation with digital information: at stake in our encounter with the digital is nothing less than an opportunity for us to carry out our own embodied virtualization.

With this conclusion, we come back to the starting point of our consideration of the fate of the image and of perception: John Johnston's claims for "machinic vision" as a postimagistic mode of perception. Extending our analysis of the splitting of perception in chapter 3, we can now specify an alternative "cause" for the demise of the image that lies alongside Johnston's account of machinic vision and, indeed, serves to qualify its impact. This is precisely the (human) capacity for absolute spacing as it is technically extended in certain forms of new media art and specifically in aesthetic experimentations with VR. By placing us into "direct coupling" with information, this technical extension not only dissolves the mediating (framing) function of the image, but it renders perception itself secondary in relation to the primary affective experience of self-enjoyment. Consequently, the radical consequences Johnston derives from the machinic distribution of perception have no impact to speak of on the absolute domain of human sensation: as more and more "perceptual

labor" gets performed by machines, the human capacity for absolute subjectivity attains a new importance both as what specifies human embodiment against the machinic embodiment and as what allows for their fruitful cofunctioning in the production of sensation. Far from inaugurating a form of machinic vision, VR is simply the most advanced instance of such cofunctioning: what it facilitates is not a becoming-inhuman of perception but instead a technical extension of the (human) domain of absolute subjectivity and of the (human) capacity for affective self-intuition.

Figure 6.1 (opposite and following pages) ▶
Robert Lazzarini, *skulls* (2000). Sculptural installation consisting of four skulls created via digital deformation and rapid-prototyping. (a) Installation view. (b)–(e) Close-up of skulls.

6

The Affective Topology of New Media Art

> . . . If the frame has an analogue, it is to be found in an information system rather than a linguistic one. The elements are the data, which are sometimes very numerous, sometimes of limited number.
>
> —Gilles Deleuze

You enter a tiny, well-lit room. On the four walls, you see what look to be four sculptures of a human skull, apparently cast from different points of view (figure 6.1a–e). Yet as you concentrate on these objects, you immediately notice that something is horribly amiss; not only is the play of light and shadow that defines their sculptural relief somewhat odd, as if they were meant to be seen from the ceiling or the floor, but the skulls themselves seem warped in a way

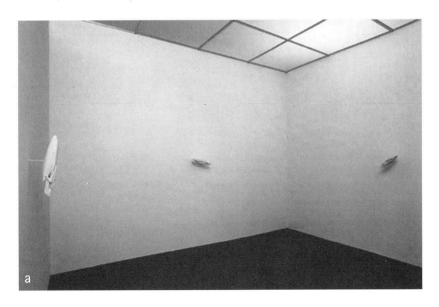

a

Theoretical Aim	Body	Image	Artwork
To correlate affectivity with a shift from visual space to haptic space	From body as source for perception of extended, geometric space to body as affective source for haptic space	From correlate of perceptual gaze to processural affective analogy for the "warped space" of the computer	Lazzarini's *skulls*; Kalpakjian's *Hall, Duct, HVAC III*

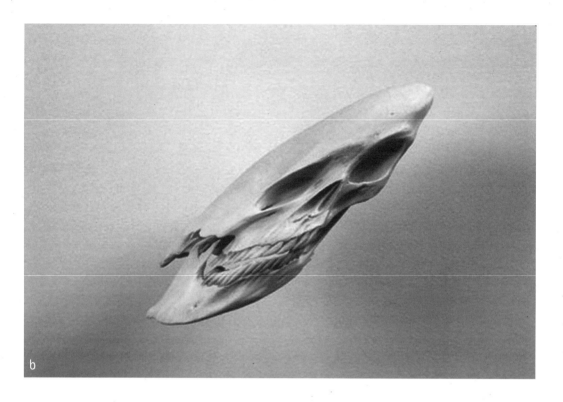

b

that doesn't quite feel right, that just doesn't mesh with your ingrained per-
spectival sense. You begin to explore these sculptures more carefully, moving
close to one, then turning away, then moving close to another, and so on, and
then circling around as if to grasp in your very movement and changing po-
sition the secret of their relation to one another. As you continue to explore
them, you find yourself bending your head and contorting your body, in an
attempt to see the skulls "head-on." At each effort to align your point of view
with the perspective of one of these weird sculptural objects, you experience
a gradually mounting feeling of incredible strangeness. It is as though these
skulls refused to return your gaze, or better, as though they existed in a space
without any connection to the space you are inhabiting, a space from which
they simply cannot look back at you. And yet they *are* looking at you, just as
surely as you *are* looking at them! Abruptly you step back and stand rigid in the
center of the room, as far from the skulls as you can get. However still you try
to remain, you feel the space around you begin to ripple, to bubble, to infold,

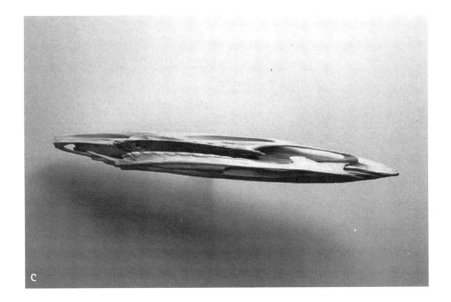

as if it were coming unstuck from the fixed coordinates of its three-dimensional extension. You soon become disoriented, as this ungluing of space becomes more intense. Again you contort your body—or rather, you feel your body contorting itself—and you notice an odd tensing in your gut, as if your viscera were itself trying to adjust to this warped space. You find this experience alternately intolerable and amusing, as you once again move in to focus on still another skull, until finally, having grown impatient or unable to endure the weird sensation produced by this work, you abruptly pass through the door-sized opening cut into one of the room's four walls and seek solace in some less unsettling portal to the digital world.

The work just described is Robert Lazzarini's *skulls* (2000) as exhibited at the Whitney museum's "Bitstreams" show. It is, as you have just had occasion to experience, a sculptural installation composed of four skulls hung about eye-level and protruding about a foot from the walls of a small, well-lit, clean and bright room. To create this deceptively low-tech installation, Lazzarini laser-scanned an actual human skull to create a three-dimensional CAD (computer-aided design) file, which he then subjected to various distortions. The resulting distorted files became the models for four sculptures cast in solid bone. As your

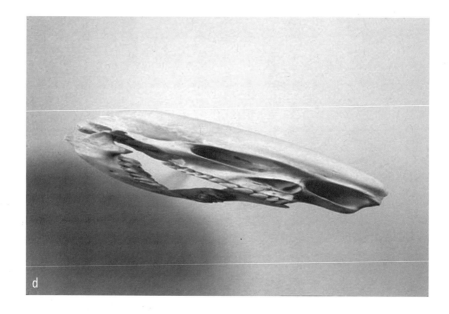

d

experience testifies, Lazzarini's work functions by catalyzing a perspectival crisis, confronting us as it does with "the disorienting ambiguities of digital space"[1]—with what would seem to be *indices* from a world wholly alien to our habitual perceptual expectations and capacities.

At first, we might be tempted to liken Lazzarini's installation to traditional anamorphic representations: not only does his subject matter iconographically recall the bizarrely distorted skull that appears repeatedly in the anamorphic tradition, and most famously in Hans Holbein's 1533 *The Ambassadors,*[2] but the perceptual problem the installation presents seems to mirror the problematic of anamorphic distortion. Needless to say, this correlation has found its way into descriptions of Lazzarini's work. Florian Zeyfang, for example, portrays *skulls* as four sculptures that have been "anamorphically deformed" in the computer, and the Pierogi Gallery description of Lazzarini cites his use of "distortions such as anamorphism."[3] Nonetheless, despite their undeniable resemblance to traditional icons of anamorphosis, Lazzarini's skulls cannot be considered anamorphic in any conventional sense of the term, since they do not resolve into a normal image when viewed from an oblique angle, but confront the viewer with the projection of a warped space that refuses to map onto her habitual spatial schematizing, no matter how much effort she

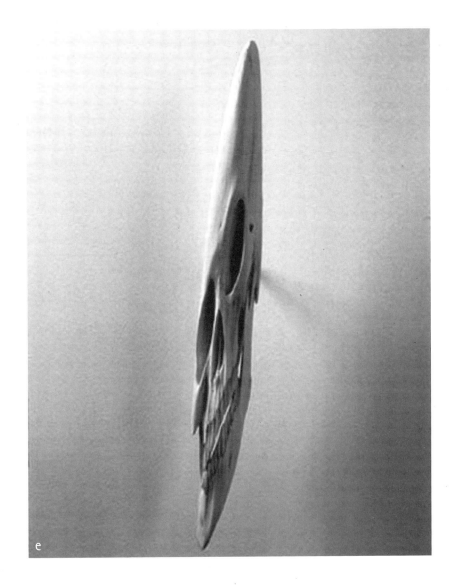

e

puts into it, no matter how many angles she tries. This effect of protracted—indeed, interminable—anamorphosis results from Lazzarini's peculiar engagement with the three-dimensional media of sculpture: as the Pierogi description insightfully points out, Lazzarini utilizes what are, in effect, two-dimensional distortion techniques in order to model three-dimensional objects. The result is sculptural objects whose own depth interferes with the illusionary resolution of perspectival distortion. Accordingly, if *skulls* does inaugurate some new kind of anamorphic image, it could only be a radically attenuated anamorphosis that functions less to infold some secret[4] than to mark our radical *exclusion* from the space the skulls inhabit and from which they come out to greet us, as it were, as envoys from elsewhere. *Skulls* confronts us, in short, with a spatial problematic we cannot resolve: with the "fact" of a perspectival distortion that can be realized (and corrected)—and that "makes sense" visually—only within the weird logic and topology of the computer.[5]

Our experience of these *warped indices* does not end, however, with the frustration of our visual mastery over them, but gradually and seamlessly shades over into the domain of affective bodily response: "As the object becomes a projection of the image," the Pierogi description continues, "the wall becomes a projection of the ground," which is to say that the perceptual experience of the work yields an oscillation or leveling of the figure–ground distinction and with it, an end to any hope of visual entry, let alone mastery, of the work. That the work aims to provoke precisely such a shift to a nonvisual, affective domain of experience finds corroboration from the artist who, in comparing the impenetrable, apparently irrational form of these objects to "the emotionally keyed distortion evident in the sixteenth-century paintings of El Greco,"[6] foregrounds their role as triggers for affect.[7] Even in doing so, however, Lazzarini adapts this minor tradition in figurative art to the specific problematic of the digital image: here, the affective response of the viewer is "keyed" by the impenetrability of the digital processing involved and the warped topological space projected by the objects it yields. By triggering a bodily intuition of a computer-processed form, the work mobilizes anamorphosis—according to its more general sense as a transition between forms[8]—as the operator of a suture between disjunctive formal dimensions, or what Edmund Couchot calls "diamorphosis."[9] In so doing, it deploys the *anamorphing* of form as the opening of a whole new domain—the synthetic modulation operative in contem-

porary computer music and computer graphics that has recently been dubbed "hyper-nature" by Friedrich Kittler.[10] Because our constitutive embodiment prevents us from following along such modulation at the molecular level and in real time, whatever possibility we may have for experiencing it can only come via an affective "analogy" produced by our bodily response to it and whose "content" is a warped space felt *within* the body. "What [the skulls] do," one particularly astute viewer-participant observes, "is force the Viewer/User to summon up one paradigm of perceptual abstraction after another only to discard it as the eye moves a few centimeters this way or that, and in this way the beholder is forced to acknowledge that they are witnessing the operation of a process *within their own* Minds which normally is performed for them through the agency of formal abstraction or in the familiar distortions of TV or film, or more recently upon a computer monitor."[11] If we substitute "body" for "mind" in this passage, we are well on our way to grasping just how *skulls* situates the viewer in between the machinic space of the image and the normal geometrical space of visual perception: to the extent that our perspectival grasp of the image is short-circuited, we do not experience the image in the space between it and our eye (as in normal geometric perspective); and to the extent that we are thus "placed" into the space of the image (though without being able to enter into it), our visual faculties are rendered useless and we experience a shift to an alternate mode of perception rooted in our bodily faculty of proprioception.

We could say then that Lazzarini's work functions by *catalyzing* an affective process of embodied form-giving, a process that creates *place* within our bodies. And since it is through such a *creation* that we get a sense for the "weirdness" of digital topology, we might well think of it as a correlate to the impossible perceptual experience offered by the work. In sum, if *skulls* is exemplary of new media art, it is not simply because it manages to capture or synthesize what is at stake in the host of products and practices that have typically, if more or less randomly, been grouped under this confused and confusing rubric. Rather, its exemplarity stems from its success at deploying the capacities proper to the digital image—or better, to the process of digital modulation[12]—*without* channeling these through the coordinates of an image designed for interface with (human) vision.

In this respect, *skulls* exploits the extreme flexibility and total addressability that Couchot, Deleuze, and Kittler have all attributed to the digital im-

age.[13] Yet whereas these critics explore this unprecedented flexibility and addressability in terms of its consequences for the optical properties of the image,[14] Lazzarini's work mobilizes the digital image in order to catalyze a bodily intuition of space, an intuition of the origin of space in the bodily spacing explored in the previous chapter. Rather than acting as the "object" of digital modulation, the image here functions as a catalyst for the breakdown of the visual register itself: whereas computer graphics, in its quest to determine the "optimal algorithm for automatic image synthesis," hypostatizes the optical dimension, *skulls* explores the topological freedom of digital modulation and attempts to give the viewer (or rather the "looker on"[15]) some interface with this visually impenetrable domain. Consequently, the image marks a break in the flux of digital modulation designed to interface us with its weird topology; it furnishes what amounts to a cipher or index of a process fundamentally heterogeneous to our constitutive perceptual ratios. To grasp this point, contrast the experience catalyzed by *skulls* with the representation of digital space as imagined by, say, a film like *Lawnmower Man:* rather than inventing a purely arbitrary metaphor for digital flux (e.g., the swirling, psychedelic forms that "signify" cyberspace), *skulls* presents us with actual artifacts from the digital realm—digitally warped forms bearing traces of inhuman topological manipulation. If our apprehension of these artifacts doesn't give us direct experience of digital space, it does comprise a new form of "affection-image"—a digital affection-image that unfolds in and as the viewer-participant's bodily intuition of the sheer alienness of these forms.

In this sense, *skulls* might be said to engage the image as an "image to the power of the image," following Couchot's concept:

> The synthetic image . . . [is a] recomposition outside of time, outside of the event temporality of instantaneity, and outside of the place where the object is located. The image of 3-D synthesis is a quasi-infinite potentiality of images, all similar to one another [*à la fois semblables*], . . . since they are capable of showing [their] object under a multiplicity of points of view and singular aspects. It is an image to the power of the image [*image à la puissance image*]. Never visible in their totality, consequently impresentable in any single time, these images of image no longer belong to the visual order of representation, they can no longer be submitted to its topology.[16]

Indeed, the synthetic image might be said to occasion a shift in the ontology of our spatial experience as such—a shift from an optically grounded spatiality in which object matches image according to a strict correspondence to a topology where image infinitely exceeds object. Here we are no longer in the geometric space that anamorphosis can puncture;[17] nor are we, to reiterate the argument I have been pursuing throughout this book, in the ontology of images set out by Bergson and retooled by Deleuze in his study of the cinema.

In this chapter, I give an account of the factors that make *skulls* exemplary of aesthetic experimentation with the digital image. In a certain sense, this account brings to a close the larger argument pursued in this book: for by extending the function of bodily spacing beyond the domain of virtual perception and by soliciting a response in which affectivity *takes the place of* perception, *skulls* calls affectivity into play as a phenomenological modality in its own right—that is, a mode of experience autonomous from perception, and indeed, one with a certain priority in the context of contemporary digital convergence. To unpack this liberation of affectivity from perception, I expand my earlier consideration of Deleuze's notion of the any-space-whatever (ASW). Specifically, I propose that *skulls* triggers the production of a "digital ASW"— a genesis of an internal bodily space or spacing in response to a warped spatial regime whose realization is enabled by the accelerated symbol-shuffling capacity of the digital computer. The digital ASW is both like and unlike the cinematic ASW explored by Deleuze. It is like the cinematic ASW in that it demarcates a fundamental shift in the human experience of space, a shift from an extended, visually apprehensible space to a space that can be felt only by the body. But it differs from the cinematic ASW on account of the means by which it operates this shift: whereas the cinematic ASW emerges as a transfiguration of an empirical spatial experience, the digital ASW comprises a bodily response to a stimulus that is both literally unprecedented and radically heterogeneous to the form of embodied human experience. To put it more simply: because it must be forged out of a contact with a radically inhuman realm, the digital ASW lacks an "originary" contact with a space of human activity (e.g., the "disconnected" or "empty" spaces of postwar Europe)—and thus any underlying *analogy*—from which affect can be extracted.

As a consequence of this difference, the problematic of restoring belief will have to be reconfigured in a manner at odds with that developed by Deleuze in *Cinema 2:* rather than a liberation of the "formal linkages of

thought" within the image, what is necessary is a supplementary connection, *beyond* or *outside* the image, with the bodily basis of belief—namely, touch. For this reason, the digital ASW (which, remember, is a process of bodily framing [or spacing] and not a type of technical image) invests proprioception as a fundamentally embodied and nonvisual modality of experience, and one that—by lending affectivity an autonomy from and a priority over perception—takes Bergson's analysis to its logical conclusion. As an example *par excellence* of the digital ASW, the experience of *skulls* yields a bodily intuition of internal, affective space that itself forms "a sensually produced resemblance" to the forces of our digital technosphere. Like the concept Deleuze develops in his study of painter Francis Bacon, such a produced resemblance does not in fact resemble the forces it channels; rather, it emerges as the result of a bodily processing of these forces that, in this case, also happens to be the very medium of the "resemblance"—the affectively attuned, haptic, or tactile body functioning as an "aesthetic analogy" for the digital realm.

Insofar as it catalyzes a shift to a production of haptic space within the body, *skulls* perfectly encapsulates my argument concerning the distinction between the virtual and the digital and underscores the crucial connection of the former with human embodiment. Rather than deploying the digital as a new vehicle of expression, Lazzarini mobilizes the digital in order to provoke a virtualization of the body. What *skulls* affords is, consequently, not a direct apprehension of an alien space that *is* digital, but a bodily apprehension of just how radically alien the formal field of the computer is from the perspective of the phenomenal modes of embodied spatial experience. In the end, it is this difference that forms the "content" of our experience of *skulls:* by presenting us with warped indices of a weird, inhuman topological domain, the installation provokes an affective response—bodily spacing or the production of space within the body—that is unaccompanied by any perceptual correlate. In so doing, *skulls* extends our previous analysis of bodily spacing beyond the domain of VR, demonstrating that it comprises the affective basis for *all* so-called perceptual experience and that affectivity is also operative independently of perception in *nonvirtual* sensory experiences. As an aesthetic mediation of the digital that can only be felt, *skulls* furnishes eloquent testimony of the generalized priority of affectivity and embodiment in the new "postvisual topology" of the digital age.

The Digital Any-Space-Whatever

With his concept of the any-space-whatever (ASW), Deleuze furnishes a means to appreciate what is at stake in the spatial problematic presented by Lazzarini's work and the larger body of digital art for which it stands. For if the digital space we encounter in *skulls* can be understood as an extension of the cinematic ASW, it is one that overturns its basic structure: its constitution through the extraction of an underlying potential or singularity from empirical or lived space. In the digital ASW, that is, we encounter a space whose potential or singularity is simply unrelated to any possible human activity whatsoever, such that the problematic it presents us is—not unlike the digital facial image analyzed in chapter 4—that of establishing contact with it in the first place, of forging an *originary* yet *supplementary* analogy.

Initially drawn from his analysis of Robert Bresson,[18] Deleuze's concept of the ASW finds its exemplary expression in the European cinema of the postwar period. As Deleuze sees it, this cinema can be characterized as a direct response to a vastly changed urban topography.[19] Effectively, the ASW discovers a historical motivation in the bombed out environments of postwar Europe: it is these environments that inform the desolate, haunting spaces of Italian neorealism where characters could no longer find their bearings. Faced initially with "disconnected" spaces, and subsequently with "empty or deserted" spaces, the sensorimotor *actors* of the movement-image cinema became instead the *seers* of a new cinema of pure visual and auditory images. In these images, moreover, characters are said to confront the pure potentiality of space, a potentiality strictly correlated with cinematic space and the "mutation" involved in the cinematic ASW.

Réda Bensmaïa has shown how the operative principle of the Deleuzean any-space-whatever can be found in this *mutation* to which Deleuze's thought submits empirical concepts of space like Marc Augé's "non-place" or Michel de Certeau's "place of practice."[20] For what Deleuze's analysis of the ASW accomplishes is the extraction, from such empirical notions of place, of a "pure potentiality."[21] Applied to empirical conceptualizations of place, this same virtualization of affection underwrites a fundamental philosophical mutation of space itself. Whereas the analyses of an Augé or a de Certeau "are negotiated in the geometric terms of 'elementary forms' which homogenize [place] in the

process of de-singularizing it," Deleuze submits the any-space-whatever to an analysis that "pushes it towards what is most singular. . . ."[22] By constructing ASWs through shadow play, oscillation of light and dark, and colorism,[23] cinema might be said to liberate the untapped potential lurking in the empirical spaces of the postwar situation, and to do so precisely by transforming these into a "system of emotions" that opens their virtual affective force to thought. Bensmaïa distills the "formula" for this mutation: "the space called 'whatever' is transformed into a 'philosophical persona' when it becomes the instrument of a 'system of emotions.'"[24]

The radicality of this philosophical mutation of space notwithstanding, we must not forget that the cinematic ASW stems from an analogy with real, experiential spaces. There is, in short, a preexisting *analogical* connection linking the cinematic ASW with the existential ASWs of postwar Europe, as Deleuze's preface to the English translation of *Cinema 2* makes altogether explicit:

Why is the Second War taken as a break? The fact is that, in Europe, the post-war period has greatly increased the situations which we no longer know how to react to, in spaces which we no longer know how to describe. These were "any spaces whatever," deserted but inhabited, disused warehouses, waste ground, cities in the course of demolition or reconstruction. And in these any-spaces-whatever a new race of characters was stirring, a kind of mutant: they saw rather than acted, they were seers. . . . Situations could be extremes, or, on the contrary, those of everyday banality, or both at once: what tends to collapse, or at least to lose its position, is the sensory-motor schema which constituted the action-image of the old cinema. And thanks to this loosening of the sensory-motor linkage, it is time, "a little time in the pure state," which rises up to the surface of the screen.[25]

In the "space" of this remarkable passage, we witness the almost seamless transmutation of "reality" by the cinema: in claiming the historical spaces of the postwar period as the catalyst for a "new race of *characters*," Deleuze has already crossed from the empirical-historical register to the domain of cinema.[26] It is as if the war brought about a *becoming-cinema* of experience, a fundamental transformation of human beings as existential actors into cinematic seers. That said, the very existence of an "original" correlation between the cinematic ASW

and empirical space means that there is a preexistent analogy between the human experience of space and the cinematic ASW.

It is precisely such a preexistent analogical basis that is missing in the case of the digital ASW. Unlike the cinematic ASW, this latter emerges from the bodily processing of a spatial regime that is, as it were, radically *uninhabitable*—that simply cannot be entered and mapped through human movement. This ontological difference bears directly on how affectivity can be tied to the ASW—on its capacity to become the *medium* for the experience of the ASW. For, whereas in the cinematic ASW, affection is the formal correlate of the cinematic (perceptual) act of framing, in the digital ASW, affection comprises a bodily *supplement,* a response to a digital stimulus that remains fundamentally heterogeneous to human perceptual (visual) capacities. In sum, affection becomes affectivity. To grasp this difference, consider the variant function of "tactile space" in the cinema and in digital media. When he describes Bresson's ASW as "a tactile space," Deleuze invests the tactile as an alternate visual regime: one that organizes vision in terms of what art historian Adolf Hildebrand famously called the *Nahbild* (literally, the "near-image").[27] Here, tactile space does not so much break with the dominant ratios of human perception as readjust them, and the capacity to experience the ASW is guaranteed, as it were, by the underlying perceptual analogy between the cinematic "tactile space" and the operation of a human mode of tactile or haptic vision. By contrast, the tactile or haptic space catalyzed by digital installations like *skulls* presents a more fundamental shift or realignment of human experience *from* the visual register of perception (be it in an "optical" or "haptic" mode)[28] *to* a properly bodily register of affectivity in which vision, losing its long-standing predominance, becomes a mere trigger for a nonvisual haptic apprehension.

To grasp this difference concretely, let us briefly consider the work of another contemporary digital artist, Craig Kalpakjian. Like Lazzarini, Kalpakjian migrated to digital art from sculpture, discovering in the former the possibility to move from the object to space itself. Explaining this transition in his own practice, Kalpakjian underscores the direct correlation between digital design and space: "It seemed like the sculptural objects became the things that everyone wanted to focus on, and I was really more interested in the space around them. I thought that as a medium these programmes could explore space more directly."[29] To bring this intuition to material fruition, Kalpakjian deploys the computer as a vehicle to create digital images of spaces that have no real-world

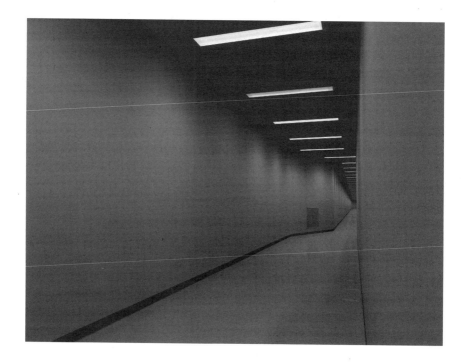

Figure 6.2
Craig Kalpakjian, *Hall*
(1999). Courtesy of the
artist and Andrea Rosen
Gallery. Continuous
video loop of movement
through a hallway with-
out any exits or
windows.

referents. Video presented the artist with an initial means to eliminate the object from his practice; his first nonsculptural work, *Hall* (1999) is a continuous video loop of movement through a hall without any exits, which generates in the spectator a vertiginous feeling of being trapped in a deadly, because thoroughly generic, space (figure 6.2). Kalpakjian's subsequent shift from video to still images produced entirely on the computer allowed him to eliminate movement as well. His digitally composed images of corporate air ducts (in works like *Duct* [1999] *HVAC III* [2000] and *HVAC* IV [2000]) confront us with neutral, generic spaces that have been thoroughly depotentialized, that is, stripped of all signs of force (figure 6.3). Viewing these oddly pristine images, we are made acutely aware of the capacity of movement—even the allegedly "inhuman" movement of the video camera—to introduce an analogical connection between our perception and space.

Kalpakjian's aesthetic strategy can be understood as a drive to short-circuit precisely this analogical connection without embracing the technicist logic of computer graphics that forms the motor of Kittler's radical posthumanism. To do so, he creates images that are literally supersaturated with in-

Figure 6.3
Craig Kalpakjian, *HVAC III* (2000). Courtesy of the artist and Andrea Rosen Gallery. Digitally composed still image of corporate air duct superposing incompossible shadows and lighting effects.

formation, but that nonetheless address the constraints of human perception.[30] In a work like *Duct*, for example, Kalpakjian builds in information from incompossible perspectives in order to highlight the extraction of human presence from the artificial corporate spaces he renders (figure 6.4). The technical fact that these images are entirely computer-rendered is thus made experientially salient via the embodied, aesthetic process of assimilating these incompossible perspectives. What results is something like "a claustrophobic hall of mirrors," as the brochure to the Whitney "Bitstreams" exhibit puts it, except that this space does not resolve in optical-geometric terms, but rather, via the various lighting effects supersaturated into the image, superposes what would in Euclidean space constitute incompossible visual "grabs." The resulting space is certainly tactile, but in a sense altogether different from that which Deleuze associates with Bresson (and with the larger art historical tradition it instances): here space becomes tactile precisely to the extent that it ceases being visual or mappable through vision (whether as distance or near viewing, i.e., in optical or haptical modes). It is tactile because it catalyzes a nonvisual mode of experience that *takes place* in the body of the spectator, and indeed, as the production of place within the body.

Figure 6.4
Craig Kalpakjian, *Duct* (1999). Courtesy of the artist and Andrea Rosen Gallery. Builds in information from incompossible perspectives to highlight the extraction of the human presence from the image.

Because of its implicit reference to Augé's notion of the "non-place," Kalpakjian's work helps us appreciate another crucial difference demarcating the digital ASW from its cinematic cousin: far from being the virtual correlate of an empirical space, the digital ASW emerges as a response to the rapid and in some sense "inhuman" acceleration of life in the age of global, digital telecommunications. In this respect, Augé's theorization of the non-place forms the very antithesis of the Deleuzean ASW: for Augé, the problem is "not the horrors of the twentieth century (whose only new feature—their unprecedented scale—is a by-product of technology), nor its political and intellectual mutations, of which history offers many other examples," but rather the temporal and spatial situation we confront in the face of contemporary technology: "the overabundance of events."[31] The problem, in short, is the radical disjunction between the technical capacity for producing events (instantiated

or expedited by the digital computer's ahuman acceleration of formal operations) and the human capacity to experience those events.[32] As the site for the production of the event, the non-place thus demarcates a space that has *always already been de-actualized*—a space without any "original" analogical correlation with human activity.

As exemplified in the process catalyzed by Kalpakjian's digitally created spatial images, the digital ASW can be understood as a radical transmutation of the non-place: works like *Duct* offer images of non-places that are designed to trigger a bodily response and thus to reinvest the body as a privileged site for experience. Such *images* of non-places are fundamentally antithetical to the empirical non-places analyzed by Augé and by contemporary architects like Rem Koolhaas.[33] For, as both Augé's analysis and Koolhaas's application of it to contemporary "global" architecture attest, non-places are, despite their impersonal neutrality, nonetheless intended as sites for "generic" *human* activity; although they may bring about a shift to "disembodied" modes of social interaction (i.e., disembodied in the sense of "stipped of particularity"), they still function as spaces for empirical activity and are to this extent marked by an "original" analogy with the human. It is as if space and activity were governed by a strict principle of reciprocity: just as identity "happens" only when the user of a non-place proves his innocence,[34] non-places materialize only at these same moments when they function as vehicles for social control over human bodies. Kalpakjian's images, on the other hand, function by foreclosing all possibility of human entry, and precisely for this reason, they catalyze the production of a space within the body that is without direct (perceptual) correlation with the non-places they present. Kalpakjian's digital images thus part company with Augé's non-places to the extent that they foreground the autonomy of the digital image—its status as what the artist calls "completely abstract points."[35]

Up to a point, we can compare Kalpakjian's transformation of the non-place with Deleuze's transformation of the "disembodied" and "empty" spaces of postwar Europe: just as the cinematic ASW extracts the potential from empirical space, the digital ASWs triggered by Kalpakjian's images tap into the potential latent within contemporary non-places. In light of such a consequence, what Kalpakjian's work offers to experience is not the images of empirical non-places, but the *infraempirical* forces underlying their production. Insofar as these forces emerge from the digital mediation of the event—and specifically, from

the "overabundance" of events that results from this mediation—Kalpakjian's images catalyze a corporeal apprehension of the mutation in the correlation of space and time (i.e., in the very basis of empirical experience) effectuated by the digital. In this respect, they comprise a concrete instance of what Edmond Couchot calls "time-objects," objects of which time—here understood as a cipher for the triple overabundance constitutive of supermodernity—comprises an essential formal component. Just as digital design processing presents us with virtual objects that cannot be fabricated, the incorporation of time (the triple overabundance) into the image presents us with intervals between forms or spaces that cannot be actualized, or more precisely, that can be actualized only as the process of transformation itself. Insofar as they can only be felt (or experienced through the affects they catalyze), such "virtual images" are not images of empirical spaces but rather triggers for the process of bodily spacing from which concepts of empirical space (including the non-place) emerge. It is precisely to stress its status as a transformation that takes place "*between* forms" (or empirical places) that Couchot dubs this autonomous domain of process "diamorphosis."[36]

This engagement with the non-place as a "time-object" strains the homology with the Deleuzean mutation. Given the specific problematic presented by the digital image—the difficulty of forging any analogical connection to it whatsoever—the mutation of the non-place into the digital ASW will have to follow a wholly different trajectory from the one pursued by Deleuze. What is called for is not a potentialization of digital space itself so much as a potentialization of our capacity to generate spatial analogy within our own bodies. Instead of a *deactualization* that transforms the ASW into a "new figure of Firstness" or "system of emotions," what is needed is a supplementary *actualization* that articulates the always already *deactualized* spaces of the digital with the constitutive virtuality of our bodily activity. In short: we must combine the potential of the Deleuzean ASW with the productivity or creativity of the body such that the body itself becomes the "place" where space is generated.

How Can We Restore Belief in the World?

Of all the questions one could pose to the modern cinema, this one (how can we restore belief in the world?) certainly looms large for contemporary readers of Gilles Deleuze's *Cinema 2.* Faced as we are with the standardization

of digital processing and the specter of "digital convergence," we have every reason to doubt the philosophical burden Deleuze accords the modern cinema of purely visual and sound situations. How can such purified images—images that are at heart (at least within today's media ecology) only contingent configurations of information (digital data flow)—possibly restore our link with the world? From where does belief acquire its efficiency, if not from the sensorimotor body left behind following the "crisis of the action-image"? And can thought—even when it is provoked by the intolerable, the impossible, the unthought—still succeed today in conferring reality on the purely imaginary?

If raising the question of belief today requires us to rethink what Deleuze (following Pasolini) calls the *theorematic* basis of cinema's construction of space (space as the correlate of a formal logic internal to the image), it does so first and foremost because digital modeling of space would seem to overturn the subordination of technics to aesthetics that lies at the heart of Deleuze's theory. In the digital space-image, it is the technical basis of the image itself that alters or catalyzes the alteration in our relation with space: thus, in *skulls,* what causes the installation space to become visually impenetrable is precisely the digital transformational process to which Lazzarini submits the original, nondeformed skull. The projected installation space does not simply happen to be uninhabited at a certain moment; it is *uninhabitable in principle.* Moreover, affect cannot be extracted from this projected space for the precise reason that it was never there in the first place; this space is a radically nonhuman one, one without any analogical correlation to human movement and perception, and one into which affection can be introduced only from the outside, as a supplement that originates in the embodied response of the viewer-spectator. Accordingly, rather than a virtuality emanating from the image itself (the "problematic" or "theorematic" catalysis of thought),[37] what the digital modeling of space both introduces and solicits—as an activity necessary for its own constitution—is the *virtuality of the body itself.*

This conclusion has profound implications for how we configure the problem of restoring belief in a world where the sensorimotor logic internal to the image has been radically suspended. Among other things, it returns us to the correlation of body and affection that was so central to Bergson's understanding of the body as a "center of indetermination." Specifically, it allows us to appreciate that affectivity, beyond its function as a bodily element contaminating

perception, itself forms the source from which belief—that is, belief in a perceived world—acquires its force. Such an understanding of the affective basis of belief follows directly from Bergson's deduction of the body as a privileged image:

> My perception . . . gradually limits itself and adopts my body as a center. . . . [I]t is led to do so precisely by experience of the double faculty, which the body possesses, of performing actions and feeling affections; in a word, *it is led to do so by experience of the sensori-motor power of a certain image,* privileged among other images. For, on the one hand, this image always occupies the center of representation, so that the other images range themselves round it in the very order in which they might be subject to its action; on the other hand, I know it from within, by sensations I term affective, instead of knowing only, as in the case of other images, its outer skin. There is, then, in the aggregate of images, a privileged image, *perceived in its depths and no longer only on the surface*—the seat of affection and, at the same time, the source of action. . . .[38]

Not surprisingly, the paradigmatic example of this "double faculty" is touch, a point that links Bergson's analysis to that of phenomenologists like Merleau-Ponty and Hans Jonas. Indeed, with his demystification of the "nobility of vision" and exposition of its dependence on the lowlier (bodily) sensory modalities, Jonas brings out the crucial connection between Bergson's position and the problematic of belief.[39] For Jonas, tactility is the source of the "resistance" or "impact" that "brings the reality of its object within the experience of sense," and affectivity is the modality through which I come to feel (or to believe in) this reality: "external reality is disclosed in the same act and as one with the disclosure of my own reality—which occurs in self-action: *in feeling my own reality by some sort of effort I make, I feel the reality of the world.*"[40]

To understand how affectivity can confer reality on our sense experience (including perception) we will have to modify our conception of the sensorimotor interval in a fundamental manner. For as the source of the force of sensation, affectivity does not simply occupy the interval between a sensory stimulation and a motor response; rather, it opens an interval within the body itself—an interval that allows the body to act on itself and thus to operate as

an internal space, or better, as a continuous bodily spacing. As cultural critic Derrick de Kerckhove points out, it is precisely such an internal interval that is at issue in aesthetic experimentations with digital media:

> The only sense in which we can truly trust is touch, because it is through touch that we really exist [*denn er ist da, wo auch wir wirklich sind*]. Through the vehicle of electricity, we are in contact with the whole world. Thus only the rediscovery of proprioception will make it possible for us to trust in our feelings, in the sense not of emotions which accompany us in daily life, but of the much deeper sensation of being in the center of our own perception of the world that surrounds us. This form of intercourse with information . . . is rooted in a fully realized proprioceptive sense. It calls on us to transform our personal center of reference [*Bezugszentrum*] into a "point of being."[41]

This "deeper sensation of being" is precisely the reality-conferring affectivity that, de Kerckhove claims, has become instrumental in today's informational universe. Accordingly, in calling for a transformation of our "personal center of reference" into a "point of being," de Kerckhove proposes the very shift I have been urging in reference to Bergson's theory: from the body as a filter of preexistent images to the body as a "proprioceptive interval" that extracts a lived space from the universal flux of information and in so doing restores the possibility for belief in the world.

In line with this shift, the internal interval of affectivity calls for a supplementation of Deleuze's account of the affection-image—a reembodiment of the affection-image in the form of the digital ASW. This supplementation introduces yet another mutation of the affection-image following in the wake of the transformation of the close-up into the (cinematic) ASW. While the close-up affection-image haunted the cinema of the movement-image generally as a potential cog in the sensorimotor circuit, and while the ASW, by liberating the force of affect from the close-up, formed the genetic principle for a "problematic" or "theorematic" understanding of space, the digital ASW *reinvests the body* as the productive source of affection. In dubbing this mutation the internal or proprioceptive interval, my intention is precisely to mark its difference from the interval as it functions in the previous moments:[42] rather

than a gap or indetermination separating an internalizing sensation and an externalizing response, and rather than a "pure" interval liberated from the sensorimotor circuit altogether, what we encounter in the digital ASW is an interval *within* the body, a *supplementary* interval that establishes affectivity as a *sensorimotor* power of the body itself.[43]

Producing Resemblance through Sensation

We can now formulate the crucial question posed by the problematic of the digital ASW: how can the sensation of "reality" generated by the internal (affective) interval be correlated with the informational universe that is, in some sense, its catalyst? Put another way, how can an analogy be produced in the absence of any preexistent resemblance between body and informational environment?

Deleuze's concept of the "sensually produced resemblance" takes up this problematic. Introduced at the end of his study of the painter Francis Bacon, this concept invests in the possibility for *analogy to be produced as a supplementary resemblance:*

> [E]ven when analogy is independent of every code, one can still distinguish two forms of it, depending on whether the resemblance is the producer or the product. Resemblance is the producer when the relations between the elements of one thing pass directly into the elements of another thing, which then becomes the image of the first—for example, the photograph, which captures relations of light. . . . In this case, analogy is figurative, and resemblance remains primary in principle. . . . On the contrary, one says that resemblance is the product *when it appears abruptly as the result of relations that are completely different from those it is supposed to reproduce:* resemblance then emerges as the brutal product of nonresembling means. We have already seen an instance of this in one of the analogies of the code, in which the code reconstituted a resemblance as a function of its own internal elements. But in that case, it was only because the relations to be reproduced had themselves already been coded, whereas now, in the absence of any code, the relations to be reproduced are instead produced directly by completely different relations, creating a resemblance through nonresembling means. *In this last type of*

analogy, a sensible resemblance is produced, but instead of being produced symbolically, through the detour of the code, it is produced "sensually," through sensation. The name "aesthetic Analogy" must be reserved for this last eminent type, in which there is neither primary resemblance nor prior code, and which is both nonfigurative and noncodified.[44]

What would affective bodily spacing be if not an "aesthetic Analogy" in precisely this sense—that is, an analogy forged through sensation rather than figuration or coding? By calling into being an interval internal to the body, the affective experience catalyzed by *skulls* forms a nonresembling, bodily correlate to the stimulus of the information environment. Unlike all previous technical frames, which form "figurative" analogies, and unlike digital coding, which operates on the basis of preconstituted, produced analogies, what is at issue in the digital ASW triggered by *skulls* is an indirect, supplementary bodily analogy.

In this respect, Deleuze's conceptualization of sensually produced resemblance furnishes something of an updating of his neo-Bergsonist ontology of the cinema.[45] Specifically, the priority he accords analogy or "analogical language" as the condition of possibility for both figurative analogy and digital code[46] correlates the subtractive function of the center of indetermination—that is, the basis of his neo-Bergsonist reinvestment of the cinematic frame—with the "modular" ontology of information. Precisely this correlation is at stake in Deleuze's appropriation of the concept of "modulation" from music theory. As a figure of the "proto-analogical," or the analogical beyond analogy, modulation serves to differentiate the digital and the analogical in two concrete ways: first, whereas the digital sound synthesizer is "integral," analogical synthesizers are "*modular*"; and second, whereas the digital filter proceeds by additive synthesis of elementary codified "formants," the analogical filter involves *subtraction* of frequencies. Analogical modulation thus combines an "immediate" and "literally unlimited possibility of connection" between "heterogeneous," but necessarily "actual and sensible" elements, with an addition or additive synthesis of "intensive subtractions" that constitutes "sensible movement as a fall."[47]

At first glance, these two functions appear to reproduce the two processes central to Bergson's concept of the movement-image: the universal flux of images and the subtraction that constitutes the body as a privileged image or

"center of indetermination." Yet, as Deleuze explains in the recapping that begins *Cinema 2,* modulation effects an interpenetration of the two processes that challenges the discrete givenness of matter in the form of images:[48] "The movement-image is the modulation of the object itself. We encounter 'analogical' again here, but in a sense which now has nothing to do with resemblance, and which indicates modulation, as in so-called analogical machines."[49] As in the case of painting, modulation is thus said to underlie resemblances of both sorts—analogical similarity (in the narrow sense) and digital code. Indeed, it is what introduces movement into these equally static forms of resemblance: "The similar and the digital, resemblance and code, at least have in common the fact that they are *moulds,* one by perceptible form, the other by intelligible structure. . . . But *modulation* is completely different; it is a putting into variation of the mould, a transformation of the mould at each moment of the operation."[50] This function has particular significance for Deleuze's understanding of the capacities and limitations of the digital, not only as concerns cinema's capacity to accommodate the "electronic image," but for all systems that would seek to ground themselves in the operations of code. In other words, modulation is what effectuates the potential latent in digital coding: "If [modulation] refers to one or several codes, it is by grafts, code-grafts that multiply its power (as in the electronic image). By themselves, resemblances and codifications are poor methods; not a great deal can be done with codes, even when they are multiplied. . . . It is modulation that nourishes the two moulds and makes them into subordinate means, even if this involves drawing a new power from them."[51]

Still, even as it significantly nuances Deleuze's commitment to Bergson's ontology of images, this application of the concept of modulation to the cinema cannot overcome the limitations of his conceptualization of the digital. Despite indications to the contrary, Deleuze's analysis continues to invest in the disembodied reality-conferring capacity of cinematic framing; it accordingly fails to grapple with the challenge posed by the informational ontology of the contemporary technosphere—namely, the fundamental absence of any preexistent connection with embodied life and the necessity to invest the latter as a sensorimotor force *supplementary* to the image.

What is at stake in the digital ASW triggered by Lazzarini's *skulls,* by contrast, is a process of modulation that is operated *by the affective body itself.*

Here we encounter a situation where digital decoding is precisely *not* put in the service of producing analogy through a familiar image frame (photograph, cinematic shot, video still, etc.), but is instead liberated from any preexistent analogical correlation with human perceptual experience. Accordingly, rather than reconstituting the identity of image and object—the complementarity of the center of indetermination and the (objective) universe of images—*skulls* effectuates a disjunction between the universal flux of information and the perceptual center of indetermination. Unlike the cinema, which deploys the movement-image to modulate the object, *skulls* offers us analog "moulds" of a digital process or modulation with which we can have no *systemic*—that is, reality-conferring—relation.[52] In Lazzarini's work, the digital does not *reproduce* so much as it *deforms.* Far from treating the digital as code, Lazzarini invests it as an autonomous source of modulation—what we might call the modulation of information—that *indirectly* triggers analogy, in the form of the sensually produced resemblance generated through embodied response to it. Accordingly, what *skulls* presents is the catalytic potential of the digital *once it is freed from the requirement of analogy.* Despite its origin in a digital decoding of a common object (a human skull), *skulls* functions by effectuating the potential of digital processing beyond the scope of reproduction.

This function of *digital modulation* separates the contemporary problematic of the digital image (and the digital ASW it catalyzes) from Deleuze's cinematic model of the image as a "system of reality." For in digital modulation, we encounter the potential of digital processing to open autonomous "informational universes" that simply possess no necessary correlation with our perception, or, put another way, that operate entirely *beyond* or *outside* analogy.[53] As exemplified by *skulls,* new media art acquires its function from its negotiation with digital modulation understood in this sense. In catalyzing the process that I am calling the digital ASW—the production of space within the affective body—what *skulls* does is transform the body into a sensually produced resemblance *to the infosphere.* Without directly resembling the modulation of information to which it is fundamentally heterogeneous, this sensually produced resemblance furnishes an aesthetic analogy for the latter, in the sense that it comprises its embodied human correlate. New media artist and critic Kathy Rae Huffman has recently named this bodily analogy "media volume." For Huffman, the body, or embodied response, functions precisely to give form

or volume to the otherwise seamless flux of digital information: situated within today's global "transmission of . . . communication energies and impulses . . . , we participate in the network of intense frequencies that intrude into—and upon—the rhythm of the human body." Accordingly, insofar as it seeks to introduce "the trajectory of movement into experiential trails of electronic memory"—or, in my terms, to frame information through the sensorimotor body—contemporary media art aims to make physically experienceable "both tangible and intangible effects of this information bombardment."[54]

Although it breaks with the "system of reality" instantiated in the cinema, the modulation of the body catalyzed by Lazzarini's *skulls* does bear certain resemblances to Deleuze's analysis of the art of painting in his study of Francis Bacon. Just as the diagram functions in Bacon's practice to dissolve preexisting resemblances (*clichés* on the canvas or in the painter's mind), so too do the warped skull sculptures catalyze a deformation of the preinscribed reproductive vocation of visual perception.[55] And just as the Figure emerges out of a double movement of expansion and contraction *within the pictorial space,* so too does the affective reaction of the perceiver result from a simultaneous opening up and remapping of sensory modalities within the sensing body. Still, the affective body catalyzed by *skulls* differs in one crucial way from Bacon's Figure: it functions specifically to liberate sensation from the technical frame (the canvas or sculptural space). It thereby dissolves the role of pictorial space as a *container* of sensation—as an *objective* expression rendered autonomous from the process or event out of which it emerged.[56] Accordingly, whereas the sensually produced resemblance or Figure emerges from the modulation of those forces—plane, color, and body—*intrinsic to the pictorial space itself,*[57] the sensually produced resemblance operative in new media art involves the confrontation of two incompossible operations of modulation. Modulation in the context of today's infosphere defines, *at one and the same time,* what we might call the autonomous system of the digital and the embodied system of affection. Precisely because they are incompossible, these forms of modulation effect a split in the function of modulation, one that parallels the contemporary splitting of vision into properly machinic and reconfigured human (i.e., embodied) modalities. What *skulls* makes overwhelmingly salient is our need to forge a relation between these two forms of modulation: by confronting us

with a modulation from which we are fundamentally excluded, this work so-licits or catalyzes the production of a supplementary analogy through the em-bodied modulation that defines us as centers of indetermination. In other words, the advent of an autonomous *modulation* of the digital calls for a mod-ification in (our understanding of) the *modulation* of the body:[58] rather than a "Body without Organs" that "liberates the eye from its adherence to the or-ganism" and reinvests it "through color and line,"[59] modulation of the body concerns the body's proper virtuality, its potential to introduce, always from the outside and yet necessarily from *within* itself, a sensory element on the basis of which a produced resemblance can be forged.

The Internal Interval, or Affective Virtuality

In his account of the transition from *Cinema 1* to *Cinema 2,* Éric Alliez has traced the affection-image to Deleuze's analysis of sensation in the Bacon study: according to Alliez, Deleuze "poses the question of how cinematographic affec-tion 'explodes' in the neorealism–New Wave periods by means of the pictorial sensation that emerges from the Cézanne-Bacon lineage."[60] This lineage in-forms Deleuze's understanding of the tactile basis of the pure visual and audi-tory image:

> [I]t is the tactile which can constitute a pure sensory image, on condition that the hand relinquishes its prehensile and motor functions to content itself with a pure touching. . . . [I]t is Bresson . . . who makes touch an object of view in itself. Bresson's visual space is fragmented and discon-nected, but its parts have, step by step, a manual continuity. The hand, then, takes on a role in the image which goes infinitely beyond the sensory-motor demands of the action. . . . The hand doubles its prehen-sile function (of object) by a connective function (of space); but, from that moment, *it is the whole eye which doubles its optical function by a specifically 'grabbing' [haptique] one, if we follow Riegl's formula for indi-cating a touching which is specific to the gaze.* In Bresson, opsigns and son-signs cannot be separated from genuine tactisigns which perhaps regulate their relations (this is the originality of Bresson's any-space-whatevers).[61]

By forging a link between the ASW and the haptic tradition in figurative art, this passage configures the logic of sensation embodied in the Figure with the technical form of the cinematic image (the medium shot). Rather than a liberation of the tactile from the visual form of the image, what results from this configuration is a strong correlation of the ASW (the genetic element of the affection-image) with the haptical function of sight as it takes form in and orients the discipline of art history. Within the history of figural art, and also within contemporary art theory, the haptic designates a *mode of vision* that stands opposed to the optical mode. In the technical terms of art history, it names a type of figuration that requires close viewing (Hildebrand's *Nahsicht*) where vision becomes something like a simulated form of touching the object. Following the historicization proposed by art historian Alois Riegl, this haptic mode of figuration gives way to the optical mode (far-viewing, the *Fernbild*) and the form of geometrical perspective so central to art from the Renaissance on.[62]

In his study of cinema, as well as his monograph on Bacon, Deleuze deploys the haptic according to this art-historical vocation: for Deleuze, as for Riegl, the haptic forms the basis for an alternate mode of vision. In Bresson's any-space-whatever, the tactile linkages within the image play a role formally homologous with that of the diagram in Bacon; in both cases, that is, what is at stake is the "imposition of a violent manual space."[63] And if the tactile acts as a modulator in both cases, it is precisely because it recreates a properly *haptic* function *within sight itself:* "The diagram always has effects that transcend it. As an unbridled manual power, the diagram dismantles the optical world, but at the same time, it must be *reinjected into the visual whole, where it introduces a properly haptic world and gives the eye a haptic function.*"[64] In Bacon, it is the visual impact of color that grounds such a haptic world.[65] Likewise, in Bresson, it is tactility that opens the haptic within sight: freed from its sensorimotor function, the hand takes on the connective function, opening a visual space graspable only through haptic vision.

What would it take to move beyond the visual frame in which the haptic has been theorized? Would a conception of affection emancipated from vision allow us to grasp bodily modulation as the sensory production of a haptic space *within* the body itself? When he correlates the acceleration of televisual images with the awakening of proprioception, Derrick de Kerckhove begins to address such questions: "If we attempt to follow images," he notes, "we are always a step

behind. That leads to . . . the 'collapse of the interval' between stimulus and response. This is not necessarily a tragedy, because the collapse of the interval corresponds to the moment in which touch is rediscovered. Once information has become extremely complex and once it begins to emanate from various sources at the same time, it is often easier to 'feel' it than to try to understand it."[66] By displacing the tactile-haptic from the image to the body, de Kerckhove furnishes a refunctionalization of the interval fundamentally divergent from the one at issue in Deleuze's time-image. Whereas the latter liberates the interval from its sensorimotor vocation in order to couple it with the (irrational and hence creative) power of time, the digital image capitalizes on the external sensorimotor collapse—that is, the collapse of the sensorimotor logic of the *image*—by triggering the emergence of an *internal sensorimotor interval:* an interval that is not so much occupied by affection (like the movement-image), as it is constituted through affectivity *qua* the activity of the body on itself.

As we have seen, it is Bergson himself who postulates the existence of such a sensorimotor space *within* the body. As he sees it, affection is itself a kind of action distinct from perception:[67] "real" rather than "virtual" action. Thus, far from simply occupying the interval constitutive of perception, affection must be said to emerge *on the basis of another interval altogether:* the distance internal to the body as form. This understanding yields a view of the body as an active self-organizing (autopoietic) kernel possessing a virtuality proper to it.[68] Nowhere does this elemental coupling of affection and body emerge with more insistence than in the passage, already cited above, where Bergson correlates the sensorimotor power proper to the body with its status as a "double faculty."[69] As against Deleuze's reduction of the body to an aggregate of the three varieties of the movement-image, Bergson's conception of double sensation reserves a specific and irreducible function for affection: to occupy—and indeed to create—the space of the body. What this means is that bodily sensations are themselves extended: they *are themselves actions,* and as actions of the body on itself, they open an expressive—that is, affective—space within the body.

This understanding of affection as an extended internal interval—as affectivity—flies in the face of Deleuze's transformation of affection into a quasi-autonomous function within the cinematic image. For as a modality of action proper to the body, affectivity is irreducibly bound up with the function of the "organism as a whole" from whose sensorimotor "logic" it is thus

indissociable.[70] Far from being the autonomous element of Deleuze's reckoning, affectivity is thus imbricated within a larger organic unit. Indeed, the organism (or body) might be said to form a center of indetermination *within an affective space that is proper to it* (and, thus, distinct from the perceptual space of objects, i.e., the universe of images). Consider, in this regard, Bergson's account of pain as an action of the body on itself. Exemplary of internal sensation *per se,* pain involves a certain separation of a sense organ from the organism as a whole. Yet, despite the functional differentiation of sensory from motor elements that characterizes complex organisms like human beings, our sense organs "remain exposed, singly, to the same causes of destruction which threaten the organism as a whole."[71] While the organism is able to escape destruction by performing a motor action, the sense organ "retains the relative immobility" imposed on it by its differentiation from motor functions. Pain is thus, as it were, the expression of the impotence of a sense organ: a doomed effort on its part "to set things right" or, equivalently, "a kind of motor tendency in a sensory nerve."[72] What is crucial here is not this tendency by itself, as Deleuze maintains, but this tendency correlated with the movement (action) of the organism as a whole: "Every pain is a *local* effort, and in its very isolation lies the cause of its impotence, because the organism, by reason of the solidarity of its parts, is able to move only as a whole."[73] What this means is that affectivity comprises a *separate sensorimotor system internal to the body:* what Bergson describes as the body's "actual effort on itself."[74] That is why, incidentally, there can be no perception without affection (although there can be affection without perception): affectivity constitutes an interval within the internal space of the body, an interval between an isolated sensory organ and the action of the body on that organ. Affectivity, in short, names the body's agency over itself: the capacity of a sensitive element to isolate itself and to act on the whole body as a *force,* or rather, to catalyze the body's action on itself.

In this sense, affection supposes a virtual field of forces (affectivity): it constitutes "an internal space which isolates an effort or a *force* rather than an object or a *form.* Affectivity is a field of forces that is internal to the body, while perception is a space of external and objective forms."[75] Affectivity names the limitless potential for sense organs to isolate themselves and act on the body as forces. As a spatiality or spacing where the body is felt from within, rather than seen from without, affectivity "appears as a sort of permanent and diversified

experience of oneself, in a body which becomes in this way the body of *some-one,* and not only that of a living and acting being *in general.*"[76] What is more, affectivity infiltrates perception in a way that renders the latter irreducibility bodily and that reveals the full richness—the multimodality or, we might say, high bandwidth—of embodied perception.[77]

Affecting Haptic Space

This understanding of affectivity (the internal interval) as an experience of one's own bodily virtuality resonates with Brian Massumi's recent theorization of affect as "the perception of one's own vitality, one's sense of aliveness, of changeability. . . ."[78] According to Massumi, affects open a virtuality proper to, yet not confined within, the body: "Affects are *virtual synaesthetic perspectives* anchored in (functionally limited by) the actually existing, particular things that embody them. The *autonomy* of affect is its participation in the virtual. *Its autonomy is its openness.* Affect is autonomous to the degree to which it escapes confinement in the particular body whose vitality, or potential for interaction, it is."[79] Threading a path between Bergson's and Deleuze's respective conceptions of affection, Massumi's position combines the processual, virtual dimension of the Deleuzean time-image with Bergson's insistence that affection demarcates the potentiality of the body.[80]

For this reason, Massumi's work can help us understand how the body can respond to a digital any-space-whatever, like the one presented by Lazzarini's *skulls,* from which the possibility of bodily movement in space is, in principle, excluded. Following Massumi's negotiation of Deleuze and Bergson, we can fathom exactly what happens in the body when it acts on itself in order to produce an internal haptic space.

Crucial for this purpose is the differentiation Massumi introduces between movement-vision and proprioception. *Movement-vision* is "an *included disjunction,*" an "opening onto a space of transformation in which a de-objectified movement fuses with a desubjectified observer. This larger processuality, this *real movement,* includes the perspective from which it is seen."[81] The obverse of mirror-vision, movement-vision "grasps exactly and exclusively what mirror-vision misses: the movement, only the movement."[82] Accordingly, it comprises a form of "vision" that "passes into the body, and through it to

another space," into the "body without an image" where what is "seen" is movement extracted from its actual terms. This is an impossible "vision," a seeing with the body, an experience of the body's direct registering of movement. *Proprioception* is the flip side—or rather, the underside—of this bodily vision:

> The spatiality of the body without an image can be understood even more immediately as an effect of *proprioception,* defined as the sensibility proper to the muscles and ligaments. . . . Proprioception folds tactility into the body, enveloping the skin's contact with the external world in a dimension of medium depth: between exodermis and viscera. The muscles and ligaments register as conditions of movement what the skin internalizes as qualities. . . . Prioprioception translates the exertions and ease of the body's encounters with objects into a muscular memory of relationality. . . . Proprioception effects a double translation of the subject and the object into the body, at a medium depth where the body is only body, . . . a dimension of the *flesh.* . . . As infolding, the faculty of proprioception operates as a corporeal transformer of tactility into quasi-corporeality. . . . Its vectors are perspectives of the flesh. . . . It registers qualities directly and continuously as movement. . . .[83]

Movement-vision and proprioception, in short, comprise the visual and corporeal dimensions, respectively, *of a single perceptual experience.*

In Massumi's work on hypersurface architecture, this distinction between movement-vision and proprioception (and the opposition between two modalities of vision on which it is based) falls away, as the dialectical correlation of vision and proprioception takes on increased importance. Here, the emphasis is less on the limitations of vision per se, than on the embeddedness of vision within proprioception (and tactility).[84] This imbrication of vision and proprioception that Massumi discovers in hypersurface architecture anticipates the effects of Lazzarini's *skulls:* in both cases, there is a specific attempt made to short-circuit ordinary perception *by interrupting vision.*[85] Moreover, both hypersurface architecture and *skulls* foreground a certain experience of being lost as their respective catalysts.[86] But this parallel holds up only to a certain point, for the experience of disorientation in *skulls* is (as we have already

had occasion to note) a radical one: what we experience in *skulls* is not a local instance of perceptual disarray, one that calls on us simply to realign our perceptual modalities, but rather a *protracted failure* of our double-valenced orientational system. Instead of an adjustment in the dialectical correlation of movement-vision and proprioception, what is required is a shift from the former to the latter as a properly affective faculty.

In this sense, we might say that *skulls* forms a challenge to Massumi's correlation of vision and proprioception. By short-circuiting perception *as such,* *skulls* catalyzes the subsequent transformation of proprioception from a perceptual faculty into an affective one—into a vehicle for intuiting our own body in the very process of creating an internal analog for this space. Whereas hypersurface architecture yields a deepened notion of a *perceived* place "out there" (in the sense that place now encompasses the proprioceptively infolded movements that potentialize a locus), *skulls* yields an *affective* place "in here," a place *within* the proprioceptive body (in the sense that place is now completely self-referential, self-generated, and "tactile" in Deleuze's sense: purely intensive and without geometrical coordinates). Put another way, the production of affective place requires that proprioception be *detachable* from vision, that it be available to form the basis for a bodily sense or modality of affection not itself in the service of perception.

In light of this contrast, we can pinpoint exactly why *skulls* requires us to produce a haptic spacing within our bodies. In presenting us with a space from which our movement is radically excluded, *skulls* effectuates a divergence between vision and proprioception that cannot be resolved through a synesthetic realignment. Yet if vision is severed from bodily movement in this experience, it is nonetheless *doubled* by what we might call *affective proprioception,* that is, a form of bodily sense that has no intrinsic correlation with what is seen, that does not function in the service of perception, and that consequently defines a *creative, autopoietic* response *on the part of the body itself.* Put in the art-historical terminology employed by Deleuze, we could say that *skulls* solicits a haptic mode of vision that cannot anchor itself in anything *pictorial* or s*culptural* and that consequently requires us to transform the haptic *from a modality of vision (perception) into an modality of bodily sense (affection).* Rather than yielding to a mode of visuality consistent with sculptural form, the complex folds and

hollows of these warped skulls generate a total short-circuiting of vision and a violent feeling of spatial constriction that manifest, literally, as a haptic experience of the space of the body.

As exemplified in the experience of *skulls,* this transformation proceeds through two stages, both of which deform Massumi's concepts to subtle, yet significant effect, and which together transform the affective body into a sensually produced resemblance—into the very medium or support of the work's "figuration." First, what *skulls* offers as a haptic mode of vision must be converted into tactility through response. Because actual bodily movement is foreclosed as a means of experiencing the work, whatever haptic vision it solicits lacks any correlation with tactility, even in the virtual form envisaged by Massumi. Consequently, tactility can be generated only by the movement that takes place *within* the body (affectivity as action of the body on itself) as it responds to this impossible solicitation. In this sense, it is precisely the suspension of movement-vision that triggers the ensuing, self-generated—we might even say, self-affecting—tactility. Second, what *skulls* offers as tactility—an intense and internal experience of being touched (though, remarkably, in the absence of any *physical* contact)—must subsequently be folded into the body in a way that "registers" it (and not what the "skin internalizes as qualities" from the outside) as "conditions of movement." In this sense, what is at stake here is precisely the shift from perceptual to affective proprioception, since the in-folding of tactility by the body serves not to realign the forces that disturbed perception (i.e., the ordinary cofunctioning of vision and proprioception), but rather to create a bodily spatiality that is without correlation to an externally projected (and perceived) space.

We can now pinpoint exactly what hangs on the distinction between movement-vision and proprioception. For although both can be said to involve properly bodily (that is, proprioceptive) modalities of sensation, the difference between them concerns the system in the service of which each labors: movement-vision names the bodily "underside" of vision, a form of proprioception oriented toward external perception, whereas proprioception proper designates the body's nonvisual, tactile experience of itself, a form directed toward the bodily production of affection (affectivity).

What is ultimately at stake in *skulls,* then, is the transformation of the haptic any-space-whatever (*espace quelconque*) into the haptic any-body-whatever

(or whatever body, *corps quelconque*).[87] This transformation extends the detachment of proprioception from vision just proposed, and indeed, requires something like a doubling of the haptic that parallels the doubling of proprioception. By contrast with the circumscription to which art history submits the haptic (namely, the dialectical coupling of a kinesthetic visual modality with an optical one),[88] the haptic at issue in the whatever body is a modality of spacing that has been wholly detached from vision, that has become affective. This autonomy of the haptic from vision finds a crucial precedent in Walter Benjamin's theorization of the shock effect of cinema. In laying stress on the physiological impact of cinema, Benjamin in effect transformed Riegl's categories, replacing the visual modality of the haptic with a properly bodily modality of the "tactile" [*taktisch*]. In this way, he managed to undo the sublimation of the tactile into the visual that is foundational for the discipline of art history. Film scholar Antonia Lant presents this inversion as the theoretical hinge of her account of space in early film: cinema "had no actual tactile properties of its own (in the dark the screen offered no modulated surface to feel)," which meant that these properties had to be supplied by the viewer, via the *physical* impact of the images on (or better, in) the viewer's body: cinema was "not *fernsichtig* but rather *nahsichtig*."[89] Benjamin's great insight was to have accorded this properly *tactile* modality of the haptic equal place alongside the more familiar visual modality: cinema, Lant continues, "is haptic both because of the cameraman's profilmic penetration of the world . . . and because of film's physical impact on the viewer, especially through its startling juxtapositions of scale, time, and space created in rapid editing. . . . Riegl's terms are [thus] inversely applied, now describing more the art maker and perceiver than the object. . . ."[90]

Following Derrick de Kerckhove, we can conceptualize this tactile modality of the haptic as a "seeing with the entire body." According to de Kerckhove, contemporary media involves a bodily miming that is entirely separate from vision, narrowly construed: "We understand moving spectacular experiences through submuscular integration and not, as for example is the case in dance, because we directly take part in them. In contrast to the interpretation of a pure mental representation, television offers a stresslike [*stressähnliche*] form of cognition. We understand what we see because we imitate or mime the events with our neuromuscular responses. . . . [C]oordinated and simultaneous alterations in our pulse [and] blood pressure . . . demonstrate that we see that

which we observe *with our whole body*, and not only with our eyes."[91] Indeed, de Kerckhove's argument helps us appreciate the metaphoric deployment of vision in the term "seeing with the entire body": rather than a bodily modality of vision (Massumi's movement-vision), what is at stake in the tactile modality of the haptic is an affective apprehension of space in which vision has, as it were, been assimilated into the body. The affective body does not so much see as *feel* the space of the film; it feels it, moreover, as an energized, haptic spatiality within itself. Set in this lineage, what *skulls* presents is a radicalization of the physico-physiological experience of cinema, since the digital space it projects is literally impenetrable to touch and can be felt only through an internal tactility that emerges in lieu of any external contact with it. The affective response does not arise when we place ourselves *within* the image, as it does in film, nor does it arise through our movement toward or away from a space that presents itself as autonomous (as is the case with the relief contour of antiquity).[92] Rather, the affective response produces place within our bodies, an *internal interval* that is radically discontinuous with, but that nonetheless (and indeed, for this very reason) forms an affective correlate to the digital topological manipulation of space.

Part III

Time, Space, and Body

Body Times

Theoretical Aim	Body	Image	Artwork
To trace the bodily capacity to create space to the temporal basis of affectivity	From affective body as the source for haptic space to affectivity as the bodily origin of experience *per se* (embodied temporality), including perception	From objective, perceptually apprehensible "object" to "subjective image" that can only be felt	*Transverser*; Reinhart and Wiedrich's *TX-Transform*; Gordon's *24-Hour Psycho*, Viola's *Quintet of the Astonished*

The Dutch Electronic Art Festival devoted its 2000 exhibition and program to the topic of "Machine Times." As stated in the accompanying catalog, the festival sought to highlight new media artworks that, in various ways, explore the "latitude that machine time allows us in the physical, artistic, musical, cultural, scientific, biological, and economic senses."[1] For all their diversity, the catalog introduction tells us, such explorations center on the confrontation of potentially incompatible embodiments of time: the lived affective temporality of human experience and the "intensive" time of machine processing. If the former temporality centers around the fusion interval of the "now," which, neuroscience has recently informed us, lasts approximately 0.3 seconds, the latter is, literally speaking, "beyond experience," that is, beneath the 0.3-second threshold. This latter, intensive time is, consequently, the time of digital information flow: "the time of e-mail and surfing, the time which eliminates space: arrival and departure occur in the same moment in real-time. . . . Intensive time is the time that exists only in machines and between them, the context of the slow human 'now.'"[2]

A similar understanding of the embeddedness of human within machine time informs Stephanie Strickland's recent analysis of Web-based hypermedia. According to Strickland's analysis, Web literature and art "exploit different aspects of the time-based human perception process," furnishing unique opportunities for play "with the fusion interval limits" and the "synchronized neuronal patterns that must be mobilized for action."[3] Web-based works offer our perceptual system a "new calisthenics" that enlarges the "window of the 'now'"; and they do so, specifically, by drawing our perceptual attention to more fine-grained levels of stimuli—"by bringing into consciousness many more of the microfluctuations and/or fractal patterns that had been

smoothed over, averaged over, hidden by the older perception and knowledge processes."[4]

As these analyses suggest, machinic processes have fundamentally altered the infrastructure of our contemporary lifeworld in ways that directly impact our embodied temporal experience. We now live in a world of around-the-clock information exchange where the profound increase in the speed of information-processing has greatly shortened response time in any number of cultural domains.[5] In this chapter, we shall take the phenomenon of machine time as a pretext for delving further into the operation of bodily spacing explored in the last two chapters. By unpacking the intrinsic correlation of temporality and affectivity, we will come to see that bodily spacing is consubstantial with the living present or duration. The example of contemporary neuroscientific research into time consciousness will help fill out the imbrication of space and time introduced above in chapter 5. While I there portrayed spacing as the condition for the givenness of time, I will now be able to reconfigure temporality as the medium for the spacing that we (following Ruyer) earlier called the absolute volume: insofar as it constitutes the sensory mode through which we experience the emergence of the present, affectivity simply *is* the *content* of bodily spacing.

How exactly, I shall ask, does affectivity correlate with the subperceptual time of information? Does it form a nonconscious neural scale of duration that somehow constitutes an embodied equivalent of machine time?[6] If so, can the time of information be understood to provide a catalyst for this nonconscious embodied equivalent? And can it do so even though information continues to be mediated for our perception through electronic machines—video recorders, televisions, and networked computers—that are indelibly "linked to our historical sense of time," to the "extensive time" of lived experience?[7] Finally, what role can new media art play in bringing the potential of intensive, machinic time to bear on human temporal experience? How can it broker an opening of embodied experience to the subperceptual registration of intensive time?

From Transition to Transformation: The Video Image

Much attention has recently been given to the role of the video image as a privileged mediator of the transition from the cinema to the digital. Media critic

Joachim Paech speaks for a host of scholars when he suggests that the video image has taken over the role formerly performed by the brain in transitioning from one image to the next; the video image, contends Paech, "dissolves the distance separating images."[8] Like the analyses for which it speaks, Paech's account foregrounds the singularity of the video image as a kind of mediator between extensive and intensive—human and machine—time. On the one hand, video is celebrated for its capacity to subsume the role formerly performed by the brain, and thus for its contribution to the autonomization of perception analyzed so perspicuously by critics like Paul Virilio and John Johnston.[9] (Just as the automation of vision technically materializes a capacity formerly bound up with human embodiment, the video image embodies the transition between images formerly possible only through the human perceptual apparatus.) Yet, on the other hand, video is given priority precisely because of its close correlation with the extrinsic time of human perceptual experience: insofar as it perpetuates the function of the image, video's function remains that of interfacing information *for human consumption.* Precisely on account of this double vocation, video (and particularly digital video) has been invested with the task of expanding our experiential grasp of the complex embodiment of temporal perception.

Consider in this regard two of the works featured in the "Machine Times" exhibition, both of which play with the space-time configuration constitutive of normal cinematic perception. Christian Kessler's interactive computer-video installation *Transverser* (*Querläufer*) comprises an apparatus for "rearranging the temporal and spatial structure of vision."[10] The installation transforms the movements of viewer-participants into a continuous stream of image and sound, what the project description glosses as a "time-space-distorted reflection of the viewers . . . , varying according to their movements in front of the installation." *Transverser* expands a technique already extensively deployed in art photography—namely, the technique of freezing a period of time in a still image in order to generate odd distortions of reality, such as the multiple appearance of a person in a photograph. In the installation, a slowly rotating camera scans only a small strip of the space at a time and gradually builds an image in which all that moves is deformed (figure 7.1).[11] Effectively, *Transverser* updates the classical model of chronophotography by using a computer and video camera as a way of autonomizing the

Figure 7.1
Christian Kessler, *Transverser* (2000). Reconfigures filmic projection such that temporally distinct images of a single space are superposed onto one another.

image of time: whereas the classical model required the brain to suture the discrete frames of movement, in *Transverser*, "the development of the images can be followed in real-time," as a continuous morphing of the viewer's movements into an ever growing and stretching strip of time.

The second work provides the possibility to build movies out of *Tranverser*-like images. The digital film, *TX-Transform,* makes use of a new film technique, also called TX-transform, that allows the time axis (t) and the space axis (x) to be transposed with one another. Like *Transverser,* this technique exploits the autonomy of the video image—its incorporation of the passage between images as a technical property of the image itself. In a TX-transformed film, a segment of video is reconfigured via the conjoining of the constant vertical scanning of the video image with the temporal progression of filmic frames. Progressively from left to right, the vertical lines constituting the video image correspond to their counterparts not in one filmic image, but in a series of filmic images, each one a fraction further away in time. In this way, each frame of the transformed movie scans the whole time-period from left to right (fig-

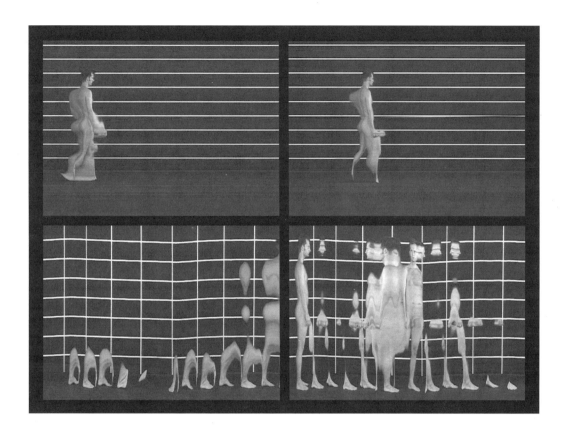

ure 7.2). As its inventors explain, TX-transform involves treating the film as an "information block" that can be "cut through" in variant ways; they compare it to a flip-book that furnishes sequential pictures on the space axis rather than the time axis.[12]

In their TX-transformed film, *TX-Transform,* Martin Reinhart and Virgil Wiedrich compress the substance of the theory of relativity, as mediated by Bertrand Russell's story of two brigands robbing a train, into a cinematic form. Their specific aim is to embody the idea of relativity sketched by Russell: the transversal transformation of film allows for a direct expression of the paradoxes of divergent frames of temporal reference. In this respect, the film exemplifies the capacity of the technique to "invert the system of filmic order": with TX-transform, "sequences can be produced in which filmic representation

Figure 7.2
Martin Reinhart and
Virgil Wiedrich, *TX-Transform* (2000). Generates filmic sequence of objects no longer fixed through spatial presence but rather as a condition over time.

is no longer fixed exclusively through the spatial presence of an object; rather its form depends upon a complex interplay of relative motions. Accordingly, an object on film is no longer defined as the likeness of a concrete form of existence, but rather as a condition over time."[13]

These two experiments with the cinematic order of images would appear to traverse the same territory as Gilles Deleuze's conception of the time image in *Cinema 2*. According to Deleuze, cinema acquires the capacity to present direct images of time when it displaces a totalizing aesthetic of the whole in favor of an opening to the outside. Such an opening to time is precisely what Deleuze identifies as the operative basis of the time-image: the opening of the image to something not only outside the frame, but *outside the "whole" set of images* that can potentially be framed, regardless of whether these be organized on the temporal axis or the spatial axis. Only by opening an "outside" "between two images" can cinema present a direct image of time.[14] Not only do *Transverser* and *TX-Transform* appear to effect precisely such an opening, but they seem to coincide perfectly, at least on initial glance, with the two types of "time-image" differentiated by Deleuze. By superposing temporally incompossible images of the viewer-participant in a single temporal frame, *Transverser* might be said to exemplify the first time-image: the "coexistence of sheets of past." And *TX-Transform,* insofar as it superposes incompossible temporal frameworks (the conductor has already been killed and has not yet been killed, the bullet has been heard and has not yet been heard), can be likened to the second time-image: "the simultaneity of peaks of present." Indeed, both works might even be thought to mediate these respective time-images beyond the limits placed on the cinema by Deleuze, for what they present us is not simply a "neurocinema" rooted in the isomorphism of brain and cinematic apparatus, but a richly embodied interface with the time-image. By presenting the time-image to our embodied perception, that is, these works transform it into the catalyst for a bodily reaction, a supplementary sensorimotor correlation: *Transverser* allows for a certain amount of play with the temporality of one's self-image, with the linearity of the self as a stable object through time; *TX-Transform* attempts to break open the rigidity of the cinematic order of images itself in favor of the flexibility of embodied perception, to present visual phenomena that "stimulate our perception as an elastic and alterable matrix."[15] In both cases, embodied aesthetic response appears to undergo a certain emancipation from the

technical image: instead of simply registering the force of the image, here the spectator's bodily response seems to move beyond a strict correlation with the image and thus to become the vehicle for an affective experience of itself.

In the end, however, this apparent emancipation is more a consequence of the disappointment of cinematic expectations (e.g., mapping the time axis rather than the space axis) than the result of a displacement of the correlation of cinema and the body–brain. Despite the attempt both works make to exploit the autonomy of the video image as a catalyst for a new perceptual experience of time, neither manages to create real "time-images," that is, direct presentations of time. Indeed, in both cases, time gets subordinated to space just as it does in the classical cinema, though certainly through new techniques and in novel permutations. (*Transverser* presents incompossible past moments in a continually morphing passage though a unified space, while *TX-Transform* "synthesizes" incompossible temporal conditions into the space of a single frame.) What is missing from both is an opening to the outside, an opening to time beyond the space of the frame and the open set of images that can be framed. Contextualized against this shift in the status of the whole, both *Transverser* and *TX-Transform* retain clear ties to the classical cinema. *Transverser* unpacks the dynamics of a temporal unit by projecting it spatially, and *TX-Transform* merely displaces the temporal basis of the "out-of-field" in favor of a spatial basis, but without undoing the image of the whole as an open set.

This limitation arises because these works attempt to carry out the transformation from the "movement-image" to the "time-image" *solely through the technical capacities of the video image.* Insofar as they wholeheartedly embrace video's technical subsumption of the transition between images, both works attempt to literalize the theoretical claims made for the video image. On this score, Deleuze's analysis would seem to furnish an important corrective: in teaching us that the time-image must be situated "between-images," or in other words, outside the image proper, he shows that the direct presentation of time cannot be a function of the image itself (the representational image)—a result of an internal modification performed by the image on itself—but can emerge only as a function of the gap between images, of the aesthetic organization of images to generate an interstice.[16] Accordingly, so long as it is understood from the standpoint of its technical autonomy, the video image simply cannot present a direct image of time. As the "passage capacity itself," the embodiment of

"processural visuality," or simply "transformation" incarnate, the video image can only ever make linkages, via the internal technical transformation of the image itself, between images.[17] For purely technical reasons, it simply cannot mark a cut between two series of images. Thus at the same time as it replaces the sensorimotor logic of transition (the classical cinema), video also displaces the formal linkage or irrational logic of the interstice (the modern cinema).

Yet before we rush to endorse current *clichés* about the video image—that it devalues cinema, or in a more Deleuzean vein, that it destroys thought—we would do well to recall the advice with which Deleuze chose to conclude his study of the cinema: whatever hope exists that cinema can be revitalized beyond cybernetics rests in the possibility of pursuing a "new will to art."[18] Specified in the terms of our analysis, this maxim calls on us to elevate an *aesthetic* deployment of the video image over—and indeed against—its technical capacities.

Perceiving the Video Image

Precisely such a new will to art is at stake in the career of Scottish artist Douglas Gordon, whose work forms something like an antithesis to the literalization of the technical capacities of the video image in *Transverser* and *TX-Transform*. Though Gordon works in a variety of media, his appropriation pieces involving digitial manipulation of found film footage are of particular interest to us here. In various works including *24-Hour Psycho* (1993), *Confessions of a Justified Sinner* (1996), *Through a Looking Glass* (1999), *left is right and right is wrong and left is wrong and right is right* (1999), *Déjà Vu* (2000), and *5 Year Drive-By* (1995–present), Gordon engages with issues of cinematic time, the time-image, and specifically the interstice or "between two images." Moreover, Gordon engages the temporal dimension of cinema through a practice that is specific to video not simply or primarily as a technical image medium but as the privileged mode through which images, as the material basis of contemporary perception, are actually lived or experienced. Gordon's essays and interviews repeatedly emphasize this aspect of video: again and again he insists that video time—the time of slow-motion, freeze-framing, and repetition—is the "given time" of his generation. Having grown up with

the video recorder, this generation "has lived a different relation to the cinema," one in which video slow-motion and freeze-framing function less as analytical techniques (as they were for an earlier generation of film scholars) than as instruments of desire: "with the arrival of the VCR," Gordon recounts, we lived a "different film culture, a replay culture, and a slow-motion take on things."[19]

Only in this context can we appreciate Gordon's account of the seminal moment in his apprenticeship as an artist—the genesis of *24-Hour Psycho:*

> In 1992 I had gone home to see my family for Christmas and I was looking at a video of the TV transmission of *Psycho.* And in the part where Norman (Anthony Perkins) lifts up the painting of *Suzanna and the Elders* and you see the close-up of his eye looking through the peep-hole at Marion (Janet Leigh) undressing, I thought I saw her unhooking her bra. I didn't remember seeing that in the VCR version and thought it was strange, in terms of censorship, that more would be shown on TV than in the video, so I looked at that bit with the freeze-frame button, to see if it was really there.[20]

This experience of the discordance between the TV and video versions of the film left Gordon with an overwhelming sense that, to put it in the terms of *cliché,* there is more there than meets the eye: that the flow of images itself—and specifically, the "space" between images—contains a wealth of information not directly presented by a given (and indeed by *any* given) viewing apparatus. The result, of course, is the work that marked Gordon's appearance on the international art stage—the monumental *24-Hour Psycho* (1993). In *24-Hour Psycho,* Gordon treats Hitchcock's most famous film as a piece of found footage that he reframes through technical modification and institutional displacement: specifically, he slows down its projection speed to 2 frames a second (instead of 24) and presents it in the space of an installation where the viewer-participant is encouraged to walk around what is in fact a double-sided image of the film projected on an elevated screen (figure 7.3).

The effect of this radically decelerated and decontextualized presentation of Hitchcock's most familiar film is an eerie experience of protracted

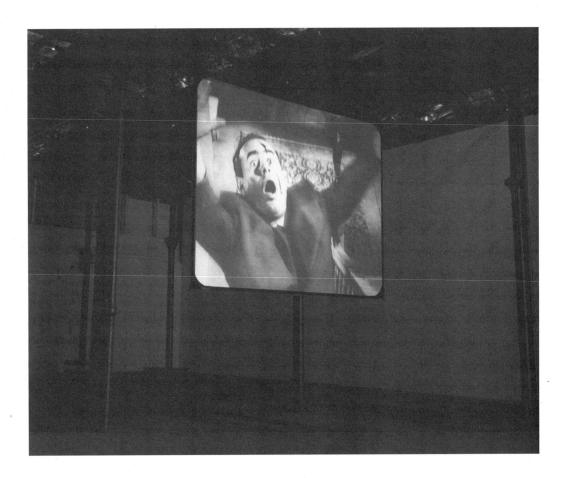

Figure 7.3
Douglas Gordon, *24-Hour Psycho* (1993). Projects Hitchcock's *Psycho* over twenty-four hours (at two frames a second) in order to foreground the problematic of viewer anticipation.

anticipation accompanied by a sobering insight into temporal relativity. Since the time any viewer has to devote to *24-Hour Psycho* is limited (in the extreme case, to the opening hours of a museum or gallery), her capacity to perceive the work is itself severely constrained (since no perception of the whole film is possible) and radically dependent on where precisely the film is in its progression when she enters to perceive it. More significantly still, these twin lessons concerning the intrinsic excess of "given time" are brought home to the viewer through the dynamics of affective anticipation: since the image changes only once every twelve seconds, the viewer quickly finds her attention intensely concentrated on anticipating this moment of change; moreover, as the viewer be-

comes more and more caught up in the halted progression of the narrative, this process of anticipation becomes ever more affectively charged, to the point of becoming practically unbearable.

Despite his attraction to material rich in psychological qualities,[21] Gordon's technical modifications of cinema are designed specifically to induce particular physiological effects: in various ways, his works submit their audiences to experimentations that call into play—and thus call attention to—the body's mediation of the interstice or between-two-images. Accordingly, the time-image Gordon foregrounds is one that must be said to occur in the act of reception, in the concrete activity performed by the embodied viewer-participant as she grapples with the specific problematic staged in the various works. In a way that resonates with contemporary neuroscientific research on perception, Gordon describes this time-image as a certain relativization not of the time frameworks within the image or between images in the film, but of the time frameworks of lived experience itself: "A lot of the work for me is about trying to induce a perceptual shift from where you are to where you were or where you might be. I'm fascinated by the fact that as a human being you can coexist on various levels simultaneously. So if someone was in a gallery and caught ten minutes of *24-Hour Psycho*, later, when they were out shopping, they might remember that it was still happening."[22]

To make this point concrete, we need simply enumerate a handful of Gordon's most important strategies: (1) temporal deceleration (central to *24-Hour Psycho* as well as *Five Year Drive-By,* a planned public projection of *The Searchers* over a five-year period); (2) foregrounding the moment of perceptual shift (as in *Confessions of a Justified Sinner* [figure 7.4], where inverted negative images of Dr. Jeykll's transformation into Mr. Hyde are set into a perpetual loop); (3) mirroring with slight temporal discordance (as in *Through the Looking Glass* [figure 7.5], where slightly diverging twin images of the scene from *Taxi Driver* featuring Robert DeNiro pulling a gun and speaking to himself in a mirror are placed on opposite walls of a gallery); (4) exposing perceptual shift as the very texture of perception (as in *left is right and right is wrong and left is wrong and right is right* [figure 7.6], where Otto Preminger's obscure 1949 film noir, *Whirlpool,* is projected in reversed images on two screens, one of which presents every odd frame of the film and the other, every even frame); and (5) catalyzing the relativization of time within the viewer's body (as in *Déjà-Vu*

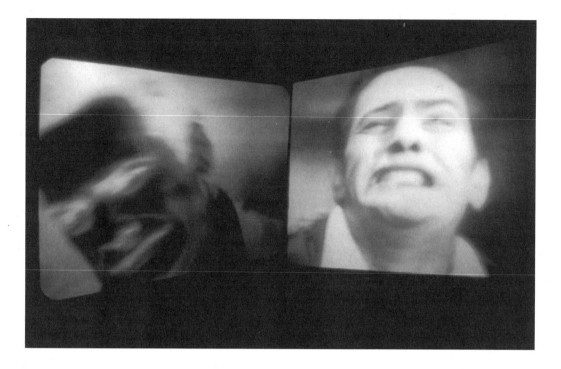

Figure 7.4
Douglas Gordon, *Confessions of a Justified Sinner* (1996). Via inverted, negative images of Dr. Jekyll's transformation into Mr. Hyde in Rouben Mamoulian's film, the moment of perceptual shift is insistently foregrounded.

(figure 7.7), where three projections of *DOA,* at respectively 23fps, 24fps, and 25fps, are placed one beside the other).

Contrasted with Deleuze's conception, Gordon's deployment of these strategies relocalizes the time-image from a purely mental space contained, as it were, within or between the formal linkages of a film, to an embodied negotiation with the interstice or between-two-images that necessarily takes place *in the body–brain of each specific viewer-participant.* At stake here is more than just another variant of the Deleuzean time-image, however, since Gordon's practice engages a model of cognition and of the physiological processing of images fundamentally at odds with Deleuze's. Whereas Deleuze sees the time-image as marking a fundamental break with the sensorimotor logic of the movement-image, Gordon's work constructs the time-image *on the basis of a refined sensorimotor interval*—of the sensorimotor interval specific to the process of neural selection as understood by contemporary neuroscience. Unlike the sensorimotor interval at work in the cinema of the movement-image, this refined sensorimotor interval is not immanent to the logic of the image or of film as the art

Figure 7.5
Douglas Gordon,
*Through the Looking
Glass* (1999). Two op-
posed screens project a
scene from *Taxi Driver;*
slight discordance in
projection speed sub-
jects mirror effect to
temporal fragmentation.

Figure 7.6
Douglas Gordon, *Left is
right and right is wrong
and left is wrong and
right is right* (1999).
Projects Otto Preminger's
Whirlpool in reversed
images on two screens,
one showing even
scenes, one odd scenes;
exposes perceptual shift
as the very texture of
perception.

Figure 7.7
Douglas Gordon, *Déjà Vu*
(1997). Projects *DOA* on
three screens at 23, 24,
and 25 frames per sec-
ond respectively; thereby
relativizes time within
the viewer's body.

of moving images, but emerges directly from the human processing of infor-
mation. Consequently, it is a sensorimotor interval that taps the potential of
the body to exceed its own contracted habits and rhythms.

Accordingly, Gordon's work can be said to expose the fundamental limi-
tation of Deleuze's cinema of the brain: its investment in an isomorphism be-
tween the time-image and the contemporary brain. This investment necessarily
follows from Deleuze's decision to situate time within the virtual dimension
opened by the interstice; for him, such an isomorphism is the necessary conse-
quence of the differentiation between classical and modern cinema, as the con-
trast between Eisenstein's and Alain Resnais's intellectual cinemas makes clear:
"intellectual cinema has changed, not because it has become more concrete (it
was so from the outset), but because there has been a simultaneous change in
our conception of the brain and our relationship with the brain."[23] In contrast
with Eisenstein's intellectual cinema, which focused on the sensorimotor pro-
duction of dialectical concepts, Resnais's intellectual cinema functions to

catalyze fundamentally "new orientations" in the cerebral processes of the "indeterminate brain."[24] When Deleuze suggests that invention in the cinema doubles and must be doubled by invention in the brain—that new circuits in the cinema generate new cerebral circuits—he effectively renders the time-image something that can only be thought. Put another way, by strictly correlating the presentation of the outside in cinema with a modification of the brain, Deleuze asserts a *direct* transmission of the force of time into thought.[25]

Gordon's work contests Deleuze's model of the time-image precisely by questioning such a direct transmission of time into experience. By producing the time-image as/in the viewer-participant's richly embodied physiological response to the interstice or between-two-images, Gordon's work questions not just the abstract isomorphism central to Deleuze's model of the modern cinema, but specifically the model of the brain as "irrational," "indeterminate," and beyond the sensorimotor. Indeed, Gordon's experimentations with the temporal limits of visual art force us to confront the origin of temporal consciousness (and hence consciousness per se) in the experience of affectivity that neurobiologist Francisco Varela has recently identified with the Husserlian category of "protention." In this way, Gordon's works directly engage the complex neural processing underlying the time-image, from its "origin" in the preconceptual experience of a "primordial fluctuation" to its "occurrence" as a neural emergence.

Refining the Sensorimotor

Varela's recent work on time consciousness and affectivity marks a refinement of his ongoing effort to grasp the autopoietic basis of human perception.[26] In this work, he seeks to correlate phenomenology and neurobiology—lived experience and its embodied basis—through "mutual constraints provided by their respective descriptions."[27] To that end, Varela attempts to furnish a neural correlate for Edmund Husserl's explorations of internal time consciousness and specifically for two central achievements of Husserl's analysis: the complex texture or "thickness" of the present (retention, nowness, protention) and the notion that temporal consciousness *itself* constitutes an ultimate substrate of consciousness, that time is less an object of consciousness than its very foundation. Varela pursues this task by arguing for the primacy of affectivity in the

genesis of time consciousness: affectivity links the temporal modality of "pro-tention"—the striving of the human being to maintain its mode of identity—with the embodied basis of (human) life. In sum, affectivity comprises the motivation of the (human) organism to maintain its autopoiesis in time.

What Varela's analysis contributes to our understanding of the time-image and machine time is a thematization of affectivity as a concrete constraint on the human temporal experience.[28] By correlating the phenomenological category of affectivity with the temporality of the neuroprocessing underlying the emergence of the perceived now, Varela makes a strong case for linking the particular flexibility and limitations of the human experience of time—in-cluding any image of time—with the capacities and constraints of the more or less fixed "hardware" of our neural architecture and its sensorimotor embodi-ment. Yet at the same time, by exposing the complex hierarchy of temporal scales that lies at the basis of time-consciousness, Varela's analysis opens per-ception to the microphysical domain in an unprecedented manner. On both counts, his analysis furnishes a perfect opportunity to evaluate the complex in-terconnection of affection and temporality that is strongly implied but never explicitly worked out in Bergson's *Matter and Memory*. For what it suggests is the necessity of introducing into the experience of temporality the very same "impurity"—the impurity of affection—that so markedly flavored Bergson's account of perception.

Varela's proximate goal is to reconcile two facets of Husserl's analysis of time-consciousness: on the one hand, the rich texture of the present, and on the other hand, the multiscalar hierarchy of temporal registers that underlies the flow of time. In more technical terms, he seeks to explain the retentional-protentional structure of the "now" in terms of a fundamental distinction between three levels of duration: those of elementary events (1/10 scale), of perceptual integration (1 scale), and of descriptive-narrative assessments (10 scale). Only in this way, he insists, will we come to appreciate just what it means that we (humans) are beings not simply in time but *of* time.

To explain "how something temporally extended can show up as present but also reach far into my temporal horizon," Varela focuses on the abrupt per-ceptual shift that occurs in so-called Necker cube phenomena.[29] According to Varela, "the gesture of reversal is accompanied by a 'depth' in time, an incom-pressible duration that makes the transition perceptible as a sudden shift from

one aspect to the other, and not as a progressive sequence of incremental changes."[30] In neuroscientific terms, what is at stake here is the concurrent participation of functionally distinct and topographically distributed regions of the brain and their sensorimotor embodiment: the moment of reversal corresponds to a temporary stabilization of the distributed cognitive system, while the "depth" or "thickness" correlates with the host of competing distributed neural processes from out of which this stabilization emerges. Varela's account furnishes the mechanism for machine time to affect time-consciousness: as constitutive elements of what we might call a microphysical temporal object, the elementary events (at the 1/10 scale) of a machinic event, which are subperceptual, can trigger neural processes at this same microphysical scale, which are themselves likewise subperceptual. Yet rather than yielding a *direct* inscription of the microphysical temporal object, this process serves to trigger an endogenous response that Varela, with great significance for the central thesis of this book, likens to a process of *framing:* "these various components [of neural processing] require a *frame or window of simultaneity that corresponds to the duration of lived present.* . . . [T]he constant stream of sensory activation and motor consequence is incorporated within the framework of an endogenous dynamics (not an informational-computational one), which gives it its depth or incompressibility."[31]

On this view, the "now" of present-time consciousness (the correlate of the 1 level) comprises a frame placed on the microphysical elements (neural dynamics corresponding to the machinic quanta) as these are selectively combined into aggregates (cell assemblies) that emerge as "incompressible but complete" cognitive acts. Not insignificantly, it is this conception of an endogenous dynamics that differentiates time in experience from time as measured on a clock or machine: by operating the formation of cell assemblies among microphysical elements, the endogenously constituted frameworks account for perceived time as "discrete and nonlinear," or in other words, as a "horizon of integration" rather than a simple "string of temporal 'quanta.'"[32] Moreover, endogenous dynamics generate time in a manner that must be said to be radically creative, since integration is always an emergent and intrinsically unstable phenomenon: "completion time is dynamically dependent on a number of dispersed assemblies and not on a fixed integration period; in other words, it is the basis of the *origin of duration without an external or internally ticking clock.*"[33]

Two important consequences result from this neurodynamic understanding of time-consciousness: first, time-consciousness must be said to incorporate microphysical registrations that have no direct perceptual correlate but that underlie the emergence of the perception of time (these registrations make up the retentional thickness of the Husserlian now); and second, the now itself must be accorded a lived quality that makes it more than a mere point or temporal location though which an object passes, and indeed, more like a space in which we dwell, "a space *within* time itself."[34]

To develop these consequences, Varela draws on Husserl's conception of "double intentionality." According to this conception, object-intentionality (consciousness-of) is doubled by an intentionality of the flow itself (the experience of consciousness-of): the object-event, explains philosopher Dan Zahavi, is "not only given as having-just-been" but also "as having-just-been *experienced*."[35] Retention, accordingly, designates the retaining of the preceding object (e.g., a musical tone) *as well as* the just passed perception of that object: the actual phase of the flow thus includes, in addition to the retention of the just passed object-event, the just elapsed phase of the flow itself.

By showing how the consciousness of a temporal object is doubled by a consciousness of the flow itself and by opening this double intentionality—with its complex structure or constitutive "thickness"—to registration at the microphysical level, Varela's work furnishes the conceptual mechanism for understanding how machine time can, in some sense, be said *to enlarge the frame of the now itself.* For if the exposure to machine time functions to stimulate neural dynamics and ultimately to trigger the emergence of new "nows," then it might legitimately be said to contaminate the now with "elementary elements" that are properly inhuman.

Such contamination must, of course, be differentiated from the *direct* correlation between machine time and human perception posited by the "Machine Times" curators and by Stephanie Strickland. What is at stake here is an *indirect* correlation that not only is channeled through the imperceptible and nonexperienceable domain of *embodied* neural dynamics, but whose "medium" is affectivity, the very dimension of embodied time consciousness that serves to differentiate it from machinic registration of time. As the phenomenological correlate of the neural dynamics from which the present emerges, affectivity is inseparable from the *protentional* dimension of time consciousness: unlike re-

tention, protention intends the new *prior to any impression or perceptual present,* and for this reason, it "is always suffused with affect and an emotional tone that accompanies the flow. . . . [P]rotention is not a kind of expectation that we can understand as 'predictable,' but an openness that is capable of self-movement, indeterminate but about to manifest. In this quality it provides the natural link into affection or, more aptly, with some form of self-affectedness. . . ."[36] This correlation with affect underscores the embodied dimension of time-consciousness, since in order to intend the new prior to the constitution of an impression, protentional consciousness must, as it were, draw on itself. Affect, accordingly, must lie at the very origin of time.

Insofar as affect structures or "sculpts" the dynamic temporal flow, it prefigures changes in perception and thus plays a major role in the constitution of object-events. More precisely still, affective protention guides the "mutual bootstrap" between the consciousness of the temporal flow and that of the object-events that appear in it: the trajectories to which affect gives rise "provide the very conditions for an embodied coupling [of object-event and temporal flow], since through their coupling they shape their dynamical landscape."[37] Affect, in other words, forms a bond between perceptual event and temporal flow, and as such, attests to the embodied basis of time consciousness. This is why Varela can claim that "affect *precedes* temporality: affect implicates as its very nature the tendency, a 'pulsion' and a motion that, as such, can *only* deploy itself in time and thus *as time.*"[38]

We can now understand exactly why machine time can be made to influence human time-consciousness only via the dynamics of affect. As a process that is properly subperceptual, the constitution of a temporal object from microphysical machinic fluxes furnishes time-consciousness with a "content" that is not given—and that in principle *cannot* be given—by an impression. As a consequence, the resulting temporal object can be experienced only through affective anticipation, or in other words, as mediated by the process of nonconscious neural dynamics from which the now emerges continually and perpetually. It is as if the affective dynamics of embodied cognition actually *took the place of* the perceptual "content" comprising the temporal object in its traditional form.

Varela's reconstruction of a genetic phenomenology of time-consciousness ultimately allows us to extend our understanding of Bergson's crucial claim

that "there can be no perception without affection." Specifically, Varela's work underscores what we might call the constitutive *impurity* of time-consciousness: the rootedness of the (human) temporal dimension in the valence of primordial affect (movement toward and away). For this reason, it suggests a very different path from the movement-image to the time-image than the one followed by Deleuze—a path that does not eschew the sensorimotor embodiment of time-consciousness.

Not surprisingly, this is precisely the path followed by Douglas Gordon. Viewed in the context of Varela's neurophenomenological account of time-consciousness, Gordon's experimentations with the temporal boundaries of the image do not open a fluid exchange between machine time and the temporality of the body so much as they compel us to confront the rich temporal depth, or affective bodily spacing, that underlies our complex experience of time. Where Resnais and Godard carry out a fundamental reconfiguration of the cinematic apparatus *beyond* the sensorimotor logic of the movement-image, Gordon approaches the temporal "content" of the filmic image through a radicalization of this very sensorimotor logic. By slowing down the movement between images to a point where the machinic connection no longer makes perceptual sense—that is, where we might be said to enter the realm of machine time—Gordon compels the viewer-participant to experience the affective basis of the constitution of time. We might even say that for Gordon, the time-image has, in a sense, always inhered within the movement-image, as a kind of "origin" that is occulted by the technical autonomy accomplished in the classical cinema and carried on in the modern cinema. Or, put somewhat differently, for Gordon the direct presentation of time constitutes an aspect of all images (and not just time-images) in the sense that affect forms the basis for the act of framing constitutive of the image as a perceptual and temporal form.

Technical Contamination

If Varela's neuroscientific treatment of protention furnishes a model for time-consciousness that—as it is instantiated in Douglas Gordon's work—stresses the creative dimension of the between-two-images, it says nothing concerning the correlation between technicity and time-consciousness. Yet, if new media technology furnishes the means for aesthetic experimentations with the neuro-

embodiment of time-consciousness and with the impact of machinic time on it, then we will need to give an explicit account of precisely this correlation.

With his work on temporal objects and image technology, French philosopher Bernard Stiegler furnishes the perfect vehicle to pursue this imperative. As the (to date) culminating move in what already comprises an important and original philosophy of technology,[39] Stiegler proposes an interpretation of Husserl's analysis of time-consciousness and temporal objects whose aim is to foreground, against Husserl's own hesitations, the radical consequence of his analysis: the intrinsically technical basis of time-consciousness.[40] Stiegler begins his intervention by ratifying Husserl's decision to channel his analysis of the temporality of consciousness through the temporal object. (A temporal object is defined as an object that is not simply in time but is constituted through time and whose properly objective flux coincides with the flux of consciousness when it is experienced by a consciousness. Husserl's favored example is a musical melody.) According to Stiegler, this decision is necessary to grasp the temporal basis of consciousness: given the status of consciousness as a structure of flux, one cannot conduct an analysis of the phenomenological conditions under which this flux is constituted at the level of consciousness, but can account for them only through an analysis of an object that is itself temporal. Focusing on the temporal object allows Stiegler to complicate Husserl's analysis of time-consciousness by introducing technicity—what he calls "tertiary memory" (a gloss on Husserl's "image-consciousness"[41])—into the heart of primary retention.[42] (Tertiary memory can be defined as experience that has been recorded and is available to consciousness without ever having been lived by that consciousness.)

Suffice it to say that the philosophical payoff of Stiegler's analysis is to level any absolute distinctions between primary retention, secondary memory, and tertiary memory, and in fact to invert the hierarchy proposed by Husserl such that *it is tertiary memory that introduces secondary memory into primary retention*. Insofar as it always and necessarily finds itself in the midst of a horizon—a world already constituted and comprising both what it had experienced in the past *and* what of the past it never experienced (i.e., what was experienced by others and gifted to it through technical memory supports)—primary retention is not only thoroughly contaminated with the other forms of memory, it is in fact conditioned by, and thus dependent on, them.

That this situation is the rigorous and radical consequence of Husserl's own recourse to the temporal object can be discerned (and discerned solely) through an analysis sensitive to the technical specificity of the temporal object. Like Kittler, though for precisely opposite reasons, Stiegler insists that the advent of technical recording marks a fundamental break in the history of the correlation of technology and time. Indeed, it is recording that, in giving the possibility to perceive (hear or see) more than once an exactly identical temporal object, brings home the inversion to which Stiegler submits Husserl's analysis of time-consciousness: to the extent that two perceptions (auditions or visions) of the same temporal object *are themselves not identical,* we confront the necessity to recognize some form of selection *within* retention, and thus the constitutive contamination of retention by secondary memory. How else, indeed, could we explain the way in which the first audition (or vision) modifies the second audition (or vision), if not by saying that the modification of the second audition is rooted in the secondary memory of the first, that is, the recollection of it as past? Moreover, insofar as it comprises the very condition of possibility for this contamination, recording also marks the moment at which tertiary memory becomes the operator of this contamination, and thus the condition of possibility for both secondary memory and primary retention themselves: "Image consciousness . . . is that in which the primary and the secondary are both rooted, owing to the technical possibility of repetition of the temporal object. . . . Recording is the phonographic revelation of the structure of all temporal objects."[43]

For Stiegler, this situation is best exemplified by cinema. This is so in the first place because of the "singularity" of cinematic recording technology, its capacity to bring together two coincidences: on the one hand, the "photo-phonographic coincidence of past and reality," and on the other, the coincidence "between the film flux and the flux of the consciousness of the film's spectator that it triggers."[44] But it is all the more so because cinema is the technological art of selection *par excellence.* In cinema more than any other recording technology, the selection criteria through which consciousness passes on prior retentions is, first and foremost, the work of tertiary memory: in cinematic perception, we select almost exclusively from memories of experiences that have not been lived by us. According to Stiegler, this accounts for cinema's enduring power to compel belief: by suturing the flux of consciousness to the

flux of a temporal object that is almost entirely composed of tertiary memories, cinema exerts an objective stranglehold over time-consciousness. Indeed, Stiegler goes so far as to assert that "consciousness is cinematographic": as the "center of post-production . . . in charge of editing, staging and realizing the flux of primary, secondary and tertiary retentions," its operations are the very techniques of time-consciousness itself.[45]

For all its apparent resonance with the Bergsonist conception of perception as subtraction, however, Stiegler's position cannot in fact be reconciled with the Bergsonist–Deleuzean understanding of cinema that, as I have taken pains to emphasize, rejects the identification of the cinematic object with a temporal object *of consciousness*. What is crucial about Bergson's conception of perception as subtraction—not to mention Deleuze's transformative appropriation of it—is precisely the way that perception places consciousness into a relation with a domain fundamentally heterogeneous to it.[46]

This difference comes to the fore when we contrast the Deleuzian time-image with Stiegler's analysis of film as a temporal object. For Deleuze, as we have seen, what marks the crucial break instigating the shift to the cinema of the time-image is the breakdown in the logic of the connection between images: in the space of the irrational cut or interstice between two images, access is opened to a series of virtual images that instantiate the force of time itself. Accordingly, "perception" of the time-image—if we can even still call it that—necessarily takes place from a position that simply cannot be identified with the zero-point occupied by the perceiving human body: precisely because it opens "perception" to the imperceptible, the time-image is an image that can only be thought. In identifying the flux of the cinematic temporal object with the flux of consciousness of the spectator perceiving it, Stiegler, by contrast, asserts a *de jure* homology between cinematic image and perception such that whatever the film presents is in principle perceivable from the embodied zero-point occupied by the spectator. For Stiegler, that is, the range of what a film can present is necessarily limited to that which can take the form of memory—of memory that *could* be proper to consciousness, even if for the most part it is not.[47]

Doesn't Stiegler thereby place a fundamental constraint on the potential impact technology can have on perception? Doesn't the exclusivity of his emphasis on cinema as a recording technology close off precisely that dimension most dear to Deleuze (and to the proto-cinematic phenomenology of

Matter and Memory), namely, the way that cinema can supplement—by exceeding the limits of—natural perception? And isn't it precisely the wholesale assimilation of cinematic technology (and technology more generally) to *tertiary memory* that is to be faulted here, insofar as it severely limits cinema's capacity to change life?

Nowhere are the consequences of this fundamental difference more significant than in the context of machine time. Unlike the audiovisual and televisual technologies that comprise tertiary memory,[48] the technologies that materialize machinic temporalities in the contemporary technosphere do not function by opening perception to memory, but rather by broadening the very threshold of perception itself, by enlarging the now of perceptual consciousness. This is precisely how Bergson conceives of technology—as the preeminent means by which human beings employ intelligence to extend their perceptual grasp over matter, to enlarge their own living duration. Indeed, with the priority he places on the action by which the past is reactualized in the present of duration, Bergson furnishes the very vehicle through which we can understand cinema (and media technology generally) beyond the frame of tertiary memory. In a way that differs fundamentally from the opposition Husserl institutes between perception and imagination, Bergson subordinates memory to present perception, or more exactly, to the living duration that fills out the perceptual present.[49] Accordingly, he approaches technology in a way fundamentally at odds with Stiegler's account: for Bergson, technology is materialized as the vehicle not for the direct assumption of an impersonal or nonlived historicity, but rather for the enlargement of living duration itself. If such an enlargement has the subsequent effect of opening the living (human) being onto its historicity, it remains the case that the enlargement is primary in relation to the opening, or in other words, that tertiary memory can invade primary retention (duration) *only because of the activity of living duration itself,* one that is, moreover, *made possible by its technical supplementation.* From the perspective of living duration (or perceiving consciousness), the technical supplementation of duration forms the very condition of possibility for the assumption of tertiary memory.

Bergson's analysis thus helps pinpoint the source of Stiegler's overly narrow treatment of technology *qua* memory: his assumption that tertiary memory, by invading primary retention, dissolves any meaningful sense of dis-

tinction between them.[50] By contrast, the Bergsonist notion of duration manages to distinguish perception from memory, without needing (as Husserl did) to confer on it the secure status of an absolute opposition. (In Bergson's terminology, there is only a difference of degree, and not one of nature, between them.)[51] Now it is precisely such a nonabsolute distinction that allows us to do justice to the important "phenomenological difference" that *does* in fact exist "between [retention and memory as] two modifications of nonperception."[52] We have, in our above analysis of Husserl's time-consciousness, already seen the double structure of retention in virtue of which the object-event is given not only as "having-just-been," but also "as having-just-been *experienced*."[53] Transposed to Stiegler's neo-Husserlian analysis of the temporal object, what this structure introduces is a doubling between, on the one hand, the *entire complex* encompassing primary retention, secondary memory, and tertiary memory that is responsible for the perception of the object as having-been and, on the other hand, a *distinct retention* that intends this complex perception as a whole. Put another way, there is (corresponding to the first case) a consciousness of the content of the flux and (corresponding to the second) a consciousness of the flux itself. This distinction allows us to differentiate the perception of something that has not been lived (and which is, Stiegler being quite right here, necessarily contaminated with secondary and tertiary memory) from the perception *of this perception* in a distinct present act of perception that *is* lived.

It is in the context of this difference that we can grasp the essential significance of Varela's work on the neuro-temporality of perception. Insofar as it objectively fixes the temporal threshold for present-time consciousness (roughly 0.3 of a second) and differentiates it categorically from the time of elementary events (including neural events before they have formed cell assemblies), Varela's work allows us to postulate a technico-historical determination of what constitutes the "now" of perception (i.e., duration or the retentional-protentional matrix of perception) on the basis of and yet in contradistinction to the time of machine processing. Moreover, it makes such a determination the task of an ethics of temporality: in the context of contemporary technologies that do in fact compute on the microphysical instant, it is imperative that we bring out the "phenomenological difference"[54] or singularity specific to retention—that is, the synthetic interval comprising duration—and that we identify it (in distinction to the microphysical, but also to memory) as the now, the very basis of

human experience *qua* living.[55] Following Bergson, we must allow the now of perception to become contaminated with affectivity: we must identify the now with that threshold within which perception of the flux of an object affects itself, and thus generates a supplementary perception, a perception of the flux itself, time-consciousness.

The "Subjective" Image

By correlating the physiological threshold of the present now, the priority of protention, and affectivity, Varela's analysis pinpoints the two basic limitations of Stiegler's approach: its fundamental orientation toward memory and the past and its decision to ground the openness to the future exclusively in the essential incompletion of the present.[56] To overcome these limitations, we now need to explore the impact of the technical contamination of time-consciousness on our understanding of human temporal consciousness as fundamentally future-directed.

Among contemporary artists working with new media, it is the work of Bill Viola that can best guide us in this exploration. In his recent aesthetic experimentation with radical temporal acceleration and deceleration, Viola has deployed cinema and video technologies in order to enlarge the now in a manner that is precisely antithetical to cinema's role as the exemplary support for tertiary memory. Rather than opening the now to the past, to the nonlived experience materialized in technical objects, Viola's aesthetic experimentation with new media intensifies the now by literally overloading it with stimuli (units of information) that are properly imperceptible (i.e., imperceptible to natural perception).[57] In his current *Passions* series, which includes works like *Quintet of the Astonished* (2000), *Quintet of Remembrance* (2000), *Anima* (2001), *Six Heads* (2001), and *Man of Sorrows* (2001), Viola uses a technical capacity intrinsic to cinema, the capacity to shoot at high-speed, extended and transformed by video, in order to contaminate the perceptual present with a nonlived that is not, as in photography or the cinema of the time-image, the recurrence of a tertiary past, but rather *the material infrastructure of the enlarged now itself*, or in other words, the affective texture of the neuro-dynamics that, as Varela has shown, conditions time-consciousness.

Since the formal principle is the same in all of these works, I shall focus on one of them, *Quintet of the Astonished* (2000), whose clear iconographic references and complexity make it exemplary of the series. Inspired by Hieronymous Bosch's *Christ Mocked* (c. 1490), with references to Caravaggio and the Weeping Mary, the sixteen-minute video features five figures, four male and one female, who appear to undergo extremely subtle, at times literally imperceptible, shifts in emotional, or better, affective tonality (figure 7.8). Without a doubt, the experience afforded by this work can be described as one of affective attunement: by presenting what psychoanalyst Daniel Stern has called "vitality affects" (as opposed to "categorical affects" or emotions)—that is, normally imperceptible facial cues that signal the very fact of the body's aliveness—the affective shifts on the faces of the represented figures trigger richly nuanced resonances in the body of the viewer. These resonances can be understood as a kind of embodied correlate of the microphysical stimuli themselves (i.e., the machinic registration of temporal phenomena).[58]

Viola has explained that the motivation of this piece, and of the series as a whole, comes from his own wonder at the paradoxical duplicity of emotions—their status as both the most fleeting of experiences and in some curious sense autonomous from or outside of experience.[59] This duplicity was brought home to the artist in a project he undertook in 1987 involving the videotaping of a children's birthday party. Noting that of all beings, children wear their emotions right on the surface, Viola recounted being dumbstruck by his observation of joy literally growing and moving through the faces of his subjects. When, later in the process of creating what would become his 1987 piece, *Passage,* Viola had the opportunity to observe his footage as still images, he found himself dumbfounded once again, this time by the fact that even in a still image, which, after all, represents a cut with a duration of 1/30 of a second (in video) and which is therefore well below the neurophysiological threshold of the now, there was not only an excess of emotion, but a certain temporal expansion of it beyond the confines of what was captured in the image (figure 7.9). In something like an equivalent of Douglas Gordon's inspirational viewing of *Psycho* on television, this seminal moment gave Viola a certain insight that would become the catalyst for his later work. Yet whereas Gordon became attuned to the rich expansiveness of the "between-two-images," Viola was

Figure 7.8
Bill Viola, *Quintet of the Astonished* (2000). Shot at
high-speed but projected at normal speed, this film
of five figures undergoing extreme emotional
change supersaturates the image with ordinarily
imperceptible affective content. (See plates 10, 11.)

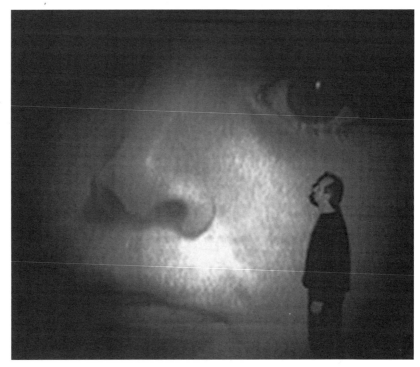

Figure 7.9
Bill Viola, *Passage*
(1987). In filming
footage for *Passage*,
Viola found himself
struck by the excess of
emotion in children's fa-
cial expressions.

struck by the peculiar autonomy of emotion from the temporal flux of per-
ception. The experience of the still image as exuding a rich plenitude of emo-
tion, as an extreme contraction of intensity, led Viola to conclude that
"emotions are outside of time," that they "exist somewhere outside of time."[60]

Now this difference between Viola's and Gordon's glimpses into the tem-
porality of mediated images is in no way a trivial one, since it is precisely Vi-
ola's insight into the autonomy of emotion from time—and thus *from any
temporal fixation of it in any particular medium*—that makes his work the ex-
emplar of the medial revolution I have been exploring in this book: the move-
ment of new media art beyond cinema. Whereas Gordon takes the cinematic
object as a given (he literally works with found, that is, already constituted ma-
terial) in order to pressure the correlation of its objective flux and the flux of
the viewing consciousness to the point of its breakdown,[61] Viola contaminates
cinema with video (and vice versa) in a way that transforms the resulting hy-
brid (cinema-video) in a fundamental manner.[62] Specifically, by exploiting the

technical capacity to shoot film at high-speed and then, following its conversion to digital video, to project it at normal speed, Viola manages to invert its "intentionality" as a temporal object such that rather than taking the viewer through an experience of the past, it brings her face-to-face with the temporal (affective) dynamics underlying the emergence of the present.

Viola shot *Quintet of the Astonished* on high-speed film (roughly 16 times faster than normal speed, or 384 fps), which was subsequently digitally converted to video and projected at normal speed. Accordingly, the roughly 16-minute video shows events that actually transpired in the space of about one minute. What is crucial about Viola's technique, however, and what distinguishes it from Gordon's radical use of slow-motion, is that he exploits the recording potential of film to its fullest: *each second of film encompasses (roughly) 384 (i.e., 16 × 24) increments of motion, 384 discrete captures of information.* Playing this back at normal speed (at 24 fps though now "channeled" through video's 30 fps) literally exposes the viewer to the imperceptible: to incredibly minute shifts in affective tonality well beyond what is observable by (nontechnically supplemented) natural perception. When the viewer takes in this intensely oversaturated temporal object, the guiding mechanism of cinematic temporality—the perceptual coincidence between the flux of the film and that of consciousness—gives way to a kind of affective contagion through which consciousness, by being put face-to-face with what it cannot properly perceive and yet what constitutes the very condition out of which the perceiveable emerges, undergoes a profound self-affection. In this incredibly intense experience, consciousness is made to live through (affectively, not perceptually) the very process through which it continually emerges, from moment to moment, as the selection from a nonlived strictly contemporaneous with it (the nonactualized, virtual potentialities vying against one another in Varela's model of neuro-processing as "fast dynamics").

We can thus say that Viola's work deploys media to catalyze a temporal experience that moves beyond the "cinematographic grammatization" that, for Stiegler, forms the basis for contemporary real-time media (the global televisual system) and for the age of digital television to come:[63] what Viola shows is that media, far from being the vehicle for a reproduction (writing, grammatization) of life, is a mechanism for exposing the fundamental correlation of life with what Gilbert Simondon calls the "preindividual," the domain of a nonlived

that is strictly contemporaneous with the living and that forms the condition of possibility for its continued viability in the future.

It is no accident that, in Simondon's much neglected ontology, this exposure to the preindividual occurs through the experience of affectivity, which names a modality that differs fundamentally from perception. While perception draws on already constituted organic structures, affectivity mediates between the constituted (organic) individual and the preindividual milieu to which this being is structurally coupled. Whereas the faculty of perception has already been completely individuated and can thus be exercised only within fixed constraints, affectivity comprises the faculty of the new: it is the modality through which the individuated being remains incomplete, which is to say—*in contradistinction to* the Stieglerian–Derridian problematic of a memorial incompletion—open to the force of the preindividual, to that which it is not, or most accurately, to its own constitutive excess, its being essentially out-of-phase with itself. As an extension, indeed a coherent working-through, of the Bergsonist category of affection, Simondon's concept of affectivity explains, justifies, and lends significant nuance to my neo-Bergsonist claim that perception is necessarily anchored in the activity of the body via the modality of affect. More precisely, affectivity names the capacity for the body to be radically creative, that is, to be the agent of a framing of digital information that generates images independently of all preexistent technical frames.

Viola's work thus does for protention what cinema (following Stiegler's analysis) does for retention: namely, operate its technical contamination by that which has traditionally been subordinated, if not simply nonexistent, to it. Indeed, if Viola's particular experimentation with the temporal flexibility of new media exposes the complication of protention by the nonlived that is contemporaneous with it, it *necessarily* introduces technicity into time-consciousness. Unlike Stiegler's tertiary memory, however, this technicity is strictly contemporaneous with the protentional dimension of time-consciousness: far from furnishing a nonlived *content* that exposes the selectional basis of retention, it comprises a techno-functional extension *of protention itself,* one that exposes the selectional process through which consciousness extends itself into the future. Viola's work thus installs the technical supplement smack in the heart of the present itself: as a techno-functional extension of protention, new media technology operates entirely within the interval of the now, as the supplement

of protention that, by oversaturating the now with information, enlarges it, and by enlarging it, catalyzes the self-affection of consciousness that is constitutive of time-consciousness. In sum, new media technology mediates the openness of protentional consciousness to the nonlived—and indeed the properly nonlivable—domain of the preindividual and thus reveals affectivity as being always already, that is, essentially, contaminated by technicity.

What this means, ultimately, is that we must identify the flux of consciousness not with the flux of the intermediary temporal object, but *with the flux of affectivity itself.* For this reason, the isomorphism constitutive of cinematographic grammatization—between machinic and spectatorial synthesis—no longer holds in the context of new media.[64] The machinic synthesis is accordingly demoted to the role of mediator in *Quintet of the Astonished:* far from controlling the flux of spectatorial consciousness, the machinic synthesis has become a mere instrument facilitating the "communication" between the domain of properly imperceptible microphysical stimuli and the phenomenological dimension of affectivity constitutive of the essential openness of human beings to the future. Viola's work can thus be said to enlarge the now precisely by putting perception into the service of affection, or in other words, by opening perception to the very principle of its own self-perpetuation, to its own radical imperceptible—affectivity.

In this way, Viola's work anticipates a new configuration of human experience and machinic recording that can help us tap into the potential that "machine time" holds for extending the scope of the perceptual now and thus, in a way that pushes the Bergsonist vocation toward its most radical potential, for expanding our grasp over the material world. By deploying media technology within a framework of digital convergence (yet in a way that refuses Kittler's dedifferentiation) in order to bring the properly imperceptible, microphysical machinic inscription of matter (time) into the sphere of human experience, Viola's work exemplifies a digital aesthetic that not only looks beyond current media forms (and thus breaks with the "cinematocentrism" plaguing most accounts of new media), but actively seeks to reconfigure in a fundamental—and fundamentally empowering—way the correlation of the human with the technical. In short, Viola's aesthetic deprivileges the technical frame (Stiegler's machinic synthesis) in favor of the framing activity of a body affectively open to the nonlivable, nonactual, and imperceptible. For this reason,

the aesthetic he exemplifies can be said to deploy the digital toward a truly creative end, one that can be creative precisely because it causes to pass through the human (the spectatorial synthesis) the properly imperceptible—that which is nonsynthesizable within the temporal range of human perception.

This digital aesthetic thus seeks to tap the potential of the digital following a trajectory precisely antithetical to the one followed by both Kittler and Stiegler, but that nonetheless borrows something from each. Like Kittler's digital convergence, the digital aesthetic at issue here recognizes and accepts the autonomy of the technical in the form of digital information; yet, rather than viewing this as a threat to human experience, as a material shift that makes human perception henceforth irrelevant, it seeks to pinpoint and exploit the potential of information to empower the human, to enlarge the scope of the human grasp over the material world—in short, to assist the human in framing information in order to create images.[65] And like Stiegler's cinematographic grammatization, this digital aesthetic grammatizes life—or, more exactly, "overgrammatizes" life—in the sense that it deploys technology to inscribe the microphysical traces of the material flux that it subsequently delivers to the spectatorial synthesis; as an "overwriting" of life, the inscription of a potentiality (the preindividual) that exceeds the scope of the living duration in the very process of forming its precondition, paradoxically shows life to be properly unrecordable, always in excess of what can be inscribed and made available for repetition. Accordingly, it contrasts markedly with Stiegler's understanding of the digital as a vehicle for the "critical analysis" of the image.[66] For what Viola's work exploits is precisely the capacity of the digital to dissolve the image in a far more radical sense than simply "decomposing" it. Viola's work perfectly exemplifies the radically new configuration of the image presented in this book: its reconfiguration, as the correlate of a process of embodied, affectively catalyzed framing. This is why Viola refers to the "content" of his experimentations with temporal acceleration and deceleration as the "subjective image"— "an image that can only be experienced internally."[67] In the end, Viola's work helps us see that the digital image in fact *is* the affection-image, since its materiality—its framing of this and not that information—is both continually in process and routed through affectivity as that extraperceptual "faculty" that ensures our openness to the preindividual, the preperceptual, the new, and with it, the very future-directedness of the constitutively incomplete present.

Conclusion

Given the importance of Viola's lesson regarding the "subjective image" and the exemplarity of his work for my claim regarding the digital image, I think it only fitting to conclude my triple narrative of image, body, and affect by recapping how the embodied aesthetic of his work accomplishes the tasks I projected for myself in the introduction. In the first place, because he deploys media technology to create affection-images that cannot be identified with any technical images, Viola manages to move beyond the cinematic framework that, in my opinion, has severely limited appreciation of both the heterogeneity and the radicality of new media art. While it directly contests the thesis of Lev Manovich along the lines explored in chapter 1, we can now see that this accomplishment is particularly significant in relation to Deleuze's conception of the affection-image, and the entire sublimation of affection into the image that lies at the heart of his admittedly inspiring effort to expand in the most radical way the scope and philosophical vocation of cinema. Indeed, Viola's liberation of affectivity as the condition for the emergence of perception serves to mark the limitations of Deleuze's two cinematic regimes. On the one hand, it exposes a domain of Intensity that lies beneath Quality and Power—the two poles of Deleuze's conception of the affection-image. Accordingly, our analysis of Viola might be said to complete our earlier engagement with the digital facial image in chapter 4: it furnishes the very mechanism through which the incommensurability foregrounded in our confrontation with these images can be transformed into an intense and vitalizing affective experience. In this way, it traces a beyond of the movement-image that leads in a very different direction than does Deleuze's study. And, on the other hand, Viola's liberation of affectivity restores a continuity to the experience of time that is stripped from it by Deleuze's conceptualization of the time-image as an *interstice*. In exposing the

time-image's dependence on an act of spectatorial synthesis for its effectuation, Viola's work thus reveals embodied affectivity to be the condition of possibility for the apprehension of the time-image.

In this way, Viola's aesthetic experimentation with machine time shifts the purport of Deleuze's analysis in a fundamental manner: specifically, the time-image can no longer simply be the expression of the inhuman power of time, but rather, as something like the inscription of machinic time, can only be the catalyst for an affective experience through which the human being confronts her own dependence on the inhuman, or better, the preindividual.[1] Here, needless to say, it traces out a beyond of the time-image that leads beyond the confines of Deleuze's study, as he himself has anticipated with his call for a "cinema beyond cybernetics." For this same reason, it leads directly back to Bergson's fundamental, coimplicated conceptions of the body as a center of indetermination and of the imbrication of perception with affection. Indeed, by expanding affectivity in a fundamentally embodied, yet profoundly empowering manner, Viola's work significantly expands Bergson's crucial insight into the bodily basis of intelligence, including, above all, technical intelligence, revealing it to be even more crucial at this later phase of our ongoing technogenesis.

At the same time, however, Viola's work retrospectively legitimates the trajectory I have taken in this book, that of transformatively appropriating Deleuze's work on the cinema in order to redeem Bergson's fundamental insight into affective embodiment. Juxtaposed with Stiegler's allegedly Bergsonist affirmation of the identity of cinema and life, Viola's work teaches an altogether different lesson, one that is, I have been arguing, truer to the radical experimental vocation of Bergsonism. Specifically, his work helps us appreciate the crucial importance of Deleuze's study: the imperative to recognize the radical heteromorphism between human capacities and machinic functions. Thus, Viola's work helps us enlist Deleuze in the updating of Bergson that I have proposed in this study: against his own move to appropriate Bergson's ontology of images, Deleuze's analysis of cinema shows that the material universe cannot be materialized via the image, and accordingly, that the focus must shift to the post-cinematic problem of framing *information* in order to create (embodied, processural, and affectively constituted) *digital images*. And in a similar way, Viola's work helps us to redeem Deleuze from his own tendencies toward abstraction and programmatic antihumanism: by foregrounding the need to undo

the humanist isomporphism between media inscription (cinematographic grammatization) and time-consciousness, Viola's work urges us both to accept the new machinism that is instantiated in the phenomenon of "machine time" and to explore this machinism *as the very catalyst for an empowering technical transformation of the human.* In this way, it helps us to resituate Deleuze's work— and in a sense, to revivify it—in the context of contemporary media technology, where the notions like the "machinic" and "becoming-other" might be said to find their "natural" home as, in effect, updatings of (broadly) Bergsonist conceptions of technical supplementation and duration as (hetero-)affectivity.

Notes

Introduction

1. I made a preliminary effort in this direction in my reading of Benjamin. See Mark Hansen, *Embodying Technesis: Technology beyond Writing* (Ann Arbor: University of Michigan Press, 2000), chapter 9.

2. Francisco Varela, to cite one central example, speaks of the emergence of neural patterns as "embodied enaction," in recognition specifically of the embeddedness of neural activity in the embodied phenomenological activity of living beings. See Varela, "The Reenchantment of the Concrete," in *Incorporations,* ed. J. Crary and S. Kwinter (New York: Zone, 1993). Similar accounts can be found in the work of Gerald Edelman, Antonio Damasio, and Walter Freeman, among others. I return to Varela's argument in chapter 7.

3. Henri Bergson, *Matter and Memory,* tr. N. M. Paul and W. S. Palmer (New York: Zone Books, 1988), 17–19.

4. Ibid., 25.

5. Ibid., 35–36.

6. Ibid., 38.

7. Gilles Deleuze, *Cinema 1: The Movement-Image,* tr. H. Tomlinson and B. Habberjam (Minneapolis: University of Minnesota Press), 1986, 61.

8. Ibid., 62.

9. Ibid., 64.

10. Brian Massumi, *Parables of the Virtual: Movement, Affect, Sensation* (Durham: Duke University Press, 2002), 1. I should note that I disagree with Massumi's account of the body's indeterminacy as "incorporeal" and would dispute his attribution of this view to Bergson. To my mind, the indeterminacy of the body is correlated with its concrete embodiment, which is precisely what Bergson means by saying that indetermination forms a

correlate of nervous system complexity. As we shall see in chapter 6, the ultimate stakes of this difference concern the differentiation of affectivity from perception.

11. Simondon, who is little known in the English speaking world, was a student of Merleau-Ponty's and an important mentor to Gilles Deleuze. His oeuvre consists of a study of technology entitled *La Mode d'existence d'objet technique* and two correlated works devoted to the process of individuation, *L'Individu et sa genèse physico-biologique* and *L'Individuation psychique et collective.* To date, only the introduction to *L'Individu* has been translated into English (in *Incorporations,* ed. J. Crary and S. Kwinter [New York: Zone Books, 1992]). I explore the relation between Deleuze's conception of intensity and Simondon's individuation in my essay, "Internal Resonance, or Three Steps Towards a Non-Viral Becoming," *Culture Machine* 3 (March 2001): http://culturemachine.tees.ac.uk/frm_f1.htm.

12. Gilbert Simondon, *L'Individuation Psychique et Collective* (Paris: Aubier, 1989), 108.

13. According to the tripartite division proposed by film scholar Vivian Sobchack. "Three metaphors have dominated film theory: the *picture frame,* the *window,* and the *mirror.* The first two, the frame and the window, represent the opposing poles of classical film theory, while the third, the mirror, represents the synthetic conflation of perception and expression that characterizes most contemporary film theory. What is interesting to note is that all three metaphors relate directly to the screen rectangle and to the film as a static *viewed object,* and only indirectly to the dynamic activity of viewing that is engaged in by both the film and the spectator, each as *viewing subjects*" (*Film and Phenomenology* [Princeton: Princeton University Press, 1993], 14–15).

14. Edmond Couchot, "Image puissance image," *Revue d'esthétique,* no. 7 (1984): 123–133, here 124.

15. "[T]he image, in its traditional sense, no longer exists! And it is only by habit that we still refer to what we see on the real-time screen as 'images.' It is only because the scanning is fast enough and because, sometimes, the referent remains static, that we see what looks like a static image. Yet, such an image is no longer the norm, but the exception of a more general, new kind of representation for which we do not yet have a term" (Lev Manovich, *The Language of the New Media* [Cambridge, Mass.: MIT Press, 2001], 100).

16. Following Manovich again: "Visually, these computer-generated or manipulated images are indistinguishable from traditional photo and film images, whereas on the level of 'material' they are quite different, as they are made from pixels or represented by mathematical equations or algorithms" (Manovich, *Language,* 180).

17. Ibid., 183.

18. For an informative survey of the variety of media art in the last decade, see Stephen Wilson's encyclopedic study, *Information Arts* (Cambridge, Mass.: MIT Press, 2002).

Chapter 1

1. Krauss, *"A Voyage on the North Sea": Art in the Age of the Post-Medium Condition* (London: Thames and Hudson, 1999), 27.

2. Ibid., 56.

3. Ibid., 25.

4. Ibid., 31.

5. Ibid., 56. For Krauss's account of Coleman, see Krauss, "Reinventing the Medium," *Critical* Inquiry 25.2 (winter 1999): 289–305, and Krauss, "And Then Turn Away? An Essay on James Coleman, *October* 81 (summer 1997): 5–33. For Krauss on Kentridge, see "'The Rock': William Kentridge's Drawings for Projection," *October* 92 (spring 2000): 3–35.

6. Krauss borrrows her conception of medial self-differing from Sam Weber, "Television, Set, and Screen," in *Mass Mediauras: Form, Technics, Media* (Stanford: Stanford University Press, 1996).

7. Kittler demonstrates convincingly that the term medium is a relative one, that is, pertinent only where there are a plurality of media. Thus, in his media-technical history of culture, he postulates a first "pre-medium" epoch (that of alphabetization) in which the universality of language renders it something like an Ur-medium, a universal form for the inscription of all experience. Kittler stresses that this universal form of the alphabetic monopoly is not, properly speaking, a medium. The concept of medium and media differentiation first arises, on his (admittedly schematic) history, at the moment when the technologies of gramophone, film, and typewriter furnish to voice (or sound), image (or vision), and writing autonomous inscriptional instruments. This epoch of media differentiation is precisely what is now coming to an end in the context of digitization; with the possibility for universal convergence of media, i.e., translation of all media into each other through a digital universality, the concept of the medium is becoming obsolete. This, we should stress, is a very different understanding of the "post-medium condition" than that offered by Krauss.

8. Erwin Strauss, *The Primary World of the Senses: A Vindication of Sensory Experience,* tr. J. Needleman (London: Collier-MacMillan, 1963); Henri Maldiney, *Regard, Parole, Espace* (Lausanne: Éditions l'Age d'Homme, 1973); José Gil, *Metamorphoses of the Body,* tr. S. Muecke (Minneapolis: University of Minnesota Press, 1998); Brian Massumi, "The Autonomy of Affect," *Cultural Critique* (fall 1995): 83–109.

9. Daniel Stern, *The Interpersonal World of the Infant,* 1985. See also Félix Guattari, *Chaosmosis,* tr. P. Bains and J. Pfannis (Bloomington: Indiana University Press, 1995).

10. Deleuze, *Difference and Repetition,* tr. Paul Patton (New York: Columbia University Press, 1994), chapter 2. For an extremely helpful discussion of the aesthetic consequences

of Deleuze's concept of transcendental sensibility, see Daniel W. Smith, "Deleuze's Theory of Sensation: Overcoming the Kautian Duality," in *Deleuze: A Critical Reader,* ed. P. Patton (London: Blackwell, 1996).

11. Yve-Alain Bois and Rosalind Krauss, *Formless: A User's Guide* (New York: Zone Books, 1997), 32.

12. Ibid., 135.

13. Ibid.

14. Ibid., 161.

15. Ibid., 163.

16. Ibid., emphasis added.

17. I discuss Gordon's work in detail in chapter 7 below.

18. Debra Singer, "Paul Pfeiffer," exhibition brochure, The Contemporary Series, Whitney Museum of Art, December 13, 2001–February 24, 2002, no pagination.

19. Paul Pfeiffer, cited in Singer, "Paul Pfeiffer."

20. And indeed, not only is there much reason to question whether it is one, but there is much reason to question whether the digital will become obsolete in the same way that the slide-tape or animation, not to mention the gramophone, film, and typewriter have (allegedly) become obsolete. That is to say, with the digital, what is at issue is not so much a concrete medium as a condition for mediality.

21. Manovich, *Language,* 47–48.

22. See Manovich, *Language,* 6–7.

23. Ibid., 78–79.

24. This overdetermination is, to some extent, mitigated by Manovich's attention to the "anticinematic" legacy of American experimental cinema of the 1960s and 1970s. It must be said, however, that this legacy can furnish nothing more than a theoretical counterperspective capable of demonstrating that cinema did not have to develop as it did. In other words, given the wide sway of Manovich's empiricism, the mechanisms of experimentalism are simply powerless to resist the contemporary institutionalism of the cinematic model.

25. Manovich, *Language,* 71.

26. Ibid., 180. He concludes simply that "the visual culture of [the] computer age is cinematographic in its appearance" (ibid.).

27. Here the counterexample of Friedrich Kittler is important. Unlike Manovich, Kittler seeks to conceive the material or ontological potentiality of new media independently of its contemporary (and to his mind severely constrained and anthropomorphic) forms. Although I shall later argue that Kittler goes too far in this direction, his warnings on the coercive function of software (to ease our interface with digital data and the computer architecture and thus to anesthetize us to the importance of learning programming) serve equally as injunctions against identifying today's embodiments of new media with its material (and I would add, aesthetic) potentiality.

28. Once again, this position is, empirically speaking, correct, but it has the stultifying effect of cutting off both alternative technical possibilities that were not adopted, such as Douglas Engelbart's fully embodied keyboard interface, and aesthetic possibilities, both contemporary and historical, that challenge this convention.

29. Manovich, *Language,* 86.

30. See Manovich, *Language,* 80–81.

31. Or, more cautiously, if it still is so bounded, it is for entirely different, dare I say technically contingent, indeed nontechnical, reasons.

32. See especially Manovich, *Language,* chapters 1 and 3.

33. Ibid., 180, emphasis in original.

34. Ibid.

35. Ibid.

36. Ibid., 302, emphasis in original.

37. Ibid., emphasis and ellipsis in original.

38. This is already evident in Manovich's characterization of the history of cinema understood as the art of motion: if we approach cinema in this way, he suggests, "we can see how it superseded earlier techniques for creating and displaying moving images" (ibid., 296). Isn't this effectively an argument that explains cinema's regime of realism as a consequence of the specific capacities of its technology? Confirmation on this score comes via Manovich's own characterization of his argument concerning digital cinema's return to the precinematic moment: "It would not be entirely inappropriate," he contends, "to read this short history of the digital moving image as a teleological development that replays the emergence of cinema a hundred years earlier" (ibid., 313).

39. Ibid., 308, emphasis added.

40. Jonathan Crary, *Techniques of the Observer: On Vision and Modernity in the Nineteenth Century* (Cambridge, Mass.: MIT Press, 1990) chapter 4. Indeed, Crary's analysis requires

us to differentiate between mobility and tactility, since many of the precinematic devices enforced a condition of immobility at the same time as they afforded tactile interfaces to the image. Moreover, Crary emphasizes the specifically optical nature of the tactile experience—what he calls "tangibility"—afforded by the stereoscope: "the desired effect of the stereoscope was not simply likeness, but immediate, apparent *tangibility.* But it is a tangibility that has been transformed into a purely visual experience" (122–124). The important point remains the difference of these precinematic devices in relation to cinema: whereas cinema enforces immobility in two senses—it both fixes the position of the viewer and suspends the function of any external (tactile) bodily or manual activity—*all* the precinematic devices foreground some bodily activity, whether this be actual movement in a space (panorama) or manual play (phenakistiscope, stereoscope).

41. Linda Williams, "Corporealized Observers: Visual Pornographies and the 'Carnal Density of Vision,'" in *Fugitive Images: From Photography to Video,* ed. P. Petro (Bloomington and Indianapolis: Indiana University Press, 1995): 3–41.

42. For example, Williams stresses the "tactility of the body's engagement with the particular apparatus of vision" in the precinematic regime (ibid., 17).

43. Ibid., 15, emphasis added.

44. In a certain respect, these two instances of a supplementary tactile element represent extreme deployments of the function of the "shock" in cinema as Walter Benjamin theorized it. Just as the modernist viewer had to be subjected to the perceptual shock of the cinematic apparatus in order to overcome her constitutive distractedness (and thus to embody or "innervate" the image), here the body must be stimulated in excess, as it were, of the "content" of the image in order for the latter to make its impact. In these cases, however, the solicitation of the body has been rendered autonomous, as it were, since it is no longer entirely rooted through the (referential) force of the image (or, to pursue the comparison with Benjamin, the dissociative force of the cinematic machine). For further discussion of Benjamin's understanding of the shock experience and the bodily dimension of cinematic experience, see Steven Shaviro, *The Cinematic Body* (Minneapolis: University of Minnesota, 1993), especially chapter 1, and Hansen, *Embodying Technesis,* chapter 9.

45. Hans Jonas, "The 'Nobility' of Vision," in *The Phenomenon of Life* (Chicago: University of Chicago Press, 1982). I discuss Jonas in detail in "Embodying Virtual Reality: Touch and Self-Movement in the Work of Char Davies," *Critical Matrix* 12 (1–2) (fall 2000/spring 2001): 112–147, available at www.chardavies.com/bibliography/Mhansen=F.html.

46. Richard Held, "Plasticity in Sensory-Motor Systems," in *Perception: Mechanisms and Models,* ed. R. Held and W. Richards (San Francisco: W. H. Freeman, 1972). I discuss this classical experiment, as well as more recent research in motor physiology with specific reference to telepresence, in "Embodying Virtual Reality."

47. Francisco Varela, "The Organism: A Meshwork of Selfless Selves," in *Organism and the Origins of Self,* ed. A. Tauber (Dordrecht: Kluwer Academic, 1991).

48. Crary, *Techniques,* 110.

49. Manovich, *Language,* 211. Incidentally, this would include the (admittedly minimal) manual activity of the mouse, which has the effect of rendering the embodied viewer an active viewer.

50. Ibid., emphasis added.

51. Indeed, it is telling that Manovich does not even mention telepresence in his discussion of virtual reality, though he does analyze it elsewhere in the book, in a section of the chapter entitled "Operations" and devoted to the function of the computer as image-instrument.

52. See, for example, Humberto Maturana, "Realität, Illusion und Verantwortung," in *Illusion und Simulation: Begegnung mit der Realität,* ed. S. Iglhaut et al. (Ostfildern: Cantz Verlag, 1995). This understanding of perception as hallucination is widespread in contemporary psychology and neuroscience and has been applied to virtual reality by various critics, including Florian Rötzer. I discuss this in detail in chapters 4 and 5.

53. But it must be pointed out here that the embodied constraints of human perception do place limits on how "alien" virtual spaces can in fact be.

54. Manovich, *Language,* 86–87.

55. Ibid., 87.

56. A telling instance of this omnivorous capacity of cinema comes by way of Manovich's discussion of the loop structure in Jean-Louis Boissier's CD-ROM *Flora petrinsularis,* where the uneven rhythm of the image movement has the effect of sublimating into the virtual space the manual dimension of the precinematic moment: "As you watch the CD-ROM, the computer periodically staggers, unable to maintain consistent data rate. As a result, the images on the screen move in uneven bursts, slowing and speeding up with human-like irregularity. It is *as though* they are brought to life not by a digital machine but by a human operator, cranking the handle of the Zootrope a century and a half ago . . ." (Manovich, *Language,* 321–322, emphasis added).

57. See Manovich, *Language,* 217.

58. Ibid., 282.

59. I should point out that these insights were first raised by Anne-Marie Duguet in her excellent 1997 essay on Shaw and prior to that by Shaw himself, in (for instance) his description of *EVE* for its exhibition at the ZKM's Multimediale 3 in 1993. See Duguet, "Jeffrey Shaw: From Expanded Cinema to Virtual Reality," in *Jeffrey Shaw: A User's Manual—Eine*

Gebrauchsanweisung, ed. M. Abel (Karlsruhe: ZKM, 1997): 21–57; Shaw, "EVE-Extended Virtual Environment," in *Multimediale* 3, ed. H. Klotz (Karlsruhe: ZKM, 1993), 60–61.

60. Manovich, *Language,* 282.

61. Incidentally, Shaw's works speak equally to Krauss's argument concerning the post-medium condition. For in both *EVE* and *Place: A User's Guide* the experience of the medium—and indeed the identification of the work with specific media—is not dictated by the conventions immanent to a particular medium, but rather by the body's ability to synthesize conventions *belonging to different, and antithetical, media interfaces.*

Chapter 2

1. As Shaw explains, these two interface traditions correspond to the two major trends in the history of the technological development of media: one of which encompasses "photography, cinema, and television" and "establishes the power of media to reassemble space and time as a contemplative experience"; and the other "the development from panorama painting to 'Virtual Reality' which establishes the power of media to reproduce space and time as a surrogate experience" (Jeffrey Shaw, "EVE—Extended Virtual Environment," in *MultiMediale 3,* ed. H. Klotz [Karlsruhe: ZKM, 1993], 60–61).

2. Extensive documentation of Shaw's projects can be found at www.jeffrey-shaw.net.

3. Peter Weibel, "Jeffrey Shaw: A User's Manual, in *Jeffrey Shaw: A User's Manual—Eine Gebrauchsanweisung,* 19.

4. Jeffrey Shaw, "Reisen in virtuellen Realitäten," in *Cyberspace: zum Medialen Gesamtkunstwerk,* eds. F. Rötzer and P. Weibel (Munich: Boer, 1993), 318.

5. Other critics have recognized Shaw's pioneering role in the domain of new media art. See especially Söke Dinkla's chapter on Shaw in her book, *Pioniere Interaktiver Kunst von 1970 bis heute* (Karlsruhe: Edition ZKM/Ostfelden: Cantz Verlag, 1997), 97–146.

6. Weibel, "Jeffrey Shaw: A User's Manual," 11.

7. Shaw, "Reisen," 324.

8. Bergson, *Matter and Memory,* 32.

9. Shaw, "Description of *Continuous Sound and Image Moments* (1966)," in *Jeffrey Shaw—A User's Manual,* 60.

10. Shaw, with T. van Tijen and W. Breuker, "Synopsis of Film Project," in *Jeffrey Shaw—A User's Manual,* 60, emphasis added.

11. This is a point made by Duguet, who cites its deployment of animation, temporal acceleration, flipping of images, and especially flicker effects (see Duguet, "Jeffrey Shaw," 25).

12. The synopsis speaks directly to both of these points. "The film was conceived from the need to explore a graphic idea throughout the infinite possibilities of its forms. . . . Each image contains an implicit idea of its continuity beyond the given frame. The showing of these images on four screens will emphasize this by appearing as four areas of limited materialization of an implicit unlimited spatial continuity of the image forms" (60).

13. Duguet, "Jeffrey Shaw," 27.

14. Bergson, *Matter and Memory*, 35.

15. Shaw, "Description of *Corpocinema*," in *Jeffrey Shaw—A User's Manual*, 68.

16. "Our representation of matter is the measure of our possible action upon bodies: it results from the discarding of what has no interest for our needs, or more generally, for our functions" (Bergson, *Matter and Memory*, 38).

17. Shaw, "Description of *MovieMovie*," in *Jeffrey Shaw—A User's Manual*, 70.

18. Shaw, "Reisen," 329–330.

19. In his description of the work, Shaw emphasizes three crucial elements: first, the "inherent brightness" of the projection system, which allowed for the fusion of projected images with the brightly lit museum environment; second, the structural isomorphism between the represented space of the projected images and the space occupied by the screen, which yielded a "seamless continuity between virtual and actual spaces"; and third, the use of slide projection (rather than film or video) in order to "enunciate a clear difference between the actual and projected events" (Shaw, "Description of *Viewpoint*," in *Jeffrey Shaw—A User's Manual*, 86).

20. Duguet, "Jeffrey Shaw," 38.

21. Ibid., 37.

22. Shaw, "Modalities," 153.

23. Shaw, "Description of *The Narrative Landscape*," in *Jeffrey Shaw—A User's Manual*, 108.

24. Shaw, "Modalities," 153.

25. The analysis in this section is a much condensed version of my paper, "Cinema beyond Cybernetics, or How to Frame the Digital Image," *Configurations* 10 (2003): 51–90.

26. Friedrich Kittler, *Gramophone, Film, Typewriter*, tr. G. Winthrop-Young and M. Wutz. (Stanford, CA: Stanford University Press, 1999), xxxix and 3, citing Norbert Bolz. This priority of technology (or rather media) over aesthetics serves to demarcate Kittler's work from that of McLuhan: "Understanding media—despite McLuhan's title—remains an impossibility precisely because the dominant information technologies of the day control all understanding and its illusions" (Kittler, *Gramophone*, xl). Media, that is,

ground the hermeneutic circle and are, for that reason, by definition beyond the grasp of interpretation.

27. Ibid., 1–2.

28. Ibid., 2.

29. Kittler, "Computer Graphics: A Semi-Technical Introduction," *The Grey Room,* no. 2 (winter 2001): 30–45, here 32.

30. Ibid., 35.

31. Deleuze, *Cinema 2: The Time-Image,* trans. H. Tomlinson and R. Galeta (Minneapolis: University of Minnesota Press, 1989), 265–266.

32. Although it is constantly at issue in the two volumes of Deleuze's study, he specifically addresses the problematic of framing in *Cinema 1,* chapter 2.

33. Deleuze, *Cinema 2,* 270.

34. Kittler, "Geschichte der Kommunikationsmedien," in *Raum und Verfahren,* ed. J. Huber and A-M Müller (Frankfurt am Main/M: Stroemfeld/Roter Stern, 1993); cited following English version, "The History of Communication Media," *Ctheory,* www.ctheory.net/text_file. asp?pick=45, 1, first sentence of translation modified in accordance with Winthrop-Young's translation, "Silicon Sociology, or, Two Kings on Hegel's Throne? Kittler, Luhmann, and the Posthuman Merger of German Media Theory," *Yale Journal of Criticism* 13 (2) (2000), 408.

35. Here I am following the astute criticism of Geoffrey Winthrop-Young, "Silicon Sociology," 407.

36. Accordingly, information can be defined as a statistical measure of uncertainty equal to the logarithm taken to base 2 of the number of available choices. Thus, if a message can be specified following five binary steps or choices, the statistical measure of uncertainty (or information) can be specified as: $C = \log_2 32 = 5$. This logarithm allows the message to be specified probabilistically, without any recourse being made to its meaning.

37. In his own supplement to Shannon's mathematic theory, Weaver has proposed an account of meaning in terms of behavioral effect that would leave intact the structural separation central to Shannon's theory. Effectively, Weaver introduces two levels beyond the technical level (Level A)—transmission and reception (Levels B and C)—only to subordinate them to the former: since Levels B and C "can make use only of those signal accuracies which turn out to be possible *when analyzed at Level A,*" not only do "any limitations discovered in the theory at Level A necessarily apply to levels B and C," but in fact, "the theory of Level A *is, at least to a significant degree, also a theory of levels B and C*" (Weaver, "Recent Contributions to the Mathematical Theory of Communication," in Claude Shannon and Warren Weaver, *The Mathematical Theory of Communication* [Urbana: University of Illinois

Press, 1972], 6, emphasis added). Behavioral effect—that is, the measure of the effectiveness of a message—is entirely a function of technical possibilities.

38. As Kate Hayles mistakenly alleges in her account of MacKay. See Hayles, *How We Became Posthuman: Virtual Bodies in Cybernetics, Literature, and Informatics* (Chicago: University of Chicago Press, 1999), 55. This point notwithstanding, my argument here is heavily indebted to Hayles's excellent exegesis of the history of cybernetics.

39. Donald MacKay, "The Place of 'Meaning' in the Theory of Information," in *Information Theory: Papers Read at a Symposium on "Information Theory" Held at the Royal Institution, London, September 12th to 16th 1955* (New York: Academic Press, 1956), 218–219.

40. MacKay, "The Informational Analysis of Questions and Commands," in *Information Theory: Papers Read at a Symposium on "Information Theory" Held at the Royal Institution, London, August 29th to September 2nd 1960* (London: Butterworths, 1961), 471.

41. Reprinted in MacKay, *Information, Mechanism, Meaning,* (Cambridge, Mass., MIT Press, 1969), 42.

42. Here we see that for MacKay, pattern does not adhere in information, but comes from the receiver. For this reason, one can usefully contrast MacKay not simply with Shannon and the dominant voice of first-generation cybernetics, but with the more general privilege of pattern over materiality that, as Hayles has convincingly argued, represents one of its most significant legacies to us (if not the most significant of all).

43. MacKay, *Information, Mechanism, Meaning,* 54.

44. Deleuze, *Cinema 2,* 332, n. 21.

45. Raymond Ruyer, *La Cybernétique et l'origine de l'information* (Paris: Flammarion, 1954), 81.

46. Ruyer, *La Cybernétique,* 81.

47. One must bear in mind that the French term *conscience* has a broader semantic range than the English *consciousness.* Ruyer uses the term to designate a function of human being (and indeed of all biological or subjective beings as such) that goes well beyond the empirical notion of consciousness as awareness or representational thinking. Indeed, Ruyer goes to great lengths to distinguish between primary and secondary consciousness, the former being identified with the basic equipotentiality and internal resonance of the living, and the latter identified specifically with the nervous system of higher-order animals and the cortex of human beings. Ruyer insists that primary consciousness is fundamental. See Ruyer, *Néo-Finalisme* (Paris: PUF, 1952), 40ff. and 79.

48. "Equipotentiality" is a biological concept from the subdiscipline of embryology that designates the embryo's capacity to develop in a variety of incompossible ways.

49. Ruyer, *La Cybernétique,* 9–10. Here Ruyer's position is the inverse of Kittler's, since for him it is simply meaningless to speak of information without (human) framing. This becomes even clearer later in the text when Ruyer considers a scenario wholly akin to Kittler's posthistorical optoelectronic future: "A circulation of waves from machine to machine in a closed circuit, without origin nor exit oriented toward [*donnant sur*] an individual consciousness, cannot be called information" (29).

50. Ibid., 23.

51. At the core of Ruyer's neo-finalism is the fundamental notion that living beings enjoy a kind of absolute self-knowledge, an experience of themselves as absolute forms. This is what Ruyer calls the capacity for "absolute survey." This notion finds a paradigmatic illustration in the example of vision. In chapter 9 of *Néo-Finalisme,* Ruyer distinguishes between the physical and the trans-spatial dimensions of vision in order to show how the former is secondary to and thus dependent on the latter. When we look at a physical surface (defined *partes extra partes*) such as a checkered table-top, we must be positioned in space such that our retina is at some distance from and along a dimension perpendicular to the table-top. Ruyer compares this visual experience with that of a camera, which likewise must occupy a position in space at a distance from and perpendicular to the surface. On the basis of this comparison, Ruyer introduces a certain regress of physical vision (or observation), since in order to see (or photograph) the visual field *n,* an observer (or camera) would have to be located in an *n*+1 dimension. In simpler terms, in order to see the image (or photograph) of the table-top, an observer (or camera) would have to be at some distance and perpendicular to it, and so on for each higher level or dimensionality. However, Ruyer notes, this "geometrical law," which governs the "technique of perception," i.e., perception "as a physico-physiological event," *is not valid for visual sensation as a state of consciousness.* When we consider visual sensation in itself, we no longer observe our sensation from the outside, from a dimension perpendicular to it, but stand, as it were, "at all places at once in the visual field" (99). This is what Ruyer means by "absolute survey": a kind of absolute grasp of (in this case) the visual field, a "self-enjoyment" that dispenses with the mediation of observation and the infinite regress bound up with it. It is, says Ruyer, "a surface grasped in all its details, without third dimension, . . . an 'absolute surface,' which is relative to no external point of view, which knows itself without observing itself" (98). This notion forms the basis for my exploration of virtual reality in chapter 5 below.

52. I have elected to translate *le montage* in two ways, as "assembly" and as "assemblage," in order to reflect the distinction in Ruyer's conception between its active and its passive sense.

53. Ruyer, *La Cybernétique,* 81–82. MacKay also presents consciousness as creative of information: "Consciousness, for example—if I dare stick my neck out—might be introduced in this way: We might say that the point or area 'of conscious attention' on a field of data is the point of area under active internal symbolic replication, or evocative of internal

matching response. When a man speaks to another man, the meaning of what he says is defined by a spectrum over the elementary acts of internal response which can be evoked in the hearer" (MacKay, *Information, Mechanism, Meaning,* 53).

54. See Ruyer, *La Cybernétique,* 85.

55. Shaw, "Description of Place: A User's Manual," *Jeffrey Shaw—A User's Manual,* 145.

56. I discuss *EVE* below in chapter 4.

57. Manovich, *Language,* 241.

58. Ruyer, "Le Relief Axiologique et le Sentiment de la Profondeur," *Revue de Métaphysique et de Morale,* 61 (1956): 242–258, here 247.

59. Ibid., 265.

60. Duguet, "Jeffrey Shaw," 46.

61. "Inframince. Reflections / of light on diff. surfaces / more or less polished—Matt reflections giving an / effect or reflection—mirror in / depth / could serve / as an optical illustration of the idea / of the infra-thin as / 'conductor' from the 2nd to / the 3rd dimension" (Marcel Duchamp, *Notes on the Inframince,* cited in Duguet, "Jeffrey Shaw," 45).

62. Shaw, "The Dis-Embodied Re-Embodied Body" (1995), in *Jeffrey Shaw: A User's Manual,* 155.

63. The notion of a virtualization of the body (as distinguished from the embodied actualization of the virtual) is explored below in chapter 4.

64. Duguet, "Jeffrey Shaw," 44.

65. Ibid., 51.

66. Ibid., 46.

Chapter 3

1. William J. Mitchell, *The Reconfigured Eye: Visual Truth in the Post-Photographic Era* (Cambridge, Mass.: MIT Press, 1992), 7.

2. Ibid., 43.

3. Ibid., 17, 225.

4. Lev Manovich, "The Paradoxes of Digital Photography," in *Photography after Photography.* Exhibition Catalog (Germany, 1995), 4, cited at www-apparitions.ucsd.edu/~mauovich/text/digital_photo.html.

5. Ibid.

6. Manovich, "Automation of Sight: From Photography to Computer Vision," 1994, 6, available at http://www.manovich.net/docs/automation.doc.

7. Ibid., 15.

8. N. Katherine Hayles, "Virtual Creatures," *Critical Inquiry* 26 (autumn 1999): 1–26.

9. See in this regard Kittler's recent discussion of the digital image in "Computer Graphics" as well as my above discussion.

10. Crary, *Techniques of the Observer,* 1–2, emphasis added.

11. John Johnston, "Machinic Vision," *Critical Inquiry* 26 (autumn 1999): 27–48, here 46.

12. Ibid., 47.

13. Ibid., 45.

14. Ibid. Perception *qua* machinic vision thus requires "an environment of interacting machines and human-machine systems" and "a field of decoded perceptions that, whether or not produced by or issuing from these machines, assume their full intelligibility only in relation to them" (27).

15. Ibid., 39.

16. Bergson, *Matter and Memory,* 58, emphasis added.

17. On this point we should bear in mind Johnston's own qualifications regarding the homology of computer and brain: "By conservative estimates, in the milliseconds before a visual image even reaches the brain, it has already been subjected to literally millions of calculations in the retina and optic nerve. . . . These calculations . . . are massively parallel and cannot be simulated by the von Neumann, one-step-at-a-time architectures of most digital computers. Hence they constitute a serious obstacle to the effort to build a vision machine" (Johnston, "Machinic Vision," 41).

18. The term is Paul Virilio's and, in accord with my above distinction between "vision" and "sight," would better be rendered as "sight machine."

19. Lacan develops his materialist notion of consciousness in *Seminar II*. Kittler appropriates it in his understanding of the technical properties of computer graphics: "in a 'materialist definition' of consciousness any 'surface' suffices where the refraction index biuniquely transfers individual points in the real to corresponding though virtual points in the image. So-called Man, distinguished by his so-called consciousness, is unnecessary for this process because nature's mirrors can accommodate these types of representation just as well as the

visual center in the occipital lobe of the brain" (Kittler, "The World of the Symbolic—A World of the Machine," in *Literature, Media, Information Systems,* ed. J. Johnston [Amsterdam: Overseas Publishers Association, 1997], 131).

20. Paul Virilio, *The Vision Machine,* tr. J. Rose (Bloomington: Indiana University Press, 1994), 61.

21. Ibid.

22. "Don't forget," he reminds us, "that 'image' is just an empty word . . . since the machine's interpretation has nothing to do with normal vision (to put it mildly!). For the computer, the optically active electron image is merely a series of coded impulses whose configuration we cannot begin to imagine since, in this 'automation of perception,' *image feedback is no longer assured*" (ibid., 73).

23. Virilio, *Open Sky,* tr. J. Rose (London: Verso, 1997), 93.

24. "Ophthalmology thus no longer restricts itself to practices necessitated by deficiency or disease; it has broadened its range to include an intensive exploitation of the gaze in which the depth of field of human vision is being progressively confiscated by technologies in which man is controlled by the machine . . ." (ibid.).

25. Virilio, *Vision Machine,* 73.

26. Virilio, *Open Sky,* 96.

27. Ibid., 90.

28. In his brilliant analysis of the "nobility of vision," Hans Jonas shows how touch and other bodily modalities "confer reality" on perception:

> Reality is primarily evidenced in resistance which is an ingredient in touch-experience. For physical contact is more than geometrical contiguity: it involves impact. In other words, touch is the sense, and the only sense, in which the perception of quality is normally blended with the experience of force, which being reciprocal does not let the subject be passive; thus touch is the sense in which the original encounter with reality as reality takes place. Touch brings the reality of its object within the experience of sense in virtue of that by which it exceeds mere sense, viz., the force-component in its original make-up. The percipient on his part can magnify this component by his voluntary counteraction against the affecting object. For this reason touch is the true test of reality. (Jonas, "The 'Nobility' of Vision," 147–148)

29. Florian Rötzer, "Re: Photography," in *Photography after Photography: Memory and Representation in the Digital Age,* ed. H. v. Amelunxen et al. (Amsterdam: G + B Arts, 1996), 17–18, emphasis added.

30. In his treatment of digital design, architect Bernard Cache insists that digitally facilitated topological spaces should not be opposed to Euclidean space—as they so often are—precisely because of their experiential dimension, i.e., their capacity to be experienced by us. See Cache, "A Plea for Euclid," www.architettura.supeveva.it/extended/19990501/ep07en_03.htm, accessed April 14, 2001.

31. Margaret Morse, "Description of *The Garden*," in *Hardware-Software-Artware* (Karlsruhe: ZKM, 2000), 28.

32. Brian Massumi, "Sensing the Virtual, Building the Insensible," *Architectural Design* 68 (5/6) (May/June 1998): 21.

33. Roy Ascott, "Photography at the Interface," in *Electronic Culture: Technology and Visual Representation,* ed. T. Druckrey (Denville, N.J.: Aperature, 1996), 166.

34. Documentation of *Lovers Leap* can be found at www.rogala.org.

35. Miroslaw Rogala, cited in Morse, "Description of *Lovers Leap*," in *Hardware-Software-Artware,* 95.

36. Morse, "Description of *Lovers Leap*," 95.

37. Timothy Druckrey, "*Lovers Leap*," in *Artintact 2* (Karlsruhe: ZKM, 1995), 75.

38. Miroslaw Rogala, cited in Morse, "Description of *Lovers Leap*," 94.

39. Morse, "Description of *Lovers Leap*," 96.

40. As if to reinforce this shift, the work includes a "distorted, circular image," a kind of anamorphic stain—"eerie fish-eye images that look like a ball with building growing out of them" (Morse, "Description of *Lovers Leap*," 95, citing Charlie White)—that does not resolve itself into a photo-optic image, but rather calls into being a "mental construct of the omniscient gaze made visible" (ibid.).

41. Documentation of Waliczky's work can be found at www.waliczky.com.

42. Anna Szepesi, "*The Forest*," in *Artintact 2,* 102.

43. Ibid., 103.

44. Morse, "Description of *The Way*," in *Hardware-Software-Artware,* 31.

45. For the notion of embodied schemata in cognitive linguistics, see Mark Johnson, *The Body in the Mind: The Bodily Basis of Meaning, Imagination, and Reason* (Chicago: University of Chicago Press, 1987).

46. Duguet, "Jeffrey Shaw," 41.

47. In line with this theory, new media art would comprise an instance of the augumentation of experience through intelligence that Bergson associates generally with technology. See *Creative Evolution,* tr. A. Mitchell (Mineola, N.Y.: Dover, 1998).

48. Lars Spuybroek, "Motor Geometry," *Architectural Design* 68 (5/6) (May/June 1998): 49, emphasis added.

49. Ibid.

50. In this sense, I can agree with Deleuze that there has been a break with the sensorimotor logic of the movement-image without endorsing his rejection of the body. Simply put, the sensorimotor connection is no longer internal to the image, but is rather something that is imposed through the process of framing information (and thus creating images).

51. Virilio anticipates this break in his characterization of the shift from natural light to laser delivery of light: "Faced with this sudden 'mechanization of vision,' in which the *coherent* light impulse of a laser attempts to take over from the fundamentally *incoherent* light of the sun or of electricity, we may well ask ourselves what is the real aim, the as yet unavowed objective, of such instrumentation—of a kind of *perception* no longer simply enhanced by the lenses of our glasses . . . but by computer. Is it about improving the perception of reality or is it about refining reflex conditioning, to the point where even our grasp of how our perception of appearances works comes 'under the influence'?" (*Open Sky,* 94). If we supplement this picture with the scenario of direct stimulation of the optic nerve, we confront a situation where vision occurs in the total absence of light.

52. Spuybroek, "The Motorization of Reality," *Archis* (November 1998), emphasis added, cited at www.uni-kassel.de/fb12/fachgebiete/cad/cax/lars/motor.htm, accessed November 12, 2001.

Chapter 4

1. In this sense, my argument contrasts with Lev Manovich's recent call for a "Software" aesthetic that invests in the "tactical" uses of software functions. As I see it, this aesthetic risks a conceptual positivization not unlike that of Manovich's argument for the "cinematic metaphor" that, as I argued in chapter 1, compromises his study of new media. For, so long as we accept the software functions as preconstituted for us by industry, we have already sacrificed too much. This claim, incidentally, dovetails with Kittler's critique of software in "There Is No Software" and, especially, "Protected Mode" (both in *Literature, Media, Information Systems*). Manovich outlines his conception of a software aesthetic in "Avant-Garde as Software," available at http://www.manovich.net/docs/avantgarde_as_software.doc.

2. Gilles Deleuze and Félix Guattari, *A Thousand Plateaus,* tr. B. Massumi (Minneapolis: University of Minnesota Press, 1987), 181.

3. Deleuze, *Cinema 1,* 87–88; translation modified.

4. And in a more general sense, the "white wall/black hole" system of faciality has been recast as the expressive milieu par excellence of the cinema: the system of light and darkness that comprises the primordial soup of cinematic construction.

5. Deleuze, *Cinema 1,* 95–96.

6. Ibid., 96.

7. Daniel Stern, *The Interpersonal World of the Infant,* chapter 4.

8. Deleuze and Guattari criticize all efforts at a "return to . . ." as always already and necessarily co-opted by very success of the semiotic of overcoding. Instead they advocate a radical deterritorialization, becoming-animal, schizogenesis. See Deleuze and Guattari, *Plateaus,* 188–189.

9. Following the conception of Gilbert Simondon discussed in the Introduction.

10. "If it is true that the cinematic image is always deterritorialized, there is . . . a very special deterritorialization which is specific to the affection-image" (Deleuze, *Cinema 1,* 96).

11. Ibid., 65.

12. Ibid., emphasis added.

13. Ibid., 65–66.

14. Bergson, *Matter and Memory,* 53–55.

15. Deleuze, *Cinema 1,* 66.

16. Ibid.

17. Ibid.

18. Ibid., 97. Incidentally, here we might note that Peirce—Deleuze's source for this argument—himself insists on the necessary correlation of Firstness and Secondness, the fact that there can be no instance of Firstness (no matter how autonomous it may be from the expressive dimension) without Secondness. At the very least, this would complicate Deleuze's alliance of Firstness with the affect as Entity (e.g., pure redness).

19. Ibid., 87.

20. Ibid., 88.

21. Ibid., 89.

22. Ibid., 88–89.

23. Ibid., 89.

24. Ibid.

25. Ibid., 90.

26. Ibid., 89–90.

27. Ibid., 92.

28. Ibid., 96.

29. Ibid., 97.

30. Ibid., 99.

31. Catalog description from the Whitney Museum "Bitstreams" exhibition.

32. *Portrait no. 1* was originally developed as an installation, involving a computer monitor and trackball mounted on an arch-shaped base. It has subsequently been reformatted onto a CD-ROM and is available as part of the ZKM's publication, *Artintact 1.*

33. Documentation of *Portrait no. 1,* as well as other related works by Luc Courchesne, can be found at www.din.umontreal.ca/courchesne. An interactive online version of *Portrait no. 1* can be found at www.fondation-langlois.org/portrait1.html.

34. Further documentation of *Touch Me* can be found at www.durbano.de/touchme/index.html.

35. A work in which the viewer's eye-movement across the surface of a digital projection of a painting has the effect of destroying the image. For a discussion of *Zerseher,* see Derrick de Kerckhove, "Touch versus Vision: Äesthetik Neuer Technologien," in *Die Aktualität des Ästhetischen,* ed. W. Welsch (Munich: Wilhelm Fink Verlag, 199?): 137–168.

36. Hans-Peter Schwarz, *Media—Art—History: ZKM/Center for Art and Media Karlsruhe* (Munich: Prestel, 1997), 158.

37. Geisler's earlier *Who Are You?* (1996) already explored this convergence of the two tendencies. In this work, the viewer-participant is confronted with a puzzle of indiscernibility that foregrounds viewer expectations as one of the central components for the autonomy of the digital image. *Who Are You?* is composed of two images of what appears to be the same female face, one a video registration, the other a digitally generated image. Housed within adjacent wooden frames, the two "portraits" move in slow rhythm from the front to the side view and back again. As soon as they come to a standstill, the viewer-participant hears a female voice pose the question: "Who are you?" three times, as each portrait interrogates the other, and then both together interrogate the viewer-participant. In this experience, the affection-image becomes the bearer not of the autonomy of affect but of the traces of its

very materiality, and if the viewer-participant is, as the description accompanying the work suggests she will be (and as this particular viewer-participant most certainly was), led by convention to associate the video image with a "real" person and to dismiss the computer-generated image as artificial, she is compelled to recognize the central role her own affective response plays in her commerce with digital images. In what amounts to an inversion of the problematic of indiscernibility that, following Arthur Danto's thesis, informed the conceptual turn in modern art, an initial perceptual indiscernibility opens onto a difference largely borne by the bodily registered expectations that a viewer brings to the experience of the image. Paradoxically then, the "autonomy" of the affection-image is shown to be indelibly bound up with the connotations of the digital medium *as these are mediated through embodied response.*

38. Pierre Lévy, *Qu'est que le Virtuel?* (Paris: La Découverte, 1998), 14.

39. Lévy, *Collective Intelligence: Mankind's Emerging World in Cyberspace,* tr. R. Bononno (New York: Plenum, 1997), 123.

40. Ibid., 48.

41. Ibid., 49.

42. Timothy Murray, "Digital Incompossibility: Cruising the Aesthetic Haze of the New Media," *Ctheory,* 2000, http://www.ctheory.net/text_file.asp?pick=121, accessed February 21, 2001.

43. Deleuze develops this understanding with specific reference to art: "When it is claimed that works of art are immersed in a virtuality, what is being invoked is not some confused determination but the completely determined structure formed by its genetic differential elements, its 'virtual' or 'embryonic' elements. The elements, varieties of relations and singular points coexist in the work of the object, in the virtual part of the work or object, without it being possible to designate a point of view privileged over others, a centre which would unify the other centres" (Deleuze, *Difference and Repetition,* 209). The claim that the work of art is immersed in a virtuality requires a distinction between two conceptions of the object: insofar as it is *complete* and insofar as it is *whole.* The former defines the object as Idea; the latter as empirical actual. With this distinction, we get a sense for the properly *philosophical* work that the concept of the virtual is meant to perform: in determining the reality of an object as an Idea, it differentiates the actualization of the virtual from the *realization* of the possible. For Deleuze, the virtual defines a reality that is, quite simply, without relation with empirical reality.

44. Murray, "Digital Incompossibility," emphasis added.

45. Félix Guattari, *Chaosmosis: An Ethico-Aesthetic Paradigm,* tr. P. Bains and J. Pefanis (Bloomington: Indiana University Press, 1995), 25.

46. Ibid., 9. In this sense, it is not insignificant that Guattari credits Bergson as his source here: "We can trace this intuition to Bergson, who shed light on the non-discursive experience of duration by opposing it to a time cut up into present, past and future, according to spatial schemas" (25).

47. Ibid., 4.

48. Following the conception of Gilbert Simondon discussed in the introduction.

49. Deleuze, *Cinema 1,* 110.

50. Ibid., 102.

51. Ibid., 108.

52. Ibid., 109, emphasis added.

53. Ibid.

54. See www.mongrelx.org for further documentation of this and closely related projects.

55. Mongrel, http://www.mongrelx.org/Project/projects.html#colour, accessed May 23, 2001.

56. Feingold's Web site contains a description of his work over the past two decades. See www.kenfeingold.com.

57. "Neither human, nor machine," creations like Feingold's can be said to share in "the birth of a new medium. Up until now, you could not listen to a text without listening to someone's body. The independent text, independent of the human body, was always the *printed* text. For the first time, language now has a sound independent of the body—a sound that directly emanates from the linguistic system, from syntax and phonemes." Remko Scha, "Virtual Voices," cited at http://www.iaaa.nl/rs/virtual.html, page 12, accessed April 2, 2002.

58. Consider the smiling, clownlike bald head of *Head,* the mannequin-like bald heads as "replacement parts" of *If/Then,* and the oddly rigid self-portrait of *Sinking Feeling.*

59. Ken Feingold, "Selected On-Line Bibliography," www.kenfeingold.com/notes.html, 21.

60. According to the press release for Feingold's 2001 exhibition at Postmasters Gallery.

61. Feingold, "Selected On-Line Bibliography," 21.

62. As the jury statement for Vida 3.0 (a 2000 international competition on artificial life in which *Head* was a prize winner) puts it, "Feingold chooses to explore the zones of non-response, of mischief and misbehavior, or distortion, of scrambled and failed communication. [His work] makes us question the basis for everyday dialogue we tend to take for

granted: how far is our exchange with others conditioned and limited by our own, thoroughly encoded eccentricities, our own programmed bugs and quirks? When indeed true communication occurs, how much is this just a matter of chance?" (Cited in Feingold, "Selected On-Line Bibliography," 22.)

63. Barthes, of course, linked the "grain of the voice" to the throat (as opposed to the breath), imbuing it with an expressive physicality. See "The Grain of the Voice" in Roland Barthes, *Image-Music-Text,* tr. R. Howard (New York: Hill and Wang, 1977).

64. A similar problematic is at issue in our experience of virtual characters created for Hollywood movies and, in a slightly different form, virtual creatures deployed by artists like Pierre Hughye.

65. In truth, Huge Harry is one of the personalities of the speech synthesis machine, MITalk, designed by Dennis Klatt at the MIT Speech Laboratory, who has been acquired by a Dutch artist, Arthur Elsenaar.

66. www/iaaa.nl/hh/cv.html, accessed April 1, 2002.

67. "An artistic project that wants to acknowledge [the arbitrariness of the artistic process] faces an interesting technical challenge: to avoid choices, to transcend styles, to show everything: to generate arbitrary instances from the set of all possibilities. The spontaneous individual artist will not be able to accomplish this. Only a deliberate scientific/technological undertaking will be able to approximate the ideal of a serenely all-encompassing art" (Huge Harry, "On the Role of Machines and Human Persons in the Art of the Future"), http://iaaa.nl/hh/pose.html, accessed April 1, 2002.

68. Huge Harry, "On the Mechanism of Human Facial Expression as a Medium for Interactive Art," www.iaaa.nl/hh/face/HHLecture2.html, accessed April 1, 2002.

69. As Stephen Wilson has recently suggested in his account of Huge Harry in *Information Arts,* 162–164.

70. Eric Kluitenberg, "Human Art Is Dead. Long Live the Algorithmic Art of the Machine: A *Mute* Exclusive Interview with Huge Harry," *Mute* 19 (February 1998): 14–21, accessed at www.iaa.nl/hh/div/MuteInterview.html, April 1, 2002.

71. This will presumably not be the case so long as the affective states utilized are those of the so-called categorical affects, that is, the basic human emotions. I return to this issue below in chapter 7, where the machinic inscription of time yields the potential to present ordinarily imperceptible "vitality affects," affects that testify to the sheer fact of being alive, of continuing to live, of being essentially oriented to the future.

72. The work of Paul Ekman, for example, has demonstrated the correlation between facial expressions and affective brain states. See Paul Ekman and R. J. Davidson, "Voluntary Smiling Changes Register Brain Activity," *Psychological Science* 4 (1993): 342–345.

1. Brian Massumi, "Line Parable for the Virtual (On the Superiority of the Analog), in *The Virtual Dimension: Architecture, Representation, and Crash Culture*, ed. J. Beckman (Princeton: Princeton Architecural Press, 1998), 9.

2. Ken Pimentel and Kevin Teixeira, *Virtual Reality: Through the New Looking Glass* (New York: Intel/Windcrest McGraw Hill, 1993), 11.

3. To avoid confusion, let me further say that VR gloves, far from having the task of allowing for tactile navigation in the dataspace, function primarily to situate the viewer within a space that is to be visually apperceived. Just as our partial view of our bodies in the space of visual perception serves to fix our standpoint in relation to that space, so too do the gloves function in VR space.

4. For a useful account of the requirements of VR systems, see Jonathan Steuer, "Defining Virtual Reality: Dimensions Determining Telepresence," *Journal of Communications* 42, 4 (1992): 73–93. I discuss Steuer in "Embodying Virtual Reality."

5. My claim here loosely follows that of Andrew Murphie, "Putting the Virtual Back into VR," *Canadian Review of Comparative Literature* (September 1997): 713–742, here 735.

6. For an excellent account of this correlation, see Hans Jonas, "The Nobility of Vision." I develop the implications of Jonas's argument for VR, and specifically in relation to Char Davies's *Osmose* and *Ephemère,* in "Embodying Virtual Reality."

7. Bergson, *Matter and Memory,* 57.

8. Ibid., 43, emphasis added.

9. In this respect, the Bergsonist maxim that has been my guiding light in this study (there is no perception without affection) by itself does not accord agency to the body; rather, it exposes the way in which the body's affection and personal memory have an impact on its selection of images. That is why I introduced Simondon as a development beyond Bergson in chapter 4. I will do something similar with the help of Raymond Ruyer here.

10. I synthesize the term "autopoietic affective kernel" from the analysis of Éric Alliez in *La Signature du Monde ou Qu'est-ce la Philosophie de Deleuze et Guattari* (Paris: Les Éditions du Cerf, 1993), 78.

11. For a helpful account of the scientific and entertainment deployments of VR as a form of hypertourism, see Dean MacCannell, "Virtual Reality's Place," *Performance Research* 2(2) (1997): 10–21.

12. Simon Penny, "Consumer Culture and the Techhnological Imperative: The Artist in Dataspace," published in *Critical Issues in Electronic Media,* ed. S. Penny (Buffalo: SUNY

Press, 1995), accessed at www-art.cfa.cmu.edu/penny/texts/Artist_in_D'space.html, November 20, 2001.

13. Penny, "Agents as Artworks and Agent Design as Artistic Practice," published in *Human Cognition and Social Agent Technology,* ed. K. Dautenhahn (Amsterdam: John Benjamins Publishing Company, 2000), accessed at www-art.cfa.cmu.edu/Penny/texts/Kerstin_Chptr_Final.html, November 20, 2001.

14. Further documentation of "Fugitive" can be found at www-art.cfa.cmu/Penny/works/fugitive/fugitive.html.

15. Penny, "Agents."

16. Ibid.

17. Derrick de Kerckhove, "Virtual Reality for Collective Processing," in *Ars Electronica: Facing the Future,* ed. T. Druckrey (Cambridge, Mass.: MIT Press, 1999), 237, citing engineer Eric Gullichson.

18. Lévy, *Cyberculture: Rapport au Conseil de l'Europe dans le cadre du projet "Nouvelles technologies: cooperation culturelle et communication"* (Paris: Editions Odile Jacob, 1997), cited in Murray, "Digital Incompossibility," 1.

19. Raymond Bellour, "The Double Helix," in *Electronic Culture,* 185.

20. Following Bergson's definition of affection. I return to this in chapter 6.

21. Maturana, "Realität, Illusion und Verantwortung," 80.

22. Florian Rötzer, "Von Beobachtern und Bildern erster, zweiter und n'ter Ordnung," cited in Annette Hünnekens, *Der Bewegte Betrachter: Theorien der Interaktiven Medienkunst* (Cologne: Wienand, 1997), 133. Rötzer's claim is made in the midst of an analysis that engages Niklas Luhmann's constructivist epistemology. Accordingly, as Rötzer goes on to note, it would only be from the standpoint of an observer of the system that distinctions between image and environment can be made. As I see it, the implications of the primacy of affection over perception are somewhat more radical. This understanding of the effects of the VR interface underscores the importance of the operational perspective against any effort to circumscribe it from a supplementary observational perspective. Otherwise put, VR simulation does not present an epistemological problem that can be "solved" systems-theoretically, but rather involves a case where the autonomy of the operational body is central and in a sense untranscendable.

23. I borrow this term from Hans Jonas.

24. Weibel, "Virtual Worlds: The Emperor's New Bodies," in *Ars Electronica: Facing the Future,* ed. T. Druckrey with *Ars Electronica* (Cambridge, Mass.: MIT Press, 1999), 221. Incidentally, Weibel's argument here sounds a lot like Ruyer's claims for consciousness in *La*

Cybernétique et l'origine de l'information: "Consciousness, in the course of evolution through survival of the fittest, has created simulation, and through the simulation of survival ever more complex models and media, the legendary ghost in the machine creating ever improved machines for itself. Consciousness as the driving force behind evolution also creates the simulation of consciousness. Reality is perforated with simulation, with strategies of semblance and deceit, founded precisely in those mechanisms of selection I have described when I cited mimicry as an instance of adaptoral strategy. . . ." (220).

25. Crary presents these two models in *Techniques of the Observer,* 129ff.

26. Ibid., 129.

27. Ruyer, "Le Relief Axiologique," 245.

28. Shaw, "Project Description of EVE," in *Jeffrey Shaw: A User's Manual,* 139.

29. Ruyer, *Néo-finalisme,* 96.

30. Ruyer makes a distinction between "knowledge-consciousness" and "knowledge-observation" and argues that the former, that is, the state of consciousness correlative to the absolute survey is necessary to dispense with the infinite regression of the observational perspective: "Observation of an experience must thus still be the observation and description of this experience as mine. But another observer would be required to observe and describe the second observer, who observes and describes the first, etc." (ibid., 98).

31. Ibid., 97–98, emphasis added.

32. In a lecture given at the Institute for Advanced Study, April 6, 2002 at the behest of John Walsh. I thank Bill Viola for permission to cite his lecture.

33. On this point, Ruyer's analogy between the absolute surface and the Möbius strip (the exemplar of a topological figure) is revealing: Ruyer defines the absolute surface as "a surface with only one side (like the surface of Möbius, but in a completely different sense): if I see in my visual field a peripheral luminous spot moving in front of me, no mental procedure can allow me to see it moving away from me. . . . This fact is linked to the non-geometrical character of the conscious survey. If the sensible surface could be seen from two sides, it would not be a sensation, but an object" (*Néo-Finalisme,* 99).

34. Ruyer, "There Is No Subconscious: Embryogenesis and Memory," tr. R. Scott Walter, *Diogenes* 142 (summer 1988): 24–46, here 25.

35. Ruyer would, accordingly, agree with Bergson that consciousness *is* something, although for entirely opposite reasons: "What follows the 'of' of 'consciousness of . . . ,'" Ruyer suggests, "is not necessarily nor habitually an image of a visual nature. It is form being formed. A visual image is a particular form of form. But not every form is image" (ibid., 28). Specifically, it is not a consciousness of a content of consciousness (as it is for phenomenology);

nor is it a consciousness as the material content of perception (as it is for Bergson). (For an account of Bergson's understanding of consciousness, see *Cinema 1,* 60–61.) All "consciousness of . . . ," we might say, is the absolute self-possession of "consciousness-texture." It is the "equipotentiality" of a form: its biologically rooted capacity to be in excess of its own actuality, to be an autopoietic affective kernel.

36. For this reason, VR cannot be theorized as an extension of perception, as Andrew Murphie, following Deleuze, has proposed. Rather than a neo-Leibnizean "modulation of modulation" that effectuates "a change in the nature of the perception of the threshold of perception," what is at stake in VR is an extension of sensation itself. (Murphie, "Putting the Virtual Back into VR," 734).

37. Ruyer, "There Is No Subconscious," 36.

38. Here Merleau-Ponty's conception of the body, especially in his later ontology of the flesh, takes an important step beyond Ruyer's division of the body into the "organism" (which is more or less consubstantial with the cerebral cortex) and what he calls the "body" (which is an object of a scientific or observational standpoint and hence an epiphenomenon).

39. See *Néo-finalisme,* 105–106:

> since the absolute surface is intuited without a third dimension, nothing prevents us from conceiving of more general absolute domains [than the absolute surface], for example, absolute volumes. Primary organic consciousness must resemble [*ressembler à*] an absolute volume rather than an absolute surface, since, observed as body, it appears as volume. But, since geometric laws do not apply to subjective domains, the primary consciousness of a three-dimensional organism . . . does not require the hypothesis of a subject loged in a fourth dimension. Primary organic consciousness must in fact correspond to an absolute domain of space-time. The organism is never an instantaneous anatomical structure, but a set of processes. A species is characterized as much by the stages of its development as by its adult form. . . . Absolute domains imply, in principle, a possibility for the survey of time, as for that of space. . . .

40. *La Conscience et le Corps* (Paris: Librairie Félix Alcau, 1937), 27. This is Ruyer's doctrine of "reversed epiphenomenalism: "We are objects only in appearance, that is to say that our body is an object only abstractly, in the subjectivity of those who observe us (or even, partially, in ours, when we look at ourselves in a mirror. . .). We are not, and other beings are not any more than us, really incarnated. The duality of the body and the mind is illusory, *because we do not have body,* our organism is not a body" (ibid.).

41. Ibid., 139.

42. The term "warped surfaces" is adapted from Anthony Vidler's "warped spaces." The modification is meant to emphasize that the warping is of an operational, and not a psy-

choanalytic, nature: that it is an instrument to catalyze a survey of the body as absolute volume. See Vidler, *Warped Spaces* (Cambridge, Mass.: MIT Press, 2000).

43. This is the emphasis of Brian Massumi's work on hypersurface architecture, as I shall argue at length in chapter 6.

44. Consider, in this regard, Ruyer's disclaimer regarding his own apparent privileging of vision. While he notes the importance of considering vision, first and foremost, in order to understand consciousness (since it is the "most characteristic," if not the "highest" form), he warns of the "inconvenience" of this manner of proceeding. "It risks giving a falsely intellectualist, as well as a falsely static, appearance to psychological reality" (*La Conscience,* 135). Specifically, it risks obscuring the fact that consciousness is in the service of the real body, that the body is the "force which is served by articulations of the conscious surface and which leads 'the adventure and the drama'" (ibid.).

45. Diane Gromala, "Virtual Bodies: Travels Within," http://art.net/~dtz/vb.html, accessed June 13, 2002.

46. Documentation of this and other of Gromala's projects can be found at www.cc.gatech.edu/gvu/people/faculty/gromala.html.

47. Gromala, "Re-embodiment—Dancing with the Virtual Dervish: Virtual Bodies," in *Riding the Meridian,* 2(2): Women and Technology (2000), http://heelstone.com/meridian/gromala/gromala.html, accessed June 19, 2002.

48. Documentation of *Topological Slide* can be found at http://emsh.calarts.edu/~aka/topological_slide/Introduction.html.

49. Michael Scroggins and Stewart Dickson, "Topological Slide: Artist's Statement," http://emsh.calarts.edu/~aka/topological_slide/Artists_Statement.html, accessed June 13, 2002.

50. Ibid.

51. *The Parallel Dimension* is documented at www.nada.kth.se/~teresa/PDVR.html.

52. The VR-Cube is housed at the Center for Parallel Computers in Stockholm, where Wennberg was a resident artist. According to the PDC website, the Cube is "a room in which stereoscopic images are displayed on the four walls, the floor, and the ceiling. The six displays are synchronized to provide the users with a single surrounding 3D view. The perspective in the images displayed is adjusted according to the position and viewing direction of one of the users" (pdc.kth.se/projects/vr-cube, accessed June 13, 2002).

53. Teresa Wennberg, "The Parallel Dimension," nada.kth.se/~teresa/beskr.html, accessed June 13, 2002.

54. *Brainsongs* is documented at www.nada.kth.se/~teresa/BRS.html.

55. Wennberg, "Brainsongs," nada.kth.se/~teresa/BRS.html, accessed June 13, 2002.

56. Wennberg, "Artist's Statement," *ICC Online,* www.ntticc.or.jp/Calendar/2002/BRAINSONGS/preface.html.

57. Ibid.

58. Ibid.

59. Wennberg, "Brainsongs."

60. Wennberg, "Artist's Statement."

61. Documentation of *Room of Desires* can be found at http://pavel.cicv.fr/eng/chambre/index.html.

62. Louis Bec, "Pavel Smetana: The Room of Desires," in *Hardware—Software—Artware: The Confluence of Art and Technology. Art Practice at the ZKM Institute for Visual Media, 1992–97* (Ostfildern: Cantz Verlag, 1997/2000), 130.

63. Pavel Smetana, "Description of 'The Mirror,'" http://pavel.cicv.fr/eng/miroir/introduction/ssp32_art.html, accessed June 19, 2002.

64. Bec, "Pavel Smetana," 131.

65. Ibid., 132.

66. Alan Dunning and Paul Woodrow, "Einstein's Brain," www.ucalgary.ca/~einbrain/EBessay.htm, accessed June 19, 2002.

67. Documentation of the entire "Einstein's Brain" project can be found at www.ucalgary.ca/~einbrain.

68. Dunning and Woodrow, "Living Architecture: The Stone Tape, the Derive, the Madhouse," unpublished paper.

69. Antonio Damasio, *The Feeling of What Happens* (New York: Harcourt Brace, 1999), 171.

70. These include *Derive, The Fall/The Furnace/The Flesh,* and *Errant Eye.* In *Derive,* participants interact with an anatomically correct model of the human body into which are set approximately 100 proximity, pressure, light, and sound sensors. By means of this interface, participants modify a projected field of light so that points of light resolve into identifiable objects. As the artists describe it, the effect of this work is an "immersive experience in which participants find themselves disoriented and misled by the usual visual codes." The work thus suggests "an understanding of a world in flux, sustained only by the flimsiest of signposts and the most fleeting of memories." In *The Fall/The Furnace/The Flesh,* participants enter an immersive space comprising three rooms, each containing one porous wall made up of thousands of mono-filament nylon strands onto which is projected a video loop of (re-

spectively) a waterfall, a blazing fire, and human skin in extreme close-up. Within each room, the participant has the opportunity to interact with an anatomically correct model of a human head into which are placed pressure-sensitive pads and light and sound sensors corresponding to the 37 organs of mental and moral faculties identified by phrenology. Touching these pads and sensors triggers changes in corresponding images and texts projected on the walls and selected to provide evocative experiences of neurological sense processes. I discuss *Errant Eye* below.

71. See for example, Peter Fromherz, "Neuron-Silicon Junction or Brain-Computer Junction? (1997)," *Ars Electronica,* 166–167.

72. Dunning and Woodrow, "Errant Eye," www.ucalgary.ca/~einbrain/errant%20eye.htm, accessed June 19, 2002.

73. Dunning and Woodrow, "Einstein's Brain."

74. Ruyer borrows the term "self-enjoyment" from American philosopher Samuel Alexander. It designates the direct experience (primary and secondary) consciousness has of itself.

75. Bender, *Environmental Design Primer,* cited by Scott Fischer, "Virtual Environments, Personal Simulation & Telepresence," in *Ars Electronica,* 107.

76. Following my analysis above in chapter 2.

77. Ruyer himself notes that the absolute survey proves that a "certain part at least of the organism . . . is capable of being directly conscious of itself" (*Néo-Finalisme,* 102–103). The same is true of the absolute volume, which simply extends this capacity for direct experience to a larger part of the organism.

78. Ruyer, *Néo-Finalisme,* 122.

79. Edmund Couchot, "*Extrait d'un entretien avec Edmond Couchot,*" 1977, http://archives.CICV.fr/ATT/entd.html, accessed March 20, 2001.

80. Indeed, Deleuze's differentiation of a cinema of the brain and a cinema of the body might be understood as a symptom of this fundamental disembodiment. Specifically, the cinema of the body represents something like an effort to build the body back in, *after it has been abstracted away.* Needless to say, this involves a fundamentally different understanding of the body from the position developed here, a difference attested to by Deleuze's identification of the body with the body of the character (represented body). See *Cinema 2,* chapter 8.

81. For this reason, we must disagree with Deleuze's correlation of the absolute survey with the cinema of the brain. And more generally, we must dispute Deleuze's appropriation of Ruyer's notion in his analysis of the virtual (see Deleuze and Guattari, *What Is Philosophy?* 210). Far from underwriting an understanding of the concept as a "pure event or reality of the virtual," the absolute survey functions to correlate the equipotentiality of the brain with

the process of embodiment. Thus, in Ruyer's original conception, the absolute survey (like the absolute volume) is a process far more akin to virtualization as we have analyzed it in chapter 4: the affective or bodily dimension of the absolute survey underscores the crucial role played the the biocultural body in bringing the force of the virtual to bear on experience.

82. Rötzer, "Virtual Worlds: Fascinations and Reactions," in *Critical Issues in Electronic Media,* ed. S. Penny (Buffalo: SUNY Press, 1995), 128.

83. For this reason, the neuroaesthetics of new media art is a fundamentally embodied one: by foregrounding the body as a supplementary sensorimotor interval, VR art expands the neuroaesthetic dimesion to encompass the entirety of the body. Whereas Deleuze's neurocinema emerges from a model of the brain beyond science, this neuroaesthetics converges with recent work in neuroscience. Consider, for example, Gerald Edelman's account of the emergence of artistic expression from the bodily richness of neural processing: "The notion of bodily-based metaphor as a source of symbolic expression fits selectionist notions of brain function to a T. . . . [The process of making art arises] out of selection from variant repertoires of diverse neural elements in the brain. These are in turn guided by the form and movement of our bodies" (Whitney Biennial Exhibition catalog, 1995, 43–44).

84. De Kerckhove, "Ein neuro-kulturelles Verständnis von Kunst und Spiel," cited in Hünnekens, 156.

Chapter 6

1. This is the phrase used to describe the work in the accompanying brochure to the Whitney exhibition.

2. For a discussion of the development of the anamorphic representation from the late sixteenth century, see Jurgis Baltrusaitis, *Anamorphic Art,* trans. W. J. Strachan (Cambridge: Chadwyck-Healey, 1977).

3. Florian Zeyfang, "Amerikanische Kunst im Digitalzeitalter: 'Bitstreams' und 'Digital Dynamics' im Whitney Museum of American Art," *Telepolis: Magazin der Netzkultur,* www.heise.de/tp/deutsch/inhalt/sa/3604/1.html, accessed December 4, 2001. Pierogi Gallery, "Robert Lazzarini," www.pierogi2000.com/flatfile/lazzarin.html, accessed December 4, 2001.

4. Whether the secret of our mortality, as the art-historical reading of the skull as a *memento mori* would have it, or the secret of our symbolic existence, according to Lacan's famous appropriation of Holbein's image in *Seminar XI,* or some other secret entirely.

5. Here it is not without interest that recent computer modeling of Holbein's anamorphic image has both complicated and also simplified our understanding of anamorphosis, for although such modeling has revealed the existence of *two* privileged viewpoints for resolving

the anamorphic stain (rather than one), it has fundamentally demystified the illusion of anamorphosis by giving it a precise location *within* the "virtual" perspectival space of the computer. See Vaugh Hart and Joe Robson, "Han Holbein's *The Ambassadors* (1533): A Computer View of Renaissance Perspective Illusion," *Computers and the History of Art* 8(2) (1999): 1–13.

6. "Bitstreams" brochure, Whitney Museum, 2000.

7. In light of my argument to follow—and particularly my appropriation of certain aspects of Deleuze's notion of the sensually produced resemblance—it is not insignificant that Lazzarini suggests El Greco instead of Francis Bacon (who is, as we shall see, the object of Deleuze's analysis), saying that, although he has "learned much from Bacon's deformation process" and especially his "representations of isolated emotional states," his work is formally more similar to the distortions of El Greco in the sense that he is interested in extending to three dimensions the play and tension between object and image, space and surface that he finds in the Spanish painter. See Max Henry, "Interview with Robert Lazzarini," *Tema Celeste: Arte Contemporanea* 83 (January–February 2001), 65.

8. *Webster's Third New International Dictionary* (1993) defines anamorphosis as "a gradually ascending progression or change of form from one type to another in the evolution of a group of animals or plants; *esp.:* the acquisition in certain arthropods of additional body segments after hatching."

9. Edmund Couchot, "Les Objets-temps: Au-déla de la Forme," *Design, Miroir du Siècle,* ed. J. de Noblet (Paris: Flammarion/APCI, 1993): 382–389.

10. Friedrich Kittler, "Computer Graphics: A Semi-Technical Introduction," 33. Architect Greg Lynn has developed a notion of "animate form" that speaks directly to this problematic (see *Animate Form* [Princeton: Princeton Architectural Press, 1999]).

11. Blackhawk, "Notes on Bitstreams and Data Dynamics," March 23, 2001, at http://bbs.thing.net/@1007497120E4jWGvJSPimyiG@/reviews/display.forum?244, accessed December 4, 2001.

12. I define this term in the course of my argument below. For the moment, suffice it to say that digital modulation concerns the way the digital itself opens onto a continuous (i.e., not integral) flux of transformation.

13. See my discussion in the introduction and chapter 2.

14. Kittler, for example, focuses on the possible "optional optic modes" that can be developed on the basis of the computer image—raytracing and radiosity. (See "Computer Graphics," 35.)

15. That is, the "regardeur," using a term employed by Couchot, though perhaps in a slightly different sense, one that foregrounds precisely the impenetrability of the digital image (or in

this case, digital space) to our visually dominated perceptual and orientational system. See Couchot, "Image puissance image," 126.

16. Edmund Couchot, "Image puissance image," 124 and 126.

17. Consequently, the virtualization of pictorial perspective imagined by art historian Michael Baxandall—that, to cite Kittler's gloss (or rather imagining, since I can't find this in Baxandall), "computer graphics provide the logical space of which any given perspective painting forms a more or less rich subset" (Kittler, "Computer Graphics," 35)—does not apply.

18. See my discussion in chapter 4.

19. Deleuze develops the any-space-whatever in chapter 7 of *Cinema 1* and chapter 1 of *Cinema 2.*

20. Réda Bensmaïa, "L'espace quelconque comme 'personnage conceptuelle,'" in *Der Film bei/Deleuze/Le Cinéma selon Deleuze,* eds. O. Fahle and L. Engell (Weimar: Verlag der Bauhaus-Universität Weimar/Paris: Presses de la Sorbonne Nouvelle, 1997): 140–152.

21. I have analyzed this process of extraction above, in chapter 4.

22. Bensmaïa, "L'espace quelconque," 146.

23. These are the three techniques for producing cinematic any-space-whatevers that Deleuze develops in *Cinema 1,* chapter 7, and associates with German expressionism, Dreyer, and Italian neorealism respectively.

24. Bensmaïa, "L'espace quelconque," 147.

25. Deleuze, *Cinema 2,* xi.

26. This seamless transmutation is even more evident in Deleuze's treatment of the problematic of spectatorship. "It may be objected that the viewer has always found himself in front of 'descriptions,' in front of optical and sound-images, and nothing more. But this is not the point, For the characters [in the prewar cinema] themselves reacted to situations. . . . What the viewer perceived therefore was a sensorimotor image in which he took a greater or lesser part by identification with the characters. Hitchcock had begun the inversion of this point of view by including the viewer in the film. But it is now that the identification is actually inverted: the character has become a kind of viewer. He shifts, runs and becomes animated in vain, the situation he is in outstrips his motor capacities on all sides, and makes him see and hear what is no longer subject to the rules of a response or an action" (*Cinema 2,* 2–3). On the important topic of spectatorship and its (in)compatibility with Deleuze's theory, see Jean-Pierre Esquenazi, "Deleuze et la théorie du point de vue: la question du signe," in *Der Film bei/Deleuze/Le Cinéma selon Deleuze,* 1997):

372–387; and Esquenazi, *Film, Perception, et Mémoire* (Paris: Editions L'Harmattan, 1994), chapter 5.

27. Adolf Hildebrand, *The Problem of Form in Painting and Sculpture,"* trans. M. Meyer and R. M. Ogden (New York: G. E. Stechert, 1932).

28. "Optical" and "haptic" are terms originally proposed by art historian Alois Riegl in his study of antique reliefs (Riegl, *Late Roman Art Industry,* tr. R. Winkes (Rome: Giorgio Bretschneider, 1985). I return to these terms—and their constitutive, if limiting, role for art history—below.

29. Kalpakjian, cited in Jason Oddy, "The Disappearance of the Human," *Modern Painters* (fall 2000): 52–53, found at www.kalpakjian.com/ModPaint2.html, December 4, 2001.

30. As Kalpakjian explains, "I got really obsessed with adding as much information as possible, and with video you can only get limited resolution. Making still images meant that I could produce enormous pictures which contain really fine detail." Kalpakjian, cited in Oddy, "The Disappearance of the Human."

31. Marc Augé, *Non-Places: Introduction to an Anthropology of Supermodernity,* trans. J. Howe (London: Verso, 1995), 28.

32. Augé correlates nonplaces with the three "excesses" defining what he calls "supermodernity" (*surmodérnité*): (1) the excess of time rooted in the superabundance of events in the contemporary world; (2) the excess of space paradoxically correlated with the shrinking of the planet; and (3) the excess of the ego conditioned by the increasing necessity for individual production of meaning. Supermodernity itself is said to be the obverse of postmodernity, in the sense that its constitutive triple superabundance transforms the negative collapse of the idea of progress into something positive. "We could say of supermodernity that it is the face of a coin whose obverse represents postmodernity: the positive of a negative. From the viewpoint of supermodernity, the difficulty of thinking about time stems from the overabundance of events in the contemporary world, not from the collapse of an idea of progress which—at least in the caricatured forms that make its dismissal so very easy—has been in a bad way for a long time . . ." (Augé, *Non-Places,* 30).

33. See Rem Koolhaas, "The Generic City," in *Connected Cities: Processes of Art in the Urban Network,* eds. S. Dinkla and C. Brockhaus (Ostfildern: Hatje Cantz Verlag, 1999).

34. This constitutes one of the fundamental paradoxes of supermodernity: the fact that, in nonplaces, the modern subject "accedes to his anonymity only when he has given proof of his identity; when he has countersigned (so to speak) the contract" (Augé, *Non-Places,* 102). In strict opposition to the identity-grounding effect of anthropological place, the nonplace rarefies and homogenizes identity, simultaneously restricting it and functioning as the very source that confers its benefits. That is why the user of the nonplace is "always required to

prove his innocence" according to "criteria of individual identity . . . stored in mysterious databanks" (ibid.). Indeed, he might be said to acquire identity only at those moments when he meets this test: "a person entering the space of non-place is relieved of his usual determinants. He becomes no more than what he does or experiences in the role of passenger, customer, or driver. . . . [H]e retrieves his identity only at Customs, at the tollbooth, at the check-out counter" (103). Not incidentally, this conception of transitory identification resonates with Deleuze's analysis in his work on control societies (see Deleuze, "Postscript on Control Societies," in *Negotiations,* trans. M. Joughin [New York: Columbia University, 1995]).

35. Kalpakjian, cited in Tim Griffin, "Thin Film: Translucency and Transparency in Contemporary Art," *Art&Text* 74 (August–October, 2001), found at www.kalpakjian.com/ar/Text.html, December 14, 2001.

36. Edmond Couchot, "Les Objets-temps," 387.

37. Here a word is perhaps in order on how the mutation of empirical space performed by the ASW correlates with Deleuze's more general understanding of modern cinema. Effectively, space as "pure potential" correlates with the "second aspect" of modern cinema (the first being the sensorimotor break itself)—the abandoning of metaphor and metonymy and the dislocation of the internal monologue—insofar as it is "theorematic," that is, insofar as the "paths of its own necessity follow on from thought" (Deleuze *Cinema 1,* 174). Like the crystalline (or time-) image more generally, the cinematic ASW thus substitutes formal linkages of thought for the external sensorimotor logic of the action-image: in it, "the necessity proper to relations of thought *in the image* has replaced the contiguity of relations of images (shot-countershot)" (ibid., translation modified). For this reason, we must say that it can only be thought, that space as pure "being of sensation" can only be perceived—or rather conceived—in the mind's eye. As a theorematic figure, the ASW comprises a cinematographic automatism, and gives rise to a "hyper-spatial figure" (175), one that "is cut off from the outside world" (179). This hyper-spatial figure is, not surprisingly, a space experienceable only in the mind, a thought-space: it is the result of "the material automatism of images which produces from the outside a thought which it imposes" (178–179).

38. Bergson, *Matter and Memory,* 61, emphasis added.

39. Jonas, "The Nobility of Sight."

40. Ibid., 148, emphasis added.

41. De Kerckhove, "Touch versus Vision," 167.

42. The notion of the interval comes from Bergson, who uses it to describe the separation of a sensation from a motor response and thus the degree of indetermination of a perceptual center. Appropriating Bergson's schema, Deleuze correlates the interval with the movement-image, and specifically, with the affection-image, in which affection occupies the gap sepa-

rating sensation and motor action. My conception of the "internal interval" furnishes an alternate understanding of the correlation of Bergson's center of indetermination with the cinema. In my effort to remain faithful to the Bergsonist maxim that "there is no perception without affection," I not only resist Deleuze's move to strip perception of affection, but I suggest that affection does not simply fill the sensorimotor interval of the movement-image, that it in fact constitutes its own interval.

43. In terms of the historical trajectory sketched by Deleuze, this third stage of the affection-image (the production of the ASW by the "internal interval") would *succeed* the culmination of the ASW in the American experimental cinema, since it responds to the technical break with the minimal analogy that remains decisive even in the most "structuralist" of films. Despite what Deleuze says about experimental cinema, and about Michael Snow's *The Central Region* and *Wavelength* in particular, this final avatar of the cinematic ASW remains correlated with the potential of human movement in space. See *Cinema 1,* 122.

44. Gilles Deleuze, *Francis Bacon: La Logique de la Sensation* (Paris: Editions de la Différence, 1981), 75; 13.3, emphasis added. First page number refers to the French original; second chapter and page number refers to an unpublished English translation by Daniel W. Smith.

45. This is the case despite the fact that the Bacon study was written five years before *Cinema 1.*

46. Here is the important passage: "Thus we cannot be content with saying that analogical language proceeds by resemblance, whereas the digital operates through code, convention, and combinations of conventional units. For one can do at least three things with a code. One can make an intrinsic combination of abstract elements. One can also make a combination which will yield a 'message' or a 'narrative,' that is, which will have an isomorphic relation to a referential set. Finally, one can code the extrinsic elements in such a way that they would be reproduced in an autonomous manner by the intrinsic elements of the code (in portraits produced by a computer, for instance, and in every instance where one could speak of 'making a shorthand of figuration'). It seems, then, that a digital code covers certain forms of similitude or analogy: analogy by isomorphism, or analogy by produced resemblance" (75; 13.2–3). Though it is important to specify that it does *not* cover analogy by *sensually* produced resemblance, as we can see from the initial long passage on produced resemblance cited in the main text above.

47. Deleuze, *Francis Bacon,* 76; 13.3–4.

48. This interpenetration thus highlights the difference between cinema as a "sign system" and any codified semiological system. According to Deleuze, semiology "needs a double transformation" or reduction: "on the one hand the reduction of the image to an analogical sign belonging to an utterance; on the other hand, the codification of these signs in order to discover the (non-analogical) linguistic structure underlying these utterances. Everything

will take place between the utterance by analogy, and the 'digital' or digitized structure of the utterance" (27).

49. Deleuze, *Cinema 2*, 27.

50. Ibid.

51. Ibid., 27–28.

52. "Systemic" in the sense of Deleuze's notion of a "system of reality" or "system of the movement-image."

53. Kittler introduces something like a notion of digital modulation in the course of his discussion of the "problem of sampling rate." Specifically, Kittler speaks of a "hypernature"—as created for example by digital music and computer graphics (at least in principle)—which is said to be "distorted" when sampling is applied to it (that is, when it is treated as a "discrete matrix"): "discrete matrices—the two-dimensional matrix of geometric coordinates no less than the three-dimensional matrix of color values—pose the fundamental problem of sampling rate. Neither nature, so far as we believe we understand it, nor hypernature (as produced by computer music and computer graphics) happen in actuality to be resolved into basic digital units. For this reason, digitalization, in terms of our perception, always also means a distortion" ("Computer Graphics," 32–33).

54. Kathy Rae Huffman, "Video and Architecture: Beyond the Screen (1994)," in *Ars Electronica*, 135.

55. This parallel might be deepened and made more complex by introducing Bacon's pronounced dislike for photographs. See Deleuze, *Francis Bacon*, chapter 11.

56. In his explanation of how modulation explains the analogical diagram (and also how painting transforms analogy into a language), Deleuze conceives of this expressive autonomy of sensation in terms of a new form of relief—a new instance of the haptic mode of figuration. "In order for the rupture with figurative resemblance to avoid perpetuating the catastrophe, in order for it to succeed in producing a more profound resemblance, the planes, starting with the diagram, must maintain their junction; the body's mass must integrate the imbalance in a deformation (neither transformation nor decomposition, but the "place" of a force); and above all, modulation must find its true meaning and technical formula as the law of Analogy. It must act as a variable and continuous mold, which is not simply opposed to relief in chiaroscuro, but invents a new type of relief through color" (*Francis Bacon*, 77; 13.5).

57. The Figure is said to form a new produced resemblance "*inside the visual whole*, where the diagram must operate and be realized" (ibid., 78; 13.6, emphasis added). As the basis for sensually produced resemblance in the domain of painting, modulation can thus be said to operate on a single plane of Analogy.

58. This understanding resonates with Couchot's claim that the numerical image breaks with an understanding of the image from the perspective of an "organizing center" or, in Bergson's parlance, a center of indetermination. According to Couchot, this exclusion has the effect of catalyzing a supplementary, extravisual contact with the image: "The subject certainly loses, in this delocalization, a part of its famous attributions: its capacity to construct perspectives. . . . The link between the 'looker on' and the image no longer exclusively follows the optical arrow of the look. . . . It borrows different means: those of the alphanumeric 'entries' of the keyboard on which are written the instructions destined to the computer, and those of direct and instantaneous analogical entries. The fingers and the hand, gestures, displacements of the body, movements of the eyes and the head, breath, the voice itself, become instruments of dialogue with the image" (Couchot, "Image puissance image," 129–130).

59. Deleuze defines the Figure as the body without organs in chapter 7 of *Francis Bacon:* "the Figure is the body without organs (dismantle the organism in favor of the body, the face in favor of the head); the body without organs is flesh and nerve; a wave flows through it and traces levels upon it; a sensation is produced when the wave encounters the Forces acting on the body, an 'affective athleticism,' a scream-breath. When sensation is linked to the body in this way, it ceases to be representative and becomes real . . ." (33; 7.1). I criticize the notion of the body without organs as a disembodying of the organic body in "Becoming Other as Creative Involution? Contextualizing Deleuze and Guattari's Biophilosophy," *Postmodern Culture* 11(1) (September 2000). Available through Project Muse at http://muse.jhu.edu/journals/pmc/vo11/11.hansen.html.

60. Éric Alliez, "Midday, Midnight: The Emergence of Cine-Thinking," in *The Brain is the Screen: Deleuze and the Philosophy of Cinema,* ed. G. Flaxman (Minneapolis: University of Minnesota, 2000): 293–302, here 302, n. 29.

61. Deleuze, *Cinema 2,* 12–13.

62. This art-historical concept of the haptic, I must insist, *does not* coincide with the use of the term in current discussions of, say, the haptic interface in digital design, where it is the sensory experience of touch (*as opposed to* vision) that becomes central.

63. Deleuze, *Francis Bacon,* 82; 14.3.

64. Ibid., 88; 15.2–3.

65. "'Colorism' means . . . that color itself is discovered to be the variable relation, the differential relation, on which everything else depends. . . . Colorism claims to bring out a peculiar kind of sense from sight: a haptic sight of color-space. . . " (ibid., 88; 15.3).

66. De Kerckhove, "Touch versus Vision," 144.

67. In fact, he claims that there is a difference in kind and not merely in degree between them.

68. This view further suggests that affection comprises a *mode of action* proper to the body, and not (as Deleuze would have it) a suspension of or alternative to action. Indeed, everything Bergson has to say about affection is oriented toward explaining the genesis of the body from the aggregate of images, that is, how the body comes to occupy a privileged position within the aggregate.

69. See above, page 216.

70. Bergson, *Matter and Memory,* 55.

71. Ibid.

72. Ibid., 55–56. This is the passage cited by Deleuze in his account of Bergson's definition of affect.

73. Ibid., 56.

74. Ibid., 57. It follows from the body's capacity to act on itself that it possesses extension in itself: it is the "internal space" of the body—the distance between the isolated sensory organ and the organism as a whole—that is constitutive of affection. Affection, in short, arises when the organism as a whole experiences the isolated sensitive element. Thus, it is not the expressive element taken by itself, as Deleuze would have it, but the body's act of experiencing this element. Put another way, we could say that, unlike perception (that is, pure perception), which "subsists, even if our body disappears," affection cannot exist independently from the body: "we cannot annihilate our body without destroying our sensations" (ibid., 58). Affection, in short, makes the body a center of indetermination or interval in a different sense than is involved in perception. Affection differs in kind from perception because it is no longer the reflection onto objects of the action given at a distance (i.e., virtually) by these objects, but real action; yet, as real action in this sense, it is not simply deterministic, like the necessary and imperceptible action of images among themselves. Rather, as one commentator puts it, affection "supposes a distance internal to an image, between the parts and a whole" (Frédéric Worms, *Introduction à Matière et Mémoire de Bergson: Suivie d'une Brève Introduction aux Autres Livres de Bergson* [Paris: PUF, 1997], 73). Affection, that is, involves a real action of a part of the body (an isolated sensitive element) on the body as a whole.

75. Ibid.

76. Ibid., 74.

77. This point is essential insofar as it establishes a generalized correlation of affect with body. While affection can be defined in relation to many types of bodies—indeed to all systems, from human beings to the most primitive organisms and perhaps even to inanimate feedback mechanisms, that display some minimal form of interval—it cannot be separated

from the perspective of some such body or other. There is, in other words, no affect in general; prior to its contraction in this or that body, the universe of images (plane of immanence) has no affective dimension. As the materiality of systems capable of acting on themselves, affects, rather, are actualizations of this universe of images, or better, effects of such actualizations.

78. Brian Massumi, "The Autonomy of Affect," 97.

79. Ibid., 96.

80. Massumi's debt to Deleuze is omnipresent, but see especially "The Autonomy of Affect," 93; Massumi, "The Bleed: Where Body Meets Image," in *Rethinking Borders,* ed. J. C. Welchman (London: Macmillan Press, 1996), notes 3, 5, 9, 10. Although he specifies his debt to Bergson, he nowhere foregrounds the Bergsonist notion of affection.

81. Massumi, "The Bleed," 23.

82. Ibid., 22.

83. Ibid., 30–31.

84. This understanding of vision contravenes the important distinction Bergson draws between perception as a virtual action of the body on things and affection as a real action of the body on itself. As I understand it, Massumi's account comprises an effort to inject a bodily element into perception without deriving it from affection (as a modality of sensation proper to the body). In this respect, it is remarkably faithful to Deleuze.

85. Massumi lists several architectural practices in "Strange Horizon: Buildings, Biograms, and the Body Topologic," in *Architectural Design: Hypersurface Architecture II,* 69: 8/9 (September/October 1999): 12–19, here 18.

86. "When we are momentarily lost, the buildings in front of us are in plain view. They may be strangely familiar, but we still can't place ourselves. Oddly, the first thing people typically do when they realize they're lost and start trying to reorient is to look away from the scene in front of them, even rolling their eyes skyward. We figure out where we are by putting the plain-as-day visual image back in the proper proprioceptive sea-patch. To do that, we have to interrupt vision . . ." ("Strange Horizon," 13). This account assumes, of course, that we are already familiar, though in a way that is momentarily forgotten or out of reach, with the space in which we are lost.

87. I borrow the notion of the whatever body from Giorgio Agamben for whom it holds the hope of producing a "community without presuppositions and without subjects" (*The Coming Community,* trans. M. Hardt [Minneapolis: University of Minnesota Press, 1993], 65). As Agamben sees it, the promise of the whatever body stems from its constitutive impropriety, its "thus-ness" (*quel-conque*), which lends it the capacity to "appropriate the historic

transformations of human nature that capitalism wants to limit to the spectacle" (50). To make good on this promise, Agamben argues, humanity must "link together image and body in a space where they can no longer be separated, and thus . . . forge the whatever body, whose *physis* is resemblance"—that is, resemblance without archetype or sensually produced resemblance (50). I discuss Agamben's concept of the whatever body in my "Digitizing the Raced Body," *SubStance,* forthcoming.

88. As is well known, Riegl defined the haptic in opposition to the optical in his consideration of the antique relief in *Late Roman Art Industry;* according to Riegl, the haptic correlates with the *Kunstwollen* of antiquity in which the dominant sculptural relief plane lent the artistic object a self-containedness and, via its projection of volume, solicited a perception via touch. As the relief plane grew flatter, this haptic modality gave way to an optical modality that led to Renaissance perspective and the classical tradition as we know it. Yet, despite Riegl's insistence on the role of shadows, the importance of the viewer's position and movement, and the tangibility of the surface that could, Riegl specified, almost be felt in the dark, what remains fundamental here is the way that perception remains identified with visuality: the haptic remains a specific modality of vision that stands alongside, and indeed in dialectical tension with, the optical, which, historically at least, is said to have succeeded it. It is remarkable how faithful Deleuze is to this determination: "we will speak of the *haptic,*" he says, "whenever there is no longer a strict subordination in either direction, but when sight discovers in itself a specific function of touch that is uniquely its own, distinct from its optical function. One might say that painters paint with their eyes, but only insofar as they touch with their eyes" (*Francis Bacon,* 99; 17.1).

89. Antonia Lant, "Haptical Cinema," *October* 74 (fall 1995): 45–73, here 68.

90. Lant, "Haptical Cinema," 69. See Hansen, *Embodying Technesis,* chapter 9.

91. De Kerckhove, "Touch versus Vision," 147.

92. Whereas cinema immobilized the viewer in order to make its (visual) haptic address more forceful, in *skulls* the viewer (or rather the "looker on") is free to move about at will (as she was in front of the antique relief), only now bodily movement does not—and cannot—join up with the warped space projected by the image.

Chapter 7

1. Joke Brouwer, "Introduction," *Machine Times* (Rotterdam: V-2 Institute, 2000), 5.

2. Brouwer, "Introduction," 4.

3. Stephanie Strickland, "Dali Clocks: Time Dimensions of Hypermedia," *Electronic Book Review* 11 (winter 2000/2001): 3, available at www.altx.com/ebr/ebr11/11str.htm, accessed October 16, 2001.

4. Strickland, "Dali Clocks," 3.

5. Although we have, arguably, lived in such a networked world since the widespread dissemination of radio in the 1920s, what differentiates our current moment is the capacity for bidirectional transmission of information in "real time" as well as the reliance on digital computing as the material infrastructure for such transmission.

6. By, for example, Francisco Varela in his recent work on time-consciousness. I discuss Varela's work below.

7. Brouwer, "Introduction," 5.

8. Joachim Paech, "Das Bild zwischen den Bildern," cited in Yvonne Spielmann, "Vision and Visuality in Electronic Art," in *Video Cultures: Multimediale Installationen der 90er Jahre,* ed. U. Frohne (Karlsruhe: Museum für Neue Kunst, 1999), 65.

9. See Paul Virilio, *The Vision Machine* and John Johnston, "Machinic Vision," as well as my analysis in chapter 3 above.

10. "Description of *Transverser,*" *Machine Times,* 83.

11. Further information concerning *Transverser* can be found at www.khm.de/projects/artcologne/christi/html/project1_en.php.

12. "A simple way to understand the information structure of TX-transform is to imagine a 'flip-book' showing sequential pictures which, when rapidly rifled with the tip of the thumb, produces the illusion of motion. Like a reel of film, this toy contains all the spatial aspects of motion and can be understood as an 'information block.' Normally this block is rifled from front to back along the time axis to create the illusion of filmic movement. TX-transform rifles through this 'information block' in quite a different way by cutting through the space axis instead of the time axis" (Martin Reinhart, "Description of *TX-Transform,*" www.tx-transform.com, 2).

13. Reinhart, "Description of *TX-Transform,*" 4.

14. Consider here Deleuze's account of the distinction between the open whole and the whole as outside: "[In the classical cinema,] the open merged with the indirect representation of time: everywhere where there was movement, there was a changing whole open somewhere, in time. This was why the cinematographic image essentially had an out-of-field which referred on the one hand to an external world which was actualizable in other images, on the other hand to a changing whole which was expressed in the set of associated images. . . . When we say 'the whole is the outside,' the point is quite different. In the first place, the question is no longer that of the association or attraction of images. What counts is on the contrary the *interstice* between images, between two images: a spacing which means that each image is plucked from the void and falls back into it. . . . The whole undergoes a

mutation, because it has ceased to be the One-Being, in order to become the constitutive 'and' of things, the constitutive between-two of images" (*Cinema 2,* 179–180).

15. Reinhart, "Description," 8.

16. Such an aesthetic function is exemplified in Godard's method: "Given one image, another image has to be chosen which will induce an interstice *between* the two. This is not an operation of association, but of differentiation, as mathematicians say, or of disappearance, as physicists say: given one potential, another one has to be chosen, not any whatever, but in such a way that a difference of potential is established between the two, which will be productive of a third or of something new" (Deleuze, *Cinema 2,* 179–180).

17. See, respectively, Raymond Bellour, "The Double Helix," in *Electronic Culture;* Yvonne Spielmann, "Vision and Visuality"; Gene Youngblood, "Cinema and the Code," cited in Spielmann, "Vision and Visuality," 64–65.

18. See, for example, Deleuze, *Cinema 2,* 266.

19. Leslie Camhi, "Very Visible . . . and Impossible to Find," *ARTNews* (summer 1999), 144.

20. Douglas Gordon, cited in Amy Taubin, "24-Hour Psycho," in *Spellbound,* ed. C. Dodd (London: BFI Publishing, 1996), 70.

21. Despite his insistence on the erotic origin of his generation's relation to film, Gordon does not focus on the psychoanalytic dimension of this wealth of secret information contained between images in film. As Boris Groys astutely points out, Gordon "bypasses what has become almost unavoidable in our century: the direct reference to the realm of the unconscious" (Boris Groys, Exhibition Review, *Artforum* [February 1999], 90). Certainly a feat remarkable in itself, this bypassing of the unconscious is made all the more remarkable since Gordon dwells in the domain of the psychological, turning repeatedly to personal histories, emotional experience, private obsessions, and perverse desire as the source of raw material for his transformative artistic practice. This situation has not prevented critics from submitting his work to a psychoanalytic protocol. See, for example, Joanna Lowry, "Performing Vision in the Theatre of the Gaze: The Work of Douglas Gordon," in *Performing the Body/Performing the Text,* ed. A. Jones and A. Stephenson (New York: Routledge, 1999): 273–282; and Christine Ross, "The Insufficiency of the Performative: Video Art at the Turn of the Millennium," *Art Journal* (spring 2001), cited at http://proquest.umi.com, accessed November 10, 2001.

22. Camhi, "Very Visible," 144.

23. Deleuze, *Cinema 2,* 210.

24. Deleuze and Guattari, *What Is Philosophy?* tr. R. Galeta and H. Tomlinson (New York: Columbia University Press, 1994), 209.

25. On this point, see Deleuze's characterization of Resnais's cinema of the brain, in the context of his discussion of the biology of the brain as a new framework to understand cinema:

> The circuits into which Resnais's characters are drawn, the waves they ride, are cerebral circuits, brain waves. The whole of cinema can be assessed in terms of the cerebral circuits it establishes, simply because it's a moving image. Cerebral doesn't mean intellectual: the brain's emotive, impassioned too. . . . You have to look at the richness, the complexity, the significance of these arrangements, these connections, disjunctions, circuits and short-circuits. Because most cinematic production, with its arbitrary violence and feeble eroticism, reflects mental deficiency rather than any invention of new cerebral circuits. What happened with pop videos is pathetic: they could have become a really interesting new field of cinematic activity, but were immediately taken over by organized mindlessness. Aesthetics can't be divorced from these complementary questions of cretinization and cerebralization. Creating new circuits in art means creating them in the brain too. (*Negotiations,* tr. M. Joughin [New York: Columbia University Press, 1995], 60)

26. See expecially Varela's account of "embodied enaction" in *The Embodied Mind: Cognitive Science and Human Experience* (Cambridge, Mass.: MIT Press, 1991). A more concise version is available in his essay "The Reenchantment of the Concrete," in *Incorporations.*

27. Varela, "The Specious Present," in *Naturalizing Consciousness,* ed. J.-P. Dupuy et al. (Stanford: Stanford University Press, 1999), 267.

28. In this sense, what matters is the general correlation of affect and time in the *human* experience of time, a correlation that Varela's analysis shares with the Heideggerian-Deleuzian genealogy of time (where time precedes affect).

29. Varela, "Specious Present," 273.

30. Ibid., 270.

31. Ibid., 272–273.

32. Ibid., 273.

33. Ibid., 277, emphasis added.

34. The spatiality or extension of temporal consciousness corresponds with the three-part structure of the now, as Husserl himself underscored: "Present here signifies no mere now-point but an *extended objectivity* which modified phenomenally has its now, its before and after" (*The Phenomenology of Internal Time Consciousness,* cited in Varela "Specious Present," 278, emphasis added). Crucial to Husserl's understanding is the incompressibility of the now that emerges from the analysis of retention: retention must be understood as a "specific

intentional act intending the slipping object"; it is an "active presentation of an absence that arises from the modifications and dynamic apprehension of the now" (282).

35. Dan Zahavi, "Self-Awareness and Affection," in *Alterity and Facticity*, eds. N. Depraz and D. Zahavi (Amsterdam: Kluwer, 1998), 213.

36. Varela, "Specious Present," 296.

37. Ibid., 302.

38. Varela and Depraz, "At the Source of Time: Valance and the Constitutional Dynamics of Affect," in *Ipseity and Alterity*, Arob@se: An electronic journal, www.liane.net/arobase, 2000, 152, accessed October 14, 2001.

39. To date, Stiegler's corpus comprises three books and a handful of articles, as well as an important interview with Derrida. These are *Technics and Time I: The Fault of Epimetheus*, tr. R. Beardsworth and G. Collins (Stanford: Stanford University Press, 1999); *La Technique et le temps II: La désorientation* (Paris: Galilée, 1996); *La Technique et le temps III: Le temps du cinéma et la question du mal-être* (Paris: Galilée, 2001); "L'image discrête," in J. Derrida and B. Steigler, *Echographies de la Télévision* (Paris: Galilée, 1996); and "The Time of Cinema: On the 'New World' and 'Cultural Exception,'" tr. R. Beardsworth, *Tekhnema* 4 (1998): 62–113. Stiegler has also written an important article on Derrida, "Derrida and Technology: Fidelity at the Limits of Deconstruction and the Prosthesis of Faith," tr. R. Beardsworth, in *Jacques Derrida and the Humanities*, ed. T. Cohen (Cambridge: Cambridge University Press, 2001): 238–270.

40. This reading is developed most explicitly in chapter 4 of *La Technique et le temps II*, "*Objet Temporel et Finitude Rétentionelle*," 219–278, and is usefully summarized in "The Time of Cinema," 68–76.

41. Husserl gives as examples of an object of "image-consciousness" a bust or a painting where the artist in effect archives her experience in the form of a memory trace. While this trace can be experienced later by another consciousness, it could not be said that it is experienced by this consciousness, since it has been neither perceived nor lived by this consciousness. It is an image of the past, and of the memory of another consciousness, but it cannot be the image of a memory that is part of the lived past of the consciousness viewing it at a later date. For this reason, Husserl excludes image-consciousness from any role in time-consciousness. Stiegler's strategy is to reverse this exclusion by showing how tertiary memory—memory that has *not been lived by consciousness*—is in fact the very condition of time-consciousness.

42. This move involves two specific critical "corrections" of Husserl's analysis, which are themselves conjugated together in Stiegler's analysis of contemporary media technology. On the one hand, Stiegler contests the fundamental opposition of perception and imagination on which Husserl's important differentiation of primary retention from secondary memory (or recollection) is based. On the other hand, Stiegler contests Husserl's blanket exclusion of

"image-consciousness" (tertiary memory) from time-consciousness. In both cases, Stiegler's criticisms involve a questioning of the primacy accorded the category of the lived (*vécu*) in Husserl's analysis. Moreover, the two corrections are, not surprisingly, themselves intrinsically correlated, since it is precisely in virtue of the absolute distinction between perception and imagination that Husserl is able to exclude image-consciousness from the phenomenon of time-consciousness.

43. Stiegler, "The Time of the Cinema," 76.

44. Ibid., 66.

45. Ibid., 84.

46. Thus, whereas Deleuze can perhaps be criticized for failing to take into account the specificity of cinema as a recording technology, Stiegler can be criticized for reducing cinema to a recording technology. For Stiegler's brief analysis of Deleuze, see "The Time of the Cinema," 66.

47. It is precisely this reduction of perception to memory that I term "technesis." See my *Embodying Technesis* (especially chapter 4) for a critique of this reduction in the work of Derrida. This same objection would also apply to Stiegler's analysis of the digital where numerization (i.e., digitization) is understood as according the spectator the means to develop a critical analysis (in the technical sense of a decomposition of elements) of the image. In this case, the digital remains exclusively a means to decompose a memory-image.

48. And here would be included the decomposition of these technologies made possible by digitization and which, for Stiegler, facilitate a critical analysis of the image and coincidence of the flux of the temporal object and the flux of consciousness.

49. Indeed, with his thesis that the entire past is condensed in every perceptual act, Bergson already puts into place something like tertiary memory, except that here it is freed from its correlation with consciousness and thus given an even more radical deterritorializing function than it is in Stiegler.

50. This assumption, in turn, is rooted in Stiegler's further conflation of retention and memory, following his appropriation of Derrida's deconstruction of Husserl. The story behind this conflation is a complex one that is largely beyond my scope here. Suffice it to say that Steigler inherits the deconstruction of the retention versus memory (or perception versus imagination) from Derrida, and specifically, from Derrida's critique of Husserl in *Speech and Phenomena*. On this account, the present can appear as such only inasmuch as it is "continuously compounded with a nonpresence and nonperception." Accordingly, the "difference between retention and reproduction, between primary and secondary memory, is not the radical difference Husserl wanted between perception and nonperception; it is rather a difference between two modifications of nonperception" (Derrida, *Speech and Phenomena*, tr. D. Allison [Evanston: Northwestern University Press, 1973], 64–65).

51. We might even speak here in terms of a distinction between two kinds of memory, following Bergson yet further: alongside an "image-memory" through which the content of the past can be reactualized in the present, there is a "habit-memory" that supplements the finite retentional power of consciousness by bringing the fruit of past experience directly (i.e., nonrepresentationally) to bear on present activity. As the embodying of skills (including technically facilitated ones), habit memory forms nothing less than the mechanism by which living duration can enlarge its own scope. We could supplement Bergson's own analysis by asserting the categorical privilege of habit memory in the context of our image saturated culture, since habit memory, *qua* mechanism for duration to enlarge itself, is itself the vehicle for living duration to select image memory, that is, for an opening onto an ever-expanding domain of tertiary memory. (This is precisely the argument made by Raymond Ruyer in "There Is No Subconscious," 36.) However, the more important point to keep in mind is that, on Bergson's account, *both* forms of memory themselves privilege activity in the present. Accordingly, both preserve some crucial sense of distinction between the living duration and its recollection or habitual prolongation of the past.

52. Derrida, *Speech and Phenomena*, 66. Here it is important that Derrida does not, as Stiegler does, simply conflate retention and secondary memory. His point is rather that both involve the modification of nonperception—and thus that there is no such thing as a perceptual instant or moment of full presence—and that they do so in different ways. It is this latter difference that is addressed in Bergson's difference of degree between perception and memory.

53. Zahavi, "Self-Awareness and Affection," 213.

54. In this sense, although Derrida may be right that, in an absolute sense (i.e., at a purely microphysical level), the durational now, no less than memory itself, can be no more than a phantom presence, a present fraught with nonpresence, such an argument in principle must be differentiated from a historically specific engagement with technologies of time. In this respect, I would side entirely with Stiegler in his debate with Derrida concerning the technical specificity of *différance*. Indeed, I see Stiegler's insistence on this specificity, and his correlation of it with the real-time mediation of our contemporary global televisual system, as an argument for identifying the now with the interval specific to human synthesis, and thus (in contradistinction to his conclusions) for distinguishing retention from tertiary memory. For the Derrida–Stiegler debate, see Derrida and Stiegler, *Echographies*. For a helpful and insightful critical commentary on this debate as a missed encounter, see Richard Beardsworth, "Towards a Critical Culture of the Image," *Tekhnema* 4 (spring 1998), accessed at http://tekhnemafree.fr/contents4.html.

55. It is not that the physiological range of the now itself changes as technology develops. Indeed, the scope of the now remains more or less constant despite the immense technologization that our culture has undergone. It would be more accurate to say that technology, by allowing for more information to be filtered through this more or less fixed interval, opens

it to the new. Furthermore, in a way not dissimilar to the operative role played by recording on Stiegler's analysis, we might say that it is current computational technology and machine time that make the identification of such a physiologically fixed scope possible at all. And they do so, moreover, not simply because they introduce the technical complexity necessary to measure brain activity, but because they make the question of the now relevant in a way that it wasn't before.

56. In this respect, it is striking that Stiegler barely mentions Husserlian protention, which does form a counterpart to retention in Derrida's analysis in *Speech and Phenomena*. When he does mention it, moreover, he reduces it to retention (see, for example, his consideration of the role "sequential expectations" in the spectatorial synthesis in "The Time of the Cinema," 102).

57. Indeed, although Viola's interest in temporal flexibility afforded by audiovisual media dates from the mid-1980s if not earlier, it is the specific conjunction of cinema and video, made technically possible by digitization, that is crucial to the aesthetic experimentation with time at issue in his current work.

58. Stern developed his conception on the basis of infant-parent observation, but he does extend it, in a very interesting analysis, to art and specifically to photography. See Stern, *The Interpersonal World of the Infant,* chapter 4.

59. In a lecture at the Institute for Advanced Study, Princeton, New Jersey, May 6, 2002, followed by a discussion with art historian and former Getty Museum director John Walsh. Hereafter cited as Viola, "Lecture." I thank Bill Viola for permission to videotape his lecture and to use this material here.

60. Viola, "Lecture." This insight into the excessive emotional plenitude is also the motivation behind Viola's systematic exploration of the representation of the passions in the Old Masters, an exploration that began during his year in residence at the Getty Center in 1998. More specifically, it helps to account for the concrete iconographic sources of *Quintet of the Astonished.*

61. Here we could say that Gordon's use of found material instantiates Stiegler's model of cinema as the exemplary engagement with tertiary memory, except that Gordon's interest in finding the degree-zero of cinematic perception lends a priority to temporal flux of consciousness over the flux of the temporal object and thus prepares the way for their disengagement.

62. In his lecture, Viola insisted on the radical difference between film and video. Referring to experimental filmmaker Hollis Frampton's claim that film is the last machine, Viola stressed that video is not directly related to film, but rather to sound technology: rather than working with an indexical inscription of the real, it works with a signal that is already a transformation-abstraction of the inscribed event.

63. Steigler, "The Time of Cinema," 110, and more generally, 92–112.

64. This isomorphism is an extension of the correlation of the flux of the temporal object and the flux of consciousness. "It is necessary," Stiegler insists in his analysis of the digital image, "to take into account *two* syntheses: one corresponding to the technical artifact in general, the other to the activity of the subject 'spontaneously' producing her 'mental images.'" In effect, this extension has the consequence of limiting the source of the spectator's affection to what gets (or can be) synthesized by the machine: "the spectator is affected *in the same manner* in which she synthesizes through the photo-graphic image as the receptacle of the 'argentic' effect without which the photographic noema *would not take*" (Stiegler, "L'image discrète," in *Echographies,* 177–178).

65. The quotation marks are meant to indicate that such images are first and foremost processual and embodied within the human and coincide only incidentally, if at all, with technical images.

66. "Analogical-numeric technology of images (as well as that of sounds) opens the epoch of the analytic apprehension of the image-object. And because synthesis is double, the payoff of new analytical capacities is also one for new synthetic capacities" ("L'image discrète," 179). Here we can clearly see that Stiegler's understanding of the digital is purely instrumental: by allowing for a flexibility in the machinic synthesis, it allows the subjective synthesis to regain an upper hand, but it does not alter in any way the givenness of the image as image.

67. Viola, "Lecture."

Conclusion

1. Jean-Pierre Esquenazi has attempted to supplement Deleuze's theory with a reception theory. See *Film, Perception, et Mémoire,* chapter 5, and especially, "Deleuze et la théorie de la point de vue."

Index

Absolute surface (Ruyer), 175

Absolute survey (Ruyer), 83, 163, 164, 170, 171, 176, 178, 188. *See also* transpatial domain

 as frameless vision, 175

 contrasted with photographic image, 174

Absolute volume (Ruyer), 178, 180, 188, 190–192, 194, 236

Aesthetic culture, as shift from ocularcentris to haptic aesthetic, 12

Aesthetics, subordination of technics to, 215

Affect, excess of, 156

Affection, 4, 11, 12, 15, 29, 39, 100, 134

 as action of body on itself, 58

 as active modality of bodily action, 7

 Bergson's vs. Deleuze's conception, 135

 as category of experience, 266

 of consciousness, 265

 as content of particular media interfaces, 87, 92

 embodied basis of, 202, 215

 as embodied form-giving, 203

 as extended internal interval, 225

 as medium of contact with digital, 141, 142

 as permutation of movement-image, 6

 priority over perception, 168

 technically extended beyond body, 58–9

 virtualization of, 207

Affection-image (Deleuze), 6, 14, 134–

138, 140, 141, 143, 147, 149, 204, 217, 268, 269

Affective anticipation, 244, 245, 253

Affective attunement, 136, 261. *See also* "Vitality affects (Stern)"

Affective body, 5, 15, 21

Affective conflict, in VR art, 180

Affective contagion, 265

Affective dimension, 101

Affective space, 147

Affective tonality, 265

Affectivity, 7, 8, 13–15, 89, 91, 101, 115, 117, 122, 124, 130, 133, 137, 146–148, 161, 176, 177, 215, 227, 229, 249, 250

 as action of body on itself, 230

 as agent of selection, 112

 as assimilation of vision into body, 232

 as basis for imaging of digital flux, 121

 as basis of perception, 269

 as bodily "capacity for. . . ," 143

 as conduit between machines and humans, 157

 as counter to automation of vision, 102

 embodied basis of, 136

 as embodied basis of time consciousness, 253

 as extended internal interval, 226

 as the faculty of the "new," 266

 and impact of machine time on timeconsciousness, 252

 as medium of any-space-whatever, 209